Transmedia Selves

This book examines the mediated shift in the contemporary human condition, focusing on the ways in which we synthesise with media content in daily life, essentially transmediating ourselves into new forms and (re)creating ourselves across media.

Across an international roster of essays, this book establishes a transdisciplinary theory for the 'transmedia self', exploring how technological ubiquity and digital self-determination combine with themes and disciplines such as celebrity culture, fandom, play, politics, and ultimately broader self-conception and projection to inform the creation of transmedia identities in the twenty-first century. Specifically, the book repositions transmediality as key to understanding the formation of identity in a post-digital media culture and transmedia age, where our lives are interlaced, intermingled, and narrativised across a range of media platforms and interfaces.

This book is ideal for scholars and students interested in transmedia storytelling, cultural studies, media studies, sociology, philosophy, and politics.

James Dalby is a Senior Lecturer in Digital Media at the University of Gloucestershire in the UK. He specialises in a range of disciplines within the creative and tech industries, including XR and immersive (virtual reality, Web3 etc.), AI, transmedia, cinematography, and visual special effects, and has published and spoken internationally on immersive and XR, transmedia, social technologies, and media economics. His work also includes the development of pioneering undergraduate curricula, in which disruptive methodologies and workflows, such as Design Thinking, are structurally embedded as part of an overall paradigm. James is currently undertaking a PhD studying correlations between the use of social, immersive, and Web3 technologies, and perceived chronoceptive distortion, and has further interests in tech, Philosophy, posthumanism, and transhumanism.

Matthew Freeman is Reader in Multiplatform Media at Bath Spa University, where he is the Research Lead for Film and Media and Co-director of The Centre for Media Research in the Bath School of Art, Film and Media. Matthew led the university's Communication, Cultural, and Media Studies submission to REF2021, and is currently the Course Leader for the BA (Hons) Media Communications degree. Matthew is the Founder and Director of Immersive Promotion Design Ltd., a new breed of R&D-led marketing consultancy that supports virtual and augmented reality creatives and businesses to better communicate with their audiences about the magic of immersive content. The company is based at The Studio in Bath, Bath Spa University's new enterprise and innovation hub for creative technology.

Routledge Advances in Transmedia Studies
Series Editor: Matthew Freeman

This series publishes monographs and edited collections that sit at the cutting-edge of today's interdisciplinary cross-platform media landscape. Topics should consider emerging transmedia applications in and across industries, cultures, arts, practices, or research methodologies. The series is especially interested in research exploring the future possibilities of an interconnected media landscape that looks beyond the field of media studies, notably broadening to include socio-political contexts, education, experience design, mixed-reality, journalism, the proliferation of screens, as well as art- and writing-based dimensions to do with the role of digital platforms like VR, apps and iDocs to tell new stories and express new ideas across multiple platforms in ways that join up with the social world.

Transmedia Narratives for Cultural Heritage
Remixing History
Nicole Basaraba

Multiplicity and Cultural Representation in Transmedia Storytelling
Superhero Narratives
Natalie Underberg-Goode

Transmedial Character Studies
Lukas R.A. Wilde and Tobias Kunz

Participatory Worlds
The Limits of Audience Participation
José Blázquez

Transmedia Selves
Identity and Persona Creation in the Age of Mobile and Multiplatform Media
Edited by James Dalby and Matthew Freeman

For more information about this series, please visit: www.routledge.com/Routledge-Advances-in-Transmedia-Studies/book-series/RATMS

Transmedia Selves
Identity and Persona Creation in the Age of Mobile and Multiplatform Media

Edited by James Dalby and
Matthew Freeman

LONDON AND NEW YORK

First published 2024
by Routledge
4 Park Square, Milton Park, Abingdon, Oxon OX14 4RN

and by Routledge
605 Third Avenue, New York, NY 10158

Routledge is an imprint of the Taylor & Francis Group, an informa business

© 2024 selection and editorial matter, **James Dalby and Matthew Freeman**; individual chapters, the contributors

The right of **James Dalby and Matthew Freeman** to be identified as the authors of the editorial material, and of the authors for their individual chapters, has been asserted in accordance with sections 77 and 78 of the Copyright, Designs and Patents Act 1988.

All rights reserved. No part of this book may be reprinted or reproduced or utilised in any form or by any electronic, mechanical, or other means, now known or hereafter invented, including photocopying and recording, or in any information storage or retrieval system, without permission in writing from the publishers.

Trademark notice: Product or corporate names may be trademarks or registered trademarks, and are used only for identification and explanation without intent to infringe.

British Library Cataloguing-in-Publication Data
A catalogue record for this book is available from the British Library

ISBN: 978-0-367-68057-2 (hbk)
ISBN: 978-0-367-68060-2 (pbk)
ISBN: 978-1-003-13401-5 (ebk)

DOI: 10.4324/9781003134015

Typeset in Sabon
by SPi Technologies India Pvt Ltd (Straive)

Contents

List of Contributors *vii*

Introduction: Conceptualising the Transmedia Self 1
JAMES DALBY AND MATTHEW FREEMAN

PART I
Communication of the Self 7

1 Story of the (Virtual) Self: Transmedial Narrative Construction through Social Media Usage 9
JEESHAN GAZI

2 Personal Storytelling: A Semiotics Approach to Constructing Identities across Media 22
PAOLO BERTETTI AND GIUSEPPE SEGRETO

3 Professional Transmedia Selves: Finding a Place for Enterprise Social Media 39
CHRISTOFFER BAGGER

4 The Post-digital Self: How Transmedia Dissolves the Boundaries of Work and Tourism 52
KARIN FAST AND ANDRÉ JANSSON

PART II
Technologies of the Self 67

5 The Transtemporal Self: Transmedia, Self, and Time 69
JAMES DALBY

6 Crossing Space-Time-Action: Digital Self-Tracking Technologies and the Zero-Dimensionality of the Transmedia Self (via Vilém Flusser's First and Second Degree Imaginations) 85
JENNA NG

7 Geotagging the Self: Analysing the Locative Dimension of Constructed Transmedia Identities 99
MILTON FERNANDO GONZALEZ RODRIGUEZ

8 Made in My Image: Co-Produced Fantasy and the Politics of Play 112
CHRIS CAMPANIONI

PART III
Politics of the Self 131

9 Trans, Media and [In]Visibility: Trans Representation in the Transmedia Era 133
KAYLEE KOSS

10 The Manosphere: Incel as Transmedial Construction 147
EMILY PRATTEN

11 #PrayforAmazonia: Transmedia Mobilisation within National, Transnational and International Identities 161
GEANE CARVALHO ALZAMORA, RENIRA RAMPAZZO GAMBARATO AND LORENA TÁRCIA

12 The Kabir Project: Using Transmedia Work to Disrupt Right-Wing Narratives of Othering 179
FATHIMA NIZARUDDIN

Index *191*

Contributors

Geane Carvalho Alzamora is a PhD in Communication and Semiotics (PUC SP, Brazil), Associate Professor at the Social Communication Department at Federal University of Minas Gerais (Brazil), and a researcher at CNPq (Process: 312279/2022-5) and FAPEMIG (Process: PPM-00562-18) – geanealzamora@ufmg.br

Christoffer Bagger holds a PhD in digital media, work and organization from the Center for Tracking and Society, University of Copenhagen. His thesis work centered on enterprise social media at the boundary between work and non-work, and how media usage complicates this dichotomy. His research has been published in *International Journal of Communication*, *Nordicom Review*, and the edited volumes *Reckoning with Social Media* and *Queerbaiting and Fandom*. His book reviews have been published in *The European Journal of Communication* and *ephemera: theory & politics in organization*.

Paolo Bertetti is researcher at the University of Turin and Professor at the University "Guglielmo Marconi" in Rome. His research interests concern Narratology, Transmedia Studies, Semiotic Theory, Film Semiotics and Semiotics of Text. Among his books: *ll mito Conan. Identità e metamorfosi di un personaggio seriale tra letteratura, fumetto, cinema e televisione* (2011), *Il discorso audiovisivo; Teorie e strumenti semiotici* (2012); *Lo schermo dell'apparire* (2013); *Transmedia Archaeology* (2014; with C. Scolari and M. Freeman); *Transmedia Branding* (2020; ed. with Giuseppe Segreto); *Che cos'è la transmedialità* (2020).

Chris Campanioni's research on regimes of surveillance, queer migration, and the auto-archival practices of people moving across transnational spaces has been published by *Diacritics*, *Social Identities*, *Life Writing*, and the *Journal of Cinema and Media Studies*. His multimedia work has been exhibited at the New York Academy of Art, and the film adaptation of his poem "This body's long (& I'm still loading)" was in the official selection of the Canadian International Film Festival in 2017. His forthcoming books include a second edition of *A and B and Also Nothing* (Unbound Edition, 2023/Otis Books Seismicity Editions, 2020) and *Windows 85* (Northwestern University Press, 2024). He is a recipient of

the International Latino Book Award (2014), the Pushcart Prize (2016), and the Academy of American Poets College Prize (2013).

James Dalby is a Senior Lecturer in Digital Media, and the creative and tech industries at the University of Gloucestershire in the UK. He specialises in a range of disciplines including XR and immersive (virtual reality, Web3 etc.), AI, transmedia, cinematography, and visual special effects, and has published and spoken internationally on immersive and XR, transmedia, social technologies, and media economics. His work also includes the development of pioneering undergraduate curricula, in which disruptive methodologies and workflows, such as Design Thinking, are structurally embedded as part of an overall paradigm. James is currently undertaking a PhD studying correlations between the use of social, immersive, and Web3 technologies, and perceived chronoceptive distortion, and has further interests in tech. philosophy, posthumanism, and transhumanism.

Karin Fast (PhD) works as Associate Professor in the Department of Geography, Media and Communication at Karlstad University, Sweden, and as Researcher in the Department of Media Studies at the University of Oslo, Norway. Her research covers topics such as mediatization, transmedia, geomedia, and digital disconnection. She has authored the monograph *Transmedia Work: Privilege and Precariousness in Digital Modernity* (2019, with A. Jansson, Routledge).

Renira Rampazzo Gambarato is Professor in Media and Communication Studies at Jönköping University, in Sweden. Her areas of expertise revolve around transmedia studies, Peircean semiotics, and design thinking. Her recent books are *Theory, Development, and Strategy in Transmedia Storytelling* (2020), *The Routledge Companion to Transmedia Studies* (2019), and *Exploring Transmedia Journalism in the Digital Age* (2018).

Jeeshan Gazi, PhD, is REF Impact Manager at Goldsmiths, University of London. His research explores a range of media, often identifying points of convergence between forms and addressing a variety of topics – from the usage of technologies to issues of representation and political engagement. His work has previously been published in journals including *Surveillance and Society*, *SubStance*, *Jump Cut: A Review of Contemporary Media*, and the *Journal of Graphic Novels and Comics*.

Milton Fernando Gonzalez Rodriguez is a Marie Curie Fellow affiliated with Cultural History since 1750 Research Group (KU Leuven). His recent publications include *Indigeneity in Latin American Cinema* (2022) and *Ontologies and Natures: Knowledge about Health in Visual Culture* (2022). He is currently working on a series of papers on the intersection between language in media, historical sociolinguistics, and science communication.

André Jansson is Professor of Media and Communication Studies and Director of the Centre for Geomedia Studies at Karlstad University,

Sweden. He is specialized in mediatization research and communication geography and has published articles in a wide range of international journals across disciplinary boundaries. His most recent monograph is *Rethinking Communication Geographies: Geomedia, Digital Logistics and the Human Condition* (Edward Elgar, 2022).

Kaylee Koss, PhD, is an internationally published and exhibiting artist, writer and musician, and is currently an adjunct lecturer in Digital Media & Marketing. She holds a doctorate in Art Production and Investigation, an MA in Media and Digital Realities, and a BA *cum laude* in Business Management. Kay was also a founding director of Dublin-based nonprofit arts organisations Moxie Music & Resources and the Independent Museum of Contemporary Arts (IMOCA).

Jenna Ng is Senior Lecturer in Film and Interactive Media at the University of York, UK. She works primarily on digital visual culture, but also has research interests in the philosophy of technology, the posthuman, computational culture, and the digital humanities. She is the editor of *Understanding Machinima: Essays on Films in Virtual Worlds* (Bloomsbury, 2013), and author of *The Post-Screen through Virtual Reality, Holograms and Light Projections: Where Screen Boundaries Lie* (Amsterdam University Press, 2021) which was awarded Honourable Mention in the Best First Monograph category by the British Association of Film, Television and Screen Studies (BAFTSS).

Fathima Nizaruddin is an academic and filmmaker. She is currently affiliated with the International Research Group on Authoritarianism and Counter-Strategies of the Rosa Luxemburg Stiftung. She was an Assistant Professor at Jamia Millia Islamia, New Delhi from 2007 to 2020.

Emily Pratten is a postdoctoral researcher at the University of Birmingham, completing her thesis on masculinities and gendered violence under neoliberalism. She received her Master's from the University of Exeter, where she researched white supremacy, the linguistics of meme culture, and the role played by fringe internet groups in the 2016 election of Donald Trump.

Giuseppe Segreto teaches Social Media Marketing within the Master's Degree Program in Communication Strategies and Techniques and carries out research on branding and digital marketing at the Department of Social, Political and Cognitive Sciences of the University of Siena. He is a member of the board and responsible for the institutional relations of the Post-degree Course in Corporate Communication of the University of Siena. As a communication consultant, he works for companies, institutions, and non-profit organizations.

Lorena Tárcia is a Professor of Communication and Arts at the Centro Universitário de Belo Horizonte in Brazil. Her most recent book is *Theory, Development, and Strategy in Transmedia Storytelling* (Routledge, 2020).

Introduction
Conceptualising the transmedia self

James Dalby and Matthew Freeman

A transmedia age

One of my former 'go-to' maxims relating to media displacement theories – which I'm sure my undergraduate students became quite tired of hearing – went something along these lines:

> we live in a post-broadcast 'transmedia age', which means we no longer equate media content with the device that we use to access it. We don't think about TV as being on televisions and we don't equate Radio to being on radios, and neither do we think of 'watching some iPad this evening'.

However, what began as a useful phrase to quickly sum up a key aspect of the contemporary media landscape became so 'obvious' (students would look at me expectantly, waiting for the delivery of something genuinely insightful!) that I had to retire one of my favourite maxims. After all, social media alone has become nothing less than Selwyn and Stirling's suggestion of 'a cornerstone of everyday life' (2018, 1), while if we look more broadly, the prevalence and ubiquity of contemporary media content occurring simultaneously and interchangeably across a broad range of platforms and touchpoints – a heterarchy we sometimes refer to as *transmedia* – is now normalised to the point of being (arguably) self-evident. While the maxim had its day therefore, the premise it contained of a 'transmedia age' is still relevant (and perhaps pertinent) to our overall principle of *transmedia selves*.

The suggestion of a 'fourth industrial revolution' (Schwab, 2017) has been with us for some time, to the extent of becoming a focus of UK government policy in a 2019 white paper examining potential regulatory strategy (Department for Business, Energy & Industrial Strategy, 2019), while more recently the so-called Industry 5.0 concept takes a similar view toward potentially intelligent and autonomous technologies in workplace environments. It is natural to define epochs of history with an identity relating to key influential imperatives such as governance, economics, and industry, given that historically (and particularly in 'Westernised' contexts) these have often been

DOI: 10.4324/9781003134015-1

principal drivers for the rest of contemporary life (society, science, education, arts, etc.). However, in the current environment we may ask whether the notion of an *industrial* revolution' – of any iteration – to describe and encompass the breadth of contributory imperatives upon the present day does full justice to the reality of the situation. It is perhaps understandable that Schwab, the founder and executive chairman of the World Economic Forum, would view the currently developing epoch through such a lens, and perhaps also that governments would take regulatory steps as such. At the same time, given the increasing decentralisation of content and delivery which has shifted the landscape firmly away from mass media to a more dynamic content-and-platform heterarchy, it is also conceivable that in our current epoch it is, in fact, the foundational interdependence of individuals and societies with various media forms, and with computing technologies and systems more broadly, which influences governance, economics, and industry, rather than the other way around.

My maxim above, then, is now not only 'obvious'; it also falls short of the mark, relating as it does to what we might consider 'entertainment media' only. The reality instead is that due to the deeply embedded and interdependent profile of transmedia content in many aspects of life to a potentially global extent – including professional, social, political, educational, governmental, industrial – it makes sense to consider a 'transmedia age' not as something distinct from a 'broadcast age' – which really applies only to more 'traditional' media concerns – but instead as the defining identity of the currently developing epoch, in the way that previous epochs have been 'industrial' or 'digital'. By this reasoning, the reach and ramifications of a transmedia age will affect all who live within it, whether they actively or extensively engage with transmedia technologies and content or not, in the same way we might view all global inhabitants of an industrial age as being affected by its fundamentals in governance, economics, and work, whether or not they are directly or personally engaged with industry.

At the same time, we may of course argue that industrial and economic concerns are still primary drivers of the current epoch, with transmedia content, platforms, and technologies remaining products of these concerns rather than the other way around, and it is not the intention of this introduction to attempt to disprove Schwab's concept. Indeed, it is highly unlikely that any research will be able to unpick such complex and systemic global interdependencies to the extent of accurately illustrating a causal hierarchy, and confidently placing the economic horse in front of the transmedia cart, or vice versa. Ultimately, though, this is just a technical distinction, because it's not a stretch to suggest that transmedia content and technologies may have the most direct and influential relationship with the day-to-day lived experience of many people around the globe (assuming of course that we position transmedia in its proper place as being of less fundamental importance than essential needs such as food and housing, which, being fundamental in any era, have rarely been distinctive enough to be used as the defining characteristic of

a particular epoch), making the suggestion of a 'transmedia age' entirely plausible, and a realistic representation of the fundamentals of the era. Consequently, if we accept that we do live in a transmedia age therefore, it follows that we may also be *transmedia selves*.

Conceptualising the transmedia self

When we originally conceived of this collection, Matt Freeman and I were very aware that the book's title – *Transmedia Selves* – and subsequent theme were based on two terms without universal, or (arguably) even widely accepted, definitions. Humans may have been discussing and trying to make sense of *self* for perhaps longer than we have had means of recording the conclusions, while *transmedia* has been a flexible term with varied definitions and conceptions for all of the two-decades-and-counting that it has been in use. The challenge posed by this is quite straightforward; any attempt to discuss either term, let alone both together, could be hobbled before it begins simply due to variance in definition of the key terms. In essence, this could produce a book in which each chapter might struggle to find a definitive conclusion, simply due to the shifting foundational sands we had asked them to be built upon.

Nevertheless, we decided to proceed!

In practice these concerns haven't been realised. On the contrary in fact, we have found the opposite; that the opacity of both terms has resulted in a breadth of conceptual latitude, from which the book's contributors have produced compelling and insightful work, examining each from a variety of perspectives, including themes of geography and location, sexuality, religious observation, economics, psychology, sociology, and politics. The end result can perhaps be conceived as somewhat analogous to the artist who draws multiple freehand lines to capture planes, angles, and contours when sketching their subject, the aggregation of marks on paper providing the suggestion of the shape to the viewer, rather than explicitly describing it. Each chapter of this collection contributes its own conceptual shape and identity, with at the same time clear areas of confluence, hopefully offering the reader the aggregate suggestion (rather than description) of aspects of a transmedia self. Throughout the collection we find discussions of changeable visibility of self (both by choice and without), the narrativity of self in various ways, the relationships of self and others, the position of transmedia selves in a neoliberal landscape – in which selves (and aspects of self) may become commodities, and traditional demarcations between professional and personal selves can become fluid, as brands become selves and selves become brands – and self as data, self as abstraction, self as memory, self in space and time.

Ultimately, this book examines a mediated shift in the contemporary human condition, focusing on the ways in which we synthesise with media content and technologies in daily life, essentially transmediating ourselves into new forms. Across a truly international roster of essays, the book aims

to establish a transdisciplinary theory for the 'transmedia self', exploring how technological ubiquity and digital self-determination combine with themes and disciplines such as celebrity culture, fandom, play, politics, and ultimately broader self-conception and projection in what Elwell (2014) calls 'the liminal space between the virtual and the real', to inform the creation of transmedia identities in the twenty-first century. Specifically, the book repositions transmediality as key to understanding the formation of identity in a post-digital media culture and transmedia age, where our lives are interlaced, intermingled, and narrativised across a range of media platforms and interfaces.

A statement of aims

While digital relationships with daily life have been argued to influence the participation of fans (Hills, 2002) and forms like advertising (McStay, 2010), most of the research on digital technologies and mobile devices has focused on commercial interactive media forms such as promotional videos and consumer websites. But as digital technologies and mobile devices continue to bring media interfaces into the workings of our daily lives, a salient question is not so much '*what* is transmedia?' but rather '*where* is transmedia?' Today, the social significance of transmediality – most broadly describing 'structured relationships between different media platforms and practices' (Jenkins, 2016) – has become intertwined with daily life, shaping the construction of personal identities and everyday behaviour in ways that go far beyond its original definitional framing of entertainment media (Jenkins, 2006), branding (Grainge & Johnson, 2015), and even cultural, political, and heritage-based projects (Freeman & Proctor, 2018). As Jansson and Fast (2018: 340) observe,

> anyone with access to a connected media device can sign up for a social media account, start spreading snapshots from his or her life, recommending things to buy or places to go, even setting up a private video channel. As media users, we are also increasingly expected to do this.

Building directly on Jansson and Fast's attempt to argue for 'the broadened relevance of "transmedia identities" as a term that captures [...]how transmediatized and liquidized lives are constituted more generally' (2018: 347), this book aims to establish a transdisciplinary theory for the 'transmedia self', exploring how we can understand the practice of 'using multiple media technologies to present information ... through a range of textual forms' (Evans, 2011: 1) as that which augments the self and our technological, political and communicative experience of it. By 'transmedia self', we mean the use of transmediated digital content – namely, across digital technologies and mobile devices – to transform how people construct and make sense of

personal identities, with the affordances of digital technologies and mobile devices bringing both digital and real worlds together in ways that create ontologically complex personas across multiple media platforms. Specifically, we focus on the ways in which people continue to be driven by meaningful social connections both on- and off-line, and how the innate human need to share stories that allow us to be part of something larger than ourselves resonates across media.

Ongoing conceptions of transmedia selves

The ubiquity and pervasiveness of media content and technologies is one of the defining characteristics of the early twenty-first century, whether or not we accept the suggestion of a transmedia age. As digital technologies continue to develop and expand their functionality and reach, and media becomes less associated with 'entertainment' and more closely aligned with the fundamentals of contemporary daily life, mobile media and computing devices have cemented their essentiality in the day-to-day lived experience of individuals in many broad, varied, and interlinked demographics. The synthesis of human and device, tangible and virtual, physical and digital, will continue to develop at a pace which could conceivably leave conceptual understanding behind; indeed, as we have seen that the concept of transmedia resists attempts to provide a single acceptable definition, so we may find the same for various conditions within Elwell's 'limbic space'. As an example, terms such as 'IRL' ('in real life'), 'flesh and blood reality', and even 'the *meat*verse' (as a counterpoint to the metaverse) have been used in a variety of contexts to attempt to distinguish the traditional lived experience of 'reality' from digital/virtual/online equivalents. None has yet found common currency, however, perhaps due to variables including the continually changing experience of such 'limbic' technologies and platforms, as well as the varied uses and engagements of individuals and groups. As we progress towards closer and more fundamental synthesis with AI and AGI technologies, and the potential for multiply aligned virtual meta-worlds – such as the themes suggested by the forthcoming metaverse – we may continue to find that broad conception is out-of-step with the breadth of opportunities within our lived experience. This may be fascinating – such as the holarchic conception of Instagram I commented on in 2021 (Dalby, 2021: 4), where we may view the platform as 'both a single-experience totality, and simultaneously an enormous breadth of varied experiences, linked as a complex system of interdependencies' – and troublesome, such as Jaron Lanier's well-documented concerns about the 'antihuman' (2011: 22) nature and design of ubiquitous computing technologies. Perhaps in such an environment, instead of attempting to find useful definitions for the continuously fluid technologies of a transmedia age, a more effective strategy is to concentrate on conception of our own transmedia selves.

A note on the collection

This book has experienced a rather troubled development. A number of unforeseen factors have delayed the project at various stages, and while delays in book publishing are not uncommon, it is important to acknowledge the fact in this case due to the rapidly changing nature of transmedia. It may be, for example, that the research and ideas of the book's contributors have developed further since their chapters were written, while discussion of some more contemporary technologies, such as AI tools including ChatGPT/GPT4 and Web3/the metaverse, which likely would have been a consideration in some chapters, are not present. Some source data referred to may also have changed or updated since chapters were written. The book remains a valuable contribution to the literature however, not least because of the (arguably) 'timeless' nature of self as the other theme of the collection, and we are confident that the reader will find plenty to enjoy within its pages.

References

Dalby, J. (2021). Holarchic Media: When transmedia just isn't Transmedia enough. *Academia Letters*. [online]. Available at: https://www.academia.edu/50142363/Holarchic_Media_When_transmedia_just_isnt_Transmedia_enough

Department for Business, Energy & Industrial Strategy (2019). *Regulation for the Fourth Industrial Revolution*. GOV.UK. [online]. Available at: https://www.gov.uk/government/publications/regulation-for-the-fourth-industrial-revolution/regulation-for-the-fourth-industrial-revolution

Evans, E. (2011). *Transmedia Television: Audiences, New Media, and Daily Life*. Abingdon, Oxon: Routledge.

Elwell, J. S. (2014). The transmediated self: Life between the digital and the analog. *Convergence*, 20(2), 233–249. https://doi.org/10.1177/1354856513501423

Freeman, M. & Proctor, W. (2018). *Global Convergence Cultures. Transmedia Earth*. Abingdon, Oxon: Routledge.

Grainge, P. & Johnson, C. (2015). *Promotional Screen Industries*. Abingdon, Oxon: Routledge.

Hills, M. (2002). *Fan Cultures*. London, England: Psychology Press.

Jansson, A. & Fast, K. (2018). Transmedia Identities. From Fan Cultures to Liquid Lives In Freeman, M. & Gambarato, R. (Eds.), *The Routledge Companion to Transmedia Studies*. Abingdon, Oxon: Routledge.

Jenkins, H. (2006). *Convergence Culture: Where Old and New Media Collide*. New York, NY: New York University Press.

Jenkins, H. (2016). Transmedia logics and locations. In B.W.L. Derhy Kurtz & M. Bourdaa (Eds.), *The Rise of Transtexts. Challenges and Opportunities* (pp. 220–240). Abingdon, England: Routledge.

Lanier, J. (2011). *You Are Not a Gadget*. London, England: Penguin Books.

McStay, A. (2010). A qualitative approach to understanding audience's perceptions of creativity in online advertising. *The Qualitative Report*, 15(1), 37–58.

Schwab, K. (2017). *The Fourth Industrial Revolution*. London, England: Penguin Books.

Selwyn, N. & Stirling, E. (2018). *Social Media and Education: Now the Dust Has Settled*. Abingdon, Oxon: Routledge.

Part I
Communication of the Self

1 Story of the (Virtual) Self
Transmedial Narrative Construction through Social Media Usage

Jeeshan Gazi

Introduction

Invoking Anthony Giddens' notion of the 'project of the self,' Rebekah Willett writes of how the media shared online by a social media user 'work to construct a coherent identity, one that may include random images, but one which is nevertheless narrated in a specific way' (2009: 220). Positing this narrated identity as the 'virtual self' of the social media user, this chapter builds on my earlier work in this area, which drew on Alice E. Marwick's conception of social media usage as being underpinned by a lateral structure of peer-to-peer surveillance – by which 'people self-monitor their online actions to maintain a desired balance between publicity and seclusion, while readily consuming the profiles and status updates of others' (Marwick, 2012: 379) – and conceptualised the images posted by and of a user (selfies) as imbued with a *soiveillant* character – the image represents not only the self, but the surveillance of one's self, figuring the selfie as an image of the user as seen by someone else (Gazi, 2018). This is to say that every image posted by a user on a social media platform is marked by the user's anticipation of how others will receive it, which determines their choice of image donation on such platforms. This theoretical structure accounts for the paranoia of social media usage that is evident in a number of recent qualitative studies in this area. (See, for instance, Caldeira, Van Bauwel and De Ridder, 2020; Terán, Yan and Aubrey, 2020).

Moving forward, this chapter conceptualises the construction of the virtual self through the use of online platforms as a form of transmedial storytelling whose components consist of a range of audio-visual and textual formats and whose overarching narrative is participatory in its nature, given that it is determined by the lateral power structure of social media by which there is the production of images but also feedback that determines such production.

In conceiving of the virtual self as a narrative construct, I am aligning my conception of narrative with that proposed by Marie-Laure Ryan: 'narrative meaning as a cognitive construct, or mental image, built by the interpreter in response to the text ... a type of meaning that transcends aesthetics and

DOI: 10.4324/9781003134015-3

entertainment' (2004: 8–9). The virtual construction of the self further aligns with Ryan's conception of a 'narrative script,' which requires three key elements: a world that is populated by characters, changes of state that create a temporal dimension, and the ability to construct a plot via the coherence produced by an interpretive framework. Each of these will be unpacked in relation to the virtual self by the end of this chapter. Ryan further draws a distinction between *being a narrative* and *having narrativity*, which also lends itself to the conception of the virtual self (2004: 10). The former is 'predicated on any semiotic object produced with the intent of evoking a narrative script in the mind of the audience,' while the latter is the ability to evoke such a script, such that 'we may form narrative scripts in our mind in response to life' (Ryan, 2004: 9).

In order to validate the proposed alignment between the virtual self as a narrative construction with the above conception of narrative, we must be able to determine the nature of the semiotic objects that constitute the narrative and the relational manner in which they are held together within the mind of the interpreter, which is the focus of the first half of this chapter, with the nuances of such construction then being demonstrated through three case studies of social media usage.

The Semiotic Units of the Virtual Self

Regarding the first point of interest, the most obvious semiotic object within the narrative script of the virtual self as produced by social media would be the selfie. This form of self-portraiture continues to be a major component of social media engagement, as evident from recent market studies – for instance, a study of 5,750 Europeans in 2019 that indicated an average of 597 selfies were taken by survey participants that year (Honor, 2019) – and the focus of much scholarship, often exploring the relationship between selfie production and dissemination to identity formation and behaviour. However, the building blocks by which social media users construct a virtual self are far broader than that of individual or group selfies, encompassing text-based posts that proffer opinions and thoughts, commentary on other social media users' posts, and the posting of content that is produced elsewhere but shared by the user on their social media profile, such as memes, videos, articles, links, other users' posts, and the media that the latter feature. The posting of such secondary units of media indicates affiliations with broader interests, ideologies, and/or discourse, or critique of the same in the cases when they are accompanied by commentary (whether textual or simply an emoji) intended to indicate this. And all such units constitute self-representation in the online sphere.

This is recognised by Katrin Tiidenberg and Andrew Whelan, who, using the heuristic of 'genre, and community genre literacies, to shift focus away from the "meaning" or referentiality of particular images, and toward the participatory practices and strategies of image production, circulation, and

use,' posit online self-representation as a genre that comprises identification with myriad visual and textual data in a flexible, intertextual, and recognisable manner (2017: 143). These scholars emphasise the importance of local contextual frames to the circulation of units of self-representation and demonstrate the nuance of context-specific practice by explicating the manner in which a range of visual materials are recognised by participants of two separate online communities with differing contexts to align with the identity of the user who posts them – that of #GPOY (Gratuitous Picture of Yourself), which revolves around explicit self-identification with images other than of one's self, and Everyday Carry, by which the community sites themselves provide the context for the alignment of visual media (here images of objects) with the poster's identity. On a similarly local level, Tiidenberg and Whelan describe 'a post that combines the caption, the hashtags, and the image' as 'an intertextually legible content assemblage' that 'is produced, and recognized as indexical to a self the poster in that moment identifies with or wants to identify with' (2017: 147). This focus on the local scale is enlarged here in order to account for the construction of the virtual self through such online activities. This is to say that the conception of the virtual self posited in this chapter is an intertextually legible content assemblage made up of the myriad of locally contextual posts that constitute the user's multi-platform social media usage.

That social media users tend to communicate through multiple platforms is evident from a survey of over 175,545 internet users aged 16–64 which found that, in 2020, social media users engaged with 8.6 different platforms on average (GlobalWebIndex, 2020: 15), with the most popular platforms being Facebook, YouTube, WhatsApp, Facebook Messenger, Weixin / Wechat, Instagram, Douyin / Tiktok, QQ, Qzone, Sina Weibo, Reddit, Snapchat, Twitter, Pinterest, Kuaishou (in descending order) (WeAreSocial and HootSuite, 2020: 95). Each of these sites enables communication through a range of visual and textual media types – from gifs to infographics to family photos; short form missives to status updates to extended textual passages; videos of various duration, style, and tone – albeit privileging some forms over others and each consisting of local contextual frames for their usage, with tacit, and sometimes explicit, rules of engagement for their respective community. Yet their individual domains converge by way of their simultaneous engagement by users, as sometimes encouraged by the site owners through their enabling of linked accounts, regardless of corporate ownership, which creates an interconnected social media identity for the user. Though many users may very well – and perhaps wisely – sub-divide their networks for professional and social purposes, and sub-divide further to separate their engagement with those inside and outside of their family, in all such cases, the cross-usage of multimodal media artefacts constitutes an assemblage by which users construct their broader online identity – their virtual self.

This construction occurs in a manner akin to Richard Saint-Gelais' concept of transfictionality, which Ryan aligns to transmedial concerns under its

first facet: 'the sharing of elements – mostly characters but also imaginary locations, events and entire fictional worlds – by two or more works of fiction' in the manner of 'extension, which adds new stories to the fictional world while respecting the facts established in the original' (Ryan, 2016: 5). Yet the nature of this extension as it relates to social media usage is that these aforementioned elements, the figures of the fiction, are understood to be the various semiotic units in circulation across the broader plane of the interconnected social media identity. It is the tapestry of such semiotic materials that renders the story of the virtual self a transmedial narrative – along with the necessarily interactive nature of this story.

The Relational Framework

The relational framework in which these semiotic objects are held together to create narrative meaning consists of the 'user' – the person who is constructing their virtual self via their social media profiles, and the 'interpreter' – the person who receives and reads the multimedia units provided by the user in a way that constructs the virtual self within their own mind as a cohesive story. The rhizomatic metaphysics of immanence elucidated across the body of work of Gilles Deleuze and Félix Guattari is used here to account for how such multimedial, and multimodal, units combine within the interpreter's mind.

Key to Deleuzian-Guattarian metaphysics is the plane of immanence – the 'pre-philosophical' plane through which thought emerges in the form of concepts produced by a convergence of components, or units, that constitute the plane itself. Aligned with the dynamic plane – or smooth space – of Riemannian mathematics, such units expand the space itself rather than traverse it, and concepts – as *intensities* – consist of a multiplicity of such components that move with the plane itself. The intensity is the vital operation of concept formation; rather than a fixed thing in-itself, an intensity is a centre of vibration that is at once relative in operation and absolute in status. In respect to the concept, it is *relative* in its acting as a bridge for the passage of components between different concepts ('ideal without being abstract'), and *absolute* in-itself as a convergence of a multitude of components ('real without being actual') (Deleuze and Guattari, 1991: 22). This is to say that concepts encapsulate both the movement of thought and thought itself. Such concept building of course itself expands as the local convergence of components passes into another, and the virtual self described in this chapter is thus conceived as a macro-level mental construct comprised of a multitude of concepts produced by micro-level constituent parts (the units I have designated as 'semiotic' in keeping with the discourse of transmedial narratology) as posted on the variety of social media platforms. As received by the interpreter, these various platforms constitute plateaus within the plane of immanence, akin to squares upon a wider patchwork: 'An amorphous collection of juxtaposed pieces that can be joined together in an infinite number of ways: we see that patchwork is literally a Riemannian space, or vice versa' (Deleuze and Guattari, 1980: 526).

It is in this respect that a 'plateau is always in the middle, not at the beginning or the end,' as a 'multiplicity connected to other multiplicities by superficial underground stems in such a way as to form or extend a rhizome' (Deleuze and Guattari, 1980: 24). Each platform is constituted by the components – the multimedial and multimodal units – of the narrative of the virtual self that coheres through their convergence within the interpreter's production of concepts; that is, the interpreter's creation of the narrative. This brings us back to Ryan's distinction between *being a narrative* (the semiotic units posted by the user) and *having narrativity* (the interpreter forming a narrative script in their mind).

The dynamism of this construction of the virtual self is contrasted with that of scientific thought / formal logic. In the case of the latter, a 'plane of reference' is imposed upon, and striates, smooth space through the fixing of coordinates. The plane of reference places 'limits or borders' in its confrontation of chaos, slowing down and fixing thought through the spatialising of components within 'irreducible, heterogeneous systems of coordinates,' which 'impos[e] thresholds of discontinuity depending on the proximity or distance of the variable' (Deleuze and Guattari, 1991: 119). Applying this to social media, we can see that though fixed coordinates appear in the interface of such platforms in a manner that produces a linear chronology of a user's posts – for instance via the user profile pages of sites such as Facebook (formerly the 'Timeline'), Twitter, and YouTube – the way the interpreter receives and reads such semiotic units is far more dynamic, given that the media attributable to any one virtual self will appear amongst a range of other media within the platform interface for the interpreter (their 'feed' of manifold semiotic units as posted by a variety of users).

The outcome of this multimedia narrative is the transmedial storyworld of the virtual self, and the dynamic relationship between the story and the narrative components from which it is constructed is explored in the remainder of this chapter.

The Storyworld of the Virtual Self and Its Narrative Construction: Three Variations

The following examples provide further nuance to this account of the relational framework by enabling us to explore how such narrative produces the transmedial storyworld of the virtual self.

The first example is that of online content creator Yovana Mendoza Ayres. A social media influencer, she had built a brand as a vegan lifestyle advocate under the name 'Rawvana' and had by March 2019 built up a following of almost half a million subscribers on her English language YouTube channel, 2 million on her Spanish language YouTube channel, and 1.3 million followers on Instagram, along with a website, all of which promoted the vegan lifestyle and featured her own paid-for weight loss programmes and the sponsored promotion of related brands (Chen, 2019; Rosenberg, 2019).

That same month, however, saw the emergence of a 16-second clip that had been drawn from the end of a video posted by a fellow healthy lifestyle YouTuber and which showed Ayres trying to conceal the fact she was eating fish. This short clip went viral via its re-posting and commentary by a range of other vloggers and social media users (general commentators rather than content creators) who accused the supposedly vegan influencer of being a fraud who had been lying to her audiences about the very lifestyle she had been promoting to them. This led to Ayres posting a 33-minute video explaining the incident and her admittance that the raw vegan diet – eating only uncooked plant-based foods – she had initially subscribed to six years earlier had been abandoned in the past two due to the health problems it had caused. Following a subsequent four-month break from social media, Ayres re-emerged online in July 2019, having re-branded her interconnected online presence as 'Yovana Mendoza – that is my real name' (Mendoza, 2019). As *The Cut* points out, Ayres has shifted her focus to self-acceptance, 'overhauled her website, had her breast implants removed, and began sharing recipes that included eggs, fish, and other ingredients she'd previously reviled (labeled #notvegan)' (Cowles, 2019).

This example is useful here for a number of reasons. Firstly, it demonstrates the way in which the storyworld of the virtual self is constructed through a narrative that is based on a range of types of media (still images and short-form videos on Instagram, extended YouTube videos, text-based blog posts on the website) that serve different functions: images (still and moving) presenting the benefits of the advocated lifestyle and instructional videos and text explaining how to achieve it, the former in a demonstrative and personable manner dependent on her charisma, the latter in the form of recipe and exercise routine outlines. And yet each of these types of media also coheres into a relatively stable story (i.e., an identity for the social media user). That the latter is the case is demonstrated by the fact that the 'Rawvana' brand had to be overhauled upon the emergence of the viral video – it had directly ruptured the virtual self Ayres had created through the narrative she had weaved through her interconnected web presence. In Deleuzian-Guattarian terms, each social media platform constituted a plateau – a patch within the Riemannian smooth space of the plane of immanence – through which concepts emerged within a specific context but would then converge into the larger macro-level mental construct of 'Rawvana' through the interlinkages afforded by the platforms: accompanying text beneath posts directly linking interpreters to Ayre's other platforms, or the content of the media itself directing interpreters towards other media related to the 'Rawvana' brand – a transmedial storyworld-building strategy akin to any top-down franchise from Hollywood or Japan (see, for instance, Jenkins, 2006; Lamarre, 2018).

Notably this rupture to the storyworld of this virtual self (i.e., 'Rawvana') occurred not only in the minds of the interpreters who had formed such a mental construct, but also Ayres herself, who found that 'I had built my whole brand and platform around the vegan diet, and I didn't really know who I was without that' (Cowles, 2019). This demonstrates the soiveillant

interplay between user and interpreter that occurs in the construction of this virtual self. This is further attested to by Ayres, who says of her four-month break from social media:

> I was used to posting every single day and having people loving it, and then suddenly I had a lot of self-doubt. Like, *What are people going to say?* Or, *Is this going to offend someone?* I was constantly thinking about how I was going to be perceived. It was paralyzing.'
>
> (Cowles, 2019)

to the extent that her rebranding announcement video took months of planning.

> For a while, I didn't even feel comfortable being on camera anymore. I spent two months filming myself every day, but I didn't post anything. ... I had a few meetings with my team, and we decided to let go of the old name, Rawvana, and rebrand everything – the name, the logo, the colors, the new mission statement.
>
> (Cowles, 2019)

As indicated, the Rawvana brand was built not just by Ayres but a team – in this case two film editors, a content campaign manager, and a social-media manager, which speaks to the corporate nature of social media influencers and further lends alignment between the transmedial storyworlds of such social media users and that of Japanese and American media corporations. However, as the qualitative studies referenced at the beginning of this chapter indicate, any regular social media user – you and me included – will self-consciously build their online personas with a similar paranoia as to how they are perceived by their intended audiences and similarly weave their narratives across multiple platforms dependent on sub-divisions described earlier (professional, social, family, etc.). For instance, the Honor (2019) study of over 5,570 Europeans found that: 'Across Europe, nearly half (45%) of the photos Europeans take on their smartphones are shared with friends and family on social media,' and that 'though it takes Europeans just 11 seconds to decide if a selfie makes the cut, we spend a further 26 minutes deliberating before it's shared on social media, suggesting that we're making conscious decisions about how we're representing ourselves online.'

The second example relates to the recent 'cancel culture' by which well-known social media users (most often those elevated to celebrity status or celebrities from traditional media now engaging with online communities) are rendered banished from the online realm, and sometimes their actual life workplaces and homes, due to online pressure from other social media users. Of relevance here are cancellations that occur due to social media postings (rather than actual-world misbehaviour or crimes), as in the case of Kevin Hart, who in 2018 was found to have posted homophobic content on his Twitter profile back in 2010 and 2011. Rather than recognising this offensive

content as the product of a younger Hart, as expressed in the apology issued by the comedian, the lobbying for cancellation unfolded in earnest (Rafferty, 2018). This, and similar instances of cancellation, speaks to the manner in which interpreters of the virtual self receive information in a context of immediacy rather than historicity. Rather than receiving the information as evidence that such a user has intellectually or emotionally grown across time, which would imply a linear narrative construction akin to traditional autobiographical writings in which such units are fixed to produce a canonical story arc of the self (Marcus, 1994: 32), interpreters instead insert these data directly into the narrative they have built around the social media user, the expansion of which doesn't take the form of an unfolding but rather an intensification. These new (to the interpreter) semiotic units thus result in the attribution of hypocrisy to the user for its incongruity with the broader virtual self the interpreters have themselves constructed around the user; such data disrupt the stability of the concept.

This might imply a lack of temporality in the transmedial storyworld of the virtual self, one of the three key elements of narrative script posited by Ryan, who specifies that changes of state 'create a temporal dimension and place the narrative world in the flux of history' (2004: 9). Instead, this marks an aspect of this text's contribution to the development of Ryan's 'model that defines narrative as a cognitive construct,' i.e., the 'mental equivalent of a multimedia construct,' since she herself 'remains uncommitted about what this construct is made of' (2004: 12). Rather than conceiving of narrative temporality along the linear coordinates by which we construct 'history,' by adopting the Deleuzian-Guattarian metaphysics of immanence to account for the mental construction of narrative we understand its temporality as the movement of thought itself, the way in which the story of the virtual self is received and read as a non-linear yet ever-expanding conceptual construct.

Regarding soiveillance, the case of Kevin Hart speaks to the nature of self-management within a lateral framework of peer-to-peer surveillance by which the strategy of the former shifts with the expansion of the latter. The changing nature of his celebrity is such that the offending posts were deemed appropriate to the audience he intended to engage in those earlier years of his career as a transgressive stand-up comedian, but would not have been (and had not been) posted in the context of his engagement with the far broader and diverse audience Hart had since garnered as a Hollywood star. As a *Buzzfeed* journalist tweeted: 'he [Hart] seems to have basically stopped tweeting those words after 2011 – i.e. the year his first stand-up movie became a hit' (Vary, 2018). One can similarly look to the case of the director James Gunn, who posted a series of tweets featuring offensive jokes about paedophilia in 2009, when he was mostly known for his work with transgressive / trashy independent production and distribution company Troma Entertainment, but whose public profile had been significantly raised via his work on the Disney-owned Marvel movie franchise *Guardians of the Galaxy* when the tweets re-emerged, leading to controversy, the frantic deletion of Gunn's Twitter history, and his subsequent firing (since revoked) (Bishop, 2018). These public figures had suffered neither a lapse of judgement nor a

lack of self-consciousness when posting their contentious tweets but rather aimed to appeal to their perceived audience of interpreters, which had shifted across time to encompass those whose conception of the virtual selves of these figures was ruptured by the re-emergence of the same content.

Both examples (Ayres and Hart/Gunn) further demonstrate that the storyworlds of virtual selves exist as multiplicities: both in regard to their dynamic construction and their interpretation. In regard to the former, both examples involve the (re-)donation of semiotic units by other social media users rather than the users around which the virtual self revolves, causing disruption in their attempts at the self-management – or self-*production* – of their online personas. In regard to the multiplicity of interpretation, where Ayres had successfully created a cohesive storyworld according to her own terms, making its disruption an all-the-more powerful destabilisation of her narrative, the likes of celebrities such as Hart and Gunn have to contend with variations of their virtual self as dependent on the level of engagement of their interpreters. The difference between these users' level of control over the interpretation of their respective storyworlds arguably relates to how online content creators (such as Ayres) build their brand through their engagement on social media where public persons (such as Hart) whose celebrity originates in traditional media – film, television, print, the music industry – engage with social media on the basis of a pre-existing brand. In the case of the latter, the social media user intervenes in a storyworld that is diffused among various donors of information: fans, journalistic media, media critics, as well as pre-existing transmedial brands.

The third example addressed here relates to the last, how the public personages, i.e., the virtual self, of celebrities can also be situated within transmedial storyworlds related to the fiction franchises typically addressed in transmedia scholarship. As part of the promotion for Twentieth Century Fox's two *Deadpool* movies (released in 2016 and 2018, respectively), its lead actor, Ryan Reynolds, has often taken on the persona of the Deadpool character to deliver promotional messages through various social media outlets. This approach to 'native advertising' encompasses a variety of platforms, such as Facebook Live, Snapchat, and YouTube (Marling, 2017). The latter includes a guest feature (as Deadpool) narrating an Honest Trailer of the first *Deadpool* movie, as part of the popular Screen Junkies series, as well as Ryan Reynolds' own YouTube channel, which has 2.4 million subscribers, as of November 2020, and is mostly used to promote his movies, own brand products, and other sponsored products, though also features sometimes non-commercial videos that highlight a running gag about his 'feud' with fellow actor Hugh Jackman. On this channel, Reynolds has posted, along with traditional promotional materials for the two *Deadpool* movies (trailers, snippets, TV spots, etc.), almost a dozen videos in which the actor – in the guise of the Deadpool character – delivers special messages to the viewers (for instance, regarding a campaign drive for a cancer organisation, or a rant about Canada's exclusion from Eurovision [Reynolds 2018a, 2018b]), skits relating to the films (such as an apology to David Beckham for

a joke made in the first movie, and a talking head piece celebrating ten years of the franchise [Reynolds 2018c, 2018d]), and additional posts that would indicate Deadpool himself was a content creator uploading onto the channel (a cheaply shot 'documentary' of Deadpool recruiting potential child sidekicks by assessing their Halloween costumes, and a 69-minute video featuring a medium shot of a paper bag – presumably filled with his excrement, given the title of "The 'Pool Log" – having been set on fire and left on someone's doorstep – presumably Hugh Jackman's – with choral singing in the background uploaded for Christmas 2015 (Reynolds, 2015a, 2015b). Aside from the latter, which takes the form of the platform-appropriate livestream, each of these videos is around one-to-two minutes long, a format intended for quick consumption and sharing via smart devices and other social media platforms.

Ryan Reynolds' posting of content in character as Deadpool – which also encompasses his usage of Instagram, which features some short-form movie / product promotion as above but also more general posts such as selfies and other images that align with social media usage by general users – is an instance where the celebrity's virtual self absorbs components of a broader transmedial storyworld, in this case Twentieth Century Fox's *X-Men* movie franchise, of which Deadpool is a key component. The two converge through the broader usage of these social media platforms by Reynolds – and his management / promotional team – which allows for Reynolds' brand, or virtual self, and that of Deadpool's storyworld to converge. For instance, Jackman played Wolverine, the leading character of Fox's *X-Men* movies, in ten films from the franchise, thus blurring the lines between Reynolds' own virtual self – a persona in which a comedic rivalry with Jackman is figured – and that of the Deadpool character, who is also in an antagonistic relationship with Wolverine.

This is an instance in which the macro-level construct of the virtual self is seen to cross over with other macro-level constructs, in this case that of the transmedial storyworld related to a fictional character who itself is split between two transmedial franchises, that of Marvel comics and, at that time, Twentieth Century Fox's extended *X-Men* movie universe. The point is that what occurs at the molecular level in the metaphysics of immanence also speaks to the nature of macro-level occurrences; no one construct is fixed in-itself but is always a dynamic collection of constituent parts that, in its absolute facet, has a stability that allows it to be recognisable but is nevertheless in constant transition, as per its relative facet.

In regard to soiveillance, Reynolds' adoption of the Deadpool persona within his own social media channels arguably allows him to undertake transgressive actions that he as a celebrity in his own right would be chastised for (as with Hart and Gunn), but also helps the actor to build his own brand among a broader audience of both comic-based movie fans and, in Sierra Marling's view, women who may not ordinarily count themselves among them, given the 'inclusive' nature of the Deadpool character, who is 'pansexual and (sometimes) effeminate, different from the norm of what society deems as acceptably masculine' (Marling, 2017: 4). Reynolds self-consciously

pursues the convergence of the storyworld of his virtual self with that of the *Deadpool / X-Men* franchises as he benefits from the positive response it elicits from his audience.

Conclusion

The construction of the virtual self – or the writing of this transmedial narrative – is one which involves an interplay between user and interpreter, and, as indicated by the examples above, the challenge for the social media user is to anticipate interpretation and direct the receiver towards their intended meaning – as is arguably the case with any media content creator aiming to cater to their audience. The question as to whether the virtual self should itself be considered a fiction – which is another area in which social media usage and transmedial narrative as more broadly conceived might converge – is somewhat complex. As per Ryan, the weaving of a narrative around ourselves is a way of making sense of our experiences, yet self-management online involves building an alternative – second order, virtual – narrative as negotiated with the audience, suggesting the latter is a fictional story created through participatory means. However, the soiveillant nature of the materials that constitute such a narrative indicate an earnestness within the user to appeal to their interpreter, that is, any untruth reflects their self-consciousness, and, as such, nevertheless communicates a facet of their authentic self. This is also the case with provocateurs – or trolls – who may not appear to much care what other people think, but who have been found to proactively seek out negative responses from interpreters as an inverted social reward, indicating that interpreter response – and soiveillance – is very much in play in their online interactions: 'Facebook® users who engage in trolling behaviours are likely to be intrinsically motivated by obtaining negative power and influence over other people as a social reward,' suggesting 'that perhaps it is social motivation, not personality, which best predicts online trolling behaviours' (Craker and March, 2016: 82–83). The fiction has some truth in it, as the saying goes. Distinguishing these part-truths from outright fiction, this chapter posits the virtual self to be a transmedial storyworld that is built and negotiated by both user and interpreter via myriad pieces of information across a plethora of social media platforms, and is one storyworld amongst a range of other – including fiction-based – storyworlds that may very well intersect with and work to shape it.

References

Bishop, Bryan. 2018. "Writer-director James Gunn fired from Guardians of the Galaxy Vol. 3 over offensive tweets", *The Verge*, July 20. https://www.theverge.com/2018/7/20/17596452/guardians-of-the-galaxy-marvel-james-gunn-fired-pedophile-tweets-mike-cernovich. Accessed 15/10/20.

Caldeira, Sofia P., Sofie Van Bauwel and Sander De Ridder. 2020. 'Everybody needs to post a selfie every once in a while': exploring the politics of Instagram curation

in young women's self-representational practices, *Information, Communication & Society*, 24(8): 1073–1090. DOI: 10.1080/1369118X.2020.1776371.

Chen, Tanya. 2019. "Fans Are Pissed after a Famous Vegan YouTuber Was Allegedly Caught Eating Fish in Another Person's Vlog", *Buzzfeed*, March 19. https://www.buzzfeednews.com/article/tanyachen/famous-vegan-youtuber-rawvana-allegedly-caught-eating-fish. Accessed 15/10/20.

Cowles, Charlotte. 2019. "The Vegan Blogger Caught Eating Fish", *The Cut*, November 11. https://www.thecut.com/2019/11/yovana-mendoza-on-watching-her-online-life-implode.html. Accessed 15/10/20.

Craker, Naomi and Evita March. 2016. The dark side of Facebook®: The Dark Tetrad, negative social potency, and trolling behaviours, *Personality and Individual Differences*, 102: 79–84. DOI: 10.1016/j.paid.2016.06.043.

Deleuze, Gilles and Félix Guattari. 1980. *A Thousand Plateaus: Capitalism and Schizophrenia*. Trans. Brian Massumi. London and New York: Continuum (1987 edition).

Deleuze, Gilles and Félix Guattari. 1991. *What Is Philosophy?* Trans. Hugh Tomlinson and Graham Burchell. New York: Columbia University Press (1994 edition).

Gazi, Jeeshan. 2018. Soiveillance: self-consciousness and the social network in Hideaki Anno's Love & Pop. *Surveillance & Society* 16(1): 84–111. DOI: 10.24908/ss.v16i1.6434.

GlobalWebIndex. 2020. *Social: Flagship Report 2020*.

Honor. 2019. HONOR 9X Research Reveals Europeans Now Post a Staggering 597 Photos of Themselves Every Year. December 9. https://www.hihonor.com/global/news/honor-9x-research-reveals-europeans-now-post-a-staggering-597-photos-of-themselves-every-year/. Accessed 15/11/20.

Jenkins, Henry. 2006. *Convergence Culture. Where Old and New Media Collide*. New York and London: New York University Press.

Lamarre, Thomas. 2018. *The Anime Ecology: A Genealogy of Television, Animation, and Game Media*. Minneapolis: University of Minnesota Press.

Marcus, Laura. 1994. *Auto/biographical Discourses: Criticism, Theory, Practice*, Manchester: Manchester University Press.

Marling, Sierra. 2017. "A New Precedent for Superhero Movies: Analyzing *Deadpool*'s Social Media Marketing Strategy", *sierramaling.com*, December 18. https://www.sierramarling.com/s/Marling_DeadpoolCaseStudy_ICC617.pdf

Marwick, Alice E. 2012. The public domain: surveillance in everyday life. *Surveillance & Society* 9(4): 378–393. DOI: 10.24908/ss.v9i4.4342.

Mendoza, Yovana. 2019. "GOODBYE RAWVANA", *YouTube*, July 24. https://www.youtube.com/watch?v=1rIyVzGZM_U. Accessed 15/10/20.

Rafferty, Brian. 2018. Kevin Hart's Tweets Didn't Doom Him—His Messy Apology Did, *Wired*, December 7. https://www.wired.com/story/kevin-hart-oscars-tweets/. Accessed 22/11/20.

Reynolds, Ryan. 2015a. "How Deadpool Spent Halloween", *YouTube*, November 3. https://www.youtube.com/watch?v=1Nvg0LwWeTU&t=27s. Accessed 18/11/20.

Reynolds, Ryan. 2015b. "The 'Pool Log", *YouTube*, December 23. https://www.youtube.com/watch?v=heQkjWWd_hA. Accessed 18/11/20.

Reynolds, Ryan. 2018a. "A Very Special Message from Deadpool", *YouTube*, April 3. https://www.youtube.com/watch?v=uKpvjqDsTcU. Accessed 18/11/20.

Reynolds, Ryan. 2018b. "Deadpool 2 | Eur Missing a Country", *YouTube*, May 8. https://www.youtube.com/watch?v=e59al0jGL8E. Accessed 18/11/20.

Reynolds, Ryan. 2018c. "Deadpool 2 | With Apologies to David Beckham", *YouTube*, May 10. https://www.youtube.com/watch?v=LVBN_QnLXCc. Accessed 18/11/20.

Reynolds, Ryan. 2018d. "Deadpool 2 – The First 10 Years", *YouTube*, May 17. https://www.youtube.com/watch?v=4VF6A_cs7HI. Accessed 18/11/20.

Rosenberg, Eli. 2019. "A vegan YouTube star went to Bali. A video of her there brought her platform crashing down", *The Washington Post*, March 22. https://www.washingtonpost.com/technology/2019/03/22/vegan-youtube-star-rawvana-gets-caught-eating-meat-camera/. Accessed 15/10/20.

Ryan, Marie-Laure. 2004. Introduction. In *Narrative across Media: The Languages of Storytelling*, edited by Marie-Laure Ryan. Lincoln: University of Nebraska Press: 1–40.

Ryan, Marie-Laure. 2016. "Transmedia narratology and transmedia storytelling", *Artnodes*, No. 18. DOI: 10.7238/a.v0i18.3049.

Terán, Larissa, Kun Yan and Jennifer Stevens Aubrey 2020. "But first let me take a selfie": U.S. adolescent girls' selfie activities, self-objectification, imaginary audience beliefs, and appearance concerns, *Journal of Children and Media*, 14(3): 343–360. DOI: 10.1080/17482798.2019.1697319.

Tiidenberg, Katrin and Andrew Whelan 2017. Sick bunnies and pocket dumps: "Not-selfies" and the genre of self-representation, *Popular Communication*, 15(2): 141–153. DOI: 10.1080/15405702.2016.1269907.

Vary, Adam B. 2018. "After seeing this @benfraserlee tweet, I did a search for...", *Twitter*, 10.55pm, December 5. https://twitter.com/adambvary/status/1070451517092651008?lang=en. Accessed 15/10/20.

WeAreSocial & HootSuite. 2020. *Digital 2020: Global Digital Overview*.

Willett, Rebekah. 2009. Always on: camera phones, video production and identity. In *Video Cultures: Media Technology and Everyday Creativity*, edited by David Buckingham and Rebekah Willett. New York: Palgrave Macmillan: 211–228. DOI: 10.1057/9780230244696_11.

2 Personal Storytelling

A Semiotics Approach to Constructing Identities across Media

Paolo Bertetti and Giuseppe Segreto

> We are what we pretend to be, so we must be careful about what we pretend to be.
> Kurt Vonnegut Jr., *Mother Night*

Introduction

Early research on digital cultures tended to clearly separate online and offline dimensions (Lanier, 2010; Morozov, 2011), considering them opposite concepts. While what was happening physically outside the internet was considered real, on the web individuals tended to develop a virtual self other than their true identity. In recent years, however, in the context of sociology of communication (Boccia Artieri et al., 2017), the context collapse and coalescence theories have highlighted the fluidity between the online and offline relational modes and the breaking down of borders between public and private spheres. In this context, particularly concerning the relationship between intimacy and identity, 'the value and meaning are not so much in producing communicative fragments of oneself, but in sharing them for the purpose of validation by others' (Boccia Artieri et al., 2017: 47). We are therefore not faced, in Goffmanian terms, with masks. It is rather definitional practices of the self that are carried out in an implicit, repetitive, ritual way (Boccia Artieri et al., 2017: 147).

This chapter begins with the question: Is it possible to reconstruct a repertoire of such practices semiotically? And more specifically, is it possible to apply a methodology of semiotic analysis previously tested to describe the construction mechanisms of fictional characters to understand the ways that people's identities are constructed across media platforms? In other words, is there an overlap in the way that individuals represent themselves in different media and the way that fictional media characters are traditionally represented? To answer these questions, we will first see how the current online identity market is configured, with brands seeking to humanise themselves and people employing personal branding strategies to increase their social visibility. Then we will consider how the concept of identity in the context of semiotic studies was conceived, that is, in its eminently discursive and relational nature. Then we will refer to the model proposed by Bertetti (2014) to

DOI: 10.4324/9781003134015-4

describe and interpret those mechanisms used to construct fictional characters and we will apply it to a corpus of analysis made up of some exemplary subjects chosen because of their keen ability to exploit the transmedia environment to narrate themselves. We will see how managing one's own transmedia narrative becomes in itself a central element of the activity of building one's own identity.

The Marketplace of Identities

The relationship between consumers and brands has always been characterised by more than just economic exchange. Today, it is increasingly enriched by cognitive, passionate and pragmatic components. Partly on the basis of this awareness, Henry Jenkins refers back to the concept of 'affective economy' (2006: 20) and the notion of *lovemark* developed by Kevin Roberts (2004). In short, in order to fulfil its function in the current socio-economic and media context, the contemporary brand must try to humanise itself (Minestroni, 2010; Segreto, 2017; Mayer, 2020). With an equal and opposite movement, however, people are now pushed to transform themselves into brands, not only on the web stage but also in the professional sphere, that is, to apply the logic and tools of marketing to their communication strategies so as to stand out from others, to increase their reputation, and to increase their relational capital. In fact, individuals now find themselves vis-à-vis their online relationships in the unprecedented condition of being at once (part of) an audience and having (their own) audience (Boccia Artieri et al., 2017). Being on social media has made this condition familiar, where it becomes that of the *prosumer* (Toffler, 1980; Ritzer, 2010), an attribute that has gone beyond market dynamics to become a cultural fact, 'an internalized assumption in online communication' (Boccia Artieri et al., 2017: 47).

In this context, in addition to the emergence of complementary phenomena such as the *privatization of the public sphere* and the *publicization of the private sphere*, the need has arisen for individuals to adopt practices that are typically managerial when constructing and managing their online identity on a daily basis. In this regard, McGuigan (2014) writes about 'the neoliberal self'. Neoliberalism here refers not so much to a doctrine of economic policy as to the principle of socialisation that follows in its wake. The neoliberal self, in fact, is a discursive and ideological framework that affirms market values in areas of everyday life that should not be regulated by the market (Boccia Artieri et al., 2017). This framework seems to fit perfectly with the logics and affordances of social networking platforms, where people increasingly present themselves as a collection of tastes (favourite TV programs, music listened to, novels read, etc.) and, as such, their ability as consumers – of cultural products and products tout court. Moreover, social networks tend to make their users' contacts public, thus encouraging the idea that it is possible to build social relationships in order to gain advantages in terms of visibility, social capital and self-promotion. The result is that individuals

online, particularly on social networks, end up 'selling themselves', highlighting their strengths and obscuring their weaknesses, seizing opportunities and avoiding threats, in line with the findings of a SWOT analysis (Hill and Westbrook, 1997). It is a real marketplace of identities. For this reason, profiles must always be kept 'clean' and updated, deleting where necessary those contents (and contacts) that could invalidate the image a user decides to share with others (ibid.).

Social media users are increasingly aware that a substantial part of their social visibility is played out on these platforms and know that audiences act as a powerful filter when choosing both content production and sharing practices. Returning to a concept from Umberto Eco's interpretative semiotics, we could say that our online audiences now perform, in whole or in part, the function of the Model Reader. In fact, as Eco writes, 'a text is a product whose interpretative fate must be part of its own generative mechanism; generating a text means implementing a strategy in which the predictions of the moves of others are part' (1979: 54). Applying this theoretical model to the realm of online personal branding processes, we can say that individuals strive to obtain a correct interpretative effect in terms of reputation and status from the assumed recipients through their choice of words, the images they post and the references they make.

We might thus claim, along with Jansson and Fast (2018), that identity is no longer a singular entity linked to a particular area of interests or narratives, but a complex interface between the Self and the Other. So, we now come up against a new version of the old problem of social reflexivity (Landowski, 1989): not only is my lifestyle shaped by the lifestyles of others, at least those closest to me, but the number of media experiences taking place is multiplying and broadening the horizon with which people make sense of the world and reflect on who they are and what they want (Jansson and Fast, 2018). In this way, identities are continuously co-created based on the fluctuations of online representations, which means users need to develop reflexive strategies that help them manage the insecurities often associated with a connected life. The latter is a risk inherent in the very logic of sharing as texts and words can easily escape the control of their authors and lend themselves to misunderstandings and exploitation (ibid.).

Identity in Semiotics

This conceptualisation of identity as an interface that constantly builds and rebuilds itself in relations between the Self and the Other was long anticipated by Semiotics, which has always defined identity in a non-essentialist, relational way. This is the case firstly for European Semiotics, whose origins are in the structural linguistics of Ferdinand de Saussure. de Saussure (1916) claimed that the definition of an element always depends on its position within the system to which it belongs and therefore on the set of oppositional relations that it maintains with the other elements in the system; its value is

always identified in a negative and differential way. However, we can find the same concept in Peircian cognitive semiotics; as Violi observes,

> in the several passages of the Collected Papers that refer to the logic of the relative, Peirce (1931–35) precisely claims the relational identity of the elements, that are identifiable only starting from the network of relationships that they entertain with other elements within a given system.
>
> (Violi, 2018)

Besides this kind of identity, called *synchronic identity* as defined by the position of an element at a given moment, there is also a *diachronic identity*, relating to the persistence of the element over time. Following Greimas and Courtés (1982, 148), 'Identity also serves to designate the principle of permanence which permits the individual to remain the "same", to "persist in its being", all through its narrative existence, despite the changes that it provokes or undergoes'.

It is the principle of permanence that enables us to recognize a given character at any point within a single text – for example, a film or a novel – despite the changes it is subjected to in the development of the plot. The principle of permanence also allows us to recognize a serial identity as it moves through the different texts in which a subject is represented or represents itself. The identity of a subject can in fact also be constructed in a transtextual and transmedial way. The diachronic identity emerges from the analysis and comparison of the constant elements and the variations it is subjected to over time when passing from one text (and/or media) to another, in a perspective in which the diachronic transformation becomes a synchronic system (see also Violi, 2018).

To better understand, we must remember that identity is not considered substantially in semiotics, but has instead a discursive nature. This position is common to other social and anthropological sciences. For example, Stuart Hall is clearly influenced by semiotics when he states that 'identities are constructed within, not outside, discourse, we need to understand them as produced in specific historical and institutional sites within specific discursive formations and practices, by specific enunciative strategies' (Hall, 1996: 4).

The semiotic construction of identity is an effect of meaning emanating from texts. This is true both in the case of totally fictional identities – as in the MUDs (Multi-User Domains) of the 1990s studied by Turkle, 1995 –, and in identities that pretend to be 'authentic', as in today's social network profiles. Actually, their 'reality' is itself a textual effect, i.e. the result of particular rhetorical and narrative strategies.

We can indeed say that, in principle, there is no difference between fictional identities and alleged factual identities. In fact, from a semiotic point of view the ontological hook-up – i.e., a consistency between the mediated and the real individual identity – is not pertinent, as the object of analysis is

the discursive strategies underlying the construction of identity (or, better, the creation of an impression of identity).

In doing this, the narrative dimension is essential: as Greimas notes, narrativity is 'the very organizing principle of all discourse' (Greimas and Courtés, 1982: 209). In semiotics, and in particular generative semiotics, the narrative component is an unavoidable condition of our experience and knowledge of the world: it is precisely this narrative form that allows us to connect single facts and organise them, giving them an order and a logic, and ultimately endowing them with meaning (on this topic see also Ricoeur, 1983; Bruner, 1990).

This narrative articulation of the real, however, precedes the narrative configurations of the stories, and to a certain degree assumes this to be the case. The world we experience, which Greimas (1987) calls the 'natural world', is in fact already meaningful; it is organised by structures that are not only linguistic (in the sense of natural languages), but more generally semiotic. Narrativity takes on a central role within these structures. Structuring models of a narrative nature circulate in culture, participate in the production of meaning and preside – indifferently – over how experiences are organised, as well as over the discourses and the texts that account for them.

Therefore, texts (literary, visual, etc.) are merely the objectification of cultural models – real interpretative patterns of reality present in the semiotic social subject – which more generally organise and give meaning to our being-in-the-world (Marrone, 2010: 55). It is precisely for this reason that it is possible to study literary and media texts and daily interactions in the same way.

Even those who do not share the idea of the central role played by narrative in the shaping of knowledge must however admit that there are narrative models that circulate inside the culture and structure the discursive organisation of the identity of a fictional character and the building strategies of online personal identity in a similar way. If the construction of an identity – be it of a fictional character or of one's own personality on the net – is always based on a discursive strategy that unfolds in the texts and has a narrative nature, it should not be surprising that we can analyse the modes of construction of an identity across social networks using – as we will do – a methodological grid used in the past for fictional characters (Bertetti, 2014).

The Model of Analysis

Our contribution aims to investigate the modes of construction of online identities as an effect of meaning across different media platforms. It uses a semiotic qualitative methodology, focusing the analysis on a corpus of 'exemplary texts' (Manetti and Bertetti, 2003), in our case 'exemplary identities'. Starting from a wider corpus of online identities, we limited the analysis to some profiles where the identity construction strategies were more evident and there was a marked awareness of the use of tools (knowledge of stylistic

and content repertoires, etc.) and in the norms governing the employment of different platforms (on the distinction between *norm* and *use* see Hjelmslev, 1942). As mentioned, we will use the semiotic grid we tried out in the past to study the identities of fictional characters, re-presented here with small variations (Bertetti, 2014, 2019; Scolari, Bertetti and Freeman 2014).

According to Marrone (2003), the semiotic construction of characters is the result of a combination of intertextual relations, based in particular on all the texts (by one or more authors), that remake, rewrite, modify and translate the character in the same medium (*transtextual* – or *serial* – *characters*) or in different media (*transmedia characters*). In this sense, 'A *transmedia character* is a fictional hero whose adventures are told across different media platforms, each one giving more details on the life of that character' (Bertetti 2014: 2345).

In semiotics and narratology, the construction of identity – both fictional or actual – is based on all the different textual levels, and the diachronic transformations of this identity must be detected at all the different levels of analysis. The analytical grid is based on a fundamental distinction between two different levels of enquiry, and two different types of identity. Referring to the classical Aristotelian dichotomy between character and action, namely between character as being and character as doing, we can first distinguish two different types of identity: *existential identity* and *narrative identity*. Each of these is divided into a series of sub-levels. The *existential identity* of a character is related to the *being* of the character and can be divided in two sub-components: the *proper identity* (the set of elements forming the identity that relate to the being of the character in itself) and the *relational identity*, based on the character's relationship with the surrounding storyworld. *Narrative identity* instead is related to the doing of the character, and, more generally, to the events that happen to it.

At each level of identity, we can identify a tension between coherence and incoherence, or between continuity and discontinuity, depending on whether the features identifying the characters at the various levels remain unchanged or vary from one text to another.

A Personal (Trans) Media Strategy

During the construction phase of the corpus, we often came across user-posted content that showed a comprehensive knowledge of the codes and practices operating in each media environment: people are increasingly aware that a personal outburst on Instagram cannot be re-posted in the same way on Twitter because the modes of expression, grammars and, above all, audiences differ between one platform and another; similarly, a bio that works – or is considered legitimate – on Telegram is not as legitimate on Facebook, because in addition to the different type of potential audience that can be reached, the two platforms allow users to manage contacts and who can see posted content in different ways.

Obviously, the broad range of cases studied also includes self-representation strategies in which any 'platform sensibility' is completely lacking – sometimes as a result of a deliberate choice on the part of the users, who decide 'to be themselves' irrespective of the type of platform, usage practices and the audiences involved; at other times it is the result of a more spontaneous and naïve approach to constructing one's presence on social media (Boccia Artieri et al., 2017: 132–145).

While an awareness of the diversity of communication in digital spaces seems on the whole to be increasingly widespread, it is even more so when analysing the accounts selected for this corpus. Here we are dealing with expert users. Let's get to know them.

Domitilla Ferrari, marketing manager, has a personal website (where she immediately defines herself as 'guru dell'ovvio' [guru of the obvious]), the blog *Semerssuaq*, the popular newsletter *tl;rl* (which, she tells us, stands for, "too long, read later"), a Telegram channel that includes ideas and links, as well as the newsletter she sometimes records herself reading, thus becoming a podcast. These online spaces often feature menu items or stand-alone boxes containing the TEDx conference she spoke at and the two books she published between 2014 and 2015: *Due gradi e mezzo di separazione: Come il networking facilita la circolazione delle idee (e fa girare l'economia)* [Two and a Half Degrees of Separation: How Networking Helps Ideas Move round (and Makes the Economy Run)] and *Se scrivi, fatti leggere: L'importanza della riconoscibilità in rete* [If You Write, Get Read: The Importance of Online Recognition]. Then, she has her own accounts on LinkedIn, Instagram (10,000 followers) and Twitter (25,000 followers).

Gianluigi Tiddia, a Sardinian engineer universally known online as @insopportabile [unbearable], also has a website, blog and newsletter. Similarly, he likes to create sporadic podcasts from the articles he publishes. He can also be found on LinkedIn, Instagram and, above all, on Twitter, where nearly 140,000 followers make him one of the most active and influential users on the Italian scene.

Then there is Riccardo Giannitrapani, a high school maths and physics teacher who, as well as his own blog, *Il Prof bicromatico* (The bichromatic teacher), is very active on social media networks, particularly Twitter (@orporick), where he has almost 40,000 followers. Due to the pandemic and the need to organise distance-learning material, he has published many YouTube videos of his lessons together with messages that, while initially specifically (or surreptitiously) addressed to his students, immediately left the school boundaries and attracted thousands of viewers.

Lastly, we have chosen to study how Emanuela Valentini, a writer and freelance editor, presents herself on Facebook and Instagram.

These people have each made specific choices regarding how they define their presence on different digital platforms. They have decided where to be and why, what topics to talk about and what to avoid, whether to show off or not, and what communication style to adopt when managing conversations

with other network users. In short, we can find social media strategies, editorial plans and community management policies at work in each of the accounts analysed. Users like @insopportabile, @orporick and @domitilla have built and employ proprietary digital spaces (personal website, blog, newsletter, podcast) which become their favourite means to share contents created by them; Facebook, instead, is used almost exclusively for passive sharing (a few or no comments at all, no interactions, etc.), making it a sort of social repository of its own content.

The case of Instagram is different. Although publication rates are much lower than on the other platforms, where they are present, all users analysed recount their stories through images, in line with its nature and how the platform is customarily used. What changes, of course, are the subjects of these visual representations: @insopportabile almost exclusively publishes photos of the dishes prepared by his wife (to whom he has dedicated a hashtag #santamoglie [holy wife]) and shots of the area of Sardinia where he lives (also in this case we have a dedicated hashtag, #sardolicesimo ["sardolicesim"]); @orporick posts only drawings and watercolors done by him; @domitilla, on the other hand, shares mainly photographs taken on her various trips, breakfasts and scenes of everyday life; finally, unlike the other accounts analyzed, @emanuelavalentiny's account contains mostly images of her (and her books).

Twitter is no longer used by Emanuela Valentini; her last tweet dates to 2016. The other three accounts in the corpus analysed, however, concentrate their online communication, and consequently the construction of their storyworld, on Twitter.

The analysis period is from September to December 2020.

Analysis

Proper Identity

Self-identity refers to the set of elements that contribute to defining a person's being. Within it we can distinguish a figurative and a thematic sub-component. Figurative identity consists of all figurative attributes (Greimas, 1987) of the character (appearance, qualities, psychological traits, physical attributes, habits, etc.), including a proper name (Barthes, 1970) and a proper image (Tomasi, 1988: 26). Analyzing the corpus from the figurative level, we first wanted to know what images of the self populate these people's online worlds. @domitilla rarely posts figurative representations of herself, hardly any photos of her or selfies of her exist on her accounts. Her figurative identity is mainly created through the use of food images and photos of the books she reads (whose inner pages are often shown in addition to the cover), although other forms of textuality are not lacking. One of the trademarks of her online presence is the use of screenshots showing extracts of her WhatsApp conversations, which she arranges to re-create polite back-and-forth chats between her private and

public dimensions. Then there are the 'end-of-the-evening' tweets, where poems and songs, but mostly gifs, are employed to express her mood and that of the day.

@insopportabile has adopted another way of constructing identity that almost dispenses with self-representation altogether. On his Instagram account we can find just one single black-and-white photo of him taken from behind from a long way off. It is a post whose caption is particularly significant for our research:

> It's hard to be yourself in a world that's always pushing you to be something else, to feel inadequate if not defective, to follow perfect and ideal models created to sell products or services, but doing so in spite of continuous conditioning is a subversive act.

While a prolific producer of content, @insopportabile practically never shows his own body. But this does not affect his online recognizability, as his profile photos and web presence almost always include a close-up image of an eye and the colour blue. LinkedIn is the only platform where we can find a real photo of him and his first name. For the thousands of people who follow him online every day at @insopportabile, he is instead a blue eye, an avatar. Now, if a semiotic analysis of images required us to restore the field of colour to the plastic level of visual texts (Eugeni, 1999), in this case the colour blue would play a figurative function or, better, stand in for an absent figurative representation. We are certainly dealing with an identifying and characterising trait, openly exploited by @insopportabile himself (in one tweet he thanks Apple for having dedicated the blue version of the new iPhone 12 to him) and recognised in this way by the users of the network; on the occasion of his birthday, in many tweets and greeting posts, he was directly referred to as *'il grande blu'* (the great blue), *'uomo dall'occhio blu'* (the blue-eyed man), *'eminenza blu'* (blue eminence), *'uomo blu'* (blue man), *'amico blu'* (blue friend).

The other two figures analysed within this corpus have chosen a different approach. @orporick is happy to appear in everyday life scenes, whether it be in selfies taken in an empty classroom at the school where he teaches, wrapped up in a woolly blanket and wearing a hat and gloves at home the day the boiler in his flat broke down, messing around with hardware equipment in the home video studio where he records his video lessons, or surrounded by the paraphernalia of a fanatical old nerd. His posts often reveal little obsessions and manias connected with doing as well as being.

Along similar lines, @emanuelavalentiny does not shun selfies or photos of her at work (her typing on her PC) and play (holiday snaps). We find her outdoors but mostly at home, whose doors she seems to open to her followers. Here we can see her having breakfast in her pyjamas, busily preparing a hot chocolate, watching TV surrounded by her cuddly toys. Particular attention is given to her style and the way she dresses (often vintage clothes) and her fashion accessories.

The *thematic sub-component* is related to the thematic roles (a term that Greimas [1987] uses to define abstract social or cultural roles, etc.; i.e., warrior, fisherman, father, barbarian, etc.). Thematic identity refers to the set of roles a character – or in our case a person – performs, simultaneously or sequentially, within a text or series of texts (Bertetti, 2014).

To most, @orporick is first and foremost a maths and physics teacher (perhaps the teacher we all wish we had had). Studying his online presence on various platforms we learn, however, that he is also a husband, father, and a nerd. While some of these thematizations (Greimas and Courtés, 1982: 344) – the professor playing online, drawing his wife naked, publicly reflecting on his parental condition – might clash with the stereotypic image of teacher, he is not afraid of revealing this co-occurrence of thematic roles in public and private spheres, and he even makes it the discriminating – and authentic – feature of his online identity.

We also find a co-occurrence of thematic roles at @domitilla, where she appears mostly as an open, curious and mindful marketer, who praises Google's PR and reflects on the role of social networks in the business models of traditional media. She also regularly mentions novels, TV series and podcasts across her accounts, especially in her newsletter. But @domitilla is also a mother – even though she increasingly posts fewer and fewer references to her private life – a plant lover, a foodie, a feminist, in a multiplicity of thematic roles that account for her centrality in numerous online communities.

Instead, the other two identity-building strategies analysed here illustrate a well-defined thematic focus and, we could say, some ancillary roles. Online, @emanuelavalentiny presents and defines herself first and foremost as a writer. She describes her feelings about and passion for writing. At the same time, she is a woman in love, a daughter, a friend, and someone who loves posting and sharing photos of the clothes and other things she buys. But these roles never even remotely affect her main identity as that of a writer.

On LinkedIn, @insopportabile also has a very specific thematic role: tourism expert. Here he publishes his articles and opinions on the subject; the same skills emerge when analysing his conversations on Twitter. Broadly speaking, these skills extend to cultural management, PR and destination marketing. The impression is that no tourism project relating to Sardinia can do without his contribution at some level. Another theme is that of reconciling technological innovation with the values and practices of country life. We have here the engineer, the farmer and, as we have seen, the 'grateful' husband. As with @emanuelavalentiny, his thematic identity is clear and strong.

Relational Identity

Alongside the *own* component we find the *relational* component. An identity is in fact also constructed on the basis of the relations it establishes and cultivates (and stages) with other subjects (actorial relations) and with the spaces (spatial relations) of the constructed narrative world, as well as with its temporal dimension (temporal relations).

Being able to explore lists of friends on Facebook or scroll through a person's followers and followings on Twitter is central to social networking practices and the strategies adopted to construct an identity being investigated here. Who are this profile's contacts? Which ones are mentioned or addressed directly? How is the social network configured? An online identity is partly determined by these variables. In this sense, the champion at constructing a personalised relational identity is without doubt @insopportabile, not so much due to his huge number of followers as to his constant commitment to networking, encouraging participation and building collective narratives. Seen this way, @insopportabile can be defined as a network animator and activist, especially on Twitter.

@domitilla also focuses a lot on building online relationships; not doing so would be strange for someone who has written two books on the subject. Her activities on social media networks sometimes resemble *content curation*, an activity that spills successfully into her newsletter. In general, however, her posts and tweets very often mention and tag other accounts and other people in her broad circle of social and professional connections. As with @insopportabile, this is, let's say, public relationality, that is, constructed from the centrality acquired over the years within the social dynamics of the network. These relationships unfold within the media sphere, the private sphere remains outside or is only hinted at.

@orporick and @emanuelavalentiny represent a different case: the construction of their relational identities owes more to private and domestic dimensions. The first produces content using not only his students but also family members: first and foremost his wife, whom he portrays almost daily – often chatting with her publicly on Twitter – as well as his four-year-old daughter and his teenage son. @emanuelavalentiny often includes her boyfriend in her narrative – but also in visual representations of her world. While @insopportabile often refers to his wife's extraordinary culinary skills, which he publishes at #santamoglie, she only ever appears metonymically in the form of photos of the dishes she has prepared.

This is the picture that emerges when looking at the relationships with the other subjects that populate the discursive universes of our corpus. Identity, however, as we said above, is also constructed in relation to spaces, since space and identity are inter-defined. When @domitilla writes, 'I always have a good excuse to go to Venice' in her Twitter bio, or the hashtag #sardolicesimo raises @insopportabile to the rank of ambassador of the Sardinian world, we clearly see how places, spaces and territories can become focal points of a personal narration. @domitilla often talks about her hometown – 'How I love Milan', 'I missed you Milan', 'Yes, I like Milan, because it's like living in a town, but with museums' – but, in general, she describes the place she is in, letting all her followers know she's in Naples by writing about *sfogliatelle*; when in Rome for a few days she floods her account with photos of *cacio e pepe* pasta, adding, 'I don't know if you agree. This is all I'll do between now and tomorrow'; then she'll publish a mini photo reportage while in Venice for the weekend. Writing about these places and posting personal opinions of

them creates relationships with meaning-carriers linked to specific urban realities, which plays a decisive role in building one's own online identity. Each of these spatial marks carries with it additional meanings that become part of the subject's universe of values and enriches the overall image that emanates from the media environments in which it is present. These universes of meaning are very different from those that in various ways are connected with the #sardolicesimo of @insopportabile: on the one hand we have an urban reality, which might be Milan's *coolness*; on the other we have the Sardinian countryside, sea and sunsets, poetic idylls posted on a daily basis at #tramontismi [#sunsetisms]. The first offers us a citizen of the world; the second is an expression of proud cultural and territorial rootedness.

The spatial discourse of @orporick and @emanuelavalentiny is more intimate, linked above all to the different environments of the home and, in general, of personal living spaces (the patio, the classroom, a book stall), without the substratum of meaning and imagery that inevitably accompanies identification with clearly recognizable spaces and territories.

The temporal dimension is of little significance in our object of study, since the interspersed narration (Genette, 1972) typical of writing on the web totally conforms temporal relations to a present in the making.

Narrative Identity

Narrative identity, we have said, is related to the *doing* of the character or person. In the case of fictional characters, the first step of any analysis is to verify whether the character is always credited with the same course of actions across different texts and media (i.e., a single life story), or of different courses of action, i.e. different life stories (Bertetti, 2014). In our case this preliminary distinction is not relevant, as the reference is always to the life story of a person – real or presumed such – which is obviously unique.

We can distinguish three different sub-components. Firstly, an *actantial identity* related to the different actantial positions (Subject, Object, Sender, Receiver, Helper, Opponent; see Greimas, 1987) adopted by the character-person. In each story, we can identify ends and means, goals to reach and strategies to be implemented or better – in semiotic terms – 'objects of value' which a subject wants to join and narrative programs (action programs) necessary to reach them (Greimas and Courtés, 1982; Greimas, 1987). Second is a *modal identity* based on the character's different modalizations. In linguistics, 'the term modalization relates to the procedure whereby a descriptive statement is modified by means of modal expressions' (Martin and Ringham, 2000: 87). Within the narrative grammar of Greimas, the term specifically refers to the motivations and the skills of the subject in relation to its doing: 'wanting' (or 'having to'), 'being able,' 'knowing' (see Greimas, 1987). On a deeper level, we can also detect an *axiological identity*, reflecting the system of values (axiologies) that govern the doing and the being of the character, which are the basis of a narrative construction of identity, regardless of the single posts.

Actantial roles (where the actantial position is modified according to the type of modal competence required by the action) can be transversal to the entire textual corpus and different media, but also be different for each textual fragment. In the analysis of any serial narrative, in fact, we must consider on the one hand the overall macro-story that accounts for the *global* identity of the character (or person), and on the other the micro-stories told in each textual fragment, which account for its *local* identity. Serial dissemination can include a whole hierarchy of narratives, with narrative arcs of different breadths: the story told in a single post, a broader story that unfolds in a series of posts, up to an overall narrative given by the set of posts or even by the whole transmedia set.

For example, an Instagram post by @domitilla is a small narrative fragment, a short and concise story of everyday life. 'And now that we have also washed the bikes – let's go back to the usual fried things'. The image shows some fruit and vegetables, including eggplant, while the text enunciates a precise action program: frying.

Certainly, it is a very elliptical narrative: @domitilla says she will fry the food, but she does not provide any details. Recipients will complete the narration according to language competence and inferences drawn from stereotyped scripts and interpretative frames that will allow them to visualise the act of frying and eventually that of eating the meal.

More information will be acquired from other textual fragments belonging to the same 'series': the followers already know that the vegetables come from @domitilla's personal garden. In another post she writes: 'What makes you happy? Things from the garden' – and her followers know that for her frying is a mood element, a category of the spirit rather than of taste. In short, the reader reconstructs a narrative component, but also a patemical dimension (the vegetable garden, the kitchen, the bike: these are the things that make her happy) and a universe of values (naturalness, and so on).

Our analysis of online identities presents us with a further problem: since we are not dealing with closed serial forms but with open narratives, we cannot grasp their totality, therefore it is not possible to reconstruct a defined global identity as the macrostory is always under construction. However, although it is not easy to identify a 'story' in its entirety, it is still possible to identify roles and objects of value, and narrative programs necessary to reach them, although not necessarily destined to end and actualize.

The global narrative dimension is strictly related to the thematic identity of each person and to the intersection of the different main and secondary thematic roles. Take the case of @orporick. As seen, his main role is that of teacher, alongside that of husband, father, nerd. This role is matched by typical behaviours and programs of action, which outline a complex actantial identity. On the one hand, as teacher he plays the typical role of Sender: he is a transcendent entity that directs and regulates the student's activity of acquiring knowledge, gives homework – for example, sends function studies and videos to watch at home – and positively or negatively sanctions their

doing. On the other hand, he also has a more active role: as a trainer of people, he is in fact a Subject of doing, actively responsible for a transformation (that of the student) and the achievement of educational objectives. In addition, the teacher is increasingly understood to be a facilitator of the student's learning activity; in terms of narrative semiotics, he is a Helper in the acquisition of the student's skills. First of all, cognitive skills, but not only: if @orporick is the one who 'lends a hand to boys and girls who are temporarily in need', especially those with a more fragile personality (tweet, 30/11/2020), it is the emotional and relational sphere that comes to the fore.

Despite his originality – and in some ways his uniqueness – as a character, @orporick fits perfectly inside narrative schemes associated with the thematic role of teacher. To a greater or lesser extent this is also true for the other identities under analysis: the fact that online accounts of their experiences almost always end up resembling each other (Bettini and Gavatorta, 2017: 93) is due not only to the forms of the discourse, but also to identification with pre-defined thematic roles, which always imply recurring narrative schemes. It is rather the intertwining of different roles (as well as the figurative and relational notations) that reveal the peculiarity of the @orporick character and the other identities.

The global narrative identity of @emanuelavalentiny is also defined by her main thematic role. As mentioned, her identity strategy is centred on presenting herself as a writer: writing is her life (FB, 8/10/2020), and her happiness derives from creating stories and building worlds

> Last night I dreamed of a new house that wasn't just a house. It was also a notebook and had to be furnished with words. In my hand I had a nib with gold ink and a sense of growth and construction vibrated in the air. It reminded me of what happiness is to me.
>
> (FB, 24/10/2020)

She carries out this activity both as a writing Subject (it is writing that represents her: a lot of posts show her intent on writing in the most diverse poses and conditions) and as a Helper in the creative efforts of other Subjects to whom she transmits her own writing competence:

> A little while ago two authors who I followed in their projects wrote to me. They both wanted to thank me, and I got excited a lot! I tell it because it's funny: they don't know each other, but they almost said the same words. That is, without me their editorial projects would never have seen the light. It is a joy for me to know that two new stories are about to reach readers.
>
> (FB, 11/11/2020)

In @emanuelavalentiny, the role of writer originates from a series of values that she is passionate about, above all authenticity: I am like this and I am the

same in writing. She presents herself as an author who writes with passion, which she pours into her books. In this sense, public and private are separable only up to a certain point; the act of exhibiting herself, her daily life, her affections, her home, is at one with her being a writer.

Unlike @orporick and @emanuelavalentiny, @insopportabile is, as we can see, primarily concerned with the public dimension. @insopportabile is an online promoter, a competent Subject in the field of tourism, where he is certainly an influencer and opinion leader. As such, is he a transforming or rather a facilitating agent? (i.e., a Helper who contributes, with his expertise and reflection, to the development of third-party initiatives?). In an open letter to the Italian Minister of Cultural Heritage and Tourism, Dario Franceschini, published on his website (http://www.insopportabile.com/2020/09/13/lettera-aperta-al-ministro-franceschini/), he acts like a sort of spokesperson for the tourism sector.

At the value level, @insopportabile is a complex figure who brings together the spheres of innovation and tradition. He has a clear vision of a possible green future: a post-urbanity (ideally linked to a sort of pre-urbanity) tempered with technological innovation. He is a techno-enthusiast, with a critical but optimistic approach, a champion of innovation, with one eye on sustainability: technology, social media, and so forth must improve us, not make us worse. We must ensure that technological development is compatible with a better quality of social life. And then there is a return to the vegetable garden, the sea, the brazier, good food and good wine. Sustainability is a key and transversal value that runs through his action and his narration: sustainable tourism, sustainable development. At the heart of his axiology, or at least of his discursive strategy, is an ideology of sustainability.

Conclusion

As already mentioned, these are the first results of a broader research that will extend the analysis to a wider corpus of different users, with a view to generalising the results, and put together a possible typology of the modes of constructing identities across media. Although the analysis was conducted on a small sample of users who are particularly aware of the languages and discursive forms of the different media, it has nevertheless shown the methodologies used for the study of fictional characters and transmedia narratives are also helpful in the study of online personal identities and their construction strategies through different media. As we said in the section "The Model of Analysis", this is due to the fact that the construction of identities, be they fictional characters or online personalities, is the result of similar storytelling strategies, based on precise narrative forms, largely stereotyped, of articulating the experience.

In particular, it clearly emerges that constructing one's own personal brand identity is a complex activity that involves more than simply 'presenting oneself': it also means making thematic choices, describing spaces, interrelating

with other identities, referring to a system of values. In other words, it is necessary to structure a narrative universe, a 'personal storyworld' (Bettini and Gavatorta, 2017: 103), variously articulated through the different media.

The work also shows that even identities with a distinct personality and a high level of competence regarding the norms and the uses of online communication – indeed, precisely because of this awareness – cannot avoid adopting sedimented thematic roles, stereotypical narrative scripts, shared performance repertoires (Boccia Artieri et al., 2017: 147) in the narrative construction of their online self.

References

Barthes, Roland. 1970. *S/Z*. Paris: Seuil.
Bertetti, Paolo. 2014. "Toward a Typology of Transmedia Characters", *International Journal of Communication* 8: 2344–2361. Accessed November 3, 2020. https://ijoc.org/index.php/ijoc/article/view/2597
Bertetti, Paolo. 2019. "Buck Rogers in the 25th Century. Transmedia Extensions of a Pulp Hero", *Frontiers of Narrative Studies* 5.2: 200–219.
Bettini, Andrea and Gavatorta, Francesco. 2017. *#Personal Storytelling. Costruire narrazioni di sé efficaci*. Milano: FrancoAngeli.
Boccia, Artieri, Giovanni, Gemini, Laura, Pasquali, Francesca, Carlo, Simone, Farci Manolo, and Pedroni, Marco. 2017. *Fenomenologia dei social network. Presenza, relazioni e consumi mediali degli italiani online*. Milano: Guerini e Associati.
Bruner, Jerome S. 1990. *Acts of Meaning*. Cambridge: Harvard University Press.
de Saussure, Ferdinand. 1916. *Cours de Linguistique Générale*. Paris: Payot.
Eco, Umberto. 1979. *Lector in fabula*. Milano: Bompiani.
Eugeni, Ruggeri. 1999. *Analisi semiotica dell'immagine: Pittura, illustrazione, fotografia*, Milano: ISU – Università Cattolica.
Genette, Gerard. 1972. *Figures III*. Paris: Seuil
Greimas, Algirdas J. 1987. *On Meaning. Selected Writings in Semiotic Theory*. Minneapolis: University of Minnesota Press.
Greimas, Algirdas J. and Courtés, Joseph. 1982. *Semiotics and Language. An Analytical Dictionary*. Bloomington: Indiana University Press.
Hall, Stuart. 1996. "Introduction: Who Needs 'Identity'?", in Hall, Stuart and Du Gay, Paul (eds.), *Questions of Cultural Identity*. Sage, London, pp. 1–17.
Hill, Terry and Westbrook, Roy. 1997. "SWOT Analysis: It's Time for a Product Recall", *Long Range Planning* 30(1): 46–52.
Hjelmslev, Louis. 1942. "Langue et parole", *Cahiers Ferdinand de Saussure* 2: 29–44.
Jansson, Andre and Fast, Karin. 2018. "Transmedia Identities. From Fan Cultures to Liquid Lives", in Freeman, M. and Rampazzo Gambarato, R. (eds.), *The Routledge Companion to Transmedia Studies*. London and New York: Routledge, pp. 340–349.
Jenkins, Henry. 2006. *Convergence Culture: Where Old and New Media Collide*. New York: New York University Press.
Landowski, Eric. 1989. *La société réfléchie*. Paris: Seuil.
Lanier, Jaron. 2010. *You Are Not a Gadget: A Manifesto*. New York: Alfred A. Knopf.

Manetti, Giovanni and Bertetti, Paolo (eds.). 2003. *Semiotica: i testi esemplari*. Torino: Testo & Immagine.
Marrone, Gianfranco. 2003. *Montalbano. Affermazioni e trasformazioni di un eroe mediatico*. Roma: Rai-Eri.
Marrone, Gianfranco. 2010. *L'invenzione del testo*. Roma and Bari: Laterza.
Martin, Bronwen and Ringham, Felizitas. 2000. *Dictionary of Semiotics*. London and New York: Cassel.
Mayer, Giuseppe. 2020. *Branding by Design. Gli otto caratteri della marca post digitale*. Milano: Egea.
McGuigan, Jim. 2014. "The Neoliberal Self", *Culture Unbound* 6: 223–240.
Minestroni, Laura. 2010. *Il manuale della marca. Consumatore Cultura Società*. Bologna: Fausto Lupetti Editore.
Morozov, Evgeny. 2011. *The Net Delusion: The Dark Side of Internet Freedom*. New York: PublicAffairs.
Ricoeur, Paul. 1983. *Temps et récit I. L'intrigue et le récit historique*. Paris: Seuil.
Ritzer, George. 2010. "Focusing on the Prosumer: On Correcting an Error in the History of Social Theory", *Prosumer Revisited* 1: 61–79.
Roberts, Kevin. 2004. *Lovemarks: The Future Beyond Brands*. New York: Powerhouse Books.
Scolari, Carlos, Bertetti, Paolo and Freeman, Matthew. 2014. *Transmedia Archaeology: Storytelling in the Bordelines of Science Fiction, Comics and Pulp Magazines*. Basingstoke: Palgrave Macmillan.
Segreto, Giuseppe. 2017. "La marca. Semiotica, marketing e comunicazione", in Masini, Maurizio, Pasquini, Jacopo, and Segreto, Giuseppe (eds.), *Marketing e comunicazione. Strategie, strumenti, casi pratici*, Milano: Hoepli, pp. 87–118.
Toffler, Alvin. 1980. *The Third Wave*. New York: William Morrow and Company.
Tomasi, Dario. 1988. *Cinema e racconto. Il personaggio*. Torino: Loescher.
Turkle, Sherry. 1995. *Life on the Screen: Identity in the Age of the Internet*. New York: Simon & Shuster.
Violi, Patrizia. 2018. "Dalla nave di Teseo al campanile di Venezia. Una prospettiva semiotica sulla identità", *Rivista italiana di Filosofia del linguaggio*. Special Issue: Italian Society of Philosophy of Language (2018): 144–155. Accessed November 2, 2020. doi: 10.4396/SFL201904

3 Professional Transmedia Selves
Finding a Place for Enterprise Social Media

Christoffer Bagger

Introduction

Picking a profile picture, choosing which biographic information to fill out, which pictures to share and even how we interact (likes, comments, messages), and with whom: these are all examples of how self-presentation may enter our considerations when we use social media. These dynamics and considerations are well described when discussing the mixed audiences of public-facing social media (van Dijck, 2013; Scolere et al., 2018). What exactly the relationship between social media and working life is supposed to be has been a source of controversy for some time (Bagger, 2021). In this chapter I will discuss how this is no less true when social media migrates clearly into the workplace in the form of enterprise social media (ESM) (Leonardi et al., 2013). I discuss this both via the existing research, and by providing three examples of how workers choose to tackle self-representation on ESM.

The argument of this chapter is that enterprise social media represents a new arena in which people's self-presentation must be communicatively negotiated. This negotiation needs to consider three major factors, namely: (1) the goals of individual employees; (2) the social context, and norms of the organisation; and (3) the medium itself and its similarity to 'personal' social media. ESMs, which include platforms such as Slack, Microsoft Yammer and Workplace from Meta (née Workplace by Facebook), imitate the look and functionalities of the more commonly used social media platforms such as Facebook (Leonardi et al., 2013: 2). I argue that a view from the extended field of transmedia theory (Fast and Jansson, 2019) can help us make sense of how people integrate these platforms into their everyday lives. Previous applications of transmedia theory to professional contexts have paid attention to specific media-driven occupations such as journalism (Gambarato and Tárcia, 2017), celebrity (Gmiterková, 2018) or media management (Rohn and Ibrus, 2018). Working life in general is rarely considered, despite the proliferation of digital media technologies herein (Gregg, 2011), and the potentially transmedial nature of current working life (Fast and Jansson, 2019). Specifically looking at ESMs affords us an opportunity to understand everyday people as conscious transmedia producers. Just like the oft-discussed

DOI: 10.4324/9781003134015-5

institutional transmedia producers in the entertainment industry, users of ESM channels must navigate and negotiate the usefulness of different media for different purposes (Jenkins, 2008; Dena, 2009). In this way, all professionals may indeed become transmedia professionals, whether they want to or not.

After a brief overview of some of the many ways in which social media in general have posed a problem to the maintenance and construction of identity, I move on to specifically discuss enterprise social media. While ESMs on paper pose a solution to many of the problems associated with identity construction on social media, I contend that their purpose can still be quite *uncertain* to the end user. I highlight this through three case studies of users of the ESM Workplace from Meta, a medium developed by Meta Platforms, Inc, more well known for their Facebook platform. Inspired by heuristics from previous studies in people's self-communication with and across media (Lomborg and Frandsen, 2016; Scolere et al., 2018), I present three case studies of how self-presentation on enterprise social media may be guided either by (1) the wish to control and construct one's own self-conception, (2) the wish to conform to the social world of the organisation or (3) the wish to exploit the playful, social affordances of the ESM platform Workplace from Meta insofar as they are similar to that of the regular Facebook platform. Proceeding along each of these axes may at first lead to an integration of the ESM into everyday life and self-presentation. However, as each case will demonstrate, going too far along any of them may also lead to the ESM itself becoming superfluous.

Background

Identity, Social Media and Transmedia

I argue that this is a conundrum which can be illuminated through the perspective of transmedia theory, insofar as it represents an opportunity for individuals to respond to the challenge of using media for appropriate and specified purposes (Helles, 2013; Lomborg, 2014). As I argue, this is analogous to the transmedia producer's challenge of having each text across media making a distinctive and valuable contribution to the whole (Jenkins, 2008). For my present purposes, the 'whole' is not some unified concept of identity of the self. Rather, just as is the case for fictional transmedia characters, the fact that a *person* is present across multiple media does not necessarily imply that these diffused media make up a coherent, univocal whole (Bertetti, 2014).

To illuminate this, I build on an expanded understanding of transmedia studies which presumes that we are in the middle of a process of 'transmediatization' (Jansson, 2013). This is to be understood as a societal shift where media are decreasing in their role as mass communication 'gathering places' and increasingly rely upon the authorship and participation of those previously called the 'audience' (Jansson, 2013: 287–288). This process then

becomes a mundane fact of everyday (working) life rather than something which is confined to specific topics or subcultures (Jansson and Fast, 2018; Fast and Jansson, 2019). In other words, digital identity and self-presentation cannot be understood as something which is singular, but rather negotiated and situational. This will become especially pertinent in the domain of the professional, which is both a source of great meaning in the lives of people (Gregg, 2011), as well as a domain filled with restrictions and structures (Anderson, 2017). Accordingly, it is a domain in which individuals must constantly negotiate the construction of their own identities (Nippert-Eng, 2008).

Regarding identity construction, Jansson and Fast (2018) note that previous transmedia studies have emphasised identity as (1) unfolding in relation to transmedia texts, (2) being unitary and (3) something which is perceivable only through obvious expressions (2018: 341). In contrast, they argue that in the current media environment, 'managing transmedia per se becomes an element of identity work' (2018: 346). This is congruent with existing communications scholarship, which emphasises that users are now left with the tasks of choosing among a plethora of media to manage their everyday (Helles, 2013) and are engaged in a constant, ongoing process of negotiating what is appropriate behaviour *on* and *with* these media (Lomborg, 2014). In this way, today's professionals (and media users in general) are now faced with the dilemma which was previously discussed as the purview of transmedia producers: finding out how to use different media for dissemination of content which is not only valuable on its own (Jenkins, 2008: 97–98), but also aimed at different, specific audiences (Dena, 2009: 237).

The problem of self-presentation to different audiences is perhaps nowhere more prominent than in the study of social media. A social media presence is something to be 'worked on' and perfected constantly (Perkel, 2008). This is especially pertinent in discussions of maintaining a professional public appearance across media (Scolere et al., 2018; Jacobson and Gruzd, 2020) in the context of the 'real-name web' (Hogan, 2013).

Confounding matters further, the spokespeople of social media platforms themselves also disagree about the proper approaches to identity construction on their media. Meta's CEO, Mark Zuckerberg, has been quoted as saying with regards to the proliferation of his own platform that '[t]he days of you having a different image for your work friends or co-workers and for the other people you know are probably coming to an end pretty quickly' (quoted in Kirkpatrick, 2010: 199). In contrast, LinkedIn CEO, Jeff Weiner, has insisted that 'Facebook is largely a social utility platform. LinkedIn is a professional network. … The key distinction is that as a professional, you want people to want to know who you are' (quoted in van Dijck, 2013: 207). If the people behind these media disagree about where and how the professional self should be disseminated, then it should be no surprise that users might be as well.

Considering this, people have developed several strategies to cope with maintaining the boundaries between work and other domains of life

(Ollier-Malaterre and Rothbard, 2015). For instance, people may self-censor posts (Sleeper et al., 2013), make profiles private or non-searchable (Tufekci, 2008) or create multiple profiles on the same site or use several sites entirely for different purposes and audiences (Kang and Wei, 2020) All of this is in aid of maintaining boundaries and preventing the so-called context collapse (Marwick and Boyd, 2011).

Enterprise Social Media and the Professional Self

During the last decade or so, a new type of business media has been on the rise. These types of software are variously referred to as 'internal social media' (Men et al., 2020), 'organizational social media' (Van Osch and Coursaris, 2013) or (in my preferred nomenclature) 'enterprise social media' (Leonardi et al., 2013). What they have in common is the distinguishing feature of being bounded off to include only members attached to a specific organisation. Enterprise social media differs from the conventional intranet in their affordance for many-to-many style communication (cf. Jensen, 2010), as opposed to the one-to-many, top-down style of communication often characteristic of traditional intranets (cf. Heide, 2015). Ordinary people are now tasked with using specific media for specific purposes and audiences. They are urged into authorship of not only organisational communication (Grudin, 2006; McAfee, 2009) but also of their strategic self-presentation (Leonardi and Treem, 2012).

Thus far, there seems to have been little research on how professional social media are integrated into people's transmedia lives. This necessitates a view of how these media are viewed and used by workers, rather than the usual focus on what these media might do *for a company* (Treem, 2015). I argue that enterprise social media – and Workplace from Meta in particular – present a new challenge for people's transmedia identity work. Firstly, this is because they are situated within the structuring context of an organisation, where rules are often formalised and power inequities between people are often both explicit and taken-for-granted (Anderson, 2017). At the same time as they are situated within this formalised system, ESMs are still designed to afford the 'personal, but not private' informal communication characterised by more public social media (Lomborg, 2014).

On paper, the ESM presents a protection to the threats of context collapse by engaging in a known audience. This is because the audience is known insofar as it is restrained to the context of work. However, given the affordance for this many-to-many communication, this can be broadly said to both empower and constrain the ability of the individual to freely express themselves, as they are now required to navigate a new communicative arena. In practice, this can lead to highly varied results. As these systems are usually voluntary, at least on paper, usage may often be low and sporadic, with many workers abstaining from use (Giermindl et al., 2018; Treem, 2015). As we will see in the following analysis, even dedicated usage may lead to rendering the ESM superfluous or marginal, thus reducing its integration into a personal, transmedia ecology.

Data Collection

The three specific choices of self-presentation discussed in this chapter are chosen as exemplary cases from a larger pool of 21 interviewees. These three specific respondents are chosen as they best exemplify three distinct approaches to presenting the 'professional self' on the ESM Workplace, namely, along the three axes of self, social world and social media system.

The original pool of 21 cases was sampled to attain a maximal variance in types of organisational type (varied on both size and industry). The organisations ranged in size from about 20 members to about 12,000 overall, and the industries ranged across non-government organisations, design bureau, health and fitness, media and publishing, medical and technical services, information technology, construction, and consumer retail. My choice of respondents is neither unusually precarious nor highly privileged power users, as opposed to recent related studies of transmedia work (e.g., Fast and Jansson, 2019).

I interviewed with the purpose of mapping their participation across several ordinary social media platforms (including, but not limited to, Facebook, Twitter, Snapchat, Instagram) and finally Workplace from Meta. As a documentation of their practices with the ESM, I would ask them to walk me through their recent activities on the platform. The interview would then end on them reflecting on the patterns of their own usage as they recalled them, including what they saw as appropriate or desirable behaviour. These reflections – along with a reading aloud of the content – would then be included in the final transcriptions. In this way, the interview was meant to elicit not only a recollection of their activities, but also a reflection of what factors structured their behaviour, and what aims they had with their patterns of action.

Analysis

Three Strategies of Integrating Enterprise Social Media

In the following section, I highlight three case studies of people who have tried to answer the question of 'What am I supposed to do with enterprise social media' differently. It will become obvious that their respective responses are curtailed by their circumstances. Most notably, this involves their respective (upper- and lower-case) workplaces. However, I argue that each of their responses is shaped by their expectations of ESM Workplace and its similarities to the personal Facebook platform.

They react to this similarity along three different heuristic lines which I borrow from studies of communicative interactions with apps and social media by Lomborg and Frandsen (2016) and Scolere et al. (2018). Either they let their response be guided by their (1) *selves*, by (2) the *system* and its similarity to other known systems or by the (3) *social world*, which most obviously entails their workplaces, but might also extend to their broader professional and personal networks. While all three cases displayed concerns along all three logics, I demonstrate that one of these logics is dominant in each of the given cases.

My first case, Isak (*self*-directed), will show a person who chooses to deal with the ambiguity of ESMs by cross-posting to both LinkedIn and Workplace. In this way, I argue that Isak represents a 'mostly professional' use of Workplace which is particularly *career-conscious*. My second case, Oliver (*social world*–directed), will discuss how Workplace can be used in a way which exemplifies *citizenship* in his organisation through his actions. The aim for Oliver is to use the platform to socialise and orient himself, contributing on occasion, but being very mindful of never transgressing any professional norms. My third case, that of Louise (*system*-directed), shows how Workplace can, quite contrary to its stated purposes, completely morph into being a less-than-serious platform. In this, I argue that her purposes for using Workplace can be summarised as an attempt to achieve *conviviality* in her small organisation. They all provide different attempts, along different axes, of how to integrate enterprise social media into a person's life. However, as we shall see, proceeding along these axes may also lead to the medium being made superfluous, or otherwise being rejected.

Case #1: Self-Directed Usage and Career-Consciousness

Lomborg and Frandsen (2016) mainly develop their ideas of digitally 'communicating with the self' with reference to self-tracking apps, where users can constantly gain new insights, document their achievements and compare themselves to their past selves. However, self-documentation is also a central aspect of social media (Mortensen and Lomborg, 2019), and of keeping track of one's own professional accomplishments. I therefore wish to discuss a respondent who has turned primarily towards this type of usage of the ESM Workplace from Meta.

Isak, our first case study, works in a project leadership position in a large Danish construction enterprise. The individual projects he leads often last upwards of several years in total, and even longer if negotiations drag on. During these periods, he will in his daily tasks deal with builders, office workers and administrative personnel from both his own organisation and the organisations for whom he is doing construction. His days are filled back-to-back with meetings. In the peak periods of the project work, Isak's days may start as early as seven in the morning and end as late as eleven in the evening, not counting the time before he gets to work and may check emails (frequently) or (more rarely) return a phone call from a partner or subsidiary.

Isak tries, on occasion, to photo-document his day-to-day on Workplace if he finds something particularly interesting going on. These photos have two usual outputs: his Workplace profile and his LinkedIn profile. Usually with highly similar texts attached, depending on the audience at hand. Isak says he is highly aware that a lot of the industry-specific terminology might not yield the intended engagement on LinkedIn, whereas this is less of a concern on Workplace, where everyone is in the same business as him.

On Workplace, his posts often yield reactions and comments from the national officers and international chief executives of his organisation. Isak

expresses a great degree of satisfaction with this, insofar as he appreciates the recognition from his superiors. In a recent case, Isak documented the entire process of construction of a large complex – from the first shovel to the ribbon-cutting – as an album on Workplace, eliciting many reactions. Isak also here engages in a very explicit documentation of his work. The documentation then appears in a form with which others can interact. This feeds into the affordance of visibility offered by ESM (Treem and Leonardi, 2013), and the visibility of connections. This allows Isak to both know for himself and display to others his connection to the executive branches of his firm.

Isak's usage pattern is aimed towards a highly professional self-presentation, and always with at least two 'imagined' audiences in mind: his internal (and mostly known) audience and his broader network (of both known and unknown persons). Since the latter is of course not available to him through Workplace, this leads him to shape his posts so that they can, with relatively little tweaking, speak to both audiences. In this way, he has appropriated two media platforms – LinkedIn and Workplace – to serve complementary purposes in his everyday media repertoire.

Isak is a representation of the fact that the usual affordances of self-presentation on enterprise social media, particularly visibility and a public display of connections, are useful but not sufficient. Rather, he wishes the effort displayed in his self-presentation to be at its most fruitful and reach the widest possible audience. As the professional self-presentation afforded by a platform such as Workplace is easily transferable to other, professional contexts, in this case LinkedIn, this presents an interesting contrast to previous examples of having to more selectively self-present across certain media (cf. van Dijck, 2013). In this way, Isak ironically renders Workplace as marginal in his own media ecology, insofar as LinkedIn becomes the place where he reaches most of his intended audience, even part of the audience he might seek out on Workplace.

Isak provides an example of a self-presentation which needs to be tailored to a diverse audience both within and without his organisation, and wishes to be visible and to excel. The next case will describe a person who tailors their professional self-presentation exclusively to be internal to the organisation and wishing to conform.

Case #2: Social World–Directed Usage and Citizenship in the Organisation

It seems almost tautological to point out that social media are, indeed, social. They allow us to feel a sense of communion with others, in which we constantly negotiate or reaffirm norms of communication (Lomborg, 2014). Knowing and reaffirming these norms may arguably be even more vital in a professional context, where people may self-censor or otherwise curb their expressions out of a fear of social and professional repercussions (Madsen and Verhoeven, 2016).

Oliver, my second case, works with the implementation of IT solutions in a large multinational firm with more than 5,000 employees. Even though Oliver's tasks are managed by a wide variety of other (usually Microsoft-based) pieces

of software, his organisation has also implemented Workplace. When I first meet him, Oliver is an active user of Workplace, and often shares, comments on and likes the posts of his colleagues.

When he posts, it is usually in groups where he either knows everyone or is highly confident about which audience he is reaching. His work involves a good deal of travelling and helping implementations and launches in different countries, as well as a fair number of conference and networking activities. This often occurs in teams, and Oliver and his team often document this with selfies or group photos shared on Workplace groups where they deem the audience to be relevant.

There is also room for more informal photographs and posts, especially when celebratory dinners with his team occur, usually when visiting foreign cities. Oliver describes a close relationship with his immediate colleagues, and a great deal of enjoyment about these outings. It is not uncommon for these outings to become rather festive, resulting in a quite informal mood, and the occasional alcohol-induced embarrassments. At this point, Oliver describes, someone usually makes sure that everyone puts down their phones and makes sure that everyone has heard a refrain of 'No workplace [for this]'.

In other words: at some point, even in a gathering exclusively among colleagues which has been continually documented for sharing on Workplace, there is a danger of transgressing the communicative norms of the internal platform. The colleagues then find themselves in a situation where the boundaries of professional courtesy in sharing must be explicitly reinstated.

I present Oliver's practices here as an example of a dutiful user of the ESM who exemplifies many of the assumed ideal traits of an ESM user: he tailors content to the internal audience of the organisation at large and to his closer group. His presence and self-presentation strike a balance between the convivial and the professional, walking the tightrope to distinguish what types of communication and self-presentation are appropriate. In this way, his usage and self-presentation is broadly aligned with what might be termed 'organisational citizenship' (Organ, 1997). Here organisational 'citizens' (employees, workers) are expected to be dutiful and communicative members within the context of the organisation.

However, citizenship may take one only so far in one's enthusiasm for an ESM. When I catch up with Oliver in a follow-up interview a year later, he is quick to try to convince me that he has not made much use of Workplace since our last encounter. I attribute this in part to the fact that he felt no need to stand out on the platform, and certainly did not consider it an essential work task. Thus, he had slipped out of the habit of contributing and checking in, and the ESM had been rendered marginal in his own media ecology.

Case #3: System-Directed Usage and Conviviality

On social media, our communicative traces and actions are viewed not only by other users, but also absorbed and analysed by the system itself, before occasionally being fed back to us. In this sense, using social media is 'speaking into [a] system' (Jensen and Helles, 2017). This system may then both

explicitly 'talk back' in the forms of messages, prompts and suggestions. In a more indirect sense, our expectations of the system are also shaped by interactions with previous, similar systems. In the case of Workplace from Meta, the obvious point of comparison in people's previous experience is with the regular Facebook platform.

The final case is that of Louise. Louise works in a small NGO of around 20 people. The team is a mixture of volunteers, interns and full-time employees, and they occupy a very narrow age range, with the oldest in their early 30s. The members of the organisation are almost all mutual Facebook friends, share lunch most days and often leave for drinks after work. The latter of this is often arranged through threads on Facebook Messenger, or simply by text message. That is, if everyone isn't just in the office around closing time, in which case all of this just happens more spontaneously and without the need to pull out a phone or open a messaging thread on a computer.

As an NGO, Louise's organisation gets free access to Workplace, and one of her colleagues chose to take advantage of this opportunity and install it. However, due to the informal nature and work environment at the organisation, Workplace sees little use. The organisation makes concerted efforts to post their Monday morning meeting notes on the platform for storage. Aside from this, most of the posting that appears on the organisation's Workplace is in a dedicated 'meme exchange' group. Louise is a frequent contributor in this group, where the level of seriousness is quite low.

I home in on Louise and the Workplace of her organisation because I believe that they represent an interesting edge case. This instance of the Workplace platform is virtually devoid of content which is, for instance, self-congratulatory, or even congratulatory of the team or their achievements. The reason for this, she believes, is simple: There is no one on there for the benefit of whom it would make sense to engage in this kind of performance. Instead, the only active forum is one where the content is decidedly unserious. In this way, this instance of Workplace has more in common with informal, humorous link-sharing services or the earlier days of the regular Facebook platform.

I emphasise this because it is not exactly a stated goal of ESMs that such modes of use occur. I argue that this is all possible, in Louise's case due to the small size and intimate culture of her organisation. In some sense, the enterprise social medium is almost superfluous, which I argue allows for the use that she and her small NGO evidence here. Since the affordances of the ESM do not – to her and her teammates – present much obvious advantage in terms of the usually stated goals of knowledge sharing (memes excluded) or de-hierarchization, it became a medium of pure sociability. As sociability was ultimately a purpose which was served by plenty of other channels in the small NGO, this ultimately resulted in them leaving the ESM by the wayside.

Conclusion

In this chapter, I have argued how we can now see individuals in general, and professionals in particular, as 'transmedia producers', especially with regard

to their production of mediated 'selves'. This is perhaps most apparent when it comes to identity construction and social media. Here, enterprise social media present themselves as a new medium to be incorporated into practices of self-presentation. As these cases have demonstrated, whether one proceeds with an eye primarily towards self-promotion, conforming to the social world of the organisation or merely trying to lean on the systems similarity to known media, this is no guarantee of a successful integration into a personal, transmedia ecology. If we are to consider the current professional as an (unwitting) transmedia producer, they certainly have their work cut out for them.

This chapter's study has purposefully focused on workers who were not particularly affected by structural inequalities and insecurities with regards to the job market. This leaves open a range of questions for other factors about people's identity per se which may influence transmedia self-presentation. As established in previous research, the much-desired 'authenticity' via social media can be especially problematic to foster for people in marginalised positions (Furr et al., 2016; Haimson and Hoffmann, 2016), and can in the end lead to the forced construction of a 'vanilla self' (Pitcan et al., 2018). I encourage future research to consider how communication of a professional self on ESM is also subject to such structuring factors.

As mentioned, the three lines of heuristics which I have emphasised in this chapter account for interactions along the lines of self-to-self, self-to-social world, self-to-system. This leaves open the door for discussions of how enterprise social media are engaged in system-to-system interaction. Given the recent prevalence of discussions about how new economies of data extraction shape our everyday lives (Couldry and Mejias, 2019; Zuboff, 2019), then this is a perspective which may be fruitfully considered. The fear regarding surveillance, tracking and loss of privacy due to the use of social media has been discussed heavily within the personal domain (Brown, 2020; Draper and Turow, 2019) but has received only scant attention within the professional domain (Treem, 2015). I encourage future research to consider this aspect as well.

Acknowledgements

The research was part of the project "Personalizing the Professional: Changing Genres Are the Work/Life Intersection", funded by the Independent Research Council of Denmark (Grant no. 8018-00113B).

References

Anderson, Elizabeth. 2017. *Private Government*. Princeton University Press. https://www.degruyter.com/document/doi/10.1515/9781400887781/html

Bagger, Christoffer. 2021. "Social Media and Work: A Framework of Eight Intersections." *International Journal of Communication* 15: 2027–2046.

Bertetti, Paolo. 2014. "Transmedia Critical | Toward a Typology of Transmedia Characters." *International Journal of Communication* 8: 20.

Brown, Allison J. 2020. "'Should I Stay or Should I Leave?': Exploring (Dis) Continued Facebook Use After the Cambridge Analytica Scandal." *Social Media+ Society* 6 (1): 1–8.
Couldry, Nick, and Ulises Ali Mejias. 2019. *The Costs of Connection: How Data Is Colonizing Human Life and Appropriating It for Capitalism*. Culture and Economic Life. Stanford, CA: Stanford University Press.
Dena, Christy. 2009. "Transmedia Practice: Theorising the Practice of Expressing a Fictional World across Distinct Media and Environments." PhD Thesis, University of Sydney Sydney.
Draper, Nora A., and Joseph Turow. 2019. "The Corporate Cultivation of Digital Resignation." *New Media & Society* 21 (8): 1824–1839. https://doi.org/10.1177/1461444819833331
Fast, Karin, and André Jansson. 2019. *Transmedia Work: Privilege and Precariousness in Digital Modernity*. New York, NY: Routledge.
Furr, June B., Alexis Carreiro, and John A. McArthur. 2016. "Strategic Approaches to Disability Disclosure on Social Media." *Disability & Society* 31 (10): 1353–1368.
Gambarato, Renira Rampazzo, and Lorena Peret Teixeira Tárcia. 2017. "Transmedia Strategies in Journalism. An Analytical Model for the News Coverage of Planned Events." *Journalism Studies* 18 (11): 1381–1399.
Giermindl, Lisa, Franz Strich, and Marina Fiedler. 2018. "Why Do You Not Use the Enterprise Social Network? Analyzing Non-Users' Reasons through the Lens of Affordances." In *Proceedings of the 38th International Conference on Information Systems*, 1025–1044. Red Hook, NY: Curran Associates Inc.
Gmiterková, Šárka. 2018. "Transmedia Celebrity: The Kardashian Kosmos—Between Family Brand and Individual Storylines." In *The Routledge Companion to Transmedia Studies*, 116–123. New York: Routledge.
Gregg, Melissa. 2011. *Work's Intimacy*. New York, NY: John Wiley & Sons.
Grudin, Jonathan. 2006. "Enterprise Knowledge Management and Emerging Technologies." In *Proceedings of the 39th Annual Hawaii International Conference on System Sciences (HICSS'06)*, 3:57a–57a. IEEE.
Haimson, Oliver L., and Anna Lauren Hoffmann. 2016. "Constructing and Enforcing "Authentic" Identity Online: Facebook, Real Names, and Non-Normative Identities." *First Monday*.
Heide, Mats. 2015. "Social Intranets and Internal Communication: Dreaming of Democracy in Organisations." In *Strategic Communication, Social Media and Democracy*, 45–53. New York: Routledge.
Helles, Rasmus. 2013. "Mobile Communication and Intermediality." *Mobile Media & Communication* 1 (1): 14–19. https://doi.org/10.1177/2050157912459496
Hogan, Bernie. 2013. "Pseudonyms and the Rise of the Real-Name Web." In *A Companion to New Media Dynamics*, edited by John Hartley, Jean Burgess, and Axel Bruns, 290–307. West Sussex, UK: John Wiley & Sons.
Jacobson, Jenna, and Anatoliy Gruzd. 2020. "Cybervetting Job Applicants on Social Media: The New Normal?" *Ethics and Information Technology* 22 (2): 175–195. https://doi.org/10.1007/s10676-020-09526-2
Jansson, André. 2013. "Mediatization and Social Space: Reconstructing Mediatization for the Transmedia Age." *Communication Theory* 23 (3): 279–296.
Jansson, André, and Karin Fast. 2018. "Transmedia Identities: From Fan Cultures to Liquid Lives." In *The Routledge Companion to Transmedia Studies*, 340–349. New York: Routledge.

Jenkins, Henry. 2008. *Convergence Culture*. London: New York University Press.

Jensen, Klaus Bruhn. 2010. *Media Convergence: The Three Degrees of Network, Mass, and Interpersonal Communication*. London; New York: Routledge. http://public.ebookcentral.proquest.com/choice/publicfullrecord.aspx?p=481099

Jensen, Klaus Bruhn, and Rasmus Helles. 2017. "Speaking into the System: Social Media and Many-to-One Communication." *European Journal of Communication* 32 (1): 16–25. https://doi.org/10.1177/0267323116682805

Kang, Jin, and Lewen Wei. 2020. "Let Me Be at My Funniest: Instagram Users' Motivations for Using Finsta (a.k.a., Fake Instagram)." *The Social Science Journal* 57 (1): 58–71. https://doi.org/10.1016/j.soscij.2018.12.005

Kirkpatrick, David. 2010. *The Facebook Effect: The Inside Story of the Company That Is Connecting the World*. New York: Simon & Schuster.

Leonardi, Paul M., and Jeffrey W. Treem. 2012. "Knowledge Management Technology as a Stage for Strategic Self-Presentation: Implications for Knowledge Sharing in Organizations." *Information and Organization* 22 (1): 37–59.

Leonardi, Paul M., Marleen Huysman, and Charles Steinfield. 2013. "Enterprise Social Media: Definition, History, and Prospects for the Study of Social Technologies in Organizations." *Journal of Computer-Mediated Communication* 19 (1): 1–19. https://doi.org/10.1111/jcc4.12029

Lomborg, Stine. 2014. *Social Media, Social Genres: Making Sense of the Ordinary*. New York, NY: Routledge.

Lomborg, Stine, and Kirsten Frandsen. 2016. "Self-Tracking as Communication." *Information, Communication & Society* 19 (7): 1015–1027.

Madsen, Vibeke Thøis, and Joost W. M. Verhoeven. 2016. "Self-Censorship on Internal Social Media: A Case Study of Coworker Communication Behavior in a Danish Bank." *International Journal of Strategic Communication* 10 (5): 387–409. https://doi.org/10.1080/1553118X.2016.1220010

Marwick, Alice E., and Danah Boyd. 2011. "I Tweet Honestly, I Tweet Passionately: Twitter Users, Context Collapse, and the Imagined Audience." *New Media & Society* 13 (1): 114–133.

McAfee, Andrew. 2009. *Enterprise 2.0: New Collaborative Tools for Your Organization's Toughest Challenges*. Brighton, MA: Harvard Business Press.

Men, Linjuan Rita, Julie O'Neil, and Michele Ewing. 2020. "Examining the Effects of Internal Social Media Usage on Employee Engagement." *Public Relations Review*, 46(2).

Mortensen, Mette, and Stine Lomborg. 2019. "The Mobile Archive of the Self: On the Interplay between Aesthetic and Metric Modes of Communication." *International Journal of Communication* 13: 15.

Nippert-Eng, Christena E. 2008. *Home and Work: Negotiating Boundaries through Everyday Life*. Chicago, IL: University of Chicago Press.

Ollier-Malaterre, Ariane, and Nancy P. Rothbard. 2015. "Social Media or Social Minefield? Surviving in the New Cyberspace Era." *Organizational Dynamics* 44 (1): 26–34. https://doi.org/10.1016/j.orgdyn.2014.11.004

Organ, Dennis W. 1997. "Organizational Citizenship Behavior: It's Construct Clean-Up Time." *Human Performance* 10 (2): 85–97. https://doi.org/10.1207/s15327043hup1002_2

Perkel, Dan. 2008. "Copy and Paste Literacy? Literacy Practices in the Production of a MySpace Profile". In K. Drotner, H. S. Jensen, & K. C. Schrøder (Eds.), *Informal*

Learning and Digital Media, pp. 203–224. Newcastle, UK: Cambridge Scholars Publishing.

Pitcan, Mikaela, Alice E. Marwick, and Danah Boyd. 2018. "Performing a Vanilla Self: Respectability Politics, Social Class, and the Digital World." *Journal of Computer-Mediated Communication* 23 (3): 163–179. https://doi.org/10.1093/jcmc/zmy008

Rohn, Ulrike, and Indrek Ibrus. 2018. "A Management Approach to Transmedia Enterprises." In *The Routledge Companion to Transmedia Studies*, 410–418. New York: Routledge.

Scolere, Leah, Urszula Pruchniewska, and Brooke Erin Duffy. 2018. "Constructing the Platform-Specific Self-Brand: The Labor of Social Media Promotion." *Social Media + Society* 4 (3): 205630511878476. https://doi.org/10.1177/2056305118784768

Sleeper, Manya, Rebecca Balebako, Sauvik Das, Amber Lynn McConahy, Jason Wiese, and Lorrie Faith Cranor. 2013. "The Post That Wasn't: Exploring Self-Censorship on Facebook." In *Proceedings of the 2013 Conference on Computer Supported Cooperative Work*, 793–802. CSCW '13. New York, NY, USA: Association for Computing Machinery. https://doi.org/10.1145/2441776.2441865

Treem, Jeffrey W. 2015. "Social Media as Technologies of Accountability: Explaining Resistance to Implementation Within Organizations." *American Behavioral Scientist* 59 (1): 53–74. https://doi.org/10.1177/0002764214540506

Treem, Jeffrey W., and Paul M. Leonardi. 2013. "Social Media Use in Organizations: Exploring the Affordances of Visibility, Editability, Persistence, and Association." *Annals of the International Communication Association* 36 (1): 143–189. https://doi.org/doi.org/10.1080/23808985.2013.11679130

Tufekci, Zeynep. 2008. "Can You See Me Now? Audience and Disclosure Regulation in Online Social Network Sites." *Bulletin of Science, Technology & Society* 28 (1): 20–36.

van Dijck, José. 2013. "'You Have One Identity': Performing the Self on Facebook and LinkedIn." *Media, Culture & Society* 35 (2): 199–215. https://doi.org/10.1177/0163443712468605

Van Osch, Wietske, and Constantinos K. Coursaris. 2013. "Organizational Social Media: A Comprehensive Framework and Research Agenda." In *2013 46th Hawaii International Conference on System Sciences*, 700–707. IEEE. Wailea, Maui, HI.

Zuboff, Shoshana. 2019. *The Age of Surveillance Capitalism: The Fight for the Future at the New Frontier of Power*. London: Profile Books.

4 The post-digital Self
How Transmedia Dissolves the Boundaries of Work and Tourism

Karin Fast and André Jansson

Introduction

In our book from 2019, *Transmedia Work: Privilege and Precariousness in Digital Modernity*, we argued that the social significance of transmedia today reaches far beyond the culture industries. In this chapter, we stick to the conceptualization, elaborated in said book, of transmedia as a dominant mode of circulation and a regime of mediatization that currently shapes ordinary culture. Writing this chapter in the midst of the Covid-19 pandemic, however, we observe that what we call *transmediatization* seems to gain even more momentum as it becomes increasingly feasible, common, attractive, *and* necessary to connect, share, and (re)store information across different media platforms and devices. In already mediatized societies, national lockdowns and social distancing strategies have made virtual concerts, "Zoom parties", video conferences, platformed teaching, online doctors' appointments, app-based food deliveries, e-shopping, streamed sports events, and other mediated practices the only possible options for fulfilling our most basic needs and consumerist desires.

Yet, while "enforcing" transmediatization, the pandemic also seems to amplify a trend that might appear to run counter to transmediatization, but which rather constitutes evidence of its magnitude: the rise of a *disconnectivity imperative* (Fast et al., 2021; see also, e.g., Light, 2014; Karppi, 2018; Syvertsen, 2020; Jansson and Adams, 2021). Studies on people's changing life conditions during the Covid-19 crisis suggest that many seek to compensate for increased "enforced" media use by also engaging, more than before, in offline or off-screen activities, like knitting, playing board games, taking walks, reading printed books, and so on.[1] Meanwhile, and under pressure by a wide spectrum of digital capitalism critics, social media companies and technology stakeholders provide us with various types of guidance for how to lead a healthy digital life. As a case in point, Norwegian telecom company Telenor teaches us, on the one hand, how to endure the crisis by help of digital tools, like video calls or streamed entertainment and, on the other hand, how to take control over our "screen-time" by, for instance, turning off push-notifications on our smartphones (Telenor.com, 2020). This all happens while trendy workplaces embrace digital disconnection both materially (e.g.,

DOI: 10.4324/9781003134015-6

in the form of recreational design) and symbolically (e.g., by hyping analogue media), and at the same time as "digital detox camps", "phone-free holidays", or "off-the-grid vacations" continue to shape contemporary tourism.

Exactly how the pandemic will change our life with media is still uncertain. Above-mentioned examples, however, suggest that various forms of *post-digital reflexivity* are both expected and demanded from people living under the transmedia regime. The "post-digital" is here taken as a realm of immanent resistance and/or disruption under conditions where computational logics and digital solutions to technological as well as social challenges are the norm (see Berry, 2014). Rather than signifying a radical break from digital society, the post-digital connotes a variety of reactions *within* the dominant order. Similarly, if transmediatization – as empirically demonstrated in our previous studies – spurs what postmodern thinkers have referred to as *de-differentiation* (cf. Lyotard, 1984; Lash, 1990a, 1990b; Harvey, 1990) and thus leaves various social spheres increasingly open-ended, digital disconnection is today framed, in diverse contexts, as a necessary means of *re-differentiation*. More concretely, it is commonly imagined and used as a tool for "work-life boundary" management, or, alternatively phrased, for sharpening the contours around our professional and private selves. The (imagined) potential of disconnection for *segmenting* rather than integrating social spheres is what underpins initiatives such as the "Right to Disconnect" jurisdiction (which regulates, among other things, employers' email use) (Eurofond, 2020), smartphone apps catered for temporal or spatial disconnection (e.g., *Hold*, *OffTime*, or *LockMeOut*), or self-help literature on how to do "digital declutter" (e.g., Newport, 2019).

In this chapter, we assess the social consequences of – and reactions to – transmediatization through two thematic lenses, *work* and *tourism*, with particular consideration of the implications of the mounting culture of disconnectivity on processes of de- or re-differentiation. Focusing on work and tourism, we try to show how people's (expected) engagement with transmedia fuses realms that were once taken as the moral and social opposites. On the one hand, "transmedia work" denotes a social condition marked by the growing prominence of *strategic recognition work* and liquid boundaries between work and leisure (Fast and Jansson, 2019). On the other hand, "transmedia tourism" captures not just the growing presence of touristic expressivity in everyday life, but also the growing day-to-day significance of *logistical practices* – which ultimately constitute a kind of labour – in the creation of tourism phantasmagoria (Jansson, 2020, 2022). Paradoxically, though, as we shall demonstrate with reference to two typical facets of post-digital work and tourism respectively, *coworking spaces* and *digital detox camps*, what is increasingly often presented as the solution to collapsing borders between work and leisure – digital disconnection – might in fact lead to more, *not less*, border collapse. In that respect, what we are able to offer with this chapter is an immanent critique of *the transmedia self*: an inquiry of its innate contradictions and ideological underpinnings in the post-digital world.

The chapter presents two empirically grounded sections aimed at teasing out the characteristics of "transmedia work" and "transmedia tourism" as increasingly liquid, open-ended and contradictory social terrains. Our ambition being to carve out principal patterns, the picture painted here is intentionally forthright. In the final section we bring together the discussions into an argument concerning the coming of the *post-digital self* as one of the main social consequences of transmediatization.

The transmedia worker

As we argue in our book, *transmedia work* does not refer to a specific type of job, occupation, or profession (Fast and Jansson, 2019). Rather, the concept is meant to indicate that work today – across job sectors – has certain characteristics that make it distinct from its earlier forms, before transmedia became "ordinary". While admitting the historical roots of transmedia work, we suggest that it was spurred especially by the normalization of social media and the smartphone, and thus with the boost in digitalization and datafication that these technological novelties prompted.

The Facebook app is emblematic of the elements that are constitutive of transmedia work, so let us approach our definition of transmedia work via this particular example. Imagine that you "check-in" at a conference venue, by taking a selfie with your smartphone, uploading it on Facebook, and "tagging" your geographical location. Your location-based selfie becomes visible to other users, who can see not only that you are working, but also where. Your Facebook "friends" can "like" your update and/or leave a comment. They can also share it with their friends. Aside from representing an affective item that makes for social interaction, your selfie constitutes big data, which means that it is automatically surveilled by Facebook and by any third-party organization to whom your data is sold. This, in turn, means that your selfie – and the work put into it – generates value. As a user, you may earn increased social recognition and social capital, which in turn might serve your career well. Facebook, on their part, earns money.

The Facebook selfie example is meant to illustrate our understanding of transmedia work as a *social condition* saturated by (1) online sharing practices that (2) render work and workers visible to other users and (3) enable real-time feedback on circulated content, which in turn facilitates (4) automated processes of surveillance, and ultimately, (5) the commodification of social practices and relations at large (cf. Fast and Jansson, 2019, p. 6). As per these characteristics and its historical context, transmedia work relates to a societal process other than just technological innovation. Among these are flexibilization, informalization, precarization, neoliberalization, and other historical changes in capitalist organization and ideology. It is under the pressures of all of these processes that workers may feel more or less obliged to stay "available", "employable", "visible", "flexible", "resilient", and in other ways *"relevant"* in today's work markets (cf. Pugh, 2016; Gill and Orgad, 2018). Sharing via Facebook an ambitious work selfie taken at a

prestigious location may be one way of doing so. Thus, it is under the influence of a range of social, economic, cultural, and technological developments that transmedia technologies became indispensable instruments for what we call *strategic recognition work* (see Fast and Jansson, 2019, Ch. 5).

"Sometimes off" is the new "always on"

Drawing chiefly on Alex Honneth's recognition theory (2004), we argue that the uncertainty and complexity of modern society create new incentives for individuals to search for *recognition* from people and institutions. Transmedia technologies offer unique possibilities for fulfilling such needs; indeed, social media rest on the assumption that people desire to display their "status" to others. At the same time, however, granted that transmedia per se produce (a sense of) even *more* liquid life conditions, they constantly reproduce the "recognition deficit" they promise to solve. Thus, as we have concluded before, "while opening new routes for recognition and self-realization transmedia work nurtures the precariousness of liquid lives" (Fast and Jansson, 2019, p. 85). Strategic recognition work through transmedia may take the form of self-promotion via social networking platforms, but also, for example, of emails or text messages sent to the "right" people, at the "right" time. Given the algorithmic logics of transmedia – and of social media especially – strategic recognition work is by default geared toward *hyper-connectivity*. We have gotten used to thinking that reputation and networks are built by being *always on(line)*.

However, as indicated in the introduction above, strategic recognition work is increasingly also about being *sometimes off (the grid)*. While to disconnect entirely is hardly an option for many workers in transmediatized societies, automatic email replies, distraction blocking apps, social media "fasts", and other measures for media self-regulation may facilitate valuable breaks from the demands of the "culture of connectivity" (van Dijck, 2013), if only temporarily. Engaged in as a form of "boundary work" (Ashforth et al., 2000; Kreiner et al., 2009), practices of disconnection may also serve to counterwork the ambiguous borderlands that tend to appear between work and leisure, as the content of one domain "bleeds" into to the other – for example via a sudden phone-call from one's child in a work meeting or a text message from one's boss during family dinner (cf. Gregg, 2011; Cousins and Robey, 2015). According to self-help advice targeting today's knowledge workers, learning how to disconnect is vital. Computer scientist and writer Cal Newport (2016), for example, states the value of *deep work*, or "professional activities performed in a state of distraction-free concentration that push your cognitive capabilities to their limit" (p. 3):

> Deep work is not ... an old-fashioned skill falling into irrelevance. It's instead a crucial ability for anyone looking to move ahead in a globally competitive information economy that ends to chew up and spit out those who aren't earning their keep. The real rewards are reserved not for those who are comfortable using Facebook (a shallow task, easily

replicated), but instead those who are comfortable building the innovative distributed systems that run the service (a decidedly deep task, hard to replicate).

(p. 14)

According to Newport (2016), deep work requires mindful media use, such as resisting to check emails outside of working-hours (p. 151), scheduling Internet use at home as well as at work (p. 164), and using social media only purposefully (p. 203). Similar advice is available in other self-help books too, such as, for example, in educator and researcher Jennifer Rauch's (2018) *Slow Media: Why Slow Is Satisfying, Sustainable, and Smart*. In line with Newport, Rauch is concerned with distracting media use and recognizes "anti-multitasking", "e-mindfulness", "unplugging", and other disconnective tactics as solutions to problems pertaining to de-differentiation (p. 86ff).

Ideas like Newport's and Rauch's materialize in today's workplaces and in visions about tomorrow's ditto (cf. Guyard and Kaun, 2018). So called coworking spaces are representative of what we here recognize as *the post-digital workplace*; that is, of hyper-connected workplaces that are designed according to the disconnectivity imperative (see also Fast, 2021). As such, they make a great prism for observing the contradictions and peculiarities that are constitutive of transmedia work as well as for grasping emergent worker subjectivities and new dynamics of social recognition. Therefore, let us inquire what transmedia work might look like in the post-digital workplace by attending to the trendy workstyle known as "coworking".

Transmedia work in the post-digital workplace

Over the last rough decade, *coworking* has emerged as a label for a new workstyle, performed at shared, curated workplaces and rooted in values like collaboration, community, sustainability, openness, and accessibility. Since the launch of the first *coworking space* in San Francisco in 2005, coworking has grown into a multibillion industry, dominated by a handful of major companies, such as WeWork, IWG (owner of Spaces and Regus), and Impact Hub. Next to these international top-players exist thousands of local firms as well as non-profit organizations that use coworking as their selling point or leitmotif. In *Transmedia Work* (Fast and Jansson, 2019), we identified coworking as a workstyle that presupposes a variety of media and connectivity platforms, and coworking spaces, subsequently, as *hyper-connected* workplaces that both respond to and intensify transmediatization. For one thing, next to high-speed Wi-Fi and advanced technology pools, many coworking spaces provide paying customers access to a branded coworking app, through which coworking life can be administered and networking accomplished.

While these observations still hold true, the disconnectivity imperative is making its imprint also on coworking. On the one hand, coworking – in most contexts – has *always* been partly signified by disconnected activities, carried

out in spaces designed for non-media use. Clearly inspired by creative, playful, office landscaping typical of Silicon Valley firms like Google, coworking spaces are normally designed to be heterogeneous milieus, where offices, conference rooms, lap-top stations, and the similar exist next to, for example, yoga rooms, table-tennis halls, cafés, gyms, lounge areas, or (semi-)outdoor milieus. The latter types of space are meant to bring out the "co" in coworking; face-to-face interactions, spontaneous encounters between workers (Jakonen et al., 2017), and "affective atmospheres" (Gregg, 2018). On the other hand, in the last couple of years especially, the disconnectivity imperative is more clearly making its way into the socio-semiotic grammar of coworking (see also Fast, 2021). World-leading and influential WeWork's discursive practices are indicative of the ways in which post-digital reflexivity is currently being elevated as a coworking ideal and thus scripted into present-day worker subjectivities. Consider, for example, the following "inspirational quotes", all from WeWork's public Instagram account and published within the last few years:

> Reminder: Don't be afraid of slow moments
>
> (August 21, 2020)
>
> How are you spending time outdoors this weekend?
>
> (August 8, 2020)
>
> Do more things that make you forget to check your phone
>
> (December 18, 2018)

Needless to say, gentle exhortations of this sort are relevant only in contexts where connectivity has reached top levels, and where individuals may recognize the need to take breaks from their laptops, smartphones, and other digital devices. Tellingly, quotes of this kind are accompanied on WeWork's Instagram by imagery of relaxed living room-like spaces, piles of books on tables, green outdoor or semi-outdoor areas, or of people meditating, doing yoga, or playing pool. In encouraging, materially as well as discursively, digital nomads to engage in recreational, *non-work*, activity, coworking spaces arguably come across as "touristified" workplaces, where hyper-mediated work "experiences" are produced.

Only in such transmediatized contexts, too, can practices of disconnection function as a means of *social distinction*. The potential of post-digital reflexivity to make ground for new dynamics of recognition is observable in empirical studies suggesting that digital disconnection might serve as a form of "conspicuous non-consumption" that awards individuals engaging in such practices a certain social status (Portwood-Stacer, 2012). On this note, a recent Bourdieusian study projecting disconnection practices and sentiments across social space reveals that feelings of digital unease and inclination to disconnect correspond positively with capital volume, and with levels of

cultural capital especially (Fast et al., 2021). With cues taken from research of this kind (see also, e.g., Thorén et al., 2019), we might conclude that the post-digital workplace – here represented by coworking spaces – paves way for a new kind of transmedia worker sensibility. Commendable today is the worker who has the *"good taste"* of disconnecting every once in a while. For workers wishing to do so through more radical – and *exclusive* – measures, a "digital detox" holiday might be just the right thing.

The transmedia tourist

If coworking spaces represent a post-digital form of territoriality where work environments are designed and promoted almost like tourist destinations, a form of retreats, we can detect the same – albeit reversed – transition if we focus on tourism. As we will show in this section, transmediatization fosters a social condition where tourism is increasingly difficult to keep apart from ordinary work tasks, and where tourism per se is turned into a form of work.

The classical conception of tourism refers to an organized form of temporary escape from familiar places and the toil and trouble of everyday life. Any theory of tourism recognizes these two aspects; the desire to get away from the home-world to experience and consume (the sights of) *other places*, and possibly nurture or explore one's personal self, *and* the institutionalized forms of such recreational journeys in modern society (e.g., MacCannell, 1976; Cohen, 1979; Urry, 1990/2002). Tourist destinations and their associated *sites* and *sights* are materially and culturally constructed to reinforce the fundamental division between the ordinary and the extraordinary, the familiar and the more exotic (see also Strain, 2003). This division is also actively performed in different ways by tourists (Haldrup and Larsen, 2009). Yet, ever since the 1980s, there are also researchers pointing to how the demarcations of tourism are getting fuzzier. One of the most famous accounts is Maxine Feifer's (1985) notion of *post-tourism* that was subsequently elaborated by Lash and Urry (1994) and incorporated into their broader sociology of *de-differentiation* (see also Lash, 1990a). While post-tourism may not signify the end of tourism, it refers to how tourism constitutes an increasingly normalized mode of encountering the world also when one is not engaged in any corporeal travelling. The abundance of touristic publicity and spatial phantasmagoria that saturates everyday life turns most people into "armchair travelers" who are constantly engaged in some sort of tourism-related consumption, captured in spaces constructed according to the liminal principles of tourism (Jansson, 2002). This condition, according to Feifer (1985), spurs new forms of reflexivity, where some groups even start playing with the typical signs of tourism to distinguish themselves from the masses of "ordinary tourists" (see also Munt, 1994). As such, post-tourists fit the general depiction of the postmodern self as a fleeting and hyper-reflexive subject.

As one of us has argued previously (Jansson, 2018a, 2018b, 2020), transmediatization in general and social media in particular prompt us to

re-actualize the theories of post-tourism and de-differentiation. Today, it is not just that tourism expands via media into the realms of daily life. There is also a movement in the opposite direction; activities and concerns related to everyday work bleed via connected devices and platforms into the "sacralized" realms of tourism (cf. MacCannell, 1976). As a consequence, and as an emergent *post-digital version of post-tourism*, various tactics of disconnection take shape.

Logistical labour and the threat of decapsulation in tourism

When Scott Lash (1990b) first wrote about de-differentiation, he referred to what he called the *semiotic society*. He drew the contours of a society where the circulation of representational goods (signs) had taken over after industrial goods as the key driver of social and economic life. Electronic media, computerization, and expanding digital infrastructures powered this transformation whereby semiotic expertise once confined to the cultural industries was adopted in a growing number of sectors of society. Industries were to an increasing extent managing information and meaning rather than material stuff. Images, brands and designs became as important as products per se – they *became* the goods. One might say that Lash "sociologized" pre-existing depictions of postmodern society as a condition where material concerns gave way for semiotic desires and where reality imploded into a realm of mediated simulacra (copies without originals) (Baudrillard, 1983). In his joint work with John Urry, the same idea was applied onto tourism. As they put it: "What is consumed in tourism are visual signs and sometimes simulacrum; and this is what is consumed when we are supposedly not acting as tourists at all" (Lash and Urry, 1994, p. 272).

Transmedia, as a mode of cultural circulation, extends the relevance of the de-differentiation thesis. Above all, people are increasingly involved in the *tourism of others* through the continuous circulation of touristic snapshots from past, ongoing, or prospective journeys via various platforms – from Instagram and Facebook to more dedicated forums for the narration of specialized tourist activities. As such, representations of tourism are present in day-to-day life in an ever-expanding range of shapes and media contexts, open to be commented upon, remixed, and spread to others, as given by Jenkins' (2006) original view of transmedia storytelling (see also Jenkins et al., 2013). Besides this escalation of representational and narrational circuits, however, there is something else going on: a form of de-differentiation that has to do with logistics and whereby work colonizes tourism. This type of de-differentiation comes in two main variants.

First, as we saw, transmedia is a regime premised on the commercial circulation and computation of data. The foundational logic is that the more data is circulated, the more the industry can learn about the users and the more valuable the information is when sold to third parties (in the shape of market segments). As such, there are strong incentives within the connectivity

industry (Facebook, Google, and other players), as well as within the tourism industry, to generate and govern digital data streams (e.g., Berry, 2012; Pigni et al., 2016). All kinds of online engagements, from information searches and hotel bookings to tagging, liking, and rating, pertain to the accumulation of data as raw material for the platform economy (e.g., Sadowski, 2019). From this perspective, the transmedia circulation of texts, images, and other types of information across platforms and technologies should be understood as logistical as much as representational processes. People's engagements constitute a form of *logistical labour*[2] in the sense that they contribute to the maintenance of transmedia streams of content and data (Jansson, 2022). Since tourism constitutes a social realm that was already from the start saturated with media practices, linked to the human desire to envision, record, and share liminal experiences, it offers a particularly fertile soil for growing the logistical labour that builds data society. The pressures and expectations on people to engage in tourism related circulation are constantly growing, whether we speak of perpetual travel-planning on various booking sites (e.g., Xiang et al., 2015; Huang et al., 2017) or the sharing of holiday photos via social media platforms (Lo and McKercher, 2015; Jansson, 2020).

Second, as transmedia enables – and invites – different forms and formats of communication to crisscross the same platforms, it also opens the gates between different realms of activity. Since online engagements are intensely promoted by the industry, and often desired by tourists, there is a risk that the relatively fragile "sense of tourism" that media rituals to some extent may reinforce during a trip is endangered (Jansson, 2007). This may happen when online engagements, like the sharing of vacation photos on Facebook, lead to unexpected and non-desired encounters with the ordinary "homeworld" of work and day-to-day logistics. As most of us have experienced, even the most basic interaction with a smartphone may result in a series of reorientations and altered modes of attention as new pieces of information nudge us to seek out additional content streams (Weltevrede et al., 2014). Hence, the world of everyday work may crash into our encapsulated bubble of touristic leisure. While this might be thought of as a form of "context collapse" (Marwick and Boyd, 2011), it is also different in that it reaches beyond the online world. We should rather think of it in terms of *decapsulation*: the opening-up of tourism spaces to intrusions that may threaten the sacredness of actually "being away".

Combined, these two aspects of transmediatization portray tourism as increasingly tied up with digital logistics and as such less and less distinct. While most people probably do not see this as a problem – for instance, there is certainly much to appreciate about the many ways of staying connected while traveling – there are also many people frustrated with the coerciveness of digital entanglements and the fact that tourism cannot offer a relief from information stress and everyday commitments. It should come as no surprise, then, that there are tourists that actively seek to disconnect (at least partially) while on vacation (e.g., Fan et al., 2019) or seek out forms of tourism that

actively resist the logics of social media (e.g., Jansson, 2018b). One of the utmost expressions of this post-digital trend is the *digital detox retreat*.

Digital detox retreats as post-digital asylums

While media resistance is not a new phenomenon (Syvertsen, 2017), the age of perpetual connectivity entails new social tensions. When connective media permeate virtually all areas of life, including tourism, resistance is less concerned with content than with the power of technology to foster addiction, distraction, and stress. Hence, there is an emerging social division between those who are permanently and deeply entangled with media and those who can afford to opt out, or, at least, maintain a sense of control. This new divide corresponds to the pathologization of media dependence, which also legitimizes the expansion of new businesses that invest into the artificial notion of "digital detox".

In this new landscape, the digital detox tourism business is one of the most emblematic examples of stakeholders that feed from digital connectivity, albeit as an alleged *opponent* to it (Fish, 2017; Syvertsen and Enli, 2019). This branch produces sealed-off places, *retreats*, where detoxing people can go for a limited time to engage in activities that are different from, yet measured against, the world outside. Digital detox tourists are not just disconnected from the digital; they are also temporarily disentangled from a range of other obligations and duties associated with mediatized life forms. In this sense, what the industry claims to offer is a particular form of post-digital territoriality where boundaries are restored and activities constructed in opposition to the digital.

Following Goffman's (1961/1991) theorization of the asylum, we might think of digital detox retreats as variants of the total institution: sites that are not merely different and separated from the outside world but also invoke rules, routines, and a sense of community that help individuals to *return to* and *cope with* their connected lives. According to an initial online overview that we conducted, there are three tentative types of digital detox retreats that can be described according to the criteria of a total institution: degrees of place-boundedness, collectiveness, regulation, and rational planning (Goffman, 1961/1991, p. 17).

First, there is "the total digital detox retreat", such as the UK-based initiative TimeToLogOff, which is exclusively focused on detoxing and arranges retreats and workshops at various locations in Europe. The company provides a digital detox "manifesto" and describes itself as "a social movement for people who don't really *do* social movements" (itstimetologoff.com). Its retreats stipulate strict rules for digital disconnection.

Second, there is "the hybrid digital detox retreat". Places like Dragebjerg, a farm located in the Danish countryside, have digital detox as their core concept but also offer art therapy, meditation seminars, communal gardening, and healing. The destination presents itself as "a place focused on

holistic thinking and action within human health" (dragebjerg.com). Tourists attending retreats are requested to hand in their technical devices and offered a daily programme.

Third, there is what we call "the ornamental digital detox retreat", such as Village Castigno in Languedoc, France, that uses the digital detox concept in its marketing (along with the slogan "disconnect to re-connect") and promotes activities like herb picking, bread-baking classes, massages, and art workshops (villagecastigno.com). The venue takes pride in having no Wi-Fi and no TVs, but there are no apparent rules for media usage, nor any specific detoxing activities.

Our overview suggests that there are today a large number of mainstream tourist destinations that in an ornamental fashion feed into the disconnection trend and embrace digital detox as part of their wellness offerings. While this is not the place to chart the digital detoxing phenomenon in detail, our preliminary categorization of retreats highlights how disconnection operates along a continuum where any total version of disconnected life, still, remains a utopian ideal (Bucher, 2020). Disconnection is to a varying degree envisioned and discursively constructed as a privilege, even a luxury, that should help participants develop skills and sensibilities for mastering transmediatization and de-differentiation within their ordinary lives and professions. Thus, digital detox retreats are more closely bound up with transmedia work than any other form of tourism. They can be thought of as post-digital asylums in the business of revitalizing digital elites and thus reproducing the dominant order.

Conclusion: the coming of the post-digital self

We have in this chapter addressed the social consequences of transmediatization from two different angles: starting out from the realms of *work* and *tourism*, respectively. While we could have started out elsewhere (as transmediatization affects social life on the whole), work and tourism are particularly interesting because of their contrapuntal social and cultural meanings. Here, "transmedia work" and "transmedia tourism" refer to something more than isolated activities or events; these notions capture social conditions that saturate human identities at large and may expand beyond the conventionally understood confines of work and tourism. The aim of our overview, then, has been to tease out how the normalization of transmedia as a mode of cultural circulation affects the conditions for self-making. Our argument can be summarized as three inter-related points that ultimately signify the coming of the *post-digital self*.

First, we argue that transmediatization sustains processes of *de-differentiation* akin to the social transformations identified and discussed by postmodern sociologists in the 1980s and 1990s. Through various empirical examples, we have shown how the circulatory logics of transmedia fuel what we might call the "touristification of work" – in the shape of, for instance, phantasmagorical coworking spaces geared towards strategic recognition work – and

the "workification of tourism" – as evidenced, for instance, in continuous processes of platformed travel planning and hyper-connected vacations. Ultimately, such instances of de-differentiation demarcate what postmodern thinkers like Baudrillard (1983) referred to as the emptying out of signifiers, the reign of simulations and simulacra. To further delineate the nature of "transmedia selves", thus, we advise scholars to pay further attention to theories of postmodern society.

Second, we argue that the supremacy of de-differentiation breeds its own internal reactions in terms of various means, actions, and sentiments of *re-differentiation*. Notably, as we have shown in our empirical illustrations, such counter-measures come in the shape of *disconnection* from digital transmedia and a (re)turn to practices and places that reinstate boundaries between different realms of activity. While such reactions may take place on the individual level, often initiated as a matter of existential urgency, they are also orchestrated by industries that profit from people's sense of information stress, fatigue, and over-extension. In this chapter, we have specifically mentioned coworking spaces and digital detox destinations as such businesses, and territories, that in different ways celebrate the "here and now" and the affordances of "the analogue". However, as it turns out, the measures taken to "cure" over-connected people are *poor* instruments of re-differentiation as they effectively normalize the dominant order of digital society.

Third, as a consequence of the previous points, we argue that one of the utmost consequences of transmediatization is a growing everyday reflexivity pertaining to boundaries and their permeability (the question of de- vs. re-differentiation) as well as to connectivity (the question of connection vs. disconnection). Along these lines, we suggest that the "transmedia self" as given by the title of this book materializes in and through a social landscape that attains *post-digital* features. It is a social landscape where the digital is the norm, and where computational logics saturate and mould individual lives down to their most mundane and intimate undertakings – *and* where we can also discern various streams of resistance and critique. What comes into being is a *post-digital self* that problematizes the norms of our digital lives and whose predisposition it is to counter the imperatives of transmedia – notably, strategic recognition work and logistical labour, as discussed above – at least for a certain time, and at least in certain spaces and places. It is our ambition to further delineate these emerging predispositions and their social underpinnings, for example in terms of habitus, in future projects.[3]

Notes

1 Results pointing in this direction surface in data from a qualitative survey investigating (mainly) Norwegians' experiences of the impact of the pandemic on everyday life, including media habits. The survey was conducted within the frames of the four-year research project Intrusive Media, Ambivalent Users and Digital Detox (Digitox), led by Professor Trine Syvertsen at the Department of Media and Communication, University of Oslo and funded by The Research Council of Norway.

2 For the sake of clarity of argument, we do not here make an analytical distinction between 'work' and 'labour' (as, for example, Hannah Arendt does in *The Human Condition*, 1958). Rather, we keep with the term 'work' throughout the chapter to signify valorized activity. However, in unison with existing conceptualizations of work and subjectivities involved in the management and maintenance of material and symbolic flows, we do employ the 'logistical labour' label.
3 One research project enabling us to do this is Hot Desks in Cool Places: Coworking as Post-Digital Industry and Movement (2021–2025). Led by André Jansson (Karlstad University) and funded by the Swedish Research Council, the project inquires how the current expansion of coworking spaces contributes to the (re)production of social and spatial power relations in the post-digital capitalist society.

References

Ashforth, B. E., Kreiner, G. E., and Fugate, M. (2000) All in a day's work: Boundaries and micro role transitions. *Academy of Management Review*, 25(3), 472–491.

Baudrillard, J. (1983) *Simulations*. New York: Semiotext(e).

Berry, D. M. (2012) The social epistemologies of software. *Social Epistemology*, 26(3-4), 379–398.

Berry, D. M. (2014) Post-digital humanities: Computation and cultural critique in the arts and humanities. *Educause Review*, May/June 2014, 22–26.

Bucher, T. (2020) Nothing to disconnect from? Being singular plural in an age of machine learning. *Media, Culture & Society*, 42(4), 610–617.

Cohen, E. (1979) A phenomenology of tourism experiences. *Sociology*, 13(2), 179–201.

Cousins, K., and Robey, D. (2015) Managing work-life boundaries with mobile technologies. *Information Technology & People*, 28(1), 34–71.

Eurofound (2020) Regulations to address work–life balance in digital flexible working arrangements. *New Forms of Employment Series*. Luxembourg: Publications Office of the European Union.

Fan, D. X., Buhalis, D., and Lin, B. (2019) A tourist typology of online and face-to-face social contact: Destination immersion and tourism encapsulation/decapsulation. *Annals of Tourism Research*, 78, Ahead of print, DOI: 102757.

Fast, K. (2021) The disconnection turn: Three facets of disconnective work in post-digital capitalism. *Convergence*, 27(6), 1615–1630.

Fast, K., and Jansson, A. (2019) *Transmedia Work: Privilege and Precariousness in Digital Modernity*. London: Routledge.

Fast, K., Lindell, J., and Jansson, A. (2021) Disconnection as distinction: A Bourdieusian study of where people withdraw from digital media. In Jansson, A. and Adams, P. C. (Eds.). *Disentangling: The Geographies of Digital Disconnection*. New York: Oxford University Press.

Feifer, M. (1985) *Going Places*. London: Macmillan.

Fish, A. (2017) Technology retreats and the politics of social media. *tripleC: Communication, Capitalism & Critique*, 15(1), 355–369.

Gill, R., and Orgad, S. (2018) The amazing bounce-backable woman: Resilience and the psychological turn in neoliberalism. *Sociological Research Online*, 23(2), 477–495.

Goffman, E. (1961/1991) *Asylums: Essays on the Social Situation of Mental Patients and Other Inmates*. London: Penguin.

Gregg, M. (2011) *Work's Intimacy*. Cambridge, UK: Polity Press.

Gregg, M. (2018) *Counterproductive: Time Management in the Knowledge Economy*. Durham, NC: Duke University Press.
Guyard, C., and Kaun, A. (2018) Workfulness: Governing the disobedient brain. *Journal of Cultural Economy*, 11(6), 535–548.
Haldrup, M., and Larsen, J. (2009) *Tourism, Performance and the Everyday: Consuming the Orient*. London: Routledge.
Harvey, D. (1990) *The Condition of Postmodernity*. Oxford: Blackwell.
Honneth, A. (2004) Organized self-realization: Some paradoxes of individualization. *European Journal of Social Theory*, 7(4), 463–478.
Huang, C. D., Goo, J., Nam, K., and Yoo, C. W. (2017) Smart tourism technologies in travel planning: The role of exploration and exploitation. *Information & Management*, 54, 757–770.
Jakonen, M., Kivinen, N., Salovaara, P., and Hirkman, P. (2017) Towards an economy of encounters? A critical study of affectual assemblages in coworking. *Scandinavian Journal of Management*, 33(4), 235–242.
Jansson, A. (2002) Spatial phantasmagoria: The mediatization of tourism experience. *European Journal of Communication*, 17(4), 429–443.
Jansson, A. (2007) A sense of tourism: New media and the dialectic of encapsulation/decapsulation. *Tourist studies*, 7(1), 5–24.
Jansson, A. (2018a) *Mediatization and Mobile Lives: A Critical Approach*. London: Routledge.
Jansson, A. (2018b) Rethinking post-tourism in the age of social media. *Annals of Tourism Research*, 69, 101–110.
Jansson, A. (2020) The transmedia tourist: A theory of how digitalization reinforces the de-differentiation of tourism and social life. *Tourist Studies*, 20(4), 391–408.
Jansson, A. (2022) *Rethinking Communication Geographies: Geomedia, Digital Logistics and the Human Condition*. Cheltenham: Edward Elgar.
Jansson, A., and Adams, P. C. (Eds.). (2021) *Disentangling: The Geographies of Digital Disconnection*. New York: Oxford University Press.
Jenkins, H. (2006) *Convergence Culture. Where Old and New Media Collide*. New York: New York University Press.
Jenkins, H., Ford, S., and Green, J. (2013) *Spreadable Media: Creating Value and Meaning in a Networked Culture*. New York: New York University Press.
Karppi, T. (2018) *Disconnect: Facebook's Affective Bonds*. Minneapolis: University of Minnesota Press.
Kreiner, G. E., Hollensbe, E. C., and Sheep, M. L. (2009) Balancing borders and bridges: Negotiating the work-home interface via boundary work tactics. *Academy of Management Journal*, 52(4), 704–730.
Lash, S. (1990a) *Sociology of Postmodernism*. London: Routledge.
Lash, S. (1990b) Learning from Leipzig – or politics in the semiotic society. *Theory, Culture & Society*, 7(4), 145–158.
Lash, S., and Urry, J. (1994) *Economies of Signs and Space*. London: Sage.
Light, B. (2014) *Disconnecting with Social Networking Sites*. Basingstoke: Palgrave Macmillan.
Lo, I. S., and McKercher, B. (2015) Ideal image in process: Online tourist photography and impression management. *Annals of Tourism Research*, 52, 104–116.
Lyotard, J.-F. (1984) *The Postmodern Condition: A Report on Knowledge*. Minneapolis: University of Minnesota Press.

MacCannell, D. (1976) *The Tourist: A New Theory of the Leisure Class*. London: Macmillan.
Marwick, A. E., and Boyd, D. (2011) I tweet honestly, I tweet passionately: Twitter users, context collapse, and the imagined audience. *New Media and Society*, 13(1), 114–133.
Munt, I. (1994) The 'other' postmodern tourism: Culture, travel and the new middle classes. *Theory, Culture & Society*, 11(3), 101–123.
Newport, C. (2016) *Deep Work: Rules for Focused Success in a Distracted World*. London: Piatkus.
Newport, C. (2019) *Digital Minimalism: Choosing a Focused Life in a Noisy World*. New York: Penguin.
Pigni, F., Piccoli, G., and Watson, R. (2016) Digital data streams: Creating value from the real-time flow of big data. *California Management Review*, 58(3), 5–25.
Portwood-Stacer, L. (2012) Media refusal and conspicuous non-consumption: The performative and political dimensions of Facebook abstention. *New Media & Society*, 15(7), 1041–1057.
Pugh, A. J. (Ed.). (2016) *Beyond the Cubicle: Job Insecurity, Intimacy, and the Flexible Self*. New York: Oxford University Press.
Rauch, J. (2018) *Slow Media: Why Slow Is Satisfying, Sustainable, and Smart*. New York: Oxford University Press.
Sadowski, J. (2019) When data is capital: Datafication, accumulation, and extraction. *Big Data & Society*, 6(1), 2053951718820549.
Strain, E. (2003) *Public Places, Private Journeys: Ethnography, Entertainment, and the Tourist Gaze*. New Brunswick, NJ: Rutgers University Press.
Syvertsen, T. (2020) *Digital Detox: The Politics of Disconnecting*. Bingley: Emerald Group Publishing.
Syvertsen, T. (2017) *Media resistance: Protest, Dislike, Abstention*. London: Palgrave Macmillan.
Syvertsen, T., and Enli, G. (2019) Digital detox: Media resistance and the promise of authenticity. *Convergence*. Ahead of print, DOI: 1354856519847325.
Telenor.com (2020) Så lär du dig äga din skärmtid. Last accessed on November 6, via: https://www.telenor.se/skarmlivet/sa-lar-du-dig-aga-din-skarmtid/
Thorén, C., Edenius, M., Lundström, J. E., and Kitzmann, A. (2019) The hipster's dilemma: What is analogue or digital in the post-digital society?. *Convergence*, 25(2), 324–339.
Urry, J. (1990/2002) *The Tourist Gaze*. London: Routledge.
Van Dijck, J. (2013) *The Culture of Connectivity: A Critical History of Social Media*. New York: Oxford University Press.
Weltevrede, E., Helmond, A., and Gerlitz, C. (2014) The politics of real-time: A device perspective on social media platforms and search engines. *Theory, Culture & Society*, 31(6), 125–150.
Xiang, Z., Wang, D., O'Leary, J. T., and Fesenmaier, D. R. (2015) Adapting to the Internet: Trends in travelers' use of the web for trip planning. *Journal of Travel Research*, 54(4), 511–527.

Part II
Technologies of the Self

5 The Transtemporal Self
Transmedia, Self, and Time

James Dalby

Each time I come to write a transmedia paper, I find myself facing the same initial problem of needing to establish what transmedia actually *is*. As a complex and continually evolving subject with a number of published interpretations, it requires a suitable and acceptable definition before any further discussion can take place, and yet this is challenging because transmedia has meant varying things at different times, to different people, and in different contexts, meaning that an updated definition might be required each time. In the case of this chapter, my perennial problem of definition has tripled in scale, because in addition to transmedia we also need to discuss the other subject of this book: self – not exactly a simple subject with a widely accepted definition – and just to make things interesting, in this chapter I will also be attempting to introduce a third complex and hard-to-define aspect: time.

Last year (2021) I attempted to provide a round-up definition of transmedia, given that the term has been with us now for around 20 years, predating both social media and smartphones, and has evolved from its initial meanings and uses as a consequence. What I found, however, is that the essential principle of transmedia still applies; while technologies, platforms, trends, economies, uses, and interactions have changed, developed, and evolved, as Jenkins (2017) reminds us, fundamentally transmedia is – and remains – an adjective, and not a noun. 'Transmedia needs to modify something' (p. 220), he confirms. If we accept this – and I argued last year that we should, by providing an alternative definition of transmedia as a noun, which I approached as a form of media holarchy – then what I propose to do in this chapter is encourage the reader to see this process of modification from another perspective. While we normally think of transmedia as being concerned with the modification of media texts, these texts and their associated technologies are transitory, whereas due to the relationship that transmedia has with time and memory, which I shall endeavour to illustrate, we will find that the consistent and lasting property of transmedia is this: that the *something* being modified is, in fact, ourselves.

As discussed then, before we examine this proposition, we first need to establish the definitions that we will base it on. Transmedia, self, and even time, are what Daniel Kahneman might refer to as 'heuristics' or mental

DOI: 10.4324/9781003134015-8

'short-cuts'; a method of referring quickly and holistically to a complex system of elements, processes, and interrelationships. Because our discussions of transmedia and time will develop as we progress, let's firstly turn our attention to the big one: What do we mean by *ourselves*? What am I, in my *self*? To get as close as we can to a 'definitive' position – at least in terms of contemporary conceptions of self – we might want to open what Rovelli (2017, p. 154) calls 'this delicate discussion' with something tangible, some sort of *evidence of self*, if we can. In his seminal work *The Ego Tunnel* (2009), Thomas Metzinger begins by explicitly stating that there is no such *thing* as self. 'To the best of our current knowledge, there is no thing, no indivisible entity, that is *us*, neither in the brain nor in some metaphysical realm beyond this world' (p. 1), he explains. For Metzinger, this is where my notion of my self as an heuristic comes from; it's a useful mental short-cut to refer to a process of making sense of the world from a unique individual perspective, a process and perspective which are both 'mine'. This process, which Metzinger describes as 'the ingenious strategy of creating a unified and dynamic inner portrait of reality' (p. 6) involves my brain producing a detailed simulation of the world around me, and then an image of my inner self 'as a whole', which includes my experience as an organism, my psychological states, my relationship to other conscious beings, and my temporal experience (my self in time, my relationship to past and future). For Metzinger, this process produces consciousness, and by placing my inner image within my external world model, I create a 'centre', a first-person perspective which helps me to find that sense of personal ownership of my conscious experience so fundamental to my conception of self. Importantly though, self is not a separate thing-in-the-world; it is a shortcut reference for a complex process, and the elements of this process can be studied scientifically.

This notion of self as a form of heuristic is shared by the philosopher Daniel Dennett, who sees my self as a useful *abstract object*, not unlike the concept of centre of gravity, which is not a physical object and has no physical properties save for spatio-temporal location, and yet is useful in my understanding of the world. Just like centre of gravity, self is not a 'real thing in the universe' (1992, p. 103); it is an abstract object, but still beneficial in helping me to interpret 'some ... complicated things moving about in the world – humans and animals' (p. 105), and importantly for Dennett, this view sees self as a 'fictional character' (p. 114) in an autobiographical narrative; the 'story' of my life produced by the totality of my experiences.

The conception of self as a form of narrative – that, in a simplistic sense, my self is my conception of the ongoing 'story' of my life as I have experienced it – is a shared conclusion from thinkers across a wide range of disciplines. For psychologist and economist Daniel Kahneman, self can be found in the deliberate mode of thinking he refers to as System 2. While System 1 refers to the automatic thinking employed when I recognise the emotion in a human face, for example, or when I turn instinctively toward a loud noise, System 2 is the deliberate and effortful thinking employed when I try to make sense of

something, form a new belief, exhibit agency, or when I make an informed decision, and as such my 'System 2 [is] the conscious being [I] call "I"' (2011, p. 27). Kahneman also illustrates how this 'I' has two selves; the experiencing self and the remembering self, and he offers various examples to illustrate that the latter is the one I identify with, because the 'experiencing self does not have a voice' (p. 381), and the comparison with the remembering self – as Hughes comments in his transhumanist discussion of Kahneman – 'shows that our memories of our lives are *fictional narratives* [my italics] that bear little relationship to our actual moment-to-moment experience' (2013, p. 229).

From another discipline, quantum physicist Carlo Rovelli offers his own expression of narrative self when he suggests that my self has three parts; firstly a clear point of view, a perspective on the world which is uniquely my own; secondly a conception which mirrors my experience of other humans (i.e., I understand selves when I 'group into a unified image that collection of processes that constitutes those living organisms that are *other* human beings' [2017, p. 152] and then find that this grouping applies to me as well, not through introspection but through experience); and thirdly the most fundamental part for Rovelli is – again – memory. 'Our present swarms with traces of our past', he writes. '[W]e are *histories* of ourselves. Narratives' (p. 154).

Arguably we may also find similar parallels with neuroscientist Dean Buonomano's explanation of consciousness as 'a highly edited version of reality' (2017, p. 217), for which he provides various evidential examples, such as the measurable delay between an event occurring in the world external to me and my conscious perception of it. An example would be the *temporal window of integration*: the period of time my unconscious mind takes to integrate 'visual and auditory information into a single unified percept' (p. 218) before 'delivering' it to my consciousness. For instance, light and sound travel at vastly different speeds, and because light travels much faster than sound, I receive visual information of an external event – if I am watching someone speaking, for example – a measurable amount of time *before* I receive the auditory information of their speech, and yet the information is combined into a single simultaneity which is presented to – and understood by – my consciousness as being a complete, holistic experience. My consciousness, then, does not 'tell me' Dennett's autobiographical narrative of my life; instead, it is presented with the pre-edited version of my experiences from my unconscious – as Metzinger confirms, my 'conscious model of reality is a low-dimensional projection of the inconceivably richer physical reality' (p. 6) – and it is fundamentally located in time, in that my consciousness is always just slightly 'behind' events external to me.

At the same time, while the conception of self-as-narrative is commonly found in various disciplines, it is by no means universal, and it is important that we view self-as-memory and self-as-narrative as being distinctly separate. Strawson (2004) provides this distinction by offering a robust critique of what he sees as the 'fashionable' suggestion of self as narrative, arguing that this doesn't account for people – such as himself – who conceive of themselves as

clearly and distinctly *different* selves at different times. He makes a distinction between 'considering oneself principally as a human being taken as a whole, and one's experience of oneself when one is considering oneself principally as an inner mental entity or "self" of some sort' (p. 429), suggesting that in the second conception, one might be either *diachronic* or *episodic*, with diachronic individuals conceiving of themselves – the inner mental entity – as 'something that was there in the past, and will be there in the future' (p. 430) while episodic individuals do not conceive of themselves as being 'there' in past or future. Strawson does not suggest that 'episodics' do not exist through time, but simply that the inner mental entity of oneself is different; that is, I might feel that the self writing this chapter in 2022 is different to the self who wrote my first transmedia paper in 2016. The important distinction is that an episodic self retains the memory aspect of Kahneman's remembering self but does not connect these memories in the form of a narrative.

Whether or not we accept such nuances as the conception of self-as-narrative seems almost to be rooted in personal preference, or rather in the way we perhaps conceptualise and verbalise lived experience. This may be a result of our wider conception of ourselves as being the totality of our experiences, and naturally we haven't even scratched the surface of the broader debates around self, which may be influenced as much by factors such as culture and faith as anything else. I therefore fully acknowledge the very real limitations of the discussion offered so far. At the same time, it is not the intention of this chapter to provide a detailed examination of theories of self, more than is necessary to establish a position from which to proceed (even if there was space to do so). The rationale behind the selection of each definition offered so far is that, firstly, they have all contributed to my own personal conception of self – and as such, it's perhaps unsurprising that they would tend to agree and complement one another – and secondly, they are all views from varied fields and disciplines (neuroscience, quantum physics, psychology, etc.) in an attempt to find a broad, tangible definition of self, even if this may be extended further at a more personal level. Without being too specific and prescriptive, then, let's proceed with the following definition so that we can make progress. From what we have seen, self is an abstract mental shortcut for a complex process; my consciousness stems from the construction of a world model – a detailed simulation of the world around me – and an inner model of myself as an organism *in time*, replete with psychological states, which has a unique perspective and sense of ownership (*my*self) from the centring of the inner self within the world model, and experiences other selves in-turn, allowing me to make that categorisation applicable to myself. The construction of this world model is continually updated, a measurable amount of time *after* events in the world take place, as edited 'highlights' are presented to my consciousness from my unconsciousness, and the deliberate ordering of these 'highlights' through the process of *memory* is where I find that which I refer to as 'I'. I might conceive of that 'I' as operating contiguously in time as a form of continual narrative – a

diachronic self – or I might conceive of it as being fundamentally different selves at different times – an episodic self – but what is important is that there is a temporal aspect to both readings. Indeed, if we examine each definition above, we will find that they all (and I've emphasised this in italics in my summary) fundamentally include time as being a necessary aspect of self. It is a common thread across a majority of interpretations; even in more faith-based definitions of self where discussions of a timeless soul may be present, the lived experience of the passage of time, of being a self in time, is normally considered crucial. Except that we are *not* selves in time; rather, as we will see, time is found within ourselves.

If we have provided only a cursory glance at a definition of self, by necessity we will need to take the same approach for our discussion of time. Given that, as Buonomano muses, 'few questions are as perplexing and profound as those that relate to time' (2017, p. 4), the best we can do here – similarly to our discussions of self – is to attempt to find a broad and workable definition that will allow us to proceed. Firstly – tangibly – as Buonomano adds, we might look to define time as 'what clocks tell' (p. 15). The problem with this is explained by Rovelli, who guides us through relativity by asking us to consider that 'clock time' is not unlike a river (2017, p. 18), which is continuously flowing, and that within this flow there will be currents operating at different speeds. Because measured time passes more slowly for moving objects than for stationary objects, and more slowly at sea level than at altitude (we will even find a differential in measured time between a clock on a table and another on the floor, if they are sufficiently precise), *that which 'clocks tell'* doesn't really give us a clear definition of time. In addition, as Rovelli also confirms, 'clock time' is a relatively contemporary form of time, artificially mechanised; prior to the need to synchronise measured time over significant distances, midday would simply be measured by sundials as being when the sun was at its apex, meaning that even measurable time was anchored to specific geographical locations (i.e., two towns even just a few miles apart would not experience midday simultaneously). Finally, because measurable time is affected by mass and speed, where we find neither (in space, away from the gravitational field of any mass), it's also possible to conceive of this space as being without time, and if we turn our attention inward rather than outward, at the Planck scale (the minimum scale of granularity) for the gravitational field, breaking time down into Planck time (10^{-44} seconds), the notion of time as we conceive of it is, again, no longer valid.

These rather complex (and possibly alarming) conclusions, while necessary to briefly examine the idea of a tangible *evidence of time* as we did earlier for self, don't necessarily have to concern us however, because we are primarily interested in time insofar as it relates to our conception of self, and for this we must turn to the subjective 'sense' of perceived time, often referred to as chronoception. For this, we can begin (in fine academic style) by reaching back to antiquity to find a potential definition in Aristotle, and what Newton-Smith (1980, p. 14) refers to as 'Aristotle's principle'. This principle

is that time is simply our conception of change, and without venturing into the objections to the modern 'verification' interpretation of Aristotle, which Coope (2001) offers, we can still find parallels between this view of time as, again, a form of heuristic to express our lived experience of change, and Rovelli when he explains that there are no 'things' in the world, there are only 'events' (p. 85). Things, he explains, persist in time, while events have a limited duration.

> The hardest stone, in the light of what we have learned from chemistry, from physics, from mineralogy, from geology, from psychology, is in reality a complex vibration of quantum fields, a momentary interaction of forces, a process that for a brief moment manages to keep its shape, to hold itself in equilibrium before disintegrating again into dust.
>
> (p. 87)

The key here is what Rovelli refers to as 'blurring'; we cannot directly perceive the quantum fields, subatomic particles, and so on that form the stone at smaller levels of granularity. Instead, the blurring of our perception reveals to us the stone, in the way that we perceive a cloud, an ocean wave, or a clap of thunder. The only difference is that we cannot directly perceive the disintegration of the stone over time, in the way that we can with a cloud; we perceive the stone at that particular level of granularity due to our perception at a *human level* of scale, which 'blurs' the smaller structures of the stone together, and we perceive the stone as a 'thing' because of our conception of it at a *human level* of change and chronoception.

We ourselves are no different. When we consider our definition of self from earlier, my world model – my detailed simulation of the world around me – is continually updated, allowing me to perceive change external to me, while my inner model – the centre of my world model which provides me with the sense of ownership of my self experience – is the same. As an organism I change, just like the stone; I can perceive changes in my psychological states, models such as the Scalar Expectancy Theory (SET) (Gibbon, 1977) and Attentional Gate Model (Zakay & Block, 1996) have been developed to explain behaviours related to my 'internal clock' and temporal changes in my physical being, and my memories of events are continually being amended and updated as I access them through the lens of more recent experiences. Time, then, in this reading is found within ourselves, because it is a heuristic through which we refer to our perception and conception of change, at a human level of granularity and chronoception.

Before we return to our primary discussion of transmedia selves, one final note concerns another fundamental aspect of our lived experience of time, which is that it passes, and seemingly in a single direction. Time may be our experience of change, but it is also important for us to be able to interpret between previous and subsequent states within any change process, and to recognise that we remember the past, and not the future. As Buonomano confirms, 'it is impossible to overstate the importance to cognition of the

temporal relationship between the events we experience' (2017, p. 25). Rovelli offers the classic principle of entropy – 'the ubiquitous and familiar natural increase of disorder' (2017, p. 28) – to explain this directionality of time. When I put down my hot cup of coffee it will gradually cool, and if nothing else changes, it will never become hot again: an example of the second principle of thermodynamics, which 'is the only equation of fundamental physics which knows any difference between past and future' (p. 25). Entropy is change, from order to disorder, but again the *ordering* occurs at a *human level*. If I take a pack of cards arranged in suits and shuffle them, perceived disorder will result and entropy will be higher, but it is only my (human) conception of the arbitrary ordering of the cards – an order I impose upon them, despite their design allowing them to be ordered in various ways – which creates the phenomenon of entropy.

Buonomano in turn offers another explanation for time's arrow in the form of spike-timing-dependent-plasticity: the sense of cause and effect potentially found in our neural pathways. Neurons are nerve cells which pass electrical signals to one another through junction points called synapses, and if we have two neurons, A and B, which are recurrently connected (a synapse allows a signal to pass from A to B, and another from B to A), and A consistently fires before B, the A-to-B synapse will be strengthened while the less familiar B-to-A synapse weakened. Buonomano's example is that neurons A and B are owned by someone called Zoe (2017, p. 29); neuron A is triggered by the sound *z* and neuron B by the sound *o* in the name *Zoe*, and because Zoe will hear her name correctly (A firing before B) far more often than hearing it backwards (where B would fire before A because the *o* sound would occur before the *z* sound) the A-to-B synapse becomes strengthened. We can experience this directionality of time through strengthened order-dependent synapses as it allows us conception of cause and effect – one neuron-triggering event occurring before another – and if we briefly consider Kurzweil's 'Pattern Recognition Theory of Mind' (2012), in which he asks us to view the human neocortex as effectively an extremely sophisticated pattern-recogniser, when we discover temporal patterns in our world model we experience this strengthening of contiguous synapses, which may provide a broader conception of cause and effect over time. Pattern-recognition may also account for our perception of lower entropy, applying human-level perception to generate positions of perceived order. While time is found within ourselves then, as our conception and experience of change, that change occurs in a particular direction which we conceive as the flow of time, again at a *human* level, and is something that can – seemingly, and to an extent – be measured and quantified in different disciplines.

We have our working definition of self then, and an approximation of time which is suitable for our purposes. We are long overdue the introduction of transmedia after all, and a final example will help us to bring things back on course. At the Transmedia Earth Conference in Medellin, Colombia, in 2017, Vincente Gosciola offered what has become one of my favourite definitions of transmedia, which is that 'music is the intervals between the notes, not the

notes themselves, and transmedia is the same'. This elegant summary accords well with Jenkins' reminder of transmedia as an adjective; individual notes do not make a piece of music, it is their relationships and the way their juxtapositions modify one another that creates the piece, and in transmedia we don't think of individual media texts or touchpoints, but rather the way that those touchpoints combine to become something that is more than the sum of its parts. It is here that we find our first parallel with our discussions of self and time; music is *our* conception of the notes played, not the notes themselves, and this is *fundamentally* located in time which, as we have seen, is found within ourselves. Both Buonomano and Rovelli offer music as an example to illustrate this, Buonomano likening our listening to music as similar to 'our ability to see a face in the relationship between the dots of a Seurat painting' (2017, p. 32) while Rovelli discusses St. Augustine's discovery of consciousness in the 'memory and anticipation' of listening to a hymn (2017, p. 158). The point is this; if we can hear only one moment of a piece of music at any given time (our experience is that we cannot listen to the entire piece simultaneously), what is it that facilitates the relationship between the notes, which gives the piece its identity over time? Because time is found within us the answer, of course, is *ourselves*. We are the glue which holds the piece together; our memory of the notes played and our anticipation of the notes to come *in time*, the experience of a note or chord modifying and being modified by that which precedes or succeeds it *in time*, the awareness of change and its directionality, which is such a fundamental part of our selves, our lived experience, is at the very heart of our experience of music. As we find parallels between transmedia and music, it also accords that we find ourselves in transmedia too; if transmedia is an adjective, then *we* are the constant factor that holds it all together. We are the ones doing the *transmediating* over the duration (time) of the experience.

This is where Gosciola's analogy of transmedia and music doesn't quite map accurately however, because transmedia and music are fundamentally dissimilar as well. Music is part of the category of media forms – such as films and theatre performances – which have a temporal aspect to their experience, and because as we have seen, time is found within ourselves (we provide music with its temporal identity by connecting the relationships between notes, etc., over time) we accordingly find ourselves within each of these forms. When watching a movie, our experience is that we cannot watch the whole thing simultaneously at the same point-in-time – our experience of time is that it flows - and while we may not be able to accurately remember the various edits which have led up to the moment we are currently watching (or refer back to those edits in the way we might do with a graphic novel), it is still our memory and anticipation of the film which allows each edit to modify, and be modified by, the next. In this process however, we are passengers; the decisions about the order of edits in an authored film, or notes in a piece of authored music, have been made for us, and consequently we are *audience* members. Transmedia does not operate this way; as I have argued

many times (2016, 2017, 2021); transmedia requires *participants*, and it's hard to conceive of transmedia *audiences* because within transmedia we have choices (and more crucially we make decisions) which, in addition to preventing suspension of disbelief as I have discussed before, means that transmedia experiences are always unique in some way, each time they are experienced. In this reading, transmedia experiences are more like games than music or films, and as Brown notes, games require players, 'and this is one of the ways they are differentiated from the majority of other media experiences which require only audiences' (2012, p. 8). The bits-in-a-box of a board game, or the file downloaded onto the console are not *the game*, they are the elements which facilitate the game experience, but it is the player who gives that game its identity each time it is played. Similarly, transmedia requires participants to engage with the process (akin to the rules of the game perhaps) in order to create the experience. This is dissimilar to the decision making we might employ when pausing music or rewinding part of a film, as while these actions may affect the specific experience of both, they are not intentional elements of the music piece or film, in the way that decisions are designed into transmedia as essential aspects of the experience. As a final example, Buonomano also includes speech as well as music in his discussion of conception over time, and again we find parallels; we cannot experience the whole of a conversation in the same instant; our memory and anticipation provide the 'glue' which holds the conversation together. If we are listening to a conversation, we might conceive of ourselves as an audience member; however, if we are involved in the conversation, we are making decisions, and as a result we become not unlike the player of a game; conception of transmedia without participants is like conception of a conversation without interlocutors.

I have mentioned that Gosciola's 'music' definition of transmedia is one of my favourites, and I have also demonstrated how it doesn't quite line up accurately as a like-for-like analogy, but there is no contradiction here. This is because we can conceive of transmedia in two modes: as a *process* and as an *experience*. The process of transmedia is like music: a temporal process of memory and anticipation in which we, ourselves, as the conceivers of time, become the 'glue' which creates the relationships of modification between notes in music, or touchpoints in transmedia, over time. Meanwhile the experience of transmedia is more akin to a game or a conversation, in which players or interlocutors provide the unique identity and become necessary participants, whereas in a piece of music – where decisions lie with the author and not the listener – we find audiences. Consequently, while I agree with Jenkins' reminder that transmedia is an adjective, as I have also discussed (2021) I disagree with his assertion in the same paper that transmedia 'is not necessarily … participatory' (2017, p. 220), and we can see the reasoning in both modes (process and experience) mentioned. If transmedia (as a process) is like music, we can see from the St. Augustine example that the listener is fundamental to the process, because without a self providing temporal contiguity across the duration of the piece, there will be nothing to provide the

memory and anticipation needed to facilitate the relationships of modification (between musical notes or media touchpoints) we've discussed. Meanwhile, if (as an experience) transmedia is more akin to a ludic ('game') process we have seen that games need players to make decisions and provide the unique identity to the experience (which, again, is located in time) and transmedia requires participants for the same reason.

Transmedia, then, relies on us, ourselves, because without our participation there is no transmedia. To suggest otherwise is to conceive of transmedia as something in-and-of itself: Transmedia the noun – which as I suggested last year should be conceived of separately as a form of media holarchy – rather than transmedia the adjective. We make decisions about the form a transmedia experience will take, and we give it identity over time through memory and anticipation, because time is found within ourselves. This relationship is also recursively connected, because while it might be a stretch to suggest that we *rely* upon transmedia in the way transmedia relies upon us, it is still easy to see ourselves *as* transmedia experiences – transmedia selves – in a sense. This is by no means a 'new' idea either, as Elwell notably commented in 2014 (p. 127):

> In our age of constant connectivity and ubiquitous computing, self-identity is increasingly fashioned according to the aesthetics of transmedia production. I thus propose that the transmedia paradigm, taken as a model for interpreting self-identity in the liminal space between the virtual and the real, reveals a transmediated self constituted as a browsable story-world that is integrated, dispersed, interactive, and episodic.

As an immediate example of this, for most of my friends and colleagues, their experience of me is as likely to be words or images on a screen as it is my physical self in the world, and in many cases, their experience of me will be almost entirely – and perhaps even exclusively – mediated in some way, particularly in a post-Covid-19 'lockdown' world. The experience of *me* to others is therefore varied; distributed across different platforms and touchpoints, just like a more conventional transmedia experience, and *participants* in the transmedia experience of *me* also have agency and make decisions about which aspect(s) of my transmedia self they access, when, and in what order. If we are the 'glue' that holds transmedia experiences together due to the combination of memory and anticipation, then others' experience of my transmedia self happens on their own terms; they are the ones transmediating me. If self is indeed a narrative over time, then the transmedia 'story' of me, presented by me on various technologies and platforms, becomes part of my self, and is negotiated with those others experiencing it on their own terms.

I may also find this process occurring internally to myself as well. If we recall our definition of self, it includes both a world model – which now includes virtual elements, and a blurring of the traditional 'physical' world with the non-physical, because my world externally to me is increasingly virtual – and it also includes the recognition of other selves, allowing me to

apply that recognition back onto myself, and again I increasingly encounter these selves in virtual contexts. As I experience more interactions with other transmedia selves, and as I *outsource* more of myself to technology – as I meet people romantically on dating apps, as I *become* various stats and 'personal bests' for others to see on exercise platforms, as I spend time in virtual worlds, perhaps in games, extended reality constructs, or in the developing metaverse – I modify my experience of self. In a process similar to that of Strawson, I might conceive of myself as being 'diachronic' or I might conceive of myself 'episodically', not across time but across the touchpoints of my transmedia self. Am I a different self online for example? My own experience is yes: I am quite a different person in my online interactions compared to those in the flesh-and-blood world, and I therefore experience a not-dissimilar conception of self to that of Strawson, when he compartmentalises his inner entity across time, except that my compartmentalisation occurs across transmedia technologies and platforms, which I might conceive of as different *selves*.

There has been much written about this process, and often in relation to the various harmful effects of transmedia self. One of the most interesting for me recently is the book *Unfit for Purpose* by my University of Gloucestershire colleague Professor Adam Hart, in which he finds challenges in social networking by comparing it with the 'Dunbar number' (2020, p. 211), and the limit to the number of effective social interactions based on the human neocortex, arguing that part of the problem of social media is that we simply don't have the cognitive capacity to be able to cope with it effectively. The specific (potential) problem with transmedia self that I wish to focus on for the remainder of this chapter, however, is the notion of transmediating oneself in relation to our ongoing discussions of self and time, and particularly that of memory. We will recall that our definitions of self have all included a fundamental temporal aspect – self and time cannot be separated – and within that, memory is naturally crucial; indeed, for Rovelli, Kahneman, and others, memory and the remembering self is the fundamental aspect of that which I conceive of as 'I'. Whether or not we conceive of our memories as providing a diachronic or episodic experience of self, whether or not we identify with the idea of memory as a narrative, making us Rovelli's 'histories of ourselves', memory is inseparable from our experience of change, which as we have seen is our conception of time: a time that 'flows' in a particular direction. Except, what if it didn't? What if, as a transmedia self, I have somehow *modified* time's arrow?

I have fond and formative memories of myself in virtual contexts; gaming, social media interactions, immersive constructs such as VRChat, collaborative work and creative projects, and so on. I have also experienced other transmedia selves in those contexts too of course. Increasingly, as I transmediate myself, I develop more and more memories from virtual contexts, and if I myself am the sum total of my experiences, if I am a history of myself, then increasingly that self is virtual because a growing percentage of my memories are from virtual sources. This might seem like a conceptual

cul-de-sac; after all, isn't there always a flesh-and-blood 'me' which is the consistent factor across all of my virtual interactions? Whether or not I conceive of my self as being different in virtual contexts, it *is* dissimilar to Strawson's 'episodic' idea, because flesh-and-blood me doesn't vanish when virtual me is operating (whereas in Strawson's conception, it is not as though my contemporary self existed when my 2016 self wrote my first transmedia paper). Even in virtual reality experiences with long-form users – such as those featured in University of Gloucestershire graduate Joe Hunting's film *We Met in Virtual Reality* (2022), where extraordinary relationships are developed and meaningful life-affirming events take place in VRChat – we can argue that there is still a human organism 'behind' the experiences. Conversely, if we accept that many users of virtual contexts – such as those in Joe's documentary – consider their 'virtual selves' as being *more* than their flesh-and-blood selves, allowing them the opportunity to *be themselves* in ways that they cannot in non-virtual contexts (and indeed it would be churlish to suggest that the participants in *WMIVR* are, in fact, primarily the flesh-and-blood selves wearing head-mounted displays (HMDs), rather than the virtual selves having meaningful and formative experiences within the platform), then we still find ourselves in the same position of 'so what'? So what if I have memories from virtual contexts?

Virtual-context memories are not *virtual memories* (i.e., simulations of memories); they are legitimate and authentic memories, but they do have one peculiar property, which is their temporality. If time is our awareness of change, virtual contexts can have distorted or inconsistent aspects 'in time' due to the rate and development of change, and/or our conception of it. A social media post, such as a tweet or a conversation in a comments section, is a snapshot of the self posting it at a specific time, but that post may remain for years or decades, a conversational moment 'frozen in time', dissimilar to a letter or other written correspondence which may also last over time, due to its intended and perceived immediacy. Social media use can affect time-perception (Gonidis & Sharma, 2017), as can gaming (Nuyens, 2019), perhaps due to 'flow states', cognitive load, or developments in working memory due to gameplay, and we are only beginning to scratch the surface of a phenomenon that those of us involved with virtual reality have known for many years: its extraordinary capacity for time-compression (Mullen & Davidenko, 2021). A working theory seems to be that a reduced or modified perception of one's own body in virtual reality may be a contributory factor.

There are a number of ways in which our hybridised transmedia selves – increasingly composed of memories from virtual contexts, replete with temporal distortions – might modify us as selves; a simple example is the distinction between prospective and retrospective timing. If I am asked to do something in five minutes' time – prospective timing – for my brain this is a timing task, because I have a point in time ($t = 0$) from which to begin my estimation. But, as Buonomano explains, if I am asked to estimate *how much*

time has passed since an event – retrospective timing – because I have no specific start point, this becomes 'an attempt to infer the passage of time by reconstructing events stored in memory' (2017, p. 60). Over the course of five minutes, we might not find much distortion of course, but over weeks, months, and years, as we build our stock of virtual, temporally inconsistent memories, we can see how our retrospective timing might become skewed. Of course, time dilation and compression have been part of the lived human experience long before transmedia technologies came along; we are all familiar with time 'dragging' during a disagreeable experience, and 'flying' during a positive one, and we are also familiar with the subsequent memory of that positive experience seeming longer than the memory of the disagreeable one. But here again we find the complication, because even with time compression and dilation, under normal circumstances we can still conceive of memories occurring contiguously, one after another with the usual arrow-of-time connection, whereas memories occurring in virtual contexts may not be contiguous, and even if they are, we may struggle to accurately conceive of them as such. During the day, my lived experience as an organism with circadian rhythms, physiological changes, and behaviours such as those expressed models such as SET, and aware of time's 'flow', allows me to conceptualise the passage of the day – I remember making a pot of coffee this morning, for example, and even though I might not be able to say precisely when I did this, I am able to locate the memory temporally – but I may struggle to conceptualise the same process in virtual contexts. If I comment on social media, or if I play a few turns of an online game on my phone, these are hard to locate temporally because they don't fit into the *joined-up* conception of my non-virtual memories. My conception of time as my awareness of change finds a gradual and consistent process through the day, punctuated by virtual memories which seem, somehow, *out of time*. I might be able to check the time of the social media post, or I might know I played my game while on the train, but this will only provide me with 'clock time' and not my sense of chronoception, of self-time as a form of change. Given how fundamental time is to our sense of self from all of our definitions, it stands to reason that modification of our conception of time will likely *modify* ourselves, and if that modification is ultimately shown to be deleterious, then the consequences could potentially be significant.

I am – as sometimes happens when discussing technology – in the unusual position of writing this chapter at the commencement of my research journey into this field, rather than at its conclusion. Similarly to Tegmark's sentiments in his seminal work *Life 3.0* (2017), where he explains that the discussions raised need to occur before artificial general intelligence progresses past a certain point, so I feel that discussions about temporality and transmedia technologies may need to be more immediately visible and present as part of the ongoing narrative of the subject, due to the potential consequences for ourselves which I have touched on here, rather than after

a consistent body of research into the subject has developed. As such, I will not conclude this chapter with a finalised 'take-home', but instead food-for-thought for ongoing discussions. Perhaps – as a growing picture of research illustrates – one aspect of the temporal inconsistencies of virtual memories may lie in their disembodiment, to some extent. If, at an extreme end of the scale, we find limited awareness of our bodies in virtual reality, which may affect our conception of change (and time as a result), then it may be that the varied degrees of (conceptual or physical) disembodiment found in other virtual contexts may also have proportional effects. We may return to Kahneman at this stage, and his discussion of the differences between the experiencing self and the remembering self. He offers an unusual experiment (2011, p. 381) in which participants must first hold their hand in very cold water for 60 seconds, and then later in very cold water for 90 seconds, with the difference that the water would warm slightly (by 1 degree) for the final 30 seconds in the longer task. When subsequently asked which task they preferred, the participants selected the longer task, despite the fact that it was a longer period of discomfort for their experiencing selves, because their remembering selves were concerned only by what Kahneman calls the 'peak-end rule': the peak discomfort of the experience, and the end of it (which had been perceived as offering marginally less discomfort in the second, longer, task) rather than the accumulated amount of discomfort in total. We might find parallels between Kahneman's experiment and recorded instances of virtual reality time compression providing perceived relief during medical procedures (Chirico et al., 2016; (Indovina, Barone, Gallo, Chirico, De Pietro, & Giordano, 2018). In both instances, the remembering self provided an inaccurate – albeit potentially useful – conception of what the experiencing self had experienced over the elapsed time. It is not difficult to draw parallels here to other forms of 'disembodied' memory, such as perhaps dreams during REM sleep, in which again our conception of elapsed time is significantly skewed after the fact. Given that during experiences such as REM sleep, we may not conceive of ourselves as being (at least conventionally) conscious, perhaps an hypothesis may be that virtual memories, replete with temporal distortions and elements of disembodiment, may also operate at a level of reduced self-awareness, and potentially even at a level of reduced or impaired consciousness.

During this necessarily brief canter through the complex topics of transmedia, self, and time, we have seen that both self and time are heuristics for complex human processes, and that transmedia technologies fundamentally rely on those processes, and may also have a consequential effect upon them. As I increasingly make use of transmedia technologies within my complex process of self, as I am transmediated by others, and encounter similar selves in return, and as I form self-defining memories in transmedia contexts, thus I become more of a transmedia self, replete with the potential and possibly serious consequences found, uniquely, within transmedia selves.

References

Brown, D.W. (2012). *The suspension of disbelief in video games* (Doctoral Thesis). Brunel University, London, UK. Retrieved from https://bit.ly/2CDQayn

Buonomano, D. (2017). *Your Brain Is a Time Machine. The Neuroscience and Physics of Time*. New York, USA. Norton & Company, Inc.

Chirico, A. et al. (2016). 'The Elapsed Time during a Virtual Reality Treatment for Stressful Procedures. A Pool Analysis on Breast Cancer Patients during Chemotherapy'. In: G. Pietro, L. Gallo, R. Howlett, & L. Jain (Eds.), *Intelligent Interactive Multimedia Systems and Services 2016. Smart Innovation, Systems and Technologies*, vol 55. Cham. Springer. https://doi.org/10.1007/978-3-319-39345-2_65

Coope, U. (2001). 'Why Does Aristotle Say That There Is No Time without Change?' *Proceedings of the Aristotelian Society* 101, 359–367. Available at: https://www.jstor.org/stable/4545354

Dalby, J. (2016). 'Immersed in Difficulty: The Problem of Suspension of Disbelief in Transmedia and VR Experiences'. *Online Journal of Communication and Media Technologies* 6 (September 2016 – Special Issue), 67–85. https://doi.org/10.30935/ojcmt/5662

Dalby, J. (2017). *Modular Stories: An examination of multi-modal transtexts in relation to The Modular Body*. Paper presented at the *Transmedia Earth Conference: Global Convergence Cultures*, EAFIT University, Medellin, Colombia. October 11–13.

Dalby, J. (2021). 'Holarchic Media: When transmedia Just Isn't Transmedia Enough'. *Academic Letters*, Article 2210. https://doi.org/10.20935/AL2210

Dennett, D. (1992). 'The Self as a Centre of Narrative Gravity'. In F. Kessel, P. Cole, & D. Johnson (Eds.), *Self and Consciousness: Multiple Perspectives.* (pp. 103–115). Hove and London, England. Lawrence Erlbaum Associates, Publishers.

Elwell, J. S. (2014). 'The Transmediated Self: Life between the Digital and the Analog'. *Convergence*, 20(2), 233–249. https://doi.org/10.1177/1354856513501423

Gibbon, J. (1977). 'Scalar Expectancy Theory and Weber's Law in Animal Timing'. *Psychological Review* 84(3), 279–325. https://doi.org/10.1037/0033-295X.84.3.279

Gonidis, L., & Sharma, D. (2017). 'Internet and Facebook Related Images Affect the Perception of Time'. *Journal of Applied Social Psychology* 47 (4), 224–231. https://doi.org/10.1111/jasp.12429

Hart, A. (2020). *Unfit for Purpose. When Human Evolution Collides with the Modern World*. London, England. Bloomsbury Sigma.

Hughes, J. (2013). 'Transhumanism and Personal Identity'. In M. More & N. Vita-More (Eds.), *The Transhumanist Reader. Classical and Contemporary Essays on the Science, Technology, and Philosophy of the Human Future.* (pp. 227–233). Chichester, England. Wiley-Blackwell.

Indovina, P., Barone, D., Gallo, L., Chirico, A., De Pietro, G., & Giordano, A. (2018). 'Virtual Reality as a Distraction Intervention to Relieve Pain and Distress during Medical Procedures: A Comprehensive Literature Review'. *The Clinical Journal of Pain* 34(9), 858–877. https://doi.org/10.1097/AJP.0000000000000599. PMID: 29485536.

Jenkins, H. (2017). 'Transmedia Logics & Locations'. In B.W.L. Derhy Kurtz & M. Bourdaa (Eds.), *The Rise of Transtexts. Challenges and Opportunities.* (pp. 220–240). Abingdon, England. Routledge.

Kahneman, D. (2011). *Thinking, Fast and Slow*. London, England. Penguin Random House.

Kurzweil, R. (2012). *How to Create a Mind. The Secret of Human Thought Revealed.* Richmond, England. Duckworth.

Metzinger, T. (2009). *The Ego Tunnel. The Science of the Mind and the Myth of the Self.* New York, USA. Basic Books.

Mullen, G., & Davidenko, N. (2021). 'Time Compression in Virtual Reality'. *Timing & Time Perception* 9(4), 377–392. https://doi.org/10.1163/22134468-bja10034

Newton-Smith, W.H. (1980). *The Structure of Time.* London, England. Routledge.

Nuyens, F.M. (2019). *The time loss effect in gaming: An exploration of gamers' time perception from a dual-process perspective* (Doctoral thesis). Nottingham Trent University, Nottingham, UK. Available at: http://irep.ntu.ac.uk/id/eprint/39483/

Rovelli, C. (2017). *The Order of Time.* London, England. Penguin Random House.

Strawson, G. (2004). 'Against Narrativity'. *Ratio. An International Journal of Analytic Philosophy* 17(4), 428–452. https://doi.org/10.1111/j.1467-9329.2004.00264.x

Tegmark, M. (2017). *Life 3.0. Being Human in the Age of Artificial Intelligence.* London, England. Penguin Books.

Zakay, D., & Block, R.A. (1996). 'The Role of Attention in Time Estimation Processes'. *Advances in Psychology* 115, 143–164. https://doi.org/10.1016/s0166-4115(96)80057-4

Film

We Met in Virtual Reality. (2022). Directed by Joe Hunting [Film]. HBO Documentary.

6 Crossing Space-Time-Action

Digital Self-Tracking Technologies and the Zero-Dimensionality of the Transmedia Self (via Vilém Flusser's First and Second Degree Imaginations)

Jenna Ng

Introduction

All media establish an actant's action in a specific matrix of space and time. In Richard Linklater's 2001 animated film *Waking Life*, a charming scene of philosophical exposition by the film director Caveh Zahedi contrasts the spatio-temporalities of action as set in literature versus cinema. In relation to the former, Zahedi states that action exists in the free-floating space and time of the reader's imagination of the text: on the story of "this guy [who] walks into a bar and sees a dwarf", "you're imagining this guy and this dwarf in this bar ... there's an imaginative aspect to it" (Linklater 2001, 52:53 to 53:01). Conversely, Zahedi continues, "cinema, in its essence, is about reproduction of reality" as recorded in its particular space and moment. Hence, in relation to the same story, "in film ... you actually are filming a specific guy in a specific bar with a specific dwarf ... of a specific height who looks a certain way.... [I]t is about that guy, at that moment, in that space" (Linklater 2001, 53:01 to 53:39). Via their respective processes of producing written text and recorded image, the ontologies of literary and visual media thus fix action in a specific physics – mentally constituted or otherwise – of space and time.

Accordingly, *recording* media renders physical action that had taken place in a specific space and at a specific time *re-presentable* in another space and time of their replay. This chapter, then, focuses on how digital self-tracking technologies – I take here Deborah Lupton's definition of self-tracking as involving "practices in which people knowingly and purposively collect information about themselves, which they then review and consider applying to the conduct of their lives" (Lupton 2016a, 3) – record actions of the self. These recordings thus enable, as with any recording technology, the reiteration of these actions in a different space and time. More importantly, this chapter will argue that such recordings reduce the actions into the *zero-dimensionality* of digital information which, in turn, places the self not simply in another space and time. Rather, they re-place the self in a *spatio-temporal*

DOI: 10.4324/9781003134015-9

matrix of algorithmic logic. The implications of such re-placement are profound, not least in view of the alarming amounts of monitoring and surveillance – or "dataveillance" (Lupton 2016b, 102, taking from van Dijck 2014) – of human activities by governments and technology companies through the algorithmic operations of their products, by now a familiar argument made by many (see Cheney-Lippold 2011; Kitchin 2014; van Dijck 2014; Amoore and Piotukh 2016). In this sense, the transposition of the tracked self into the spatio-temporalities of the algorithm renders the self, generally comprising mind and matter in a physical space and time, as immaterial computer data that is particularly subject to divisibility and dividuation. It is likewise in this sense of divisibility that Gilles Deleuze, in relation to electronic codes of control and monitoring, refers to how "individuals have become 'dividuals'" to become prime subjects for what he (1992, 5) calls "societies of control", where "what is important is no longer either a signature or a number, but a code ... that mark[s] access to information, or reject[s] it". The politics of knowledge and control from the reiteration of the self in algorithmic being is thus a significant issue, if already well discussed elsewhere (see Pasquale 2015; Danaher 2016; Galic et al. 2017; Lanzing 2019).

However, the discussion I wish to address in this chapter proposes a different focus, namely, the flattening of the digitally tracked self as an *abstraction* of the self's actions and engagement with its world. Parsing the digitally tracked self through Flusser's ([1985], 2011) theorization of the technical image and the mediation of the world towards that technicality, I argue that the digitized self and its actions thus become a mediated form of *zero dimensions*, whose being in time and space is marked not so much by the presence of being, but the absence of the immaterial. In turn, the digital self is liberated from the physics of its re-presentations, giving rise to potentially infinite imaginations of it, even as it is *also* swept into the spatio-temporality of the algorithm that not only subjects it readily to various subjugations of political power and control, but also represses its potentiality to a reduction of extreme cerebration. In Flusser's words of such abstraction, it gets "away from the mammalian essentials" ([1985], 2011, 128). The key issues of transmedia here are thus not only about how media re-locates and abstracts the self across different spatio-temporalities, but also the implications of such displacement for its power and agency. If Baudrillardian simulacra point towards an empty vortex of unceasing copies bereft of connections to the meaning of the original, the zero-dimensionality of the self as transmediated through the algorithmic logic of self-tracking directs to an internal void of hollowness and disengagement of the self with its world. In turn, I argue that this becomes – if less obviously and more insidiously – another form of control and restraint which needs to be included in the consideration of contemporary "societies of control".

The chapter will proceed as follows. The first section will trace a broad trajectory of how media change the space-time matrices of action, in particular underscored by Flusser's ([1986], 2015) ideas of first and second degrees

of imagination. The next section will examine how digital self-tracking technologies propel the recorded self into Flusser's second-degree imagination. It will explore the consequences of its immaterial culture on the futurity and potential of the self, as well as the algorithmic processes of self-tracking technologies which hijack the self into its logics. Finally, digital self-tracking also points the imagination of the self into a world model that is synaptic, punctual, quantized and profoundly fragmented. The last section will conclude.

Media and Their Dimensionalities of Space, Time and Action

At any point in time, the self exists as a physical entity in four dimensions, or, within three-dimensional space and in time. The actions of the self thus take place within physical space and throughout its perpetual present. Hence, the self in real-time, like performance (Phelan 1993), is ephemeral: its actions, happening in a particular space at a particular time, are unrepeatable and non-reproducible in their original forms. Rather, these actions in real space and time can only "happen again" in a mediated form, such as a video camera recording of the action, in which case the action re-appears as remediated in the replay's other space and time.

For the most part, the subsequent reiterations of actions in different spatio-temporalities have no material consequence to the time and space of the replay beyond functioning as documentation for the purposes of the record. However, exceptions exist, such as recordings of past gaming performances or interactive actions which may be called up by way of ghost cars or speedruns as competition for other players in their own time-space, thus altering those players' actions of gameplay in their present spaces and time. Moreover, actions in life are not equal: some are more significant than others, and whose mediated repeatability in different spatio-temporalities radically changes their nature and gravity of event. A key example is death, or the act of dying: as Bazin ([1949] 2002, 8) writes, "death is the unique moment par excellence. … [It] is nothing but one moment after another, but it is the last." Yet, a moving camera's recording of any moment of death enables it to be invoked at will in different times and space. Dying is thus no longer a moment of uniqueness, where the truth of how "we do not die twice" (8) transposes into a "Death Every Afternoon" (5), per the title of Bazin's essay. In turn, such repeatability of death in different spatio-temporalities represents no less than a violation of its fundamental nature: "thanks to film, nowadays we can desecrate and show at will the only one of our possessions that is temporally inalienable: dead without a requiem" (9). The dead thus becomes the undead – endlessly revivable and never at rest. In the case of interactive media where past actions may materially affect the present, these ghosts gain greater poignancy. A story posted as a comment to an innocuous YouTube call by PBS Digital Studios (2014) on the question, "Can video games be a spiritual experience?", relates how a past gaming performance by the commenter's father, deceased in the commenter's childhood, was saved in the game console

as a "ghost car" running the best lap time against which other players can race. As the commenter puts it, "his [the user's father] ghost still rolls around the track today" (PBS Digital Studios 2014). Years after his father set his gaming record, the commenter, now in his adulthood, races against his father's ghost car – the dead thus affecting not only the actions of his own presentness, but also constituting a deeply emotional experience in this particular state of live play amongst the living.

These selective immediate consequences aside, mediation of action into different matrices of space and time also has other and more indirect implications. For one, mediation incurs a cost, namely, the *flattening* of action into various levels of abstraction in terms of the medium's changing codification of information. Hence, an action recorded by a video camera as an indexical imprint on film is reduced from four to two dimensions. If recorded by writing, then it is further diminished into the uni-dimensionality of lines. Like shades of shadows from an object in light, each mediated transposition of action into a different spatio-temporality abstracts one or more dimensions from the dimensionalities of its original.

This framework of abstracted dimensions is indeed Vilém Flusser's taxonomy (and, impliedly, also a trajectory) of media from the alphanumeric to the anti-alphabetic. In this case, his framework is helpful in thinking through and theorizing changes between media forms. In particular, Flusser's theory sheds penetrating light on how transmediated reiterations of action occupy space and time, and the ways in which the dimensions of mediated representation thus (dis-)enable our apprehensions of our world, and affect knowledge and experience. In various writings, but particularly in a series of lectures delivered at the University of São Paolo in August 1986 (and later published as a short volume, *Into Immaterial Culture*), Flusser ([1986], 2015) writes of, among others, the leap of understanding that needs to be made between what he calls "first degree imagination" and "second degree imagination" (25–33). In Flusserian terms, *first degree imagination* is the cultural engine of *Homo sapiens* which "produces images that represent the concrete world" (31). Crucially, Flusser characterizes first degree imagination of the world as captured by and across different media forms in terms of *abstractions* of dimensions – in brief running order, from the starting point of the self, which is "just like any other living being, part of a given concrete world that is four-dimensional: space in movement" (26). With the advent of tools, imagination becomes three-dimensional without the dimension of time: "The flint knife is frozen circumstance: still (understood, *verstanden*). The temporal dimension was abstracted from the knife" (26). With painting comes "an imagined world that has lost its concretion, but has gained amplitude" (26) – namely, a bidimensional world that is "superficial and plane", with the dimension of depth abstracted. With writing, or the alphabetic and numeric codification of images, "images are decomposed into pixels and ideas into concepts" (27), or, "the recoding from plane to line" (28) in a unidimensional structure.

For Flusser, the critical turning point – in the course of a long media tectonic still in process – arrives on the realization of "the quantic character" of phenomena: that objects and structures are particulate, and that even first degree imagination itself "[is] computations with punctual elements, a kind of mosaic made up of little pebbles" (30). At this juncture, Flusser turns to what he calls a "new emerging capacity" – or, *second degree imagination* – where "clear and distinct elements, of which rational thought is composed, are being pulled from their linear structure in order to be inserted into other structures" (30). The primary reference for second degree imagination, then, is the substantive codification of the world into "the computation of punctual elements" (30), or, the abstraction of the world's representation into the zero-dimensionality of the digital point. In these terms, too, of zero-dimensionality lies the culture of the immaterial *and* the irrational. Where first degree imagination is of linear and discursive reason, second degree imagination is thereby of irrationalism, whose properties are not of reasoning (namely, "the ability to analyse, to critique, to enumerate, to align, and to calculate" [Flusser {1986} 2015, 27]). Rather, they are of modelling, intention and proposition. Flusser asserts that photography is the first instantiation of this punctual culture, but it is the computational and the digital codes which truly signify this second degree imagination of immaterial, anti-alphabetic zero-dimensional punctuality.

Reiterated and clarified over multiple years and publications, Flusser's framework of mediatized phenomenon and particularly his idea of the prospective second degree imagination is profoundly insightful in considering the implications of spatio-temporal/dimensional shifts through media technologies. Each reiteration in a different space and time diminishes (or adds, depending on which direction one takes) one or more dimensions – the abstraction of time via the knife; depth via painting; breadth via writing and so on. Onto the final reduction to the dimensionality of zero via the pixel or the computational point, a new framework of apprehension or imagination, and, indeed, a new brand of rationality, is needed. Of particular significance is that much of this new framework is to absorb not only the new representations of the digitized world, conceived as punctual quanta, but also its new affordances, actions, consequences and politics. Hence, the second degree imagination of the world is not simply about its discourse or representation. It is also about the imagination of our selves, and what is possible from as well as threatened about them in this turn of abstraction from concrete representation to immaterial culture, particularly in light of relentless digitization and increasingly invasive algorithmic operation. More importantly, contemporary power itself inevitably also channels through immaterial culture. As Cheney-Lippold (2011) writes, such is this control "enacted through a series of guiding, determining, and persuasive mechanisms of power" (16). The forms of power thus become increasingly difficult to discern. No longer, by far, are we deconstructing captive chains from dungeons by way of sociology à la Foucault (1995) or new media such as electronic collars (Deleuze

1992) – as is the organization and orientation of resistance against them. In this sense, too, the digitally tracked self, with its actions abstracted from physical space and time to the zero-dimensionality of the immaterial, thus not only unequivocally requires apprehension through the irrationalism of second degree imagination. It also constitutes its own most dangerous vanguard yet as potential threats to the imaginations and potential of the individual. The next section will explore these ideas.

The Digitally Tracked Self: From the Rational to the Irrational; From the Four Dimensional to Zero-Dimensionality

As several scholars (Lupton 2016a; Neff and Nafus 2016, 15) point out: "we have always been quantified". Self-tracking practices are neither new nor exclusively digital. Neff and Nafus (2016) trace self-tracking to United States president Benjamin Franklin's practices of diarising his activities "for self-examination" in the eighteenth century (15). Lupton (2016a) also notes pre-digital "lifeloggers" who recorded their daily activities in analogue ways: Andy Warhol, for example, in pursuing a "time capsule" project accumulated over six hundred cardboard boxes of objects which crossed his desk from 1974 until his death in 1987. The Japanese artist On Kawara spent decades noting details of all his activities in bound notebook volumes. Lupton (2016a) further notes that "nondigital methods", including pen and paper, are still used by many self-trackers today: "only one fifth of self-trackers said that they used digital technologies for self-tracking health indicators" (29).

What *is* new about self-tracking today is the advent of digital and mobile technologies which render tracking easier and more convenient to conduct. The connectivity of personal devices to the mobile Internet further offers expanded possibilities for users, such as data archiving with cloud computing and sharing on social networks. Cultural shifts such as, among others, biomedicalization (Neff and Nafus 2016) and "dataism" (van Dijck 2014; Ruckenstein and Pantzar 2017), whereby biomedical explanations and the use of data respectively play agentive roles in knowledge formation, have also stimulated the contemporary phenomenon of digital self-tracking. The "quantified self" (QS) movement most visibly manifested this cultural phenomenon. Formulated by two *Wired* magazine editors, Gary Wolf and Kevin Kelly, members of the movement engage in extensive self-tracking practices and active discussion in online fora about their self-tracking projects. They also gather in local "meetup" groups for physical "show-and-tell" talks and discussions of their practices.

The result is that contemporary self-tracking as delivered through multitudes of digital practices effectively abstracts the self. Or, rather, it renders the conduct of action by the three-dimensional body of the self in a particular space and at a particular time into figurations of zero-dimensional data points. This abstraction takes place in one of two ways, though they are not mutually exclusive. The first and more straightforward approach is through active user input. As the digital equivalents of handwritten journaling, a plethora of

mobile apps today enable the recording and tracking of virtually every aspect of life on one's mobile phone. Examples include money spent via the apps YNAB [You Need a Budget]; Mint; Clarity Money; books and articles read (Goodreads); time spent on specific tasks (Toggl); caffeine consumed (Caffeine Tracker); food intake (MyFitnessPal; Calorie Counter), and so forth. There are also apps to record the more ephemeral information of the inner life, such as dreams (Shadow, albeit now defunct) and emotions (CareClinic; Symple). These apps typically require the user to input details of the specific activity into the app, such as the coffee or food choice consumed, the health symptom experienced, or the dream just had. The app would then sort and organize the data for the user's purposes, including performing further functions such as adding up records or visualizing them into graphs or pie charts.

The second way of abstracting self-tracked actions into digital data is through autonomous processes of software or sensors installed on various devices which users wear on their bodies or carry around with them, such as mobile phones. These autonomous processes often synchronize with users' active input. For instance, the YNAB app collates expenditure data not only from the user's active input. When linked, it autonomously links up that data with the user's bank and credit card accounts. Otherwise, independent sensors on smartphones, such as global positioning systems (GPS) and digital compasses, routinely track movements and geolocations. Wearable sensors also appear in specific activity tracking devices, such as Fitbit wristbands or smartwatches, for autonomous data collection and records. In their most basic iterations, these wristbands measure and record a user's fitness activity via distances walked or run, or steps climbed. More advanced versions include functions to track sleep and heart rate. Contemporary versions (as of writing) such as the Fitbit Sense smartwatch, released in September 2020, feature "stress tracking" (via an app which "detects electrodermal activity" [Fitbit, n.d.] as an indication of bodily response to stress) as well as skin temperature sensors, breathing rates, "blood oxygen saturation level" and so on. Moreover, increasing varieties of "smart" objects "beyond the envelope of the individual human body" (Lupton 2016b, 105) also contain autonomous sensors and software to track a multitude of data about the self. As Lupton (2016b) describes:

> Cars can now monitor driving habits and drowsiness, alerting drivers if they are at risk of falling asleep at the wheel. Mattresses can monitor sleep patterns and body temperature; chairs can sense physical movements, and "smart" shoes and clothing can record activity and other physical data.
>
> (105)

In this respect, these growing collections of "smart" objects also co-constitute the Internet of Things, whereby digital objects in human environments connect to and communicate with one another independently of human intervention even as they operate with each other around a human user's actions.

A person's sleeping habits as tracked by a wearable device, for instance, may be incorporated into the software of their home's thermostat to link environmental temperature controls to the user's sleeping times. Or "smart" coffee mugs whose autonomous sensors, having registered liquid volume, temperatures and the number of refills, calculate caffeine intake which then connects to a health tracking app on a mobile phone that alerts the user on their reaching the recommended maximum daily caffeine intake (Lovejoy 2018).

This plenitude of self-tracking technologies and software thus abstracts the digitally tracked self into computational data – they *transmediate* the self from an instantiation in four dimensions into the flattened zero-dimensionality of digital code. The crux of the discussion, though, is not simply in the parsing of the action of the self from the dimensionalities of the physical to the zero-ness of the digital. As Flusser ([1986] 2015) makes clear, every mediation abstracts (or adds) dimensionalities. The model, after all, "is not a pyramid of univocal abstractions, a ladder that we climb step-by-step. On the contrary: as we live and think, we are constantly going up and down through the steps of abstraction" (32). In themselves, the addition/subtraction of the dimensionalities of digital self-tracking to the punctuality of zero-dimensionality are almost incidental; such abstraction occurs with transposition to every media form. Photography and journaling, for instance, similarly abstract actions in three-dimensional space and time into, respectively, the bi- and uni-dimensional forms of photographs and written texts. All media renders a degree of abstraction. The question is: what of it?

To that end, I argue, rather, that the critical discussion of transmediating the self through digital self-tracking lies in terms of the more radical differentiation between Flusser's first and second degree imagination. The discussion on those terms also underscores the significance of *algorithmic* time and space for the self in relation to contemporary digital self-tracking practices. I argue that parsing the first, more straightforward approach to self-tracking – that is, of active user input – renders the process accountable to Flusser's first degree imagination, or that which facilitates linear and rational thought. The abstraction of action even to the zero-dimensionality of digital data points, despite Flusser's attribution of digital punctuality to the second degree imagination, critically remains part of such rational discourse. The logic which connects the action, via its recorded input and across the app interface, to its digital data is entirely linear and discursive. It reflects the action as *rational representations* of information, be those consumed chemicals, sleep patterns, breathing rates and the like. This rationalism of first degree imagination likewise runs through the entire rhetoric of digital self-tracking, such as the headline banner of "self-knowledge through numbers" on the website of the quantified self movement (https://quantifiedself.com/). Such rhetoric and advertisement premise on precisely the linearity of reason of first degree imagination, borne out by a discourse of rationality from numerical accuracy and linear relationships whereby their enumeration *can* (allegedly) lead in direct fashion to knowledge for the self's betterment (Sharon 2017). As

Crawford et al. (2015) show, this rhetoric of the rational power of metrics runs deep, appearing not only in the advertisements and slogans of digital tracking wristbands but also in the promotions of pre-digital tracking devices such as the weighing scale. As they write, at the heart of this rationalism is "a powerful articulation of the belief that the better the data, the better the quality of self-knowledge, and so a 'better human' is created" (489). The key in this thinking about numerators is the expression of linearity – and thereby the coloring of the first degree imagination in such demonstration of technics and rational discourse.

Conversely, where and how digital self-tracking partakes in algorithmic logic via autonomous sensors and software tips the transmediation of the self into the irrationalism of Flusser's second degree imagination. Mediated as computational data that is both punctual (of zero-dimensionality) and immaterial, the digitally tracked self *free-floats* in space and time. It is neither of unique being in its physical instantiation nor fixed on a medium such as film (per cinema) or paper (writing). Rather, it exists in perpetual transition as free-floating, immaterial data points, available for manipulation, visualization, sorting and categorization, not to mention unending amounts of copying, sharing and distributing. Here is where the break with the first degree imagination manifests, for in the disengaged space and time of the digital lies the random relationships, unmapped circulations and irregular networks of digitality. Digital media thus warrants the irrationalism of second degree imagination not so much by the dimensional abstractions of the digital but, rather, these arbitrary and contingent disengagements in digital space and time. The selfie is one prime example in illustrating such irrationalism of the digital in this framework of erratic relationships. On one level, the selfie is a genuine abstraction of the self in linearity – from four to a representation of two dimensions. However, it is the selfie's myriad re-presentability on the terms of its digitality that propels it into a different rationality, whereby the selfie, in that discourse, is not only self-portraiture. Much more importantly, it is also networked subjectivity (Losh 2014); condition of social circulation (Peraica 2017); digital materiality (Risam 2015); digital object in "new biometric technosociality" (Shah 2018), among others. As Flusser points out, the conferment of meaning in the second degree imagination is not representational; it models, intends and proposes. These are the same essences of meaning which colour the specific non-linearity of the digital in its dislodged, free-floating spatio-temporalities.

For the digitally tracked self, this irrationalism signals powerful potential in terms of how the self is and can be personified. In a sense, the free-floating spatio-temporal state of digital data releases the self from its otherwise material conditions of physical grounded-ness in sleeping, eating, drinking, working and so on. As a punctual entity, the digital self is nowhere, yet also capable of being everywhere at once. The self thus *morphs* through tracked data: it sheds its material spatio-temporality to take on a sense of infinite potential, and in the process enables another kind of imagination. An

example of such an alternatively imagined sense of self comes through in Nafus and Sherman's (2014) ethnographic study of QS (quantified self) practitioners, in which they describe self-trackers' relationships with their data in terms of personal mindfulness, idiosyncratic use of data and deep in-situ reflection. Self-tracking, in its immaterial space and time, thus becomes an illumination onto differences or alternatives – Nafus and Sherman (2014) describe this relationship with data as "this ability to see the unseen" (1788) – which in turn inspires lifestyle changes. Compared to being mindless enlargements to the sweeping collections and aggregations of data sets which characterize big data collection, these members instead actively use, note and reflect on their data not only for self-knowledge of minds and bodies, but also imagination of what they could be and the life that could be led. For instance, they describe how one of their main subjects, Michael, tracks his data extensively. However, he does so as "a technology of noticing" (1789) and usually in relation to a forward-looking purpose such as cultivating a particular habit or changing an aspect of his lifestyle.

In turn, the instantiation of the self into the free-floating state of digital data enables relationships and outcomes of indeterminacy and dynamic contingency. In this sense, the digitally tracked self is of a second degree imagination, colored by the spatio-temporality of the future rather than the affixation of the document and the rationalism of documentation. The relationship between self-tracking data and spatio-temporality is thus not just about a different space and time. More specifically, it is about a space of potential and a time of futurity – of all that *could* be – that is linear only in the sense of advancement – about being "better, healthier and happier" – rather than in teleological logic. It is a logic, rather, of an undefined freedom in the imagination of new and renewed selves. The transmediated self through self-tracking thus treads both degrees of imagination in two conceptual schemas: as a transaction of the first degree – in the sense of digital input as having conducted the self into something else. At the same time, it is also a trans-action of the second – in the sense of crossing the space-time-action of the self to its indeterminate and not entirely rational futurity.

However, another logic also comes into play which disrupts this coloration of the second degree imagination – namely, that of the algorithmic. As identified per the second approach to abstracting self-tracking data, autonomously collected digital data enters a web of algorithmic processes which are "a part of the ordering, structuring and sorting of culture" (Beer 2013, 64) – *but of their own logic*. This does not necessarily refer to an alien logic intelligible only as computers chattering amongst themselves; the programming of computational algorithms, after all, is a human intervention. Rather, "logic" here refers to the complex – almost invariably to unfathomable degrees (Pasquale 2015) – processual relationships which exist with the working of any computer code. These engagements manifest in terms of both the technological mediation of computer code – as material artefacts themselves – and their cultural constructions – politics, biases, dynamics, structures and infrastructures – at work in the sorting, ordering and

categorizations of algorithms, all already well argued elsewhere (Fuller 2003; Thrift 2005; Cheney-Lippold 2011). Digital self-tracking practices partake entirely in these dynamics, primarily by way of recorded data entering data networks for algorithms' categorizations, with variables defined by culturally situated and technologically mediated logics.

In turn, the use of those data categorizations, such as in government and business spheres, brings about myriad consequences – some intended, others not – for the user. One example is users becoming marketing targets for insurance companies which link policy pricing to users' fitness data (Chen 2018). Or they might become subject to "hypernudging", where, based on large aggregates of data from self-tracking technologies, "algorithms create personalized online choice architectures that aim to nudge individual users to effectively change their behaviour" (Lanzing 2019, 550). More commonly, user data becomes monetized, such as by way of tie-ups with technology companies. Google's acquisition in 2019 of Fitbit (Goode 2019) is one high-profile example, enabling Google to acquire Fitbit's health and fitness data for its own advertising platforms and business with other companies such as health insurers and other product sellers (Sawh 2019). The digitally tracked self is thus abstracted into the displaced spatio-temporality of the zero-dimensional point situated not only in potential and futurity, but also as an algorithmic subject exposed to wider forces of categorization, assessment, monetization, surveillance and so on. This latter consequence, then, points to a different brand of irrationalism and nature of relationship between the data point (representation) and the self (subject), namely, that of the algorithmic, whose own reasoning and control (of categorization and the consequences thereof) color the discourse of the second degree imagination. The algorithmic (and the accompanying ambitions of technological companies) thus hijacks the modelling of the zero-dimensional, even as work continues on structuring governance for algorithmic control (Saurwein et al. 2015; Danaher 2016; Reddy et al. 2019).

Moreover, yet another vector comes into play in relation to the intentionality of the new imagination in relation to self-tracking. Where recorded media transpose an actant – and the possibilities of their form, existence and being – into different dimensionalities, they also re-define what the actant is, means and becomes. The transposition of the self through self-tracking into algorithmic being is thus more than an issue of control and subjugation. It is also a fundamental change in the nature of a thing, and a change in nature in turn signals a change in what it can be. Flusser ([1985], 2011) does not explicitly express this transformation. His main argument across the "crisis of alphabetic culture" (23) is the arch from the linearity of the first degree imagination to the irrationalism of the second, with each degree of abstraction invariably accompanied by some kind of loss. Certainly a loss of dimensionality, but with that dimensionality as well lies some kind of validity, even aura. As André Bazin ([1949], 2002) observes: "We know that the photographic image of a play only gives it back to us emptied of its psychological reality, a body without a soul" (7). Jonathan Safran Foer (2016) compares the image out of an ultrasound scan of a foetus with the

imaginations of the infant in a parent's mind: "If a doctor looks at a screen and tells you, you will have information. If you find out in the moment of birth, you will have a miracle" (n.p.). Roberto Mangabeira Unger's (1984) central thesis in his book, *Passion*, as a jurisprudential enquiry into law via interrogations of personality (or, more accurately, of persons in society), writes of how it is the solidity of (three-dimensional) bodies – specifically via desire and lust – which give rise to both an individual's sense of selfhood and social relations, out of which arise the normative forces of personality and society. As he writes, we are "bodies that collide and that crave one another" – only as such is conflict, resolution, need, society and law possible. In short, the flattening of the digital self thus also signals something else: a removal from some kind of a critical affiliation to activity, passion and engagement. The loss of dimensionality of space and time is thus also the loss of *a uniqueness in its spatio-temporal matrix* – of the meaning of an individual being in a place and a moment, of being here now. Where abstraction is all part of proto-digital culture – money as an abstraction of value; the photograph as an abstract sign for the object, and so forth (Gere 2008) – the abstraction of the self here in dimensionality and through digitality is more insidious than most: it is also the distance from passion and engagement, and, in turn, from true wishes, freedom and agency.

Conclusion

This chapter has argued for the transmediation of the digitally tracked self from conditions of Newtonian physics into a space and time of zero-dimensionality, or, into a culture of immateriality. In such immateriality, the self occupies new codes to be grasped by another mental capacity, namely, Flusser's second degree imagination. In the irrationalism of that imagination, the self is both liberated and empowered into all its potential and futurity of what it can be and how it may change, as well as subject to new chains of algorithmic logic whose connected networks and database logistics pre-empt and prescribe the future of the self: What will it do (so that it may be anticipated politically)? What will it want (so that it may be advertised to)? What will it desire (so that it may be sold it?).

Finally, the nature of the self also changes in its abstraction: the self as dealt with on a singular basis on different media platforms is still a stable, consistent and unified entity. The self as *transmediated* across different media platforms changes central notions of what it is in its dimensional abstractions. The meanings of these abstractions are still not yet quite clear, but one thing is certain: power and control are surely in media systems as much as they are in the political systems of power and governance about which Deleuze writes. This is probably the most powerful legacy yet of immaterial culture: the irrational logics of its horizons and instability of form with which media can be and is now used express, shape and frame human expressions and actions which, in turn, construct who we are and become. The articulation of the transmedia self is thus only the beginning of studying the latest forms and societies of control.

References

Amoore, Louise and Vohla Piotukh (eds.). 2016. *Algorithmic Life: Calculative Devices in the Age of Big Data*, London; New York: Routledge.

Bazin, André. [1949], 2002. "Death Every Afternoon," trans. Mark A. Cohen, in *Rites of Realism: Essays on Corporeal Cinema*, ed. Ivone Margulies, Durham: Duke University Press, 27–31.

Beer, David, 2013. *Popular Culture and New Media: The Politics of Circulation*, Basingstoke; New York: Palgrave Macmillan.

Chen, Angela. 2018. 'What Happens When Life Insurance Companies Track Fitness Data?' *The Verge*, September 26, https://www.theverge.com/2018/9/26/17905390/john-hancock-life-insurance-fitness-tracker-wearables-science-health

Cheney-Lippold, John. 2011. "A New Algorithmic Identity: Soft Biopolitics and the Modulation of Control," *Theory, Culture and Society*, 28(6), 164–181.

Crawford, Kate, Jessa Lingel and Tero Karppi. 2015. "Our Metrics, Ourselves: A Hundred Years of Self-Tracking from the Weight Scale to the Wrist Wearable Device," *European Journal of Cultural Studies*, 18(4–5), 479–496.

Danaher, J. 2016. 'The Threat of Algocracy: Reality, Resistance and Accommodation,' *Philosophy and Technology*, 29(3), 245–268.

Deleuze, Gilles. 1992. "Postscript on the Societies of Control," *October*, 59, Winter 1992, 3–7.

FitBit. n.d. FitBit User Manuals [online], https://help.fitbit.com/manuals/sense/Content/manuals/html/Activity%20and%20Wellness.htm#:~:text=The%20EDA%20Scan%20app%20on,scan%20or%20a%20guided%20session

Flusser, Vilém. [1985], 2011. *Into the Universe of Technical Images*, trans. Nancy Ann Roth, Minneapolis, MI: University of Minnesota Press.

Flusser, Vilém. [1986], 2015. *Into Immaterial Culture*, trans. Rodrigo Maltez Novaes, metafluxpublishing.com, Metaflux Publishing.

Foer, Jonathan Safran. 2016. "Technology Is Diminishing Us," *The Guardian* [online], December 3, https://www.theguardian.com/books/2016/dec/03/jonathan-safran-foer-technology-diminishing-us

Foucault, Michel. 1995. *Discipline and Punish: The Birth of the Prison*, New York: Vintage Books.

Fuller, Matthew. 2003. *Behind the Blip: Essays on the Culture of Software*, Brooklyn: Autonomedia.

Galic, M., T. Timan and B.-J. Koops. 2017. "Bentham, Deleuze and beyond: An Overview of Surveillance Theories from the Panopticon to Participation," *Philosophy and Technology*, 30(1), 9–37.

Gere, Charlie. 2008. *Digital Culture*, 2nd edition. London: Reaktion.

Goode, Lauren. 2019. "What Google's Fitbit Buy Means for the Future of Wearables," *Wired.com*, February, 11, https://www.wired.com/story/google-fitbit-future-of-wearables/

Kitchin, Rob. 2014. *The Data Revolution: Big Data, Open Data, Data Infrastructures and Their Consequences*. London: Sage.

Lanzing, Marjolein. 2019. "'Strongly Recommended' Revisiting Decisional Privacy to Judge Hypernudging in Self-Tracking Technologies," *Philosophy and Technology*, 32, 549–568.

Losh, Elizabeth. 2014. "Beyond Biometrics: Feminist Media Theory Looks at Selfiecity," *Selfiecity.net*: 3, http://criticaltheoryindex.org/assets/beyondbiometrics.pdf

Lovejoy, Ben. 2018. "Automatically Measure Your Caffeine Intake with Apple's Health App and a Smart Mug," *9to5mac*, October 17, 2018, https://9to5mac.com/2018/10/17/smart-mug/

Lupton, Deborah. 2016a. *The Quantified Self: A Sociology of Self-Tracking*. Cambridge; Malden, MA: Polity Press.

Lupton, Deborah. 2016b. "The Diverse Domains of Quantified Selves: Self-Tracking Modes and Dataveillance," *Economy and Society*, 45(1), 101–122.

Nafus, Dawn and Jamie Sherman. 2014. "This One Does Not Go Up to 11: The Quantified Self Movement as an Alternative Big Data Practice," *International Journal of Communication*, 8, 1784–1794.

Neff, Gina and Dawn Nafus. 2016. *Self-Tracking*, Cambridge, MA: MIT Press.

Pasquale, Frank. 2015. *The Black Box Society: The Secret Algorithms That Control Money and Information*, Cambridge, MA: Harvard University Press.

Peckham, Matt. 2014. "This Gamer Says He Found His Father's Ghost in a Game," *Time*, July 23, https://time.com/3025060/this-gamer-says-he-found-his-fathers-ghost-in-a-game/

Peraica, Ana. 2017. *Culture of the Selfie: Self-Representation in Contemporary Visual Culture*, Amsterdam: Institute of Network Cultures.

Phelan, Peggy. 1993. *Unmarked: The Politics of Performance*. London; New York: Routledge.

Reddy, Elizabeth, Baki Cakici and Andrea Ballestero. 2019. "Beyond Mystery: Putting Algorithmic Accountability in Context," *Big Data and Society*, 6(1), 1–7.

Risam, R. 2015. "Toxic Femininity 4.0". *First Monday*, 20(4). DOI: 10.5210/fm.v20i4.5896

Ruckenstein, Minna and Mika Pantzar. 2017. "Beyond the Quantified Self: Thematic Exploration of a Dataistic Paradigm," *New Media & Society*, 19(3), 401–418.

Saurwein, F., N. Just and M. Latzer. 2015. "Governance of Algorithms: Options and Limitations," *info*, 17(6), 35–49.

Sawh, Michael. 2019. "What Is Google Going to Do with Your Fitbit Data? Anything It Likes." *Wired.com*, November 5, https://www.wired.co.uk/article/google-buying-fitbit-health-data-privacy

Shah, Nishant. 2018. "The Self is as the Selfie Does: Three Propositions for the Selfie in the Digital Turn," in *Photography in India: From Archives to Contemporary Practice*, eds. Aileen Blaney and Chinar Shar, London: Routledge, 175–192.

Sharon, Tamar. 2017. "Self-Tracking for Health and the Quantified Self: Re-Articulating Autonomy, Solidarity, and Authenticity in an Age of Personalized Healthcare," *Philosophy & Technology*, 30, 93–121.

Thrift, Nigel. 2005. *Knowing Capitalism*, London; New York: Sage.

Unger, Roberto Mangabeira. 1984. *Passion: An Essay on Personality*, New York: The Free Press.

van Dijck, J. 2014. 'Datafication, Dataism and Dataveillance: Big Data between Scientific Paradigm and Ideology,' *Surveillance & Society*, 12(2), 197–208.

Filmic References

Linklater, Richard, director. 2001. *Waking Life*. Fox Searchlight Pictures.

PBS Game/Show, "Can Video Games Be a Spiritual Experience?," May 22, 2014, https://www.youtube.com/watch?v=vK91LAiMOio

7 Geotagging the Self
Analysing the Locative Dimension of Constructed Transmedia Identities

Milton Fernando Gonzalez Rodriguez

This chapter focuses on the locative dimension of transmediatised identity. Specifically, it reviews how the notion of space informs the construction of a virtual malleable self, or translocative self. As I will demonstrate, geographical considerations play a central role in the creation and expansion of digital identities and, hence, the blueprint of users of virtual venues. While technological advances have reshaped human communication by offering new possibilities to enhance interaction and connectivity, they have also introduced new strategies to negotiate online self-representation. As it is generally acknowledged, a key aspect of the digital revolution is to de-territorialise and diversify availability, accessibility and diversification of information about individuals. This is mostly due to the fact that online users are producers and brokers of content about themselves. They are all different, have different interests and inhabit different places. As I will argue in this chapter, location is an important component in the creation of a transmediatised self, primarily because it provides a context to the content being posted across many outlets. However, users of online spaces recognise that much of this content is not necessarily accurate and are able to draw a line between what they perceive as a virtual and as a real self. They are aware that data points are units of data, but also strategies to narrate, contextualise and frame self-representation. By using brief comments of users about their first-hand experience with three concrete online platforms (i.e., Instagram, Tinder and TripAdvisor) as qualitative data, this chapter sheds light on the interplay between virtual identities and mediatisation of geographical space. I posit that real-life places operate as transmediatised points of reference as they allow for the configurability, expansion and contextualisation of the content produced and shared by the digital self.

Online settings allow for the creation of configurable identities due to the broad range of unverified data that can be added and be modified at any given time. Digital identities are situationally adaptive, configurable and dependable on the set of qualitative (e.g., self-descriptions) and quantitative (e.g., age) variables entered by each user. Platforms depend on their disposition to create individualised profiles and their compliance to share personal photos, biographical details and sensitive content. A need to offer new levels

of granularity and differentiation according to the expectations and interests of users has resulted in the proliferation of digital venues of all sorts. There are currently applications that, for instance, cater for women interested in motherhood seeking to connect with other soon-to-be parents (e.g., Peanut), for people affected by the same disease seeking out others in the same situation (e.g., Migraine Buddy) or for children with a fascination for a concrete type of toy (e.g., LEGO® Life). Social media websites for admirers of men with a moustache (i.e., Stachepassions), or for those willing to support financially women considering undergoing breast augmentation (i.e., Myfreeimplants) are also examples of digital venues that revolve around the identity, interests and needs of users to exist. More importantly, these sites rely on the visual (e.g., photos) and textual content (i.e., personal preferences) of the profiles of their patrons, and on the active interaction of subscribers. Exchanges of messages, comments and reactions to the content posted and their intensity ultimately define the longevity and continuity of social media platforms. In all instances, partial or accurate information about real-life location is used as a contextual referent for the transmediatised content being shared. An underlying sense of connection, proximity and approachability explains why geographical specificity matters.

Since one of the goals of many applications is to actually facilitate the offline physical interaction of their online users, their subscribers must be willing to disclose their whereabouts. Users realise that disclosing their location entails disclosing additional details about their identities, and that the terms of this disclosure can be negotiated, manipulated and manoeuvred. For example, a photograph of a random cat posted on Instagram suddenly recovers new meaning if the location reveals the picture is taken in an exotic place. The photo of a white T-shirt is interpreted differently if the location indicates the user is shopping in an upscale shop. By the same token, audiences do not react in the same way to an image of an empty old chair tagged as if it was taken in a refugee camp, as opposed to a vintage furniture store. Geographical spaces and ideas about locations add new dimensions to the content posted by social media users, but also about their identities (Gauthier, 2002). Geotagging, the process by which a platform registers and adds geographical metadata about the content being shared online, carries a symbolic value beyond providing information about longitude and latitude coordinates. It ultimately provides the opportunity of mediating, throughout various outlets and in different ways, the spaces occupied by the digital self in the physical world. It furthermore informs how digital selves are to be perceived.

Locating the Digital Self

Although abstract in nature, digital venues are pixelized extensions of physical spaces, equally inflected by sensation, simulation and exhibition (Gauthier, 2002). Besides its physical dimension, space has long been considered as the stage where life unfolds at a cultural, social and symbolic level (Goffman,

1956/1999). In fact, a public 'front stage' and a private 'backstage' are as part of virtual spaces as they are ingrained in daily social interaction (Hogan, 2010). Online venues reproduce similar social constraints as those posed by face-to-face encounters. Location matters across digital platforms as much as it does in real life (Schwartz and Halegoua, 2014). In most cases, the virtual self is constrained to provide particulars that help others to position it somewhere across the digital ecosystem in which it operates. From a cultural viewpoint, geographical position facilitates making inferences about others, particularly because the digital self is an edited version of the user it represents (Mendelson and Papacharissi, 2010). Self-image in digital platforms is a manicured version of an idealised self that is unique, unmistakable and likeable (Chan, Berger and Van Boven, 2012). For many users of online platforms, their digital identities receive more visibility and recognition if they are associated with highly esteemed places, or locations that maximise social rewards. As De Souza e Silva and Frith (2012) point out, the presentation of location, beyond places, is strategic in terms of cultural capital (Bourdieu, 1984), but also as a tool to connect with others. Places are intrinsically linked to the time and circumstances in which events occur and memories are made. Geotagging, literally and figuratively, marks intersection points between all those for whom a specific place has a concrete meaning or serves a purpose. Allowing geodata to be collected and displayed is not simply a matter of positioning the self, but also enacting an identity that aligns with the space in question (Oeldorf-Hirsch and Sundar, 2015).

When users deliberately register instances in location-based social networks, or 'geomoments', their locative decisions speak of a need to claim ownership and situate themselves within spatial hierarchies (Papangelis et al., 2020). Since digital venues increasingly offer opportunities to share content across various media formats and platforms, places emerge as transmediatised points of reference. Parallel to its physical reality, space is expressed through the data exchanged, entered, cross-referenced, edited and retrieved by users of digital platforms. Understanding the meaning of space in virtual terms requires making sense of how territoriality is expressed digitally. To link one's identity to a specific location is a social, rather than a technical, decision. As in the physical world, to a certain degree it is possible to claim and occupy spaces online, and this process requires constant negotiation and revision on behalf of the users (Brewer and Dourish, 2008; Frith, 2012). Metadata are generated for every action registered across the internet in various ways and to various levels of referentiality, and accessibility. Entering geodata involves informing others about the locative dimension of a moment, while contextualising it symbolically and socially. Human understanding of space implies considering how a given element relates to others. Besides relationality, points in space are defined by nearness and betweenness (Gärdenfors, 2014). Presumably, digital identities are informed by notions of proximity that apply to objects in the physical world. Online hierarchies alert about how interconnected the various digital selves are across shared networks

(Papangelis et al., 2020). Space has a categorical function, while it also marks the territory where the negotiation of digital interaction occurs. Users become nodes or points across a particular network, and their shared space epitomises a connection between them. Proximity in spatial terms denotes similarity (Gärdenfors, 2014). In the same way that a concept resembles a set of approximate concepts, contiguity most likely determines how similarly digital identities behave when sharing the same space. More importantly, this means that location is signalled and signals the same for those interacting with each other in a given platform. Ultimately, location is expected to behave and be used as a marker of identity, or a category that contextualises how the self presents itself.

Corpus of Study and Methods

The corpus of study for this chapter consists of 4,071 brief reviews written between January and November 2020 and posted by users of Instagram, Tinder and TripAdvisor on Trustpilot, an independent review platform that allows consumers to share their experience free of external moderation. These three platforms were selected due to the importance that geographical location and individualised content play in the creation of profiles, interaction between users and scope. These are well-positioned user-generated content social media sites, intrinsically interlinked with other media output and formats. Their transmedial value rests on the fact that each platform allows users to express through their digital selves different ways in which they relate to various types of real-world spaces, while expanding on the amount of information available about their personas.

Instagram is a platform where users post visually oriented content that is eventually displayed publicly or to a pre-approved number of followers. Reactions of audiences are expressed in terms of 'like' options (e.g., 'hearts') or comments. Tinder is a geosocial dating media network where users are able to swipe and react to profiles based on one or several photos and limited personal details. Interaction between users is facilitated once two of them have reciprocally reacted positively to each other's profiles. Whereas TripAdvisor is a travel company, it has also become a prominent review platform for users willing to share their experience with concrete businesses in tourism-related contexts. Since the companies and visited locations being discussed are the focus point, the individual character of profiles in TripAdvisor is secondary, compared to Instagram and Tinder. However, TripAdvisor revolves around the relation between users and locations as a starting point. In fact, the level of specificity of the reviews prompts users to reveal particulars about their identity as travellers, personal background, taste and assumptions in an unrestricted environment. Unlike that on Instagram and Tinder, access to the content shared on TripAdvisor is open to everyone.

The set of data, retrieved from the website Trustpilot, sheds light on the aspects of these platforms that subscribers respectively choose to discuss in an open, public and, except for offensive language, unrestricted manner. The

rationale behind the collection of these data sets is to study how users of virtual platforms experience the interplay between space in the physical world and its referentiality across media platforms. Bearing in mind that sharing geographical details entails disclosing specifics that compromise the privacy of the users, location is expected to be a topic of discussion. The reviews are presumed to reveal those aspects first-hand users regard as important, challenging and problematic. For many users, reviews play a crucial point in the assessment of products and services. Even if reviews are overlooked and trivialised as potential qualitative pieces of data, they hold a communicational value.

Trustpilot review site has registered a total of 774 brief comments on Instagram, 756 on Tinder and 2,541 on TripAdvisor. A systematic analysis of these succinct, informal, unstructured and unconstrained types of written text is expected to provide an entry point to the discussion about the transmediatisation of space in the three selected platforms. Methodologically, content analysis is used to identify recurrent patterns in the corpus of reviews. The content of the brief critical appraisals is analysed in terms of the experiences shared by users of the selected geosocial networks. As a method, content analysis has been observed to be particularly relevant in the study of communication and as a suitable tool to work with communication-oriented digital corpuses (Lacy et al., 2015). To secure comparability and completeness, all the reviews available on Trustpilot for each of the platforms in question were analysed, irrespective of the language in question, topicality or length.

Analysis

Information about gender, age or nationality of those leaving comments is not provided, but comments are categorised according to the language in which they are written. Prevalence of Indo-European languages indicates a majority of users of Trustpilot live in Europe and North America. During the collection of the data housed on Trustpilot, it became noticeable that the reviewers are in many cases drawn to share their experiences as means to share cautionary tales and as outlets for their frustration. The only interaction between the reviewers and readers of the comments is the possibility of marking whether the review is useful or not. The reviews are subject to censorship according to a code of conduct that regulates the use of hurtful, derogatory and obscene language but guarantees complete freedom of speech. In this sense, the reviews are presumed to reflect how users of the social media platforms actually feel about the applications. While most of the reviews about TripAdvisor are positive (81%), Instagram and Tinder receive less enthusiastic comments. Respectively, only 29% and 12% of the users rate their experiences with the sites positively.

Understanding how each digital venue operates means realising that each one of them offers different possibilities. The use of location-oriented data across geosocial networks depends on the purpose of each platform and how it is visually framed and contextualised. In terms of geographical position, it

is possible to distinguish between the realisation of a digital self in spaces that are actually designed to convey specifics for logistic purposes and those where location is an additional complementary element. Whereas Instagram displays photos regardless of the physical location of audiences, Tinder considers geodata, in theory, as criteria to select which profiles are shown to each user. In the case of Tinder, reviewers comment on the fact that geographical distance is not consistently used as a criterion. One reviewer observes:

> Location is rigged to get you emailing. ... Surrey has so far been 15,41,239,359 miles from teesside. 😂😂 What a joke. Save your money, go to the pub, and pluck up the courage to actually speak to a woman [sic].

The above-cited reviewer reflects on the constraints of misleading geographical data about others, but also on digital networks as spaces that operate parallel to the physical world. Yet, regardless of its accuracy, content about any given location can be transmitted and transmediatised across the internet, serving in the process as a point of reference for the involved user or creator of content and for the particular place being mentioned. Consequently, for some users, interacting on a virtual platform involves expanding their definition of space as a concept, and understanding the implications of how location is expressed and (re)presented digitally, as per the below example:

> Location and distance is total fiction. Currently chatting to a girl in Taiwan who is apparently 4km away from me. Such a scam!

When addressing location, users vocalise their disappointment, but recognize that location is a malleable, mutable, transitory dimension across digital networks, more so than in offline spaces. Consider the below example:

> 8 annunci su 10 comunicano che la persona interessata si trova a 5 o 8 o 10 km di distanza CONTEMPORANEAMENTE specifica però che vive in una città che in pratica si trova a 300 o 500 km!!! [8 notifications out of 10 state that the one who is interested is CURRENTLY 5 or 8 or 10 kilometres away, specifying though that she/he lives in a city that is actually 300 to 500 kilometres away!!!].
>
> (Own translation from Italian)

Besides the accuracy of location, the gap between virtual and physical settings is another salient topic of discussion. Drawing a parallel between online and offline venues, for instance, the shoe shop mentioned in the following review, is indicative of the importance of geographical space as a reference to navigate and understand the world:

I am a reasonably decent looking middle aged guy, I work out a couple of times a week and am in good shape. I have good quality recent photos, and I took the time to write a hopefully interesting bio. I have swiped right on hundreds of women from my local area which is a medium sized UK city with a population of 750k people in my area. I only swiped right on women who are close to me in terms of age, and apart from the really fat ones I haven't been overly fussy as I am genuinely interested in meeting women with great personality for evenings out. Perhaps I am 'doing it wrong'. But all that I have done is wasted many hours of my time. I even paid for a month of Tinder gold, but all that did was to increase the number of prostitutes. I had three nice dates in the last month, one was a girl I met in the supermarket, another in a shoe shop. Another works at my daughters school. My advice is to ditch the app and go out into the real world and simply talk to women [sic].

Even if this is not the case, it could be argued that the capacity of, for example, the above-mentioned shoe shop to become the venue for a user's geomoment and to be shared across various platforms simultaneously, in various versions, is what underpins the transmedia nature of the digital self in relation to space.

A need, then, for social connection has driven people to create online identities that reflect intimate aspects of their spatial offline reality. By creating a profile, Tinder users invest emotionally and hence react more strongly when the platform does not meet their expectations. Location is crucial for those willing to meet someone in their vicinity. The reviews indicate users transpose the locative elements of their identity to the virtual world. In this sense, their digital self can be understood as a collection of lingering transmediatised geomoments that they expect to express, convey, and above all, transmit an idea of who they are. From their comments, it is possible to infer that many of them understand themselves in terms of the places they inhabit and expect this to be the case in online venues. Clearly, nearness matters and has a categorical value for users of Tinder.

In the case of Instagram, meanwhile, nearness and accuracy of facts do not appear to be weighty, decisive criteria to assess the platform positively or negatively. Based on the reviews, in fact, realistic images or narratives are what users expect the least from Instagram. By extension, the presentation of the self and the spaces it inhabits is expected to be filtered, visually enhanced, seductive and, above all, entertaining. Across the platform, the same location is presented in various formats, altered according to each user's editorial decisions. Filters are expected to be used to change the appearance of mundane locations. Self-representation is pixeled and manipulated to create the desired effect, not to portray the physical world as it is, which explains how configurable and unconstrained geomoments can be.

Instagram can be said to offer the possibility of maximising the potential of curated visuals that build simultaneously on the notions of self and space. In contrast with Tinder, geolocation in Instagram is expected to be interpreted in more symbolic terms than accurate coordinates about someone's position. Whereas Instagram geomoments revolve around articulating attractive, engaging and inspirational values, a Tinder geomoment serves, above all, as an addition to the repertoire of data users present as descriptors about themselves. Purposefulness and set of expectations about specific platforms explain how geodata are deployed to co-create digital identities.

Location is used to situate, contextualise and ornament identities and narratives, but also to establish hierarchised categories. A variety of tunes, textures, shade and hues are applied to produce seductive depictions of the self. Reviewers comment on the sense of futility, briefness and, above all, commercialisation of these images. Self-branding and self-marketability build on the creation of visual content that attracts viewers, followers and potential buyers of products and services advertised on the platform. Content shared on Instagram frequently enters other media outlets precisely because it is produced with the goal of drawing attention. The transmediatised nature of output is primarily a reaction to the monetisation and commodification of virtual identities and their capacity to operate simultaneously in various platforms without overlapping in terms of content, aesthetics, approach, and the like. Many reviewers discuss the commercial dimension of Instagram, but also its allure and growing influence beyond its virtual borders. For many, it is a showcase of aspirational lifestyles, appearances, sceneries, products, services and practices.

Commercialisation is also an aspect many users of TripAdvisor discuss in their reviews. As in the case of Instagram, at the interface of the self-promotion/self-expression and location-related specifics, geomoments emerge as content with a social, cultural and economic capital value in their own right. The site revolves around the idea that travellers comment on their experiences as means to help other potential travellers make the right choices. Third parties can benefit or be affected by the convincing character and number of positive or negative reviews. Since services are most often provided by private companies, there are economic interests at play. One reviewer notes:

> TripAdvisor started as a simple review company. Most people thought that there was some benefit to continue to contribute. We got all these awards and things but they can't be used to help defray costs, improve status anywhere, etc. You are asking us to simply help others. That's fine but you are making money from our reviews. You are owned by Expedia and Viator is another company that you have. Now, when I make a review, I'm asked to book a hotel or something through you. I'm not sure what your value proposition is anymore for someone like me. Can you tell me what it is? Why should I put all my reviews in your bucket so that you make more money and never give me anything?

As with Tinder, TripAdvisor users invest emotionally in the content of the platform. They share their experiences, documented often with photographs and videos, hoping to help others. Their gesture does not go unnoticed, as per the below example:

> I appreciate the reviews that are posted from travellers and customers for honesty that might not be on the website of the place [*sic*].

Transparency, honesty and accuracy are important to those using this application, then. Lack thereof triggers users to assess TripAdvisor negatively, as seen below:

> Another problem is that almost half the locations are wrong, typically it is the home of the owner and not the restaurant that is listed. A quick search on google maps will help you here – but never ever trust TripAdvisor's addresses or directions [*sic*].

Location matters, but also the sense that readers can trust those reviewing the services users are taking into consideration. In stark contrast with Instagram, shared content needs to reflect reality in as detailed a way as possible. The self of the reviewers is not compromised by their decision to write a negative or positive appraisal. Their identity is though tacitly assessed by readers based on the number and quality of reviews. Comments perceived as reliable and trustworthy increase the symbolic value of users' profiles.

While TripAdvisor and Tinder build their guidelines on trust, Instagram focuses on seduction. It appears to be the case that credibility is crucial in experience-oriented platforms where self-promotion doesn't benefit from or is affected by externals, and where there are no gains in beautifying reality. The physical world uses space as a reference, and hence, locations are also editorially manipulated, if needed, as is the case of Instagram. The digital self is locative as it is often positioned geographically, but also realised through identity geosocial markers.

Translocative Self

In varying ways and to varying extents, the creation of a mediatic, relatable virtual identity relies on the notion that the internal (offline) and external (online) self can be mapped, pinned down in terms of figures of longitude and latitude, and revealed through conflictual paradoxes that denote its borders. Sharing one's location in relation to others is partaking in a ritualised negotiation of what spaces denote and how the configurable transmediatised self relates to the landscapes it inhabits or acknowledges as its own. As in real life, across the internet, location conditions action. A network of networks of networks, such as the internet, is in itself a place and its representation of the physical world includes the representation of space. As Kant famously noted

in *Critique of Pure Reason* (1781), it is impossible to represent the absence of space. By default, users of virtual platforms and their actions are registered in terms of the relation between them. Betweenness, nearness and distance are crucial to understand how the self presents itself and is presented in relation to its environment, both in the physical and virtual world. The locative self is constrained by topological and geometrical considerations. In this sense, location is a source of information about the representational dimension of the area occupied by the self, but also its alikeness with those with whom it shares its understanding of space. Nearness and distance predict similarity (Gärdenfors, 2014). The patterns of symbolic negotiation and mutual recognition between users of a given location are expected to resemble precisely because they share a common ground (i.e., a platform). In an editable network, the physical world becomes a point of reference for the construction of transmediatised identities, but does not necessarily contain the original prototypes of whatever is represented virtually.

On the contrary, digital identities rely on symbolic markers to contextualise the accumulated narrative(s) publicly shared by users. Geotagging is facilitated by platforms *because* it strategically frames the input and output posted by the members of the virtual community. Geographical and topological information validates and contextualises information, but only under certain conditions. In all cases, visual representations communicate the complexities of geographical realities (Lois and Hollman, 2013). The internet as a space that mirrors other spaces (e.g., a specific street) allows digital identities to be perceived as mobile and locatable across various media outlets synchronously. Geotagging, and its temporality, is often an editable feature and herein lies the symbolic character of geodata. References and associations users make between spaces and identities expressed virtually are recognized to not necessarily reflect the real world.

The degree of geocentricism of platforms varies greatly. Availability of tools that facilitate sharing information about one's locations have aligned with contemporary lifestyles in terms of speediness, uninterrupted availability, mobility and interconnectivity. Digitalization has allowed cartographical data to become accessible to anyone with a device connected to the internet. Self becomes practical (e.g., sharing one's address), and public (e.g., checking into a location on social networks). Sharing one's whereabouts via text messages (e.g., WhatsApp), providing accurate position information about one's photos (e.g., Facebook) and allowing one's gallery and location to be displayed as part of a grid of potential partners (e.g., Tinder) are examples of a self that has become geographically locatable and virtually relatable. On-hand presence and information about location enhances the credibility, accessibility and legitimacy of individuals' virtual identities. This occurs even if carefully engineered, interactive and distinctively transmediatised identities become recognisable for their sense of futility, briefness and commercialisation. Spaces have become reduced to analogical grids that operate as maps, nodes of information and advertisement boards. Consuming spaces and

identities rely on a sense of approachability and availability. Reflecting on the data gathered, users make a distinction between digitally editable and *real* fixed geographical points. First-hand users acknowledge the transmutable character of digital content, including virtual identities.

Across individual-oriented platforms focused on entertainment, credibility is secondary because it is not crucial. Hence, location has an ornamental function. Space is not registered to convey quantitative, nominal, topological information, but to enhance the iconicity of an image or a moment. In Instagram, for instance, aesthetically appealing filtered and staged images are preferred over mundane, realistic depictions. The same location is presented differently according to the preferences of the owner of the content. In the same manner, profile owners present their associations to their environments following their own agendas. Buying groceries in a nearby supermarket has the potential of becoming a geomoment, as much as jumping from a plane, all depending on how the content is assembled and framed. The multiple levels of meaning attached to places can increase or decrease the social and cultural capital of those related to the locations in question. The goal of focusing the viewer's attention upon geodata is to link ideas about places to the content being posted. After all, external elements are used to strengthen a more relatable, attractive translocative self. Across experience-oriented platforms, such as TripAdvisor, users expect space to be narrated through accurate and trustworthy facts. The locative dimension of the self is relevant only if the self explains, rather than frames its relation to the space being discussed. Similarly, across Tinder, geodata become trivial if they do not convey convincingly users' real locations in real time. Even if all agree that digital identities are constructed, users are expected to be configurable and mobile, but locatable.

Conclusion

In a sense, users of digital platforms become the consumable product of the venues they use while the set of data collected about them, from a locative perspective, has progressively become more precise, traceable, cross-referential, indexical and transmediatised. Location becomes a marker of identity across digital venues because it tacitly prompts ideas, assumptions and attitudes about places. As I have demonstrated, users of online platforms recognise they choose to portray themselves through spatially negotiated representations, and acknowledge others' strategies to do the same. By entering networks dominated by the inescapable presence of space, the self becomes locative as it is understood in terms of its positionality at a symbolic and topological level. Which all works to shape the form that digital identities take under the control that those identities intend to represent. By the same token, the collection of configurable points and categories that digital identities encompass is not defined by the structure, but by external needs. Transmediatised identities ultimately sit around the need of users to

maximise their capacity to interact with others and expand their digital blueprint through various outlets.

In the process of registering specific details about location, an infinite amount of data is generated, signalling the onset of new possibilities. One of these possibilities is the commercialisation of digital personal content and, by extension, the monetisation of geodata. Another possibility is the re-conceptualisation of space as a physical dimension, acknowledging that geographical location is articulated and expressed differently across the transmedia landscape. Hence, users of the same platform experience nearness and distance according to the specific virtual space they occupy. Geodata-oriented sites frame the notions of nearness and distance in terms of the common ground shared by their users. This has an impact on how digital communities project their idiosyncratic qualities. Virtual contiguity and proximity in online spaces predicts similarities in the way transmedia users choose to portray themselves. The nature of each platform defines how digital communities relate to each other, but also the role that geodata play in the mediatisation of identities. Users' digital blueprints are expressed through configurable visual and textual content expected to align with the anticipations of the potential audiences. Connectivity constraints define how users express themselves across networks. Their presence is defined by categories (e.g., gender) and qualities (e.g., appearance) that vary in importance according to the context. Instead of a dimension, space in geosocial networks has simultaneously become a category and a quality that can be harnessed in the negotiation and accumulation of digital self-representational content. The translocative self is the externalisation of, on the one hand, the idea that places are points of emphasis linked to the identities occupying those spaces and, on the other, the emphasis placed on space in the creation of new virtual identities transmedially.

References

Bourdieu, P. (1984). *Distinction: A Social Critique of the Judgement of Taste*. [R. Nice, trans., originally published in 1979]. London: Routledge.

Brewer, J. and Dourish, P. (2008). Storied spaces: Cultural accounts of mobility, technology, and environmental knowing. *International Journal of Human-Computer Studies*, 66 (12): 963–976.

Chan, C., Berger, J., and Van Boven, L. (2012). Identifiable but not identical: Combining social identity and uniqueness motives in choice. *Journal of Consumer Research*, 39: 561–573.

De Souza e Silva, A. and Frith, J. (2012). *Mobile Interfaces in Public Spaces: Locational Privacy, Control, and Urban Sociality*. New York: Routledge.

Frith, J. (2012). *Location-Based Social Networks and Mobility Patterns: An Empirical Examination of How Foursquare Use Affects Where People Go*. Pan American Mobilities Network, Raleigh, NC.

Gärdenfors, P. (2014). *The Geometry of Meaning: Semantics Based on Conceptual Spaces*. Cambridge: MIT Press.

Gauthier, A. (2002). *Le virtuel au quotidien*. Belfort: Circé.
Goffman, E. (1956/1990). *The Presentation of Self in Everyday Life*. [Originally published in 1956]. London: Penguin Books.
Hogan, B. (2010). The presentation of self in the age of social media: Distinguishing performances and exhibitions online. *Bulletin of Science, Technology, & Society*, 30(6): 377–386.
Kant, I. (1781/1999). *Critique of Pure Reason* (The Cambridge Edition of the Works of Immanuel Kant). [P. Guyer and A. Wood, trans., originally published in 1781]. Cambridge: Cambridge University.
Lacy, S., Watson, B. R., Riffe, D., and Lovejoy, J. (2015). Issues and best practices in content analysis. *Journalism & Mass Communication Quarterly*, 92: 791–811.
Lois, C. and Hollman, V. (2013). *Geografía y cultural visual: Los usos de las imágenes en las reflexiones sobre el espacio*. Rosario: Prohistoria.
Mendelson, A. and Papacharissi, Z. (2010). Look at us: Collective narcissism in college student Facebook photo galleries. In: Papacharissi, Z. (ed.) *A Networked Self: Identity, Community and Culture on Social Network Sites*. New York: Routledge, pp. 251–273.
Oeldorf-Hirsch, A. and Sundar, S. S. (2015). Posting, commenting, and tagging: Effects of sharing news stories on Facebook. *Computers in Human Behavior*, 44: 240–249.
Papangelis, K., Chamberlain, A., Lykourentzou, I., Khan, V., Saker, M., Liang, H., Sadien, I., and Cao, T. (2020). Performing the digital self: Understanding location-based social networking, territory, space, and identity in the city. *ACM Transactions on Computer-Human Interaction*, 27: 1–26.
Schwartz, R. and Halegoua, G. R. (2014). The spatial self: Location-based identity performance on social media. *New Media & Society*, 17 (10): 1643–1660.
Trustpilot Site [www.trustpilot.com].

8 Made in My Image
Co-produced Fantasy and the Politics of Play

Chris Campanioni

How have digital media affected our interaction with others: the ways in which we articulate intimacy and desire, and paradoxically, the "freedom" that arrives within the borders of the Internet, in which pleasure is mediated by and materializes within a space, or edge, for the deployment of cruising and wish fulfillment-as-direct-message? What does the tableau of fantasy offer its audience when mediated through technology, pop culture, and the economy of facial recognition?

These questions provide a starting point to investigate the empowerment of "playing" with culture, particularly for marginalized players to re-envision their current landscape, to re-write not only their cultural texts but the cultural norms that have prevented them from accessing different versions of themselves. Any exploration of our everyday performative selves also necessarily probes issues of manufactured intimacy and the subversive potential of play, cooperative encounters that have informed broader shifts in art production while relocating customary modes of presentation. Whereas selfies have altered the genre of self-portraiture, returning to earlier media to re-shape the language of the face and its representation to unseen viewers, our physical bodies have become digital decoys at the service of always-on presence and streaming *real-time*. In looking forward, this chapter also wishes to update thinkers as wide-ranging as Gaston Bachelard, Hannah Arendt, Maurice Merleau-Ponty, and Frantz Fanon, reading a politics of play through a transdisciplinary, cross-generational framework. By calling attention to the generative fictions of individual identity formation as a game that is interactive *and* multiplayer, I want to suggest that a central characteristic of transmedia production is co-presence, wherein trace and transparency operate through a series of veils and reveals.

The Facialization of Fantasy and the Perforation of the Real

"Is celebrity a commodity that can be manufactured through publicity, not by building an audience but by building the perception that one already exists?" (Gamson 1994, 3–4). Joshua Gamson never answers his own

DOI: 10.4324/9781003134015-11

question, posed in the introduction to *Claims to Fame*, his seminal celebrity study published in 1994, before there was such a thing as online influencers, let alone social media. Nonetheless, I believe we can use his inquiry as a starting point in developing not only a trajectory of our own relationship with celebrity – a move from transference to transcendence – but also an analysis of our current culture's fascination with proliferating a persona and a popularity that is largely manufactured, the upshot of the simultaneous tethering and outsourcing of identity, along with social media's invitation, or provocation, of life as a game. Through this study of cultural impersonations and body as bait, we will see how intimacy and distance are each negotiated and played with, expanding the zone of presence while enacting alternative forms of appearance and visibility.

As our starting point, we are literally faced with the figure of celebrity, and through such facial recognition, an emphasis on the emotional, psychological characteristics of a countenance that today is both displaced and multiplied by the transmediated selfie. In an affective economy, it is the consumer – us – who can decide on one fantasy over another, and as Gamson affirms, "the pleasure is in the exchange, in the development of new story lines" (Gamson 1994, 176). Several years before Gamson and the serialized story lines of cable TV, Frantz Fanon also understood the agency borne by surface and consumption, knowing that to be full of yourself was to *return full*: to be more of yourself on account of taking in the other abroad. Indeed, as Fanon affirms in the penultimate line of *Black Skin, White Masks*: "Was my freedom not given to me then in order to build the world of the *You*?" (Fanon 1986, 181).

Celebrity promises a lot, yet its Rolodex of aspirations can be materially measured in the fostering of a community: all of us who watch, and in doing so, watch each other. Gamson calls this collective process the building of one's own "temporarily as-if-authentic text": "The celebrity text, *because* it makes visible and available its own encoding processes, is particularly suited to games of audience meaning creation" (Gamson 1994, 183). Although Gamson was providing the framework for what would eventually be known as celebrity studies, he could not have foreseen our propensity, today, to subvert distinctions between reality and performance, a collapse that has unsettled and expanded frameworks of representation in a culture very much generated by screen-play and transmedia interactions. He could not have foreseen that what's real *is* the performance, the user-celebrity that is not only a figure but a form of celebration.

Dreams reveal realities but sometimes realities can reveal certain dreams. I wish to move celebrity studies beyond their star-spectator dialectic to better understand the effects of their wholesale convergence, a performative turn brought by the disintegration of master narratives within poststructuralism, and postmodernism's invitation for reclaiming and reflexivity. In asking what performance and performativity contribute to the act and study of personal narrative, and exploring what we can learn about personal narrative in no

other way than through performance, Kristin M. Langellier (1999) distinguishes between the *narrative event* – the event in which stories are told – and *narrated event* – the events recounted. I wish to take this division, not as narrative framework's built-in fracture but, on the contrary, as an invitation for slippage. Once again, reading performance and personal narrative through audience reception theory informs not only how we show ourselves to others but how we see ourselves in the act of showing and sharing: a heightened self-consciousness that moves us beyond reflection and toward reflexivity, beyond individual experience and toward group practice. "Transmedia mobilization" (Costanza-Chock 2014) fosters greater accessibility – for users, for producers – while connecting content to larger organizational movements. Such strategies of dispersing media across multiple platforms and in alternative formats turn personal narratives into public projects.

The fundamental tension that had sustained celebrity since its inception – the "tension between the possibility and impossibility of knowing the authentic individual" (Marshall 1997, 90) – has today been resolved through its makeover in our everyday performances, in which the border between the private self and the public self has broken down and been clarified as an *authentic artificiality*, a phenomenon that could arise only in a culture of produsage and transmedia, the repetition and re-staging of content – and identity – across manifold media. In this rotating scenario, audience members are capable of rewriting the texts from which they situate themselves, signifying a relative autonomy that actual celebrities of the past never possessed. When Paul Virilio predicted, in *The Aesthetics of Disappearance*, that "[the] star will no longer be the luminous specter of the landscape, the leading lady of the scene from now on will be the mass of spectators" (Virilio 2009, 67–68), he was not so much forming a theory about new cinema as much as he was prophesying a novel way of viewing it. The move from voyeurism to active participation and the pull of being projected onto the image one has been held by or beholden to parallels today's meeting place: a point of interest in which celebrity melts into its audience.

HBO's *Westworld* (2016–present), which takes place in a technologically advanced Wild West–themed amusement park populated by android hosts, revolves on this premise. Westworld caters to guests who may indulge in their most deep-seated fantasies within the park, without fear of retaliation from the hosts or real-world consequences. In "Trompe-l'œil" the perspective begins to alter: one guest, after a season-long flirtation with an android, finally consummates the emotional romance that leads to the physical act. As William finally submits to his desires in a world of pretend, he realizes that he's only been pretending his whole life.

"Pretending I don't mind; pretending I belong," he tells Dolores, as the two travel by train through the outer limits of the simulated landscape, a territory tellingly called Ghost Nation.

My life's built on it. But then I came here and I get a glimpse for a second … of a life in which I don't have to pretend … a life in which I can be truly alive. How can I go back to pretending when I know what this feels like?

This central paradox provoked by the client's question invites us, the viewers, to re-consider a fundamental question amidst our own spectatorial tendencies – what's more authentic: faking it in the real world or being yourself in a world that is a total simulation?

William doesn't go so far as to ask the question; in reality, he needs first to go further into the fantasy. Thus, he embraces Dolores the way he probably learned by watching, stripping off her clothes and making rough love to the robot as if this were an actual movie, maybe a Western. The next morning, after an awkward greeting in the train car, Dolores acknowledges the inevitability of the real world, even if she can only guess at what it might entail; even if she can only imagine what the real world could be if not this. "I know," she says, "you have someone waiting for you at home." "Oh," William murmurs. "That feels so unreal now."

But even unreality, as we well know, can lead to a higher truth. In the imagination and performance, and the politics of play, we are given and give back: the bare self awaiting to be (ad)dressed. "I used to think this place was all about pandering to your baser instincts," William adds, finally, signaling his own shift in self-recognition. "Now I understand … it doesn't cater to your lowest self; it reveals your deepest self. It shows you who you really are."

Although the episode is titled "Trompe-l'œil," it is less about the veiling of reality than its gradual opening, a rift in our perceptual design. Likewise, the cyborg hosts that populate Westworld, and their frequency of being delivered to us not only nude, but also stripped of their surfaces – revealing muscles, glands, veins, and the metallic sheen of machine-membrane – throw into relief our own suspension of logic of what cannot actually be seen by our *naked* eyes – in other words, what can only be imagined. The body looking exists beside the body being looked at as in any other scene of voyeurism, except in Westworld, another dimension is added: the body which exists outside the gaze; that is to say, the body which can't otherwise be captured within the frame of film or our cultural frame: the hidden flash or face of flesh, so real it seems to rip apart our pre-fab fabric of reality.

The Social and Political Agency of Play and the Shifting of Glam(our)

Our inclination to re-make others in our gaze is matched only by our habitual need to also be *made*, to be looked at and formed in one's image, a profound narcissism that might have its roots in Genesis but reaches outward, into the stage of everyday life and its locus as a site of performativity and mutable identity: "not to see in the outside, as the others see it, the contour of a body one inhabits," Maurice Merleau-Ponty writes,

> but especially to be seen by the outside, to exist within it, to emigrate into it, to be seduced, captivated, alienated by the phantom, so that the seer and the visible *reciprocate one another and we no longer know which sees and which is seen.*
>
> <div align="right">(Merleau-Ponty 1968, 139; emphasis mine)</div>

We only ever see everyone else through our own eyes: duplication, reproduction, double vision. In view of that, we hardly see ourselves.

Likeness doesn't pretend to be replication, the way that the presence of phantom viewers traverses our sense of self, reflecting us from another angle, reframing us as a composite picture: Fanon's form for a brave *you* world. Virtual reality's insistence upon an alterity of seeing in a world-that-is-other, what I have elsewhere described as the decentered subjectification of entering an image as an image enters you (Campanioni 2019) is radically contested here by an alterity that relies not on sutured self-interaction but upon the striations born between appearance and disappearance, and the play of disseminating one's self through any space – to be received, taken in and re-touched. Isn't it better, or more real, when we can acknowledge the fact of the fabrication? The power of the performance doesn't diminish; on the contrary, the payoff is more powerful the moment the magician shows us it's not actually magic, which implies, of course, that the opposite is also true. That fantasy and reality can overlap means the organization of another scenario: reality can become as extraordinary as dreams.

When we arrive at this moment, something lucent leaks out: the performance, and the processes by which the performance is being enacted. We have already watched as the old constellation of stars receded into the transparency of the present, becoming merely a specter of absorption, as Virilio long ago recognized, proposed to the gaze of the spectator. And this is because the most interesting subject in every photograph is the one both inside and outside the frame. It is once again the language of the face, which, paradoxically, offers the self a way out of a static, individuated, and fixed identity. As Lyle Ashton Harris explains in his essay, "Revenge of a Snow Queen":

> Self-portraiture allowed me a way to claim a metaphoric space for myself. From the beginning I had an interest in visually exploring racial and sexual ambiguity. Through autobiography I explored the many facets of my identity: my pleasure, fears, inhibitions and desires. This metaphorical space allowed me to unveil different identities. I could choose how I wanted to be seen. Through play, I could visually address my vulnerability, and the frustration that I experienced.
>
> <div align="right">(Harris 1991, 10)</div>

But what is a game, or rather: what do games do, how do they perform for us? Games create pattern recognition, muscle memory, the expectations of a payoff – not just desire but our responses to it: habits, which in turn

habituate us to certain stimuli. It is no coincidence that the guests of Westworld can attain a greater *sense of self* only by immersing themselves in a game, and a game, moreover, which is driven by the indistinguishability between bodies: "real" or "fake," in the series' narrative as in our contemporary digital relations, are revealed to be not opposites but mutually constitutive.

In a world of infinite reproduction and infinite reproducibility, the neoliberal extension of the market to all domains of experience, the commodity that remains most attractive (and most scarce) is not pleasure, but presence. But how to reproduce presence when souls remain tethered to bodies? The trick is not to reproduce presence but to manufacture absence. Out of the 27 English translations of Genesis 1:31 open on my browser, only one (the Amplified Bible) mentions the creator's strategy of self-endorsement – "*and he validated it completely*" – as if what was produced first had to be looked at, instead of the other way around, that looking itself was an act of validation, but also the scene of nativity, that I am only here if you happen to still be looking. The volume of this body has a sound, too, as it recasts its geometry to an image constructed by others. We could say in this economy of appearances that capitalism doesn't just sell presence but omnipresence, the relentless desire – no, requirement – of being everywhere all at once. We could say that our phones and our bodies have switched places; that our phones are no longer accessories or attachments; that our bodies are in fact the inert receptacles feigning presence in public. Managing one's own absenteeism is an arduous task. We already know we each have data doubles; what's perhaps less rehearsed is the fact that we each have body doubles, or rather, that our bodies perform as decoys, presenting us *in person* so that we might escape elsewhere.

Elsewhere – always elsewhere – we might track the manipulation or disappearing of genre (erstwhile "outlaw" modes – such as speculative autobiography, or the cross-genre, critical/creative, and hybrid text – are now commonplace), alongside a marker of "identity" that is today more about presentation (mutable) than content (fixed). We know that outside of the mainstream publishing industry, genre as a determining marker has become increasingly irrelevant, whereas *format* – filetypes, markup tags, mediums – informs how a single text can be presented, re-packaged, and disseminated in several different configurations, so many of which alter the outcome, which is to say, the experience of consumption *as* production. Today there is no separation between the production and the self produced; activity and identity meet at the margins of a text whose only necessary condition is dispersal: iteration and interaction. Under the (de)sign of transmedia, the self, too, becomes portable and also porous, readable as an integrated and episodic series of appearances, *subject to use* by so many others: copyright as the right to copy and be copied, to resignify one's self in alternative dimensions.

It is this pleasure – specifically, the pleasure of play – that imbues these cultural norms of impersonation and manufactured presence with

possibilities of real subversion, real contact and engagement. "Deep play," Clifford Geertz writes,

> renders ordinary, everyday experience comprehensible by presenting it in terms of acts and objects which have had their practical consequences removed and been reduced (or, if you prefer, raised) to the level of sheer appearances, where their meaning can be more powerfully articulated and more exactly perceived.
>
> (Geertz 1973, 448)

Indeed, play is a cornerstone of intellectual rigor and creative pursuit, an "intermediate area of experience" (Winnicott 2018, 10) first learned as infants, the integrating of the past, present, and future that signals an initiation of the relationship between us and the world: our inner life and our shared, external reality. Closer attention to play necessitates that we re-read social media, not merely as an arena for selfies, catfishing, metric-manipulation, and the proliferation of fake followers, but as the open source from which to embody an identity assembled by the staging of transparency. It is precisely because "the *personal* in personal narrative implies a performative struggle for agency rather than the expressive act of a pre-existing, autonomous, fixed, unified, or stable self which serves as the origin or accomplishment of experience" (Langellier 1999, 129) that personal narrative performance is so integral to those communities left out of discourse, becoming not just a response to one's static and solitary experience but an emergent "re-storying" and a site of negotiation and contestation.

In "Untitled in the Rage (Nibiru Cataclysm)," Juliana Huxtable depicts herself as a deracialized cyborg princess, flesh filtered through a jungle-inflected lush green hue, body bent down and nude, kneeling with her legs folded underneath her ass, her head turned away from the lone pale object in the background – the moon – full red lips lit up in profile: a fluid identity that, as the artist has said, can be articulated only through integrating portraiture with writing. "My adulthood was liberated by social media," explains Huxtable, who is transgender and queer.

> It became as integral to my sense of self and psychosocial reality as my flesh. At this point, I feel like I am always living as a hybrid of my online presence and my IRL presence. I used to feel a bit powerless, and it was actually through playing with my body as an image file that could be manipulated, distorted, rendered, decorated, and placed in new contexts that I came to accept and feel at home in my body as it is currently, but also to imagine how it might move into the future.
>
> (Huxtable 2018)

The encounter with celebrity, as in today's interactions across social media, involves the recognition of social life's inherently artificial nature. It's not that

we believe the lie; it's that we believe the act of lying. Perhaps more revealingly, the systemic process of "faking it till you make it" makes room for other processes to come to light: self-recognition, in Huxtable's experience, or even the potential for a mediated intimacy. Intimacy, of course, has always been tied to the spatial manipulations of technology, and before the Internet, the task of manufacturing stars and bringing them closer to us fell to the camera. The close-up, a film technique popularized by D.W. Griffith at the end of the silent era, marked the studio as somehow more real for its *lack of authenticity*; a verisimilitude the set has which the stage can never pretend to portray. As Griffith himself observed:

> When you saw only the small full-length figures it was necessary to have exaggerated acting, what might be called 'physical' acting, the waving of the hand, and so on. The close-up enabled us to reach real acting, restraint, *acting that is a duplicate of real life.*
> (Welsh 1914, 49; emphasis mine)

To fill the gap between fantasy and reality, one would have to allow the fantasy to reproduce itself. The repetition of fantasy is its only rule in a fantasy ruled by pleasure. It is these moments, when faces are fixed in close-up, that viewers are allowed the privileged vantage point of seeing something not visible for those persons onscreen: "separated out from the action and interaction of a scene," as Richard Dyer tells us, the close-up presents the "intimate, transparent window to the soul" (Dyer 1986, 10). Fantasy and reality merge, like a cut in celluloid that lets the fiction leak out, and this is because, as Dyer explains on the first page of his *Heavenly Bodies*: "The *processes* of manufacturing an appearance are often thought to be more real than the appearance itself" (Dyer 1986, 1; emphasis mine). It is, again and again, only through an enriched focus on the practice and process of play, a meta-textual awareness of its makeup, that the performance can move outside the stage or screen of its own limitations. Moreover, I wish to suggest that this modal attentiveness contributes to the co-production or crowdsourcing of celebrity and co-presence. As processes are made transparent, they are meant to be learned and repeated. Likewise, memes, deepfakes, sex bots, and direct messages-as-intimate-encounters are not merely cultural narratives, but virtual constructions *designed* to concretize in often unintended ways. Post Internet axiom: it is not reality that creates the Internet but the Internet that creates reality. In this Möbius strip, what unfolds is not the reverse of reality but its continuous permutation. I used to think of such moments as *generative fictions*. But aren't all fictions generated and generative? – to the extent that they bring us closer to the truth, even if what's true is the presence of surface, when surfaces no longer conceal but permit. A related question: in the realm of art: Aren't all originals copies? – duplicates of the things they intend to represent as authentic representations.

Just as celebrity fosters an interactive community, the filmic technique of the close-up – or our own reversible camera self-portraits – inspires spectators to re-embody the muscular images fleshed out and tightly framed. We can locate a transferred and transferable agency between star and spectator, the body being looked at and the body looking, by pausing to appreciate how the close-up arrests its subject in a tight space while also making them able to move, to transcend the frame and become available to viewers. Michelle Ann Stephens, in her analysis of the *Skin Acts* of Paul Robeson and their mediation through the new technologies of the twentieth century, links film's motive function to a gesture like a brushstroke. "Rather than distancing the viewer from the actor as a pure, reified image-object, the close-up can bring the bodylines of the actor and the viewer in closer relationship to each other" (Stephens 2014, 89). This tactile technique, Stephens writes, forms the convergence between the body of the film and the body on film, but also, I argue, the bodies *outside* the film: subjects and objects linked through the likeness of the star re-presented on screen. This lure, or lore, provokes the viewer into an experience of materiality that is both imitative and self-reflexive, an exercise in which audience members simulate the framed subjects by leaning forward, or through moving in their seats in relation with the movement of the camera as it pans: an endeavoring toward the whirl (of the reel) made flesh.

Rather than solely serve emotive qualities, the close-up has also been used to suspend the face, along with the viewer's experience of the flesh's duration as a measure of time – a momentary implosion in which all perception seems to disappear, somewhere between image and after-image, whatever lingers and remains lodged in our pre-verbal consciousness to seep out moments or years later, a hovering that must necessarily remain virtual: neither *here* nor *there*. In a production not unlike our own fugitive and ephemeral social media "stories," Andy Warhol's three-minute screen tests purported to show everyday people as a continuous stream of faces, each framed in close-up: fleshy spasms blurred against a barren background. What better branding device exists in an affective economy than the emotion of expectation? Viewers wait for something to happen – lips to move, a pair of eyes to blink, or even the murmuring of words. In this way, subjects and spectators have already switched places; really, we occupy the same space, straddling the clickbait boundary of becoming-something-else. The faces on screen stare, star-stuck in moments of their own recurrence, looking at people who have not yet arrived (others on set) or who will never arrive (the audience). The audience stares in expectation of something other than the repetition of a face. No one in this game ever exchanges glances, yet everyone continues to wait. No one in this game ever exchanges glances – and here is where the role of the voyeur and its relationship to intimacy and incessant deferrals converge – yet everyone continues to wait.

We already know that digital self-presentation in the form of selfies has allowed users a reclamation of subjectivity within the fraught territory of belonging and visibility, the negotiation of racial, ethnic, and gender

ambiguity through play, and the seesaw of concealment and exposure. By integrating portraiture with writing, and with close attention to the affective and psychological utility of the cinematic close-up, contemporary users have also reconfigured the larger genre of self-portraiture, turning the Early Renaissance art form into equal parts process piece and the work proper.

Not unlike classical self-portraits, today's selfies can be identified through distinct taxonomies, each of which shares the same characteristic of transparency: the double relation of subject and object, compositional ingredients that can be understood as source code. Whereas the technology (the brush) and the material, alongside the act itself (the brushstroke) are typically effaced in the self-portrait, these components become, in the self-staged photograph, predominant. One pictures the photographic device at another's disposal; the outstretched arm, the unintended focal point in every reversible camera portrait, the lunging flesh that breaks, and thus transforms, the continuity of the shot (a skittish mobility magnified in every live photo). By embedding both process and material into its production, the selfie demonstrates how it is made (the angle, the lighting) and also what makes it; the displacement caused by mediation is resolved, or intensified, by incorporating the event of narrative into the narrative event. All self-portraits assume the spectral presence of a mirror, but selfies are portraits of cameras as much as they are portraits of the persons holding the technology, a disclosure that poses as an invitation for audiences to remake the tableau on their terms, or to respond by inserting themselves into the interior of the subject-object, an imaginative trespass that participates in the public grafting of a private scene.

The staging of privacy and framing of a body, or face, is precisely what turns "presence into promise and a haunting" (Cheng 2011, 31). Anne Anlin Cheng suggests that skin is never as full-frontal as the figure of the nude body would pretend to suggest: "Skin is, after all, by nature a medium of transition and doubleness: it is at once surface and yet integrally attached to what it covers. It also serves as a vibrant interface between the hidden and the visually available" (Cheng 2011, 28). In this hybrid in-between space that rubs up against both self-exposure and self-containment – even and especially the relatively curtailed dimensions of an otherwise *square* Instagram post – the performance of re-presentation can begin to unfold. Just as the new materials of modernity – plastic, nylon, celluloid – had given us fantasies of embodying a continuous and glossy surface, what Cheng calls a "new discourse of auratic plasticity ... the mutual longings and fantasies of impenetrable skin" (Cheng 2011, 115), our technological innovations in a Post-Internet dreamscape – namely, our sleek touch-screen silhouettes – have allowed us not only the desire for but the dynamic consummation of simultaneous self-transformations, a constantly assorting assemblage-of-self forged in the interplay between what we show, how we see, and what remains to be seen. It is this last consideration, the charged speculative and hypostasized what-if outside the frame, that moves manufactured intimacy from a site of transfer (the exchange of text, a photo sent, the slow delay of expectation: a video still buffering) to a space of transcendence.

Cheng, though, in applying turn-of-the-century standards to today's celebrated tastes in her tracings of the behaviors behind the aesthetics of the technologically re-presented body, couldn't disagree more, arguing that we "no longer share the ideal of plasticity or shine rooted in early century material nova" because our capacity for experiencing glamour has been curtailed through the artifice of everyday emulation. Relating her own nostalgia for glamour, Cheng claims that is has today "faded from our lives":

> The beckoning emptiness of the modern age, what Thomas Hardy called "the ache of modernism," has slipped into normative loss and daily emptiness. Indeed, we have come to see the virtue of a life without aura: we call it democracy.
> (Cheng 2011, 117–119)

I would argue, as I already have shown, that it is precisely because today's celebrity is no longer unattainable – and in Cheng's words, no longer glamorous, but "normative" and empty – that marginalized and non-normative persons have been empowered to fill the void and replace those "vanished" bodies with their own, from a lens that they can control. It is not – I repeat – that ours is a culture that is incapable of experiencing glamour, but that, in the course of the Internet's flattening of time and space, the terms of glamour, like so much else, have radically shifted – a reorientation prompted by the convergence of previously demarcated media, genres, and cultures. And although Cheng argues that the exciting and often illusory attractiveness of metallic sheen – that which beautifies a subject but also prevents us from seeing it clearly – might no longer be in vogue, I believe that we are presented with it every day, in the habitual re-formation of our Facetuned and Photoshopped selfies, and in the ways in which the positions of that binary – between seeing and concealing – are no longer at odds with each other but actually working in tandem to produce an intimacy and a self-determination that both resists and relies on the act of transparency.[1]

And yet – the pause, the delay, the pleasure of postponement in which an avatar becomes a face and a face becomes a person, and a person becomes an object of enjoyment once again: the fulfillment of a circular narrative, a spectacular and specular display of movement which repeats: a gift or GIF. Cheng insists: "[i]n the fetishizing of surface, an implosion occurs within the structure itself" (Cheng 2011, 36). What leaks out but a new way of seeing in a world mediated through screens? And it is this new way of seeing that suggests, also, a new way of recovering self-sovereignty, not through trying to recover a fractured or fragmentary self but by rejoicing in the inherent pleasures and power of fragmentation.

Today it becomes necessary to update Thomas Mathiesen's (1997) own revisitation of Foucault's (1975) panopticon to better understand social media as reversible surveillant assemblage: an interpenetrating space for watching and being watched, in which power structures of surveillance are

equally porous as they are pervasive, crowd-sourced and curatorial, post-dated and performatively live. It is this last marker that perhaps best illuminates the agential effects of transmedia for all of those absent viewers – akin to what Langellier, in considering the inherent open-sourcing of personal narrative performance, has referred to as "ghostly audiences" (Langellier 1999, 127) – the ways in which mobile technology has facilitated the contestation and reshaping of borders through an invitation toward entering virtual experience as *real-time*. Isn't it true that surveillance today is no longer panoptic (Foucault) or synoptic (Mathiesen) but a gaze that is at once entangled, fluid, contradictory, and capable of being deployed in potentially subversive ways by its own subject-objects of attention?

The Virtual Consummation of Real Intimacy

Gaston Bachelard's *Poetics of Space* offers us not only a phenomenology of the imagination and the interior, but a phenomenology of the immense; a phenomenology, as he observed, without phenomena. Under this formula, images are not meant to be visible but viable, in the sense that images are meant to be lived. Although Bachelard, in 1958, could only have imagined the geometry of a World Wide Web – another Westworld, at once desert and excess – his description of the fictitious home as "both cell and world" – a space through which we "live in … alternate security and adventure" (Bachelard 1994, 51), is useful in considering how our habits of self-presentation are mediated through a similar resolution of security and boundlessness. The image, paradoxically, is *always* more than meets the eye, and this is because images force their viewers into encountering, not the subjects contained in the photos, but themselves.

Nowhere is an analysis of the mimetic close-up and the emulative selfie more pertinent than the waystation of catfishing and direct-message-as-digital intimacy. In a world of deepfakes and metrics manipulation and fake content and catfishing, what's real except the continuous deferral of reality? And to defer means to put off and also to give way to something that one can no longer resist, understanding that submitting to one's desires can also mean postponing them, re/placing them so as to hold each – off, in, or up. Isn't it possible that we would like to be both visible and hidden? Private and public? Vulnerable and guarded? Self-composed and gaga? Above all to be seen without being known or known without being seen or each of them simultaneously, despite or maybe exactly because one so often obviates the other. To see redirects a radical intuition. To know means to close one's eyes to finally apprehend what's behind the image. What's underneath it. What's inside or at the very bottom. Writing of the "plurality of copies" within the photographic activity of postmodernism in 1980, Douglas Crimp describes the presence that is no longer just presence but "a kind of increment to being there, a ghostly aspect of presence that is its excess, its supplement" (Crimp 1980, 92). It is exactly this haunting that I wish to apply in redirecting our

attention to the relationship, forty years later, between the *reproduction* and the *original*, distinctive markers of art which are no longer opposites under the rubric of transmedia, but in fact reversible.

In the 2020s, we call up images: literally raise them – from the dead, or depths of storage – to visibility, so as to rise to visibility ourselves. It is not just the images but us who become thrust into the light of countable data. We, too, are seen; we, too, become engrained in the archiving process of the objects we seek out and reclaim: an action measured by our own use-value, our own user action. In this way, we are present even when we absent ourselves, shown to unseen spectators: all those who encounter our online behaviors, our own big reveal as the ordinary revenant of image acquisition.

We can understand this alchemical operation better by looking at our own habits, domestic rituals that, not unlike the possibilities fostered by the Internet, place us in a position to traverse or transgress the space of our habitations, if not also our inhibitions. Yet to do so we would need to re-read our economy of images, no longer as a society of spectacle, but as the hieroglyphics of labor, a co-produced, voluntary labor on behalf of social media, which asks only that we produce, and through which we ask only to find ourselves in the production. Rainer Maria Rilke's nostalgia for work, as evidenced through his correspondence with Magda von Hattingberg, briefly referenced in Bachelard's *The Poetics of Space*, is harnessed by his own furniture, a moment where object converges with labor, where the fetish of the object brushes up against the labor of the subject who's meant to maintain it. Rilke's nostalgia for work, which is a nostalgia for childhood, presents itself only because of absence, the cue for a role replacement and gender reversal, a trans-substantiation of flesh: Rilke becoming his cleaning woman. But it's not just absence that allows Rilke to move beyond time and his own spatial corporeality; it's the presence of his own belongings, and the stimulation of the act of polishing, a phatic communion with one's self through the haptic and haphazard gesture of rubbing, and of feeling with one's own hands what one has been familiarized with and yet long neglected.

In this repetitive and rhythmic milking, one finds one's self through generosity and gratitude, the mechanical purring of surface, the melting of surface with skin. Is this not the Internet of our customary and customized dwelling? *Dwell*, from Old English *dwellan*: to go astray, hinder; from Old High German *twellen*, meaning to tarry; not necessarily a place from which to remain but a temporary relief toward unlimited exits – the freedom, and pleasure, of *cutting out*. Repositioned across an Internet that provides the comfort of house and the benediction of hospitality – the *homepage*, the *favorite places*, the accumulating history of repetitive sojourns – and sates our desires of being detoured, displaced, and maybe even deterred. In these aesthetics of edging, nothing is more primal than the 404 error: you come somewhere without getting what you wanted. This necessitates only further movements, seeking out as a behavioral state of impermanence. "It is better to live," Bachelard knew well, "in a state of impermanence that in one of

finality" (Bachelard 1994, 61). What I always want, I remember writing once, is neither conviction nor consumption but a flickering awareness: the intensification of an experience that is imminent.

Frances Stark's 2018 animated video, *My Best Thing*, stars two computer-generated avatars asking each other questions, a virtual re-visitation of the relationships the transmedia artist had formed with two Italian men she met during her excursions in video sex chat rooms. "I got fascinated by feeling so intensely for people I didn't know," Stark explains:

> One of the things that made the intimacy possible was the fact that there was *no interest or expectation in gauging the "realness" of knowing each other*. There was no real need to ever think about what might happen in real life.
>
> (Stark 2018; emphasis mine)

The pleasure, as in the celebrity-audience dialectic, becomes reified in the exchange itself. Recall the charged tension – the stimulus provided by the possibility and impossibility of knowing the authentic individual. The slow unveiling – like any striptease – is not about the end itself (the body) but about the process or technique (the body being stripped of surface): both a resemblance to truth and a freedom from truth. Isn't it true, after all, that all intimacy hides from view? In this sense, as Hannah Arendt has argued, moving intimacy into the public realm would not only diminish it but invalidate it. Intimacy, indeed, *requires* privacy, for its power lies in the fact that it "must remain hidden if it is not to lose its depth in a very real, non-subjective sense" (Arendt 1958, 71). The consensual encounter probed by *My Best Thing* – the interactions between persons in a video sex chat room – requires the same undisclosed or undiscoverable substance, an absence or deliberate curtailing of consumption in place of anticipation: the expectation only that one will keep playing.

What we are encountering here is not intimacy with another person but an intimacy with one's self, the freedom *to play* with another person while ultimately satisfying – and recognizing – one's own bodily and psychological desires. If it's true, as Crimp asserts, that it is "only in the absence of the original that representation may take place" (Crimp 1980, 98), then today we may also employ the logic of deferral toward the emplotment of self, if only to demonstrate how the fulfillment of intimacy and identity, too, depends upon the cracks in the frame of its embrace. That slippage – between narrative event and narrated event, the experience and the story; between "fact" and "fiction" and their mediation – links not only a performance's dislocative charge, but also its potential to be rearranged and radically recontextualized by audience members, or the users across the screen. As Lucy Bennett (2012) has shown, individual user behavior during mediated performances is transformed into a collective experience, despite or maybe exactly *because* of the crowd's geographic dispersion. This spatial divide is both

mended and heightened during any digital encounter – mended, as Bennett has already discussed, heightened, as I argue, because the collective experience of individuals relies on the pleasure of anticipation, and the anticipation carried by the desire of distance, the distance of desire.

The question, then, becomes not one of motive but method, informing a framework filtered through an "operational aesthetic" (Harris 1973, 79) – the pleasure of process, of knowing the sleight-of-hand while simultaneously believing in the subterfuge. Authenticity here becomes anything but fixed or rooted, but instead something that covers and uncovers and, ultimately, recovers the palimpsest of a self that is necessarily repetitive and layered: a body dexterous and disposed to an undressing that unveils only another costume, from Latin *consuetudo*, the fashion of our daily digital re(-)creations.

To Produce without Reproducing: The Limit as the Edge

Thomas Mathiesen, repeating in many ways Guy Debord's 1967 argument in *Society of the Spectacle*, albeit without imagining any form of potential resistance or alternative discourses, points to the media's role in inducing passivity to the public via distraction, degrading our capability – as receivers, as audience members, as spectators – to think critically, an analysis that echoes many other voices, including the Frankfurt School (Horkheimer, Adorno) and its postwar conception of the culture industry, and even earlier, Georg Simmel, writing in 1903, who probed the effect of the metropolis's intensification of what he called "contrasting stimulations" (Simmel 1969, 51). Mathiesen's characterization of audience members as enchanted and enduring receptacles of information contradicts everything we understand today about the often dislocated and diachronic agency of performance and the reversible processes of meaning-making for spectatorial authorship, particularly across the Internet, an interconnective medium he links, instead, with its one-way opposite: cable television.

However, I believe we can take his investigation, made in 1997, as to how the modern mass media directs and controls a "viewer society" in the context of lack, desire, and wish fulfillment – "[i]t is by satisfying the need for escape," he writes, "that people are made to acquiesce, accept and fit into the requirements of our society" (Mathiesen 1997, 230) – as a counterpoint that poses important questions about the possible limits or parameters of play, particularly when the game doesn't come off IRL. "My dilemma, and that of other Chicana and women-of-color writers," Gloria Anzaldúa wrote near the very end of her life, "is twofold: how to write (produce) without being inscribed (reproduced) in the dominant white structure and how to write without reinscribing and reproducing what we rebel against" (Anzaldúa 2015, 7–8). Revising reality by altering our consensual agreements about what is real, by avoiding the trap of literalism, by writing (and reading) one's self into being is not enough; these maneuvers must also consider the limitations (im)posed by the structuring culture at large. As Douglas Crimp has shown in his discussion of Cindy Sherman's work, any project of self-creation is necessarily

also contingent upon the possibilities provided by the culture to which one belongs (Crimp 1980, 99). As performer-participants, how do users know whether they are re-writing a social script or whether they are merely following it? We need to remain attentive to questions about the images we make but moreover, about the cultural images from which we are made. And yet these limits can also be read as an edge, a necessary precipice, the threshold from which the liminal, transitional, hybrid, and dislocated self can emerge, only by emission, only by its uncertain distribution. The disclosure of a new image is the disclosure of a new world, one that needs to be imagined before it can be concretized, one that needs to be deferred before it can be consummated. As I've shown elsewhere (Campanioni 2020, 2022), it is exactly because information requires noise, and the tending toward failure, to consummate as correspondence that the glitch of facial recognition – the incapacity of machines to properly read persons – might provide new possibilities of passing, new avenues of mobility.

If the sixteenth century allowed for a new era of the face – the widespread dissemination of faces ushered in through copper engraving and printing technologies – today we are both on the receiving and deceiving end of AI personalization and impersonations; the potential for power, ultimately, surfaces in a self-directed pleasure, but one, crucially, that can only come off as a collaborative act. Transmedia identity formation, not unlike transmedia storytelling, is a process that invites attention to every text's potential as intertextual and interactive, reproduced and repetitive (Campanioni 2021). "The Other comes on to the stage only in order to furnish it," Fanon writes:

> I am the Hero. Applaud or condemn, it makes no difference to me, I am the center of attention. If the other seeks to make me uneasy with his wish to have value (his fiction), I simply banish him without a trial. He ceases to exist. I don't want to hear about that fellow. I do not wish to experience the impact of the object. Contact with the object means conflict. I am Narcissus, and what I want to see in the eyes of others is a reflection that pleases me.
>
> (Fanon 1986, 144–145)

Is it any wonder that in *Westworld*, years after Season 1's "Trompe-l'œil," in diegetic time, when William comes face-to-face with Dolores again, in an episode aptly titled "Reunion," he can only arrive at self-realization through objectifying the other?

"Do you know what saved me?" he asks, standing above a seated, naked Dolores. "I realized it wasn't about you at all. You didn't make me interested in you. You made me interested in *me*."

He shakes his head in a side-angle close-up, as if confirming his own mug shot: guilt, or shame, or just the basic transgression that comes through interrogating one's own behaviors, the danger of self-realization. "Turns out you're not even a thing; you're a reflection," he adds, as the camera cuts back to Dolores: another close-up but this one head-on, her unblinking eyes and

her half-open mouth, posed or poised into encountering the viewer, the audience, us. "And you know who loves staring at their own reflection? Everybody."

In the age of co-produced fantasy, isn't it true that we are still made – and continuously re-making – in our own image?

Note

1 The name of the popular beautifying app "Facetune" suggests that the face is a rhythmic composition, but also an instrument for playing, a utensil for uncorrected pleasure. Take, for example, "REFACE," 2020's most downloaded face swap app, which allows you to implant your head on the moving bodies of celebrated film characters and musicians.

References

Arendt, Hannah. 1958. *The Human Condition*. Chicago: University of Chicago Press.
Anzaldúa, Gloria E. 2015. *Light in the Dark/Luz en lo oscuro: Re-Writing Identity, Spirituality, Reality*. Durham, NC: Duke University Press.
Bachelard, Gaston. 1994. *The Poetics of Space*. Translated by Maria Jolas. Boston: Beacon Press.
Bennett, Lucy. 2012. "Patterns of Listening through Social Media: Online Fan Engagement with the Live Music Experience." *Social Semiotics* 22, no. 5: 545–557, https://doi.org/10.1080/10350330.2012.731897
Campanioni, Chris. 2019. "Fixing Being with Likeness: Facial Recognition as the Stage for Global Per-Formance." *Im@go: A Journal of Social Imaginary* 12 (2019): 102–123, https://doi.org/10.7413/22818138129
Campanioni, Chris. 2020. "The Glitch of Biometrics and the Error as Evasion: The Subversive Potential of Self-Effacement." *Diacritics* 48, no. 4: 28–51, https://doi.org/10.1353/dia.2020.0028
Campanioni, Chris. 2021. "Doubling the Fantasy, Adapting the Reel: Entertaining Transmediation as a Collaborative Narrative Strategy." *Journal of Applied Journalism and Media Studies* 10, no. 2: 199–210, https://doi.org/10.1386/ajms_00057_1
Campanioni, Chris. 2022. "Documenting Disappearance: Self-Forgery and Dissimulation as a Means of Mobility." *Social Identities* 28, no. 5: 658–675, https://doi.org/10.1080/13504630.2022.2118701
Cheng, Anne Anlin. 2011. *Second Skin: Josephine Baker & the Modern Surface*. Oxford: Oxford University Press.
Costanza-Chock, Sasha. 2014. *Out of the Shadows, Into the Streets!: Transmedia Organizing and the Immigrant Rights Movement*. Cambridge: The MIT Press.
Crimp, Douglas. 1980. "The Photographic Activity of Postmodernism." *October* 15: 91–101, https://doi.org/10.2307/778455
Dyer, Richard. 1986. *Heavenly Bodies: Film Stars and Society*. London: Routledge.
Fanon, Frantz. 1986. *Black Skin, White Masks*. Translated by Charles Lam Markmann. London: Pluto Press.
Gamson, Joshua. 1994. *Claims to Fame: Celebrity in Contemporary America*. Oakland: University of California Press.

Geertz, Clifford. 1973. *The Interpretation of Cultures*. New York City: Basic Books.
Harris, Neil. 1973. *Humbug: The Art of P.T. Barnum*. New York City: Little, Brown and Co.
Harris, Lyle Ashton. 1991. "Revenge of a Snow Queen." *Out/Look* 13: 92.
Huxtable, Juliana. 2018. "Untitled in the Rage (Nibiru Cataclysm)." *Art in the Age of the Internet: 1989 to Today*. Boston: Institute of Contemporary Art, February 7.
Langellier, Kristin M. 1999. "Personal Narrative, Performance, Performativity: Two or Three Things I Know for Sure." *Text and Performance Quarterly* 19: 125–144, https://doi.org/10.1080/10462939909366255
Marshall, P. David. 1997. *Celebrity and Power: Fame in Contemporary Culture*. Minneapolis: University of Minnesota Press.
Mathiesen, Thomas. 1997. "The Viewer Society: Michel Foucault's 'Panopticon' Revisited." *Theoretical Criminology: An International Journal* 1, no. 2: 215–232, https://doi.org/10.1177/1362480697001002
Merleau-Ponty, Maurice. 1968. *The Visible and the Invisible*. Translated by Alphonso Lingis. Evanston: Northwestern University Press.
Simmel, Georg. 1969. "The Metropolis and Mental Life." In *Classic Essays on the Culture of Cities*, edited by Richard Sennett, 47–60. Englewood Cliffs: Prentice Hall.
Stark, Frances. 2018. "My Best Thing." *Art in the Age of the Internet: 1989 to Today*. Boston: Institute of Contemporary Art, February 7.
Stephens, Michelle Ann. 2014. *Skin Acts: Race, Psychoanalysis, and the Black Male Performer*. Durham: Duke University Press.
Virilio, Paul. 2009. *The Aesthetics of Disappearance*. Translated by Philip Beitchman. Los Angeles: Semiotext(e).
Welsh, Robert E. 1914. "David W. Griffith Speaks." *New York Dramatic Mirror*, January 14.
Westworld. "Trompe-l'oeil." Directed by Frederick E.O. Toye. Written by Halley Gross and Jonathan Nolan. HBO, November 13, 2016.
Westworld. "Reunion." Directed by Vincenzo Natali. Written by Carly Wray and Jonathan Nolan. HBO, April 29, 2018.
Winnicott, D.W. 2005. *Playing and Reality*. London: Routledge Classics.

Part III
Politics of the Self

9 Trans, Media and [In]Visibility
Trans Representation in the Transmedia Era

Kaylee Koss

Introduction

> It is revolutionary for any trans person to choose to be seen and visible in a world that tells us we should not exist.
>
> – Laverne Cox

> This media experience has become the norm for all aesthetic experience. Hence in art there is no longer any painting outside and beyond the media experience. There is no longer any sculpture outside and beyond the media experience. There is no longer any photography outside and beyond the media experience.
>
> – Peter Weibel

This chapter should not have to exist. It is frustrating that it does. Instead, there should be a chapter about the amazing philosophical ramifications of trans identities and the relationship between humans and their technology, or whatever. Social politics are *exhausting*. Unfortunately, they are also inescapable. The simple truth is that any marginalized or minority identity in cisgender, heteronormative, white patriarchal Christian hegemonic culture is inherently political just by existing. So too, the fight for access to media and autonomy over cultural narratives is fundamentally political. Given the current constellation of media technologies, social schisms and political pressures, that is not going to change any time soon, for anyone – particularly not for transgender individuals.

A demographic which is of particular interest to my practice as an artist, as well as being "under the microscope" at the moment, the "Trans Community" clearly refers to transgender people, but written as trans*, it is also frequently used as an umbrella term that includes nonbinary and other identities. It is worth stressing here that trans people, and the trans* community, are related to "transmedia" only inasmuch as they share a prefix that suggests a crossing over, or a going beyond – a *transcendence*, if you will – of previous boundaries. But maybe that is more relevant than it first seems.

Naturally, personal experiences of identity and opinions vary widely, and no one can legitimately claim to be speaking on behalf of an entire population.

DOI: 10.4324/9781003134015-13

Therefore, it is *also* worth stressing that what is presented here are *generalities*. And, *in general*, notions of visibility are significant to trans individuals and the trans*community at large (and consequently, their relationship to media technologies). The very real material issues surrounding visibility are a sort of Catch-22 for trans* people: in the not-so-long-ago past, dealing with transitioning prior to puberty wasn't even an option, and for many individuals still isn't; so trans identities, particularly trans females, are often stereotyped as being very publicly obvious and noticeable. The community also became politically visible and active in order to gain access and rights like necessary healthcare. However, that socio-political exposure also means awareness, including by those wishing to halt or confound trans* rights like healthcare access, or even just access to gender-corresponding public facilities like toilets. During 2020 and 2021, an unprecedented spate of laws and court decisions in the US, the UK and various countries in the EU have chipped away at the few rights and limited legitimacy that the trans* community had managed to gain up until then.

Public awareness has also meant becoming a more visible target for violence. Murder rates for trans people – specifically, trans women of color – have continued to rise every year in the United States since 2014 (Allen 2018). It should also be noted that the "official" murder rates are almost always lower than the actual number of crimes, as the media, police or authorities, and even families routinely misgender or ignore the trans identity of the victims. Even worse, many murders go unreported because the victim has been cut off from family, is possibly homeless and therefore acquaintances are used to them "drifting," or because the murders are often times so incredibly violent that it takes more time than usual to find or identify the bodies.

Understandably then, autonomy over one's public visibility and how that is either thwarted or supported by various media platforms existent today is of paramount concern, as that representation critically shapes public opinion. So, presented here is a brief chronology of that relationship between trans people and media, and how paradigm shifts in technology – from the advent of *mass media*, to the *postmedia* environment, and the current *transmedia* experience as offered by Weibel above – have affected the politics of representation; some ongoing issues and arguments regarding media visibility; how the trans* community deals with those various challenges and opportunities, in such a particular cultural landscape of technology, politics and identity; and what might come next.

Mass Media & Trans Objectification

> 80% of Americans don't actually personally know someone who is transgender, so most of the information that Americans get about who transgender people are ... comes from media.
>
> – Laverne Cox (*Disclosure*)

Despite the fact that trans and gay identities are very different concepts, they have historically been conflated so much that it is impossible to present the current state of trans rights and identities without backtracking a little bit to cover why they were conflated, and when and how they finally began to be disentangled from each other. Even when the term "transsexual" started surfacing in the 1950s (mostly due to the sensation and gossip surrounding Christine Jorgensen, one of the first trans women to have Sexual Reassignment Surgery in the US), it was still widely conflated, interchanged or confused with "gay" and "transvestite" (Ekins and King 1996, 86). This also illustrates the ambivalence, ignorance or disinterest at the time (and even currently) to disentangle notions of gender and sexuality, which is what ultimately had to happen in order for a distinct trans movement. As author and art historian David Getsy states, "Transgender capacity does not derive from sexuality" (Getsy 2015, 38).

One significant difference is the frequently visible element of trans identity that has been played for laughs since the birth of cinema (and theater before that). A "man in a dress" is more visually obvious than an internal state of attraction. In 2020, Netflix released the documentary *Disclosure*, which discusses the history of the relationship between traditional media and trans people. As Laverne Cox states at the very beginning, "Some of the earliest moving images were cross-dressed images."

From 1966 to 1969, trans identities drifted in and out of public visibility, most notably coming to popular attention again in 1977 with the US Supreme Court case of tennis star Renée Richards; after gossip quieted down again, a trans identity wasn't presented (arguably as a protagonist) in pop culture again until the cinematic adaptation of the gruesome death of trans male (Female-to-Male, or FTM) Brandon Teena (*Boys Don't Cry, 1993*). That movie is somewhat of an outlier; historically, trans men have been virtually ignored by pop culture and media. The identity of "trans woman," however, has been used as the butt of jokes in countless movies, sitcoms and comedy (Talusan 2016). Any presentation of trans people in mass media has been almost exclusively one of two roles: as a (prostitute) homicide victim or as comedic relief.

> GLAAD took a look at 134 episodes of television where a transgender character was brought on just to be a guest star character and what we found in those portrayals was that the most common profession shown for a transgender character was sex worker.
> – Nick Adams, GLAAD (*Disclosure*)

In her book *Whipping Girl*, Julia Serano explains these two stereotypes of trans women that have typically been regurgitated ad nauseum in traditional media:

> Media depictions of trans women, whether they take the form of fictional characters or actual people, usually fall under one of two main archetypes: the "deceptive transsexual" or the "pathetic transsexual." While characters based on both models are presented as having a

vested interest in achieving an ultrafeminine appearance, they differ in their abilities to pull it off. Because the "deceivers" successfully pass as women, they generally act as unexpected plot twists, or play the role of sexual predators who fool innocent straight guys into falling for other "men."

(Serano 2007, 36)

Under the radar of mainstream culture, however, support and collaboration progressed unabated, and between 2002 and 2003, the Transgender Law Center and the National Center for Transgender Equality were both founded in the United States. During the next decade, individual stories of interest continued to surface, yet despite a growing frequency, they were just isolated incidents or individuals, still largely ridiculed or seen as the "weird news story of the day," and still without the support structure of a visible, larger social movement to champion and defend them (Penny 2014). Being shocked by trans women was such good sport that episodes of TV shows like *Jerry Springer* regularly centered around it (NBC Universal, 1991–2018).

Whether true or not, it was announced in 2014 on the June 9 cover of *Time* Magazine that the US had reached the "Trans Tipping Point." However, a 2017 Pew Research Center survey indicated that a third of Americans felt society had gone too far in accepting trans people (Silva 2017). According to other surveys in the same year, 27% said they would not be friends with a trans person, and over 80% said that they would not date someone who is trans; 21% believed being trans is a mental illness, and 39% believed it is a choice (Bame 2017). If Laverne Cox's statement (above) is true – that general opinions regarding trans people are based on information from the media – then that hegemonic mass media has failed trans people. Arguably, it has killed them. Authorship, authority and control over those narratives needed, and needs, to be challenged.

Postmedia & Trans Representation

> I never thought the media would stop asking horrible questions and start treating us with respect.
> – Laverne Cox (*Disclosure*)

Laverne Cox is wrong that mass media stopped asking horrible questions; it's more that a wider array of voices has been allowed to ask the questions and provide answers to challenge the narratives presented by corporate media.

What *has* changed regarding the visibility of trans people, specifically since 2012, is the opportunity for trans self-representation, authorship and ongoing dialogue. Media technologies and publishing platforms have exploded in population and popularity (bear in mind that YouTube was launched only in 2005). This conflation of news, entertainment and communication all on one platform (i.e., the internet) was heralded as the advent of a *postmedia* culture.

The term and concept of "postmediality" was coined by Félix Guattari in 1990, regarding a future he saw in which already-ubiquitous electronic mass media was subsumed by an already-burgeoning worldwide computer network:

> The junction of television, telematics and informatics is taking place before our eyes, and will be completed within the decade to come. The digitisation of the television image will soon reach the point where the television screen is at the same time that of the computer and telematics [Telecommunications + Information Systems] receiver. Practices that are separated today will find their articulation.
>
> (Guattari 1990)

Guattari saw this technological conflation as a bridge to connect, and thus empower groups and individuals that would be "different yet connected" (ibid). To him, digital networks (like social media) would offer greater expression, cooperation and 'multiform' possibilities, a much more dynamic situation than the idea of a passive consumer of media (Holmes 2013, 111).

And that "multiform" connectivity is important, for besides whatever otherwise-existing gestalt was responsible for the trans movement, social media platforms absolutely played (and play) a pivotal role in connecting isolated individuals into a visible global community, normalizing what might, in the absence of that solidarity, feel like an overwhelming burden of *differentness* that would best be kept hidden.

This paradigm shift in technology access and ubiquity is exactly why the push for trans rights has happened much more suddenly and visibly than the (ongoing) gay rights movement, the beginnings of which obviously predate the birth of social media platforms: this means both the explosion of affordable hardware, like computers, and the development of editing software and publishing platforms. Seeing trans identities on sites like Facebook or YouTube, whether or not they are representative of a "real" identity, or anonymous alter-egos, increased the visibility of trans identities in public domains, and thereby normalized their presence (Horak 2014).

A postmedia culture changes the power dynamic and authorship of the narrative. As previously mentioned, in traditional mass media, trans characters are objectified as mere plot contrivances by predominantly cisgender producers, who assume they are writing for a predominantly cisgender audience, who will also recognize the trans character as "other" (Keegan 2016). The postmedia ubiquity of hardware and software, however, means that trans people can have the authority – the authorship – to treat themselves as the subjects of narratives, and can assume a trans or trans-allied audience (Horak 2014, 576).

In fairness, Western hegemonic mass media typically presents *most* minorities as bit actors, just supporting roles for predominantly cisgender, heteronormative white characters intended for a cis-heteronormative white

audience. Although the politics of representation has changed at least to some degree for virtually all minority demographics in the postmedia environment, arguably the most visible and noticeable has been the trans community – partly because of timing, partly because of the very relationship trans-ness has with notions of visibility. Regardless, this shift in the politics of representation was one of the most monumental evolutionary changes of a postmedia culture – an increase from a few broadcast channels to hundreds of cable channels, on to internet websites, then to social media platforms – a change in content availability from the weekly show or nightly broadcast, to a 24-hour news cycle, to tweets updated minute by minute. And that is where some people claim another paradigm shift has happened, from a postmedia to a transmedia culture- the livestreaming internet leaping from desktop to pocket.

Transmedia & Trans [In]Visibility

> Visibility for transgender women comes at a cost. How do you balance trans visibility with the constant threat of violence?
> – Sarah McBride (first trans state senator of Delaware)

The difference between postmedia and transmedia seems ... unresolved, at best. Some academics use the terms interchangeably; others get extremely pedantic about the whole thing. For the purposes of this discussion, I argue that the most important distinction is *not* something like "multiplatform capacity" but rather, as mentioned before, the shift in "narrative authority" (Bettcher 2009). The online environment and sheer number of social media applications – and their ownership, the opportunity for anyone to develop and launch a social media "app" – confounds the concept of hegemonic control. Even though it would be ridiculous to argue that Guattari didn't foresee an explosion of alternative publishing options, considering his understanding of the increasing ubiquity of communication technologies, the postmedia culture could be considered to still be overwhelmingly dominated by corporate media, as the traditional broadcast corporations have all launched online channels and accounts to increase their visibility. Given their superior financial resources, they are able to buy "ranking" in Google searches, and can afford the manpower to create a greater volume of content. Both of these affect "engagement," so it's not surprising that accusations arose that the algorithms of platforms like YouTube are adjusted to direct traffic to their accounts (Camargo 2020).

This "corporate domination" is possible on what could be considered the "previous" or "postmedia iteration" of social media sites – YouTube, Facebook and even Twitter – but it is harder to maintain that pole position on newer and emergent iterations of social media platforms that favor individual content providers and personalities. This being the case, then rather than being an outdated or irrelevant term or concept, it would seem that we have only just begun the transmedia age.

Digital Natives & Trans Narratives

So how should narratives be defined in the transmedia era? It is not as easy as making a list of "accepted" formats – mainly because new technologies, new iterations and new ways of engaging are integral elements of culture and communication. Whether postmedia or transmedia, digital narratives do have some distinguishing characteristics: mutability, multiplicity, manipulation and reiteration; recombination of media, juxtaposition and repositioning; emerging art practices from emergent technologies and the recycling or re-orientation of redundant/obsolete technologies (monoskop.org 2016).

Transmedia narratives have an inherent capacity to be sequential, serial, successive storytelling (Deshane 2014). The interpretation of such a multiplatform narrative, or set of image-signs, also quite often relies upon understanding or recognition of simultaneous multiple contexts (Kinsey 2013). This is the online, digital, transmedia language of a generation of cultural content creators who have been raised online and are "digital natives" (Holmes 2013, 111). It is therefore increasingly inaccurate to refer to the physical world as IRL, or "In Real Life." However, since personal exposure and visibility is to a great extent (ideally) by choice, the "real life" identity may or may not be the same as the digital identity or online public persona, which may change (mutability) or be one of many (multiplicity).

Now compare this to the experience of trans people, who have frequently had multiple (real or online) identities, or an online identity that is contrary to the lived role in a socially created binary. Hence, there is often comfortability, or at least a familiarity with slipping in between visibility and invisibility; furthermore, their experienced gender can be mutable, varied across platforms, dynamic, undefined or ambiguous, and like serial narratives, can also be *successive* (Getsy 2015).

Given all these shared characteristics, it is not unreasonable to argue that transmedia existence +... *transcends* gender. The digital identity of any online account is just as likely to be male, female, agender or nonbinary, which may or may not correlate with the "IRL" identity of the producer. By its very design, transmedia existence is inherently *transgressive* and *transcendent* of traditional, patriarchal, Western binary gender norms.

Transmedia Is Transgender

If the current (and foreseeable future of) transmedia culture is indeed inherently nonbinary and transgender, then it helps explain why conservative, regressive interests are *so* invested and focused on erasing trans gender identity (Hughson 2021). Trans people are the visible totem of a greater cultural shift from the hegemonic binary, and a consequent shift in political power. This then presents the double-edged sword of social visibility in the transmedia era: increased awareness and participation on one side results in increased hostility and bigotry on the other. Both agendas are furthered on transmedia platforms; however, it is the difference between using transmedia as a tool, or

using transmedia as a weapon. There is a significant difference between *choosing* one's level of visibility versus having it either forced or erased by an outside agency.

[In]Visibility by Choice

> The more positive representation there is, the more confidence the community gains, which then puts us in more danger.
> – Jamie Clayton (*Disclosure*)

As mentioned, auto-ethnographic transmedia narratives notably have a capacity for serial production; they allow the author to choose the degree of personal visibility or invisibility; they can be produced in multiple and mutable editions, and one individual can produce and publish under an alternate, or multiple identities. This means an LGBT+ person can identify authentically online with minimized risk of the physical danger associated with the 'cost of visibility' for trans* people mentioned by McBride above, or it can lead to "sock accounts," which are additional accounts created to give the impression that someone has followers or people who agree with their position, or to get around being banned from a site. The following Twitter exchange illustrates the visibility and awareness that social media can provide, even with an anonymous account or profile.

> I know people talk a lot about how social media is toxic for trans people, but honestly we have to come here because it's the only form of media that has any truth about us to balance the lies.
> @transsomething, 22/06/2021

> I'm sorry that this site is bad for you. I don't know any trans people in the offline world so accounts like yours are very helpful to me that you [sic] in understanding perspectives that don't get heard much. I hope other cos [cis] people can also gain understanding through the internet.
> @alexand22574772, 22/06/2021

Also previously mentioned was the power of the presence of a group identity. This "membership" can be adopted while still maintaining whatever desired level of personal visibility; necessary, given the potential for dangerous consequences associated with group visibility mentioned by Clayton (above). For example, according to reporting trans users of the social gaming site Twitch were overwhelmingly pleased when the site introduced new "tags" for accounts that allowed them to locate and identify fellow trans profiles (Nightingale 2021b).

Besides games, there are also life-changing apps that offer anything from trans services according to area code, or a map of nearby unisex bathrooms;

these have been created from trans people working in, and challenging, the traditionally gendered field of IT work. Access to transmedia technology and platforms not only provides for multiple profiles or personas – either multiple personas that each are represented on multiple platforms, or a different persona on each platform – but a capacity for cross-platform promotion that increases potential viewership (anecdotally, I am reminded of being on Twitter and seeing a re-tweet of a TikTok video of a guy complaining on Twitch ... quite a nest of dolls). Multi-platforms run by varied interests can also counter, in a way visible to a greater variety of audiences, what would otherwise be an uncontested narrative by corporate or state media.

> The @Guardian published three articles about #trans people at the weekend & @BBCr4today had a feature about trans people this morning. No trans people al [sic] all were interviewed, quoted or included in any of them. This is the systematic silencing of trans voices by the media.
> @natachakennedy; 8/06/2021

These particular attributes of cultural production in a transmedia environment are exactly the reason why the movement for trans awareness and rights exploded into the social dialogue at a speed several factors faster than any previous civil rights issue. The ability to hide one's "real life" identity while creating a socially visible version of the self online; to "try out" or "field test" different iterations on different publishing platforms, finding different audiences or groups; to then be able to access a global network of information and peers, sharing stories, warnings and advice ... for a demographic that has survived largely by staying invisible, the isolation and feelings of otherness are greatly alleviated in the transmedia milieu. Unfortunately, all of those same attributes can be weaponized by antagonistic parties wishing to retard, obfuscate or even completely erase any progress made.

[In]Visibility by Force

> Remember friends, it's not a "war" when only one side has weapons (national newspapers, institutional power, the BBC, a platform) and the other hasn't got much more than a Twitter account. Trans people aren't in a culture war, we're in a cleansing.
> – Christine Burns MBE

Those same attributes that have allowed trans people and the trans community to thrive can also be used to target them. Anonymity, of course, allows people to vent bigoted opinions and beliefs that they know would be frowned upon in person; it also means that multiple accounts – "Sock accounts," like sock puppets being controlled by a single user – are used to amplify a message and seeming support for it (or to get around a ban by a site). This tactic to increase visibility and presence is also used by creating additional group

pages, whose administrators and actual membership can be ambiguous at best. These anonymous profiles and questionable groups also utilize the same cross-platform promoting tactics to increase their social presence- so, in theory, a handful of people, or even just one, could be running multiple "group" accounts on multiple social media sites, to create the impression of "grassroots support" for their cause – also known as "astroturfing" (fake grass, fake grassroots movement).

And forget climate change: by all accounts the greatest threat faced in the 21st century so far is *Cancel Culture*. The typical complaint is that one side is trying to stifle "good faith" debate and free speech. Disregard for the moment the validity of a "good faith" debate over the rights of a group of people by an outsider; the irony is that the most visible people are the ones usually claiming that they are being silenced. As Jo Maugham facetiously tweeted, "How I was cancelled: read all about it in the Mail, the Telegraph, UnHerd, the Times, the Spectator" (@JolyonMaugham, 25/11/2020). For example, in both the US and the UK press there are numerous "journalists" or guest writers, op-eds, and "both-sides" articles that are critical at best of trans identities, throw up strawmen arguments without any objection, and couch their attacks in dog whistles and coded language (Serano 2017) leading to the 'one-sidedness' referred to by Burns (above).

The reality, however, is that "cancel culture" is a myth (Johnston 2019). Practically speaking it is impossible, but it makes for a good talking point that allows one to be perceived as the victim or "aggrieved" party. As noted by Bernice King, daughter of Martin Luther King Jr., "Some things being labeled as Cancel Culture are actually examples of accountability." Usually at worst, someone is "deplatformed" from a particular site. This is action by the operators of a website to remove an account or profile for violating their rules. It could be for legitimately inappropriate behavior, or it could be a concerted effort by bad actors, as in the case of the trans Twitch user who had multiple false complaints lodged against her in what ended up being a successful campaign to have her account suspended (Nightingale 2021a). As unfortunate or frustrating as that is, it is not a particularly problematic issue, as a new account can usually be set up, and considering that the field of social media isn't static: the barring of accounts from Twitter for hate speech or misleading information (anti-trans, "Q-Anon" and other conspiracies) led directly to the development of "Parler," a rightwing social media site (Lerman 2020). On the other hand, the undesired visibility that results from agitators maliciously "doxxing" someone by posting their private information online – like their real name, home address, phone number and email account – has resulted not only in online harassment, but real physical violence and even death.

The reality is that access to LGBT+ content is often still stifled, throttled or completely blocked by many corporate firewalls, or dominated by rightwing criticism (January 2020). Ostensibly, under pressure either from within or without, the BBC erased all contact details and links for trans support groups from their website (Parsons 2020).

> So, I'm [writing] an article about TDOR [Trans Day of Remembrance] *for work* and I've just found that tdor. translivesmatter.info has been blocked by my work filtering software, due to it being labeled as "Alternative Sexuality/Lifestyle."
>
> – @Cassterix on Twitter

Additionally, many sites, like YouTube for example, demonetize (don't allow ads) for a lot of LGBT+, specifically trans, channels or videos. This highlights another common issue of visibility- funding. Bigotry makes for strange bedfellows, and the anti-trans movement is no different. US-based religious conservative groups designated "hate groups" by the Southern Poverty Law Center have been actively funding anti-LGBT and anti-women's rights around the world (Savage 2020b). The primary method they identified and shared, with radical UK "feminists" invited to a US conference, is to use trans issues as a wedge in order to weaken the strength and integrity of the LGBT+ community (Barthélemy 2017). Clearly, funding becomes an issue of visibility then, because as a tactic it increases the volume and "static" in the social conversation, and helps elevate the small vocal majority to seem larger than it is. This is nothing new; The Squeaky Wheel Gets the Grease – or in this case, the media coverage.

Future Media & Trans Futures

> Transgender people are making incredible waves in tech because of their presence and work that disrupts gender binaries. ... This will provide a new set of tools, skills sets and perspectives on gender that both the tech industry and the world needs.
>
> – Kortney Ryan Zeigler

As it has been presented here, however condensed, the trajectory of communication arcs toward access and immediacy. The handful of broadcasters and advertisers at the beginning of the age of mass media had near total control over both the medium and the message. The conflation of communication media, the birth of the internet and the ubiquity of computers and software during the postmedia era increased the visibility of independent creators. The domination of the internet as a medium and the explosion of social media apps has effectively checked the narratives pushed by corporate media interests at the beginning of the transmedia era. The nature of a transmedia, multiplatform environment has also challenged and transcended binary notions of gender and identity. The continued march of the transmedia age will present an ever-increasing intimacy between the biological self and communicative technology (in which trans* people are able to make significant and necessary contributions, as Zeigler mentions above), until that binary is blurred as well. It takes very little imagination to envision a near future where instant and livestreamed content is available on demand, whether on a worn or internal device; that various levels or platforms in Augmented Reality

(AR) will exist simultaneously with the "real," and you will be able to actually feel the experience of being your avatar (Opsahl and Rodriguez 2021). Or, that an audience will be able to experience an audiovisual narrative from the first-person, lived point of view of the author, trans or otherwise. The ability to understand *what it feels like to be* … This is the continued evolution of narrative technologies that we are seeing *right now*. Technology *everywhere* will mean the development of new and immediate cultural production, new information, new jobs. But as is usually the case, technology races ahead while society lags behind. It is foolish to think that legislation alone will change things. Hate crime bills clearly haven't slowed down the near-exponential growth in the annual statistics of trans murders. Actually, LGBT-directed violence across the board is on the rise in the US (Blanchet 2021), the UK and the EU (Savage 2020a).

However, despite the Herculean task of representation and visibility faced by the trans community and so many other minorities and disenfranchised people, I am optimistic – at least in the long run. Despite the disparity in power, authority and funding, the same period that the anti-trans rhetoric flared up in the UK saw the worldwide rise of the Black Lives Matter movement (Smith 2020). This included very noticeable representation of Black Trans Lives. And perhaps most exciting is the generational shift in thinking, a shift away from binaries toward a more open, accommodating view of life experienced as a spectrum (Reynolds 2021). Eventually – *eventually* – the resistance against trans lives having a legitimate and visible place in society will look as archaic and outdated to the general population as other forms of bigotry do now … most likely only to be replaced by a new incarnation of discrimination. This is the reason that the culture "war" over trans rights is so important: it is a distilled, contemporary snapshot of this broader hallmark of humanity, the continuous battle between the politics of regressive conservatism and progressive inclusion.

Bibliography

Allen, Samantha. 2018. "How the transgender murder rate reveals the ugly lie of 'acceptance'." *The Daily Beast*, February 13. Accessed 26 November, 2020. https://www.thedailybeast.com/how-the-transgender-murder-rate-reveals-the-ugly-lie-of-acceptance-10

Bame, Yael. 2017. "21% of Americans believe that being transgender is a mental illness." *YouGov*, May 17. https://today.yougov.com/topics/relationships/articles-reports/2017/05/17/21-americans-believe-identifying-transgender-menta

Barthélemy, Hélène. 2017. "Christian Right tips to fight transgender rights: separate the T from the LGB." Southern Poverty Law Center, 23 October. https://www.splcenter.org/hatewatch/2017/10/23/christian-right-tips-fight-transgender-rights-separate-t-lgb

Bettcher, Thalia. 2009. "Trans Identities and First-Person Authority." In *You've Changed: Sex Reassignment and Personal Identity*, edited by Laurie Shrage, 98–120. New York. Oxford University Press.

Blanchet, Brenton. 2021. "As reported hate crimes rise nationally, treatment of LGBTQ community remains top priority for local orgs." *The Daily Gazette*, July 24. https://dailygazette.com/2021/03/07/as-reported-hate-crimes-rise-nationally-addressing-treatment-toward-the-lgbtq-community-remains-a-top-priority-for-local-organizations/

Camargo, Chico Q. 2020. "We don't understand how YouTube's algorithm works- and that's a problem." *Fast Company*, January 24. https://www.fastcompany.com/90454610/we-dont-understand-how-youtubes-algorithm-works-and-thats-a-problem

Deshane, Eve. 2014. "This is my voice: YouTube and the transgender autobiography." *The Atlantic*, October 14. https://www.theatlantic.com/technology/archive/2014/10/this-is-my-voice-youtube-and-the-transgender-autobiography/381368/

Ekins, Richard and Dave King, eds. 1996. *Blending Genders*. London: Routledge.

Getsy, David. 2015. *Abstract Bodies*. New Haven/London: Yale University Press.

Guattari, Félix. 1990. "Towards a Post-Media Era." In *Provocative Alloys: A Postmedia Anthology*, edited by Clemens Apprich, Josephine B. Slater, Anthony Iles and Oliver Schultz, 26–27. London: Mute Books 2013.

Holmes, Brian. 2013. "Activism and Schizoanalysis: The Articulation of Political Speech." In *Provocative Alloys: A Postmedia Anthology*, edited by Clemens Apprich, Josephine B. Slater, Anthony Iles and Oliver Schultz, 106–121. London: Mute Books 2013.

Horak, Laura. 2014. "Trans on YouTube." *Transgender Studies Quarterly* 1(4), 572–585. Duke University Press.

Hughson, Greta. 2021. "Who's financing the 'anti-gender' movement in Europe?" *NAM*, May 27. https://www.aidsmap.com/news/may-2021/whos-financing-anti-gender-movement-europe

January, Brianna. 2020. "The right is dominating Facebook engagement on content about trans issues." *Media Matters*, 20 July. https://www.mediamatters.org/facebook/right-dominating-facebook-engagement-content-about-trans-issues

Johnston, Cody. 2019. "Cancel culture isn't a thing, you snowflakes." *Some More News*, 25 September. https://www.youtube.com/watch?v=szybEhqUmVI&t=2s&ab_channel=SomeMoreNews

Keegan, Cael. 2016. "Revisitation: A Trans Phenomenology of the Media Image," *MedieKultur* 61, 26–41. Society of Media Researchers in Denmark.

Kinsey, Cadence. 2013. "From Post-Media to Post-Medium: Re-Thinking Ontology in Art and Technology." In *Provocative Alloys: A Postmedia Anthology*, edited by Clemens Apprich, Josephine B. Slater, Anthony Iles and Oliver Schultz, 44–61. London: Mute Books 2013.

Lerman, Rachel. 2020. "The conservative alternative to Twitter wants to be a place for free speech. Turns out, rules still apply." *The Washington Post*, July 15. https://www.washingtonpost.com/technology/2020/07/15/parler-conservative-twitter-alternative/

Monoskop. 2016. "Postmedia." Accessed 20 November, 2020. monoskop.org/Postmedia

Nightingale, Ed. 2021a. "Trans streamer shares the vile abuse she's received – but Twitch banned her, not her trolls." *Pink News*, July 9. https://www.pinknews.co.uk/2021/07/09/twitch-trans-streamer-anne-atomic/

Nightingale, Ed. 2021b. "Trans streamers share how Twitch's new identity tags have helped them: 'They do a world of good'." *Pink News*, July 10. https://www.pinknews.co.uk/2021/07/10/twitch-trans-tag-impact/

Opsahl, Kurt and Katitza Rodriguez. 2021. "Your avatar is you, however you see yourself, and you should control your experience and your data." Electronic Frontier Foundation, June 2. https://www.eff.org/deeplinks/2021/06/your-avatar-you-however-you-see-yourself-and-you-should-control-your-experience-0

Parsons, Vic. (2020). "'Disgraceful' BBC accused of 'bowing to deliberate hate' after quietly cutting ties to trans charities." *Pink News*, 30 July. https://www.pinknews.co.uk/2020/07/30/bbc-pride-trans-hate-campaign-mermaids-action-line-transphobia-gender-trust/

Penny, Laurie. 2014. "What the 'transgender tipping point' really means." *New Republic*, June 27. newrepublic.com/article/118451/what-transgender-tipping-point-really-means

Reynolds, Daniel. 2021. "Study: half of Gen Z believes the gender binary is outdated." *The Advocate*, February 24. https://www.advocate.com/business/2021/2/24/study-half-gen-z-believes-gender-binary-outdated?utm_source=twitter&utm_medium=social&utm_campaign=business

Savage, Rachel. 2020a. "Rising populism stokes homophobic hate speech across Europe – rights group." *Reuters*, February 4. https://www.reuters.com/article/us-europe-lgbt-rights-trfn-idUSKBN1ZY0X3

Savage, Rachel. 2020b. "U.S. Christian groups spent $280m fighting LGBT+ rights, abortion overseas." *Reuters*, October 27. https://www.openlynews.com/i/?id=cdd72329-8e75-4a74-a3e9-f0fbed0b5c36

Serano, Julia. 2007. *Whipping Girl: A Transsexual Woman on Sexism and the Scapegoating of Femininity*. California: Seal Press

Serano, Julia. 2017. "Transgender agendas, social contagion, peer pressure, and prevalence." *Medium*, 27 November. https://juliaserano.medium.com/transgender-agendas-social-contagion-peer-pressure-and-prevalence-c3694d11ed24

Silva, Christianna. 2017. "A third of Americans say society has 'gone too far' in accepting transgender people." *Newsweek*, November 8. www.newsweek.com/third-americans-say-society-has-gone-too-far-accepting-transgender-people-705717

Smith, Alex. 2020. "Black lives matter protests 2020." *Creosote Maps*, 18 November. https://www.creosotemaps.com/blm2020/

Talusan, Meredith. 2016. "25 years of transphobia in comedy." *Buzzfeed*, February 27. www.buzzfeed.com/meredithtalusan/25-years-of-transphobia-in-comedies?utm_term=.bbBJlVny6#.ccWW6KG0x

Films

Boys Don't Cry. (1999). Directed by Kimberly Peirce [Film]. Fox Searchlight Pictures.
Disclosure. (2020). Directed by Sam Feder [Documentary Film]. Netflix.

10 The Manosphere
Incel as Transmedial Construction

Emily Pratten

Introduction

In this chapter, I will demonstrate how the formation of masculine identities seen across the so-called manosphere,[1] and specifically the development of 'incel'[2] identities, can be better understood through the frame of transmediality. 'Transmedia', as I conceive of it here, is allied with Fast and Jansson's model, where transmedia refers not just to stories told across multiple platforms, but also to 'a particular mode of circulation that influences social life in a broader scope' (2019: 4). I argue that it is precisely this mode of circulation of information that has been instrumental in both creating and sustaining groups of men across the world who are connected, through various channels and platforms, by their common investment in extreme misogyny and antifeminist ideologies. These groups demonstrate a common vocabulary and increasingly coherent belief system that marks them out as a relatively consistent identity with its own codes of conduct and criteria for acceptance into the group.

I will explain the cultural formation of 'Incel' as an ideology and identity[3] and situate this process within a broader context of digital culture and masculinities online, in order to demonstrate where this phenomenon originates and how it operates within a larger sphere of antifeminist sentiment we see growing across the internet.[4] I will be drawing upon previous research in transmedia studies about fan culture, worldbuilding, and storytelling, and highlighting how these frameworks can be used to better understand 'incel' as a cultural concept, particularly in the absence of, and as a foundation for, more dedicated theorisations. Whilst there is now some more detailed work interrogating the growing and complex network of vitriolic antifeminist discourse online (Banet-Weiser and Miltner, 2016; Banet-Weiser and Portwood-Stacer, 2017; McRobbie, 2008; Phillips, 2015), much of the contemporary research about Incel and the symbiosis of misogyny with extremism comes from international policy, security studies, and anti-terrorism (Díaz and Valji, 2019; Jackson, 2019; Ong, 2020). These avenues of research are vital, and need to be accompanied by research focussed on the cultural and technological apparatuses that enable these extreme ideologies to mutate and grow,

DOI: 10.4324/9781003134015-14

informing decisions about future governance and adding further nuance and empathy to the discussion.

This work also needs to be understood as appearing in direct relationship to the intensification of specifically neoliberal rationalities, such as the 'entrepreneurial self' and the 'relentless economisation of social life' (O'Neill, 2018: 22), that increasingly permeate daily life through such diverse avenues as dating, dating apps, social networks, reality television, and gender relations more broadly. These rationalities have helped to create a sexual marketplace that is itself a transmedial construction, existing as a complex ideological network created and sustained by multiple media types. Incels are a particularly reactive phenomenon within this marketplace, an increasingly resilient body of alternative facts and myths about human sexuality and social justice. The current stability of Incel and other extreme misogynist identities could not have emerged without the widespread adoption and influence of the technologies of global networked communication and ubiquitous mobile computing.

This chapter does not have the scope to describe the increasingly dense and lattice-like linguistic and rhetorical structure of digital cultures that influence modern masculinity, and aims to shine a light on a small part of this hall of mirrors and illustrate the deepening need for an interdisciplinary and keenly transmedial understanding of these identities, an understanding that is sensitive to the relationship between uses of the internet and the deeply embedded contextual and cultural factors that legitimate misogyny. Traditional transmedia research into fan cultures and engagement, along with more contemporary research that moves beyond the field's previous focus on storytelling and towards the social implications of transmedia in terms of identity creation, is especially useful and offers provocative ways of understanding how we think about and research gendered extremism across the contemporary mediascape.

The Manosphere, The Red Pill, and Incel

The manosphere has been described as an 'antifeminist coalition' (Ganesh, 2018: 34) and 'an ecosystem of disparate male grievance groups that emerged as a reaction to feminism' (Kutner, 2020: 7). These disparate groups are united in their opposition to feminism and their advocacy of men's rights, and are not isolated subcultures but a troubling reflection of the misogyny, racism, and homophobia weaved through the fabric of our contemporary public and private realities.[5] They make explicit, and catastrophise, a familiar narrative that indulges in nostalgia for a time before women's liberation and sexual emancipation, that insists that something essential was lost when women's sexuality became less heavily regulated by legislation and less heavily influenced by more traditional gender roles. These ideas are laden with a longing for a time when women more formally occupied social roles orientated towards supporting men. From this narrative, communities within the

manosphere have constructed an increasingly consistent ideology about human nature, biology, and sexuality: 'The Red Pill'.

The Red Pill itself is a metaphor from 1999 film *The Matrix* (Wachowski and Wachowski, 1999), in which main character Neo is offered two pills: one blue, which will take him back to his old life of blissful ignorance, and one red, which will show him the true nature of reality. As such, 'taking the red pill' became synonymous with becoming 'awake', or a raising of one's consciousness, a cultural awakening in which cisgender heterosexual men are 'opening their eyes to the reality of male subjugation by women' (Kutner, 2020: 7). Describing someone as 'red-pilled' implies that they are 'clear-eyed, truth-seeking heroes', and by extension, the blue-pilled 'are the intellectually lazy, scale-eyed, soma-taking masses' (Wendling, 2018). To be 'red-pilled' is to be conscious of the 'truth': that men are injured by the current social order, a social order that benefits women. This ideology is the culmination of a network of cognitive distortions taking place that centre men as the victims of a 'gynocentric social order' (Tomassi, 2013).

Rollo Tomassi is a thought leader in Red Pill circles, author of the book series *The Rational Male* (2013), and attributes the rise of gynocentrism to the introduction of the birth control pill in 1965. He argues that 'the gynocentric social order that we have is the natural logical extension of what happened once we were allowed the luxury of being able to have sex without having to worry about pregnancy' (Charlie and Ben Podcast, 2020). This Red Pill theory explains that men's innate mating strategy has been disrupted, natural biological realities have been altered, and instead of men having 'unlimited access to unlimited sexuality' (Charlie and Ben Podcast, 2020), it is women who have freedom, no longer needing to be selective about their chosen mate. Red Pill Theory states that women have become naturally hypergamous, continually and exclusively seeking relationships above their social status, both economically and in terms of a homogenous and highly normative conception of what makes people 'attractive'.

The Red Pill is a robust and coherent transmedial ideology, built on and evolving through multiple media types. Films, podcasts, dating apps, forums, blogs, YouTube channels, Discord servers all serve as arenas for collaboration on and dissemination of a very specific 'Red-Pilled' social reality. What differentiates groups and identities within these arenas is how they each respond to Red Pill Theory. Men Going Their Own Way (MGTOW)[6] is a movement dedicated to male separatism, the core ideal of which is to refrain from engaging in long-term committed relationships with women altogether. On the other end of the scale, Pick-Up Artists (PUAs)[7] take a more active approach, using social manipulation, or 'game' to try to play the system, using tricks and deceit to attract women and coerce them into sleeping with them.[8] Incel is an identity positioned around the fatalistic assumption that there is no way to combat their perceived low value on the sexual marketplace and in society more widely. There is a brand of masculinity that invests in the notion of sexual strategy and constructs its collective identity around 'a transformation

from weak beta men to strong, virile alpha men' (Dignam and Rohlinger, 2019: 600). Incel ideology rejects this transformative narrative entirely, its believers refusing to engage in the 'game' because they are certain they have already lost. In their view, their failure is biologically predetermined, a deeply nihilistic cohort who are not Red-Pilled but Black-Pilled.[9]

Incel discourse broadly claims that it is women and the freedoms wrongly gifted to them by advances in feminism that are responsible for their perceived lack of access to sex, for their 'involuntary celibacy', and because of this fate, they are doomed to loneliness, lack of physical pleasure, and the impossibility of a reproductive future. It is a rotten and deeply pessimistic mindset. Suicidal ideation is common practice, in jokes and memes and lore, in sad confessionals and cries for help. In extreme cases certain individuals have reacted to their suffering with horrific acts of violence. In California in 2014 Elliot Rodger posted a deeply troubled personal manifesto online before killing six people and then himself. In Toronto 2018 Alek Minassian drove a van through a crowd of people, killing 10 and injuring 14 (BBC News, 2018). Since 2019, The Canadian Security Intelligence Service has listed incels and gendered violence as one of four categories of 'Ideologically Motivated Violent Extremism' (CSIS Public Report, 2019), and in December 2020 there was a terror trial in Edinburgh, UK, investigating a researcher of Incel accused of 'intending to commit acts of terrorism' (BBC News, 2020). These misogynistic terror attacks demonstrate the troubling reality that these communities do not lie dormant on rogue forums across the Internet. Providing troubled individuals with cathartic escape and external validation and community, such spaces are unpredictable pressure cookers of anger and loneliness where ideas of desperate acts of evil can grow. Frustration is consistent across a community that denies that men are responsible for perpetuating gender inequality, instead claiming that 'feminism has systematically refused men's social, political, and economic opportunities, which has resulted in the oppression of men' (Dignam and Rohlinger, 2019).

Translocal Misogyny and Transmedia Technologies

Mass media has long played a foundational role in antifeminist propaganda (Faludi, 1992). Recent research has shown that antifeminism is even more virulent than previously believed (Banet-Weiser and Miltner, 2016), legitimised and distributed on an incredible scale thanks to the ever-growing efficiency of internet communication technologies. These platforms 'provide men's rights activists with relative anonymity and with the ability to confront women one-on-one, making the Internet the territory of choice for extremist misogynistic discourse' (Sobieraj, 2017).

The masculine identities we see being coded in these spaces are enabled by an organic process of engagement and performance that is strikingly reminiscent of definitions of transmediality as a kind of creative practice. While transmedia means that 'texts, users, and their practices – as digital data

– move across devices and platforms' (Fast and Jansson, 2019: 6), it also means that these texts, users, and practices are 'continually re-moulded and re-contextualised through these processes of circulation' (Fast and Jansson, 2019: 6), and as such, transmedia can be thought of as a broader social condition. These processes are foundational to the building of Incel, as the mutation of masculinity and antifeminism is absolutely reliant upon key affordances granted by multiple media platforms across the internet, such as anonymity and accessibility.

Digital sociologist Jessie Daniels has written that 'the internet's ability to facilitate a relatively inexpensive means of communication between and among people in dispersed geographic regions of the world is certainly one of the primary benefits white supremacists see in the medium' (2009: 7). Even as they have dramatically expanded the potential for online activism and social justice movements, alongside education and accessibility to information, the ways in which the internet is commonly deployed have also helped to create, sustain, and mobilise subcultures aligned with various fascistic or otherwise discriminatory ideologies.[10] Daniels describes an oppressive 'translocal whiteness', 'a form of white identity not tied to a specific region or nation but reimagined as an identity that transcends geography and is linked via a global network' (Back, 2001: 35). The capabilities of modern communication enable such intricate world-building in online spaces that the cultural impact of these ideologies is far reaching, the boundaries not set to one place, to one media type.

Misogynists and men's rights activists can gather and create mutually reinforcing groups and share language, ideology, and practices in much the same patterns as these white supremacist far-right groups. There is a translocal misogyny, a specific brand of radical masculinity with similarities to, and crossover with, translocal whiteness, but with its own specificities. Translocal misogyny, too, has been reimagined as an identity. It has transcended cultural and physical boundaries, flourishing in a viral way because of Reddit and Instagram and TikTok and targeted advertising. Liberated from geographical restriction, with 24-hour access to an antifeminist superhighway provided by social media and ubiquitous mobile computing. Misogyny is able to become the foundation for identity creation; in these circles, antifeminism is not just a political stance, but a personal philosophy attached to an essential, masculine core (Condis, 2018; Lin, 2017; Paul, 2018). Users of Incel forums and websites can access their worlds at any time, from any device, often reporting real-life events as they happen for feedback and support from the group. Reddit and YouTube are two key platforms on which the community rallies and collaborates. Videos such as 'Incels: Are women making them?' are circulated widely, voicing disdain for the community's perception of the status quo. In this instance, the creator argues that 'incels are mad because women get by on nothing but what they were born with, you have ovaries and they've got eggs in them? Congratulations you're worth something' (ReeeePost, 2020).

The community is able to discuss the ideas provoked in these videos both in the comments section and on subreddits dedicated to key aspects of the ideology. This is another way in which transmediality functions as a way of envisioning incel communities. If 'media provide unspoken guidelines for organisation of feeling' (O'Neill, 2018: 15), then the Incel community is able to access those guidelines and organise their feelings at any time from any place. In a thread titled 'Girl catches me browsing this forum on the bus' (Incels.co January 10, 2018a), the author documents his experience of being seen looking at a thread titled 'Raping sluts should be legal' by a woman whilst he is on public transport. Commenters on the post share their own experiences, with one user posting 'I browse it in my school library all the time' while another says 'hell no I wouldn't browse in public' (Incels.co Jan 10 2018a). Another user comments 'I've narrowly avoided being caught reading it in public a few times. Often on my phone at work' (Incels.co January 10, 2018a). The thread, like many others, evolves into a larger discussion about experiences with women, with one user posting 'when a female talks to me, I'm instantly irritated, roll my eyes. ... [S]he's only doing it to help herself, and I want her to burn' (Incels.co January 10 2018a). This violent rhetoric is well documented and typical in many male-dominated digital publics (Ferber, 2000; Jaki et al., 2019; Sobieraj, 2017).

The transmedial nature of these processes can be seen once again as we look to other media within the network that offer sites for the re-moulding and re-contextualising of identity (Fast and Jansson, 2018). We can observe 'the erosion of boundaries between media, which disassociates texts from particular mediated contexts and transforms them into nodes within a network of many different media' (Adams and Jansson, 2012: 303). Dating apps like Tinder and Bumble are platforms on which gender and sexuality are performed, judged, learned and controlled. In a thread about Tinder, the author has posted a screenshot from the app and titled the post '[RageFuel] JFL This is incel board user weed has already 10 likes on Tinder' (Incels.co March 31 2018c). For some the mere usage of a dating app is indication that the user is not actually a 'true' incel, with many calling him a 'fakecel' that 'needs to be banned' (Incels.co March 31 2018c).

The dating app becomes another avenue through which to reinforce the conditions of membership within the group. In this particular case, one user responds 'meanwhile I can't even get a landwhale to talk to me' (Incels.co March 31 2018c) (illustrating the way in which women are spoken about in these spaces). Another user wants evidence, writing, 'I demand seeing actual matches and you talking to them, setting up a date' (Incels.co March 31 2018c), while another is more critical still, saying 'incels are so autistic they think matches means anything, you haven't made it until you actually facefucked a girl more than once' (Incels.co March 31 2018c). The same thread also provides an example of the gatekeeping that takes place in the Incel community, where members require strict criteria for participation and are rejected if they do not possess certain characteristics. One user points out

that the author of the post 'is actually a 5'10" 24-year-old who has had multiple attractive girlfriends' and says 'lol at him trying to adjust his personality and appear "incel" to fit in here' (Incels.co March 31 2018c). Another user replies 'why isn't this fakecel banned yet?' (Incels.co March 31 2018c); having a girlfriend, or in this case having a girl acknowledge you on the bus, is cause for exile. This thread is not an isolated instance, but a common node in the network; each new thread becomes a hub within which the ideology is discussed and refined and the identity reinforced. The identity creation in these spaces is inherently a transmedial one, as real-life experiences, and other media types like television and dating apps, simply become further source material to establish the 'sense' of a core identity and check members' commitment to the cause.

A thread titled 'Roundup of Thailand Trip – girls, advice, conversation, screenshots etc' (Incels.co March 11 2018b) is an anecdote that spans several pages and details the user's sexual conquests on holiday in Thailand, down to rating the attractiveness of each woman, where he stayed, the food he ate, the SIM card he used for his mobile phone, and how he used Tinder to secure the meet-ups. The original poster types 'I met all the girls online. Tinder was 70% of the lays' and 'here's some screenshots of conversations with girls I banged to show you how it's done' (Incels.co March 11 2018b). He goes on to say 'I think girl number 3 was decent, girl 6 was OK, and girls 4, 8 and 9 were fuckable enough. Girls 1, 2 and 7 were definitely on the dodgy side, especially 7' (Incels.co March 11 2018b). In the comments on this post, which spans 26 pages, many users believe that because the original poster has had sex, he is not a true incel, and again call for him to be banned. They begin to discuss how race, class, and economic background affect how attractive they are, although not in these terms; one writes 'in the west, the average girl is far uglier than these girls', to which the original poster responds 'I was focussed on numbers, not quality' (Incels.co March 11 2018b).

These sentiments about 'quantity' and 'quality' as it pertains to the sexual marketplace are discussed in the work of Dr Rachel O'Neill, a media and communications scholar examining how gendered subjectivities are forged in and through wider cultural currents and the market mentality that defines modern dating and relationships. She discusses how

> the overwhelming concern to attain access to so-called high-value women – whose worth is calculated using aesthetic criteria that are deeply classed and racialised – demonstrates that the very architecture of desire is being remade by the economisation of social life within neoliberalism.
>
> (2018: 44)

Incels feel they cannot participate in this process, and so in a world where romantic disappointment and suffering are culturally produced and commercially managed (Illouz, 2013), extreme responses to those conditions develop.

O'Neill writes that 'sex is a commodity controlled by women and to which men seek to gain access' (2018: 34), and that it is 'ultimately recognition from other men that allows sexual capital to be translated into economic capital' (2018: 47). Within the Incel community the main source of injury is the perceived lack of access to, or active barring from, this commodity. Feeling as though their biologically predetermined traits prevent them from gaining this 'capital', incels see themselves at the bottom tier of a sexual marketplace where they are unable to accumulate the attractive partners that are (in their view) a direct indicator of a man's social value. Incel as an identity is fuelled and challenged by these neoliberal realities to terrifying effect. O'Neill notes that 'there is a profound insecurity neoliberalism fosters across a range of sites, including sexual and intimate relations' (2018, 31), and incels are a manifestation of this very insecurity.[11]

Under the pressure to participate in performative demonstrations of sexual agency and prowess, the Incel identity begins to take shape in a transmedial environment which offers constant access, an echo chamber of rhetoric and ideology, and a sense that every sphere of life reflects what The Red Pill has revealed. Rather than criticise the structures that animate narratives about the accumulation of attractive women, or attractiveness being equated with inherent value, the Incel community coalesce around a hopelessness created in direct response to the neoliberal rationalities that shape and influence intimacy and self-worth. This hopelessness is continually fed by multiple media sources (television, videos, images, dating apps, real-life experiences) across multiple platforms (Reddit, Incels.co, YouTube), and as such, is a transmedial entity.

Fan Culture and Engagement in the Incel Community

In addition to technological affordances, another key way in which a transmedial understanding of Incel can enlighten how we conceptualise the phenomenon is the way in which the community can be better understood through extrapolating from pre-existing transmedia research on fan cultures and engagement. These concepts can be used as frameworks to further conceptualise the scope of digital masculinities, highlighting the increasing relevance and social significance of transmedia studies.

Transmediated digital content has the potential and reach to transform how millions of young men construct and make sense of their masculinity, and on many of the most used platforms, individuals are increasingly trained to cultivate an oppositional consciousness to both feminism and women. Dignam and Rohlinger use the term 'oppositional consciousness' to describe the way in which virtual forums provide spaces where individuals can cultivate community (2019). Referring to an 'empowering mental state that prepares members of an oppressed group to undermine, reform, or overthrow a dominant' (Mansbridge and Morris, 2001: 25), oppositional consciousness is a helpful way of conceptualising the way in which Incels navigate and make

sense of their mutual grievances as their perceived lack of access to sex is explicitly articulated as oppression. Oppositional consciousness offers a framework for understanding the endurance of their grievances as it 'cultivates a sense of "we-ness" or collective identity among participants' (Dignam and Rohlinger, 2019: 593), which keeps them engaged over a sustained period of time.

This sustained engagement is another aspect of the Incel community which can be better understood through the lens of transmediality, as much existing research on transmedia identities coalesces around those identities being fan identities (Fiske, 1992; Jenkins, 2006). It is striking that the way in which audiences engage with content across media and are united in communities under one 'fan' identity bears a direct resemblance to the ways in which groups of men and boys engage with antifeminism across the mediascape. Just as transmedia consumers of entertainment are willing to 'chase' a story or group of characters over different content platforms (Jenkins, 2006), so do incels, gathering content from multiple sources and engaging in discussion and subsequent identity creation around shared texts and shared life experiences, 'leveraging the unique qualities of transmedia that allow for immersive representations of complex issues and environments' (Hancox, 2019: 332).

The Incel community has in fact created its own characters through which to theorise about the world. The 'Chad', for example, is the name given to the generic alpha male, an attractive man with traditionally masculine features such as a square jaw and pronounced cheekbones, who is said to be able to 'elicit near-universal positive male sexual attention at will' (Incels. wiki, December 23, 2020c). Chad's feminine counterpart is 'Stacy', an attractive woman often depicted as being vain and unintelligent, who is able to secure sexual intimacy through her good looks alone (Incels.wiki, Dec 19, 2020b). Images and memes and exaggerated caricatures of various characters circulate constantly across various platforms, with videos, diagrams, charts, and other memetic content serving to replicate and reinforce the ideological sentiment behind each of these characters within the grander narrative.

This content functions as a specific mode of transmedial circulation because of its viral and pervasive nature and its growing indispensability. It represents a kind of alternate reality constantly built and sustained, providing the vocabulary and tools on which Incel identity creation is built. Incels continually analyse the processes by which their worlds are constructed through these lenses, characters, and narratives, and then relate them back to their own self-identification. These characters exist as transmedia images that have become far more than jokes or explanatory devices; they are now powerful symbols with which many individuals deeply empathise and in which they see themselves reflected. Identification has long been highlighted as a driver of transmedia engagement in fan communities, as 'users identify with a character, or more generally with the ethos, the spirit, the mythos, the "feel" of the entire franchise world' (Lemke, 2009: 147). This sentiment again usefully describes the activities of the Incel community, where the ethos

and mythos of the narrative that positions unattractive men as the victims of an unjust system is a strong and unifying 'feel' of a 'world'.

Moreover, transmedia theories of fiction, such as those used to understand storytelling franchises, can be used to describe these communities because they are themselves engaged in fiction writing and reading as they create and share characters and language. Fast and Jansson concluded that 'identification is what attracts fans to media franchises in the first place, but also what makes them grow. Engaged fans produce their own paratexts (e.g. fanzines or fan websites), which in turn potentially reinforces fan identification' (2019: 23). Incel forums and manifestos can be interpreted as paratexts that branch from the main story of female evil and where recurring fictional characters enable them to characterise other members and relate to their experiences in language that they share and understand. Fink and Miller's (2014) work identified that transmedia platforms enable disadvantaged groups to create alternative public spheres. The Incel wiki page, YouTube channels, podcasts, and manifestos can all be seen as independent yet profoundly interrelated transmedia productions circulated to raise awareness of the suffering and oppression they purportedly face as self-diagnosed unattractive or undesirable men.

Studies have explored how transmedia narratives influence the construction of identity positions attached to markers such as gender orientation and sexuality. One such study found that when examining how young people spoke about American TV series *Glee* on social media, participants 'positioned their identities and selfhood in relation to the social and cultural themes of the programme' (Fast and Jansson, 2018; Marwick, Gray, and Ananny, 2014). These findings are in line with the Incel community, who position themselves in relation to the social and cultural themes of an ideology that states they are the victims of unfair systems, the losers of a genetic lottery. Their identities are oriented around this 'fact' with such magnetic potency that it shapes how they conceive of their existence and how they move through both the digital and real world.

Conclusion

In conclusion, there is a growing need for thoughtful and thorough research into the complex nature of incel identity, to examine cultural patterns and structures that allow such hives of dissent to flourish, and in extreme cases threaten members of the public, particularly women. When the film *Joker* (Phillips, 2019) was released, the US army was warned by the FBI about potential mass shooting threats at theatres organised by violent groups of incels who identified with the film's protagonist, a misunderstood loner character, hurt and rejected by society, who takes revenge on the system that alienates him. There is a pressing need for focussed exploration of these cultural moments and the identities and ideologies that populate and motivate them, an exploration which is conscious of the myriad cultural, economic,

and technological factors that are at play. Their violence and the relentless and unforgivable campaign that threatens, harasses, and injures women is inexcusable, and it was not created in a vacuum.

The transmedial nature of networked misogyny and antifeminist identity creation as seen in the Incel movement only increases as our society becomes increasingly dependent on networked digital technologies for self-expression and collaboration. Our sense of self is increasingly constructed within transmedia environments and reliant on transmedia technologies. The ability to connect, collaborate, store, and share information across various platforms and devices has altered the way in which we relate to, and understand, ourselves and our experiences; '[t]he socio-material prevalence of transmedia in everyday life now affects questions of who to be, who to interact with, and, ultimately, how to go about and feel about one's life, whether connected or not' (Fast and Jansson, 2019: 19). Ultimately, 'this escalating transmediatization of social practices, relations and identities produce a new kind of life environment', which includes both the foundational components of online circulation and diverse types of offline communication, called 'the transmediascape' (Fast and Jansson, 2019: 19).

The power of internet communication technologies has exponentially accelerated the formation and strength of this masculine identity, and we can observe a snowball effect occurring as these technological advancements continue to allow this ideology to spread and influence and recruit in an efficient and deliberate way. Transmediated digital content has transformed how young men construct and make sense of their masculinity. For many men in 'the manosphere', these difficult questions about who to be and how to feel about one's life are increasingly answered by radicalised communities of men's rights activists and misogynists who have gathered around the strong belief that men are the injured party in contemporary gender relations.

Notes

1 I.e., the network of new, identifiable communities of cisgender, heterosexual men and boys concerned with men's rights and antifeminism.
2 A group within the manosphere whose name, problematically, stems from the phrase "involuntarily celibate," meaning that they feel primarily injured by the fact that they perceive themselves to be unable to participate in sexual contact.
3 For the purposes of this chapter, 'Incel' with a capital 'I' refers to Incel as an ideology, a coherent belief system, whereas 'incel' with a lowercase 'i' refers to individual incels or groups of men who are incels, e.g., 'I believe in Incel' and 'I am an incel'.
4 And, increasingly, in mainstream media and political discussion, though this discussion is beyond the scope of this chapter. I explore the mainstreaming of antifeminist ideas in my current doctoral research, and my future publications will further pursue the danger of this normalisation.
5 My focus here is, roughly, on the transatlantic context of the UK, US, and Canada, but equivalent sentiments, with regional and national specificities, can be found in near ubiquity. Transmedia scholars attuned to different contexts will provide vital future work in understanding how ideas originate, travel, mutate, and sustain online and off.

6 https://www.reddit.com/r/MGTOW/; Shannon (1992); Vilar (1971).
7 https://www.reddit.com/r/seduction/;https://mpuaforum.proboards.com/; Strauss (2005); Valizadeh (2011).
8 Rachel O'Neill's (2018) book *Seduction* is a comprehensive and enlightening study of the pick-up artist community in London.
9 Incels.wiki is an online resource described as an encyclopaedia about Incel culture. It is said to be 'a repository of academia, folk theories, memes, people, and art associated with involuntary celibates' (Incels.wiki May 2020a) and was created and moderated by members of the Incel community.
10 A recent example is the coup in the US following Donald Trump's loss in the 2020 presidential election, where insurrection and outrage were partially fomented on Twitter and QAnon forums (Kendzior 2020; Neiwert 2017).
11 A key irony exists here in that those in the Incel community criticise many of the same constructions of masculinity that feminists do, "such as strength being an indicator of value, or aggression being a key trait in true manhood" (Dignam and Rohlinger, 2019). Incels, for the most part, ignore the fact that men are not the only group affected by neoliberalism's emphasis on meritocracy and entrepreneurship.

References

Adams, Paul C., and André Jansson. 2012. "Communication Geography: A Bridge between Disciplines." *Communication Theory* 3: 299–318.

Back, Les. 2001. "Wagner and Power Chords: Skinheadism, White Power Music and the Internet." In *Out of Whiteness: Color, Politics, and Culture*, edited by Les Back and Vron Ware, 94–132. Chicago: University of Chicago Press.

Banet-Weiser, Sarah, and Kate M. Miltner. 2016. "#MasculinitySoFragile: Culture, Structure, and Networked Misogyny." *Feminist Media Studies* 16 (1): 171–174. Doi: 10.1080/14 680777.2016.1120490.

Banet-Weiser, Sarah, and Laura Portwood-Stacer. 2017. "The Traffic in Feminism: An Introduction to the Commentary and Criticism on Popular Feminism." *Feminist Media Studies* 17 (5): 884–888. Doi: 10.1080/14680777.2017.1350517.

BBC News. 2018. "Elliot Rodger: How misogynist killer became 'Incel hero'." https://www.bbc.co.uk/news/world-us-canada-43892189

BBC News. 2020. "Terror trial told of 'Incels' cyber-culture backing attacks on women." https://www.bbc.co.uk/news/uk-scotland-edinburgh-east-fife-55257183

Charlie and Ben Podcast. 2020. Rollo Tomassi on Red Pill, Masculinity, and Dating in 2020. Video. YouTube: https://www.youtube.com/watch?v=GIZ269WqQZo&ab_chanel=Charlie%26BenPodcast

Condis, Megan. 2018. *Gaming Masculinity: Trolls, Fake Geeks, and the Gendered Battle for Online Culture*. Iowa City: University of Iowa Press.

CSIS Public Report. 2019. Government of Canada. https://www.canada.ca/content/dam/csisscrs/documents/publications/PubRep-2019-E.pdf

Daniels, Jessie. 2009. *Cyber Racism: White Supremacy Online and the New Attack on Civil Rights*. New York: Rowman and Littlefield.

Díaz, Pablo Castillo, and Nahla Valji. 2019. "Symbiosis of Misogyny and Violent Extremism: New Understandings and Policy Implications." *Journal of International Affairs* 72 (2): 37–56. https://www.jstor.org/stable/26760831

Dignam, Pierce Alexander, and Deana A. Rohlinger. 2019. "Misogynistic Men Online: How the Red Pill Helped Elect Trump". *Signs: Journal of Women in Culture and Society* 44 (3): 589–612. University of Chicago Press. Doi: 10.1086/701155.

Faludi, Susan. 1992. *Backlash: The Undeclared War Against Women*. London: Chatto and Windus.
Fast, Karin, and André Jansson. 2018. "Transmedia Identities: From Fan Cultures to Liquid Lives." In *The Routledge Companion to Transmedia Studies*, edited by Matthew Freeman and Renira Rampazzo Gambarato, 340–349. New York: Routledge.
Fast, Karin, and André Jansson. 2019. *Transmedia Work*. New York: Routledge.
Ferber, Abby L. 2000. "Racial Warriors and Weekend Warriors: The Construction of Masculinity in Mythopoetic and White Supremacist Discourse." *Men and Masculinities* 3 (1):30–56. Doi: 10.1177/1097184X00003001002.
Fink, Marty, and Quinn Miller. 2014. "Trans Media Moments: Tumblr, 2011-2013." *Television and New Media* 15 (7): 611–626. Doi: 10.1177/1527476413505002.
Fiske, John. 1992. "The Cultural Economy of Fandom." In *The Adoring Audience: Fan Culture and Popular Media*, edited by Lisa A. Lewis, 30–49. London: Routledge.
Ganesh, Bharath. 2018. "The Ungovernability of Digital Hate Culture." *Journal of International Affairs* 71 (2): 30–49. https://www.jstor.org/stable/26552328
Hancox, Donna. 2019. "Transmedia for Social Change: Evolving Approaches to Activism and Representation." In *The Routledge Companion to Transmedia Studies*, edited by Matthew Freeman and Renira Rampazzo Gambarato, 332–339. New York: Routledge.
Illouz, Eva. 2013. *Why Love Hurts: A Sociological Explanation*. Cambridge: Polity Press.
Incels.co. Jan 10 2018a. "Girl catches me browsing this forum on the bus." https://incels.co/threads/girl-catches-me-browsing-this-forum-on-the-bus.13626/
Incels.co. March 11 2018b. "Roundup of Thailand trip – girls, advice, conversation, Screenshots etc." https://incels.co/threads/roundup-of-thailand-trip-girls-advice-conversation-screenshots-etc.28034/
Incels.co. March 31 2018c. "JFL 'This is an Incel board' user 'weed' has already 10 likes on Tinder." https://incels.co/threads/jfl-this-is-an-incel-board-user-weed-has-already-10-likes-on-tinder.32852/
Incels.wiki. May 2020a. "Incel wiki: about." Last modified 15 May 2020. https://incels.wiki/w/Incel_Wiki:About
Incels.wiki. 19 Dec 2020b. "Stacy." Last modified 19 December 2020. https://incels.wiki/w/Stacy
Incels.wiki. 23 Dec 2020c. "Chad." Last modified 23 December 2020. https://incels.wiki/w/Chad
Jackson, Sam. 2019. "A Schema of Right-Wing Extremism in the United States." *International Centre for Counter-Terrorism*. Doi:10.19165/2019.2.06.
Jaki et al. 2019. "Online Hatred of Women in the Incels.me Forum: Linguistic Analysis and Automatic Detection." *Journal of Language Aggression and Conflict* 7 (2). Doi:10.1075/jlac.000226.jak.
Jenkins, Henry. 2006. *Convergence Culture: Where Old and New Media Collide*. New York: New York University Press.
Kendzior, Sarah. 2020. *Hiding in Plain Sight: The Invention of Donald Trump and the Erosion of America*. New York: Flat Iron Books.
Kutner, Samantha. 2020. "Swiping Right: The Allure of Hyper Masculinity and Cryptofascism for Men Who Join the Proud Boys." *International Centre for Counter-Terrorism*. Doi:10.19165/2020.1.03.

Lemke, Jay. 2009. "Multimodality, Identity, and Time." In *The Routledge Handbook of Multimodal Analysis*, edited by Carey Jewitt, 140–150. London: Routledge.
Lin, Jie Liang. 2017. "Antifeminism Online: MGTOW (Men Going Their Own Way)." In *Digital Environments: Ethnographic Perspectives Across Global Online and Offline Spaces*, edited by Frömming Urte Undine, Köhn Steffen, Fox Samantha, and Terry Mike, 77–96. Bielefeld: Transcript Verlag. http://www.jstor.org/stable/j.ctv1xxrxw.9
Mansbridge, Jane, and Aldon Morris. 2001. *Oppositional Consciousness: The Subjective Roots of Social Protest*. Chicago: University of Chicago Press.
Marwick, Alice, Mary L. Gray, and Mike Ananny. 2014. "'Dolphins Are Just Gay Sharks': Glee and the Queer Case of Transmedia as Text and Object." *Television and New Media* 15 (7): 627–647. Doi:10.1177/1527476413478493.
McRobbie, Angela. 2008. *The Aftermath of Feminism*. London: SAGE Publications Ltd.
Neiwert, David. 2017. *Alt-America: The Rise of the Radical Right in the Age of Trump*. London: Verso.
O'Neill, Rachel. 2018. *Seduction*. Cambridge: Polity Press.
Ong, Kyler. 2020. 'Ideological Convergence in the Extreme Right." *Counter Terrorist Trends and Analyses* 12 (5): 1–7. Doi:10.2307/26954256.
Paul, Christopher A. 2018. *The Toxic Meritocracy of Video Games: Why Gaming Culture Is the Worst*. Minneapolis; London: University of Minnesota Press.
Phillips, Whitney. 2015. *This Is Why We Can't Have Nice Things: Mapping the Relationship Between Online Trolling and Mainstream Culture*. Cambridge: MIT Press.
Phillips, Todd. 2019. *Joker*. Film. United States: Warner Bros.
ReeeePost. 2020. "Where do Incels come from?" Last modified 17 January 2021. https://www.reeeepost.com/news-and-politics/fraternity/where-do-incels-come-from/
Shannon, Lawrence. 1992. *The Predatory Female*. New York: Barner Books.
Sobieraj, Sarah. 2017. "Bitch, Slut, Skank, Cunt: Patterned Resistance to Women's Visibility in Digital Politics." *Information, Communication, and Society* 21 (8):1700–1714. Doi: 10.1080/1369118X.2017.1348535.
Tomassi, Rollo. 2013. *The Rational Male*. Nevada: Counterflow Media LLC. Urban Dictionary. 2020. "Incel." https://www.urbandictionary.com/define.php?term=incel&page=4
Vilar, Esther. 1971. *The Manipulated Man*. London: Seven Fires.
Wachowski, Lana, and Lilly Wachowski. 1999. *The Matrix*. Film. United States: Warner Bros.
Wendling, Mike. 2018. *Alt-Right: From 4Chan to the White House*. London: Pluto Press.

11 #PrayforAmazonia

Transmedia Mobilisation within National, Transnational and International Identities

Geane Carvalho Alzamora, Renira Rampazzo Gambarato and Lorena Tárcia

Introduction

Protecting the Amazon rainforest is one of the most important international activism topics (Zhouri, 2006). Since the 1970s, when environmental concerns emerged as a global political agenda, the Amazon has become one of the focuses of cross-border (and now transmedia) actions (Keck and Sikkink, 2014). From the perspective of global politics, the Amazon is a region in which different and conflicting cultural, social, political, and economic actors engage and compete.

In a connected environment, these kinds of disputes are spread among an array of online and offline platforms. In Brazil, the tropical forest has become one of those rich and complex story universes where power and narratives are amplified, (re)shaping identities that can be better understood when observed through the lens of what Elwell (2014) defined as the transmediated self: the implications of transmedia storytelling in transforming the identity experienced in the liminal space between the digital and analog spheres of our everyday lives.

In August 2019, a large-scale series of fires ignited the Amazon forest in Brazil and neighbouring countries. The case generated great national, transnational (other Amazon region countries), and international commotion. The collective actions were visible in media environments such as WhatsApp, online social networks such as Facebook and Twitter, and the press. The dispute of meanings among these actions – including the use of hashtags – was driven by media positioning from various and conflicting local identities, such as local residents and journalists, indigenous tribes, rural producers, prospectors, loggers, and environmentalists, as well as celebrities and representatives of international governments. Several hashtags permeated the collective actions in this scenario, including the hashtag #PrayforAmazonia, which reached online trending topics worldwide and mobilised international public opinion. The semantic ecosystem of hashtags in this context, especially the ubiquitous #PrayforAmazonia, circumscribed political positions in multiple media formats. In this chapter, we investigate how the predominant

DOI: 10.4324/9781003134015-15

trajectories of hashtags related to the Amazon fires reveal the multiplatform dispute of meanings among different identities that emerge and expand beyond local geopolitics, exposing and shaping multiple transmediated selves directly or indirectly related to the case.

Background

To introduce the context background, we present the timeline of events that led to the global spread of #PrayforAmazonia, which reached online trending topics worldwide on Twitter and mobilized international public opinion (see Table 11.1). The issue started in 2018, during the election campaign of the Brazilian right-wing president, Jair Bolsonaro, and attracted international outrage reflected on- and offline.

Table 11.1 The timeline of 2018–2019 events related to the global spread of #PrayforAmazonia

JUNE 6, 2018	Bolsonaro made disturbing statements regarding the environmental policies he was planning to pursue, triggering international concern.
	The hashtag #PrayforAmazonia appeared for the first time on Twitter, but without a political context.
OCTOBER 2018	*The New York Times* published the article "What Jair Bolsonaro's Victory Could Mean for the Amazon, and the Planet" (Sengupta, 2018).
	El Confidencial published the article "Bolsonaro Won, the Amazon Lost: Everything This Victory Implies for the Planet" (Saccone, 2018).
	After U.S. President Trump tweeted about a conversation with Bolsonaro, the hashtag appeared as an indicator of political and environmental tension for the first time.
NOVEMBER 2018	The newspaper *Folha de S. Paulo* published a report that deforestation in the Amazon region grew by 48.8% from August to October 2018, compared to the same period in 2017 (Watanabe, 2018).
	News reports published by *Folha de S. Paulo* (Brazil), NBC (United States), and *El Confidencial* (Spain) resonated on Twitter with the hashtag #PrayforAmazonia in Portuguese, English, and Spanish, but still with limited reach.
	Bolsonaro invited the lawyer Ricardo Salles to be his minister of the environment. Salles had previously been convicted of environmental fraud (Bloomberg, 2018).
JANUARY 2019	Bolsonaro assumed office on January 1 and announced new regulations that negatively affected indigenous populations. The hashtag appeared connected to negative responses to the announcement.

(*Continued*)

Table 1.2 (Continued)

MAY 2019	The newspaper *O Estado de S. Paulo* published the government's plans to use money donated by Europeans to finance the purchase of land in environmentally protected areas (Borges, 2019).
JULY 2019	Bolsonaro accused the state institution INPE (National Institute of Spatial Research), responsible for tracking deforestation, of disclosing false data.
	The tension between INPE and the government resulted in the exoneration of the president of the entity, Ricardo Galvão. The negative political backlash was huge on social media.
AUGUST 2019	On August 10, the "Day of Fire," the number of fires in the Amazon tripled from the previous 24 hours.
	European countries reacted to the fires. On August 15, Norway suspended donations supporting deforestation efforts in Brazil. Until then, Norway had donated around $1.2 billion to the Amazon fund (Reuters, 2019).
	On Twitter, Bolsonaro talked about whale hunts promoted by Norway but used a video that was not related to the country.
	On August 16, a resident of Rondônia state published images of the fires and called attention to the hashtag #PrayforAmazonia.
	Smoke from the fires in the northern region of Brazil reached São Paulo (in the southeast), with wide repercussions in the press. Images of burned animals spread across Twitter, connected to the hashtag. Twitter shares increased exponentially.
	Like a forest fire, the digital debate over burning in the Amazon spread rapidly on Twitter. Between August 20 and 23 alone, the discussion was tweeted in more than 150 countries, while the Amazon was mentioned at least 15 million times in Portuguese, English, French, and Spanish (Bernardo, 2019).
	On August 20, one of the most shared tweets using the hashtag #PrayforAmazonia – with more than a million likes and retweets – included aerial images of forest fires, but the images were not current.
SEPTEMBER 2019	On September 24, Bolsonaro addressed the United Nations (UN) General Assembly in a speech that denied that the Amazon was on fire and floated conspiracy theories.

Partly in response to the online movement, thousands of people worldwide protested in the streets regarding the burning of the Amazon (Baldauf, 2020). On August 23, 2019, demonstrations took place in cities such as London (United Kingdom), Paris (France), Madrid (Spain), Lisbon (Portugal), Berlin (Germany), Naples (Italy), and Amsterdam (Netherlands). On the same day, protests also took place in Brasília, São Paulo, and Rio de Janeiro, in Brazil (Baldauf, 2020).

Among other events connected to the Amazon crisis, we highlight the synod organised by the Catholic Church October 6–27, 2019, with the central theme 'Amazonia: New Paths for the Church and the Integral Ecology' (Baldauf, 2020). In addition, the indigenous populations in the Amazon, whose lands and livelihoods were literally burning, overcame their traditional ethnic rivalries and legacies of previous wars for a greater cause: the fight against threats to the Amazon region raised by Bolsonaro's government (Fellet, 2019). We condensed the background information on the Amazon fires due to the chapter page limits. These details are relevant for contextualising the analysis of the transmediatic nature of the communication process permeated by the hashtag #PrayforAmazonia.

The Transmediated Self in the Midst of Transmedia Mobilisation

Transmedia storytelling is a process. Gomez (2010, 10:45) characterises it as a 'process of conveying messages, themes or storylines to a mass audience through the artful and well-planned use of multiple-media platforms.' This process occurs in the liminal space between the digital and analog dimensions of everyday life, but transmedia storytelling does not concern only amorphous mass audiences. More importantly, the transmedia process intrinsically shapes our own sense of self. Elwell (2014: 244) refers to it as the transmediated self, the dispersed self:

> Like the transmedia productions of the entertainment industry, the transmediated self is dispersed across multiple media platforms, with each platform contributing according to the predominant character of its medium. Every status update, text message, and Google search represents a dispersed micro-story in the complex story-world of the transmediated self.

This chapter follows Elwell's (Elwell, 2014: 238–239) definition of the transmediated self, considering that:

> the model of transmedia storytelling and story-world construction provides a uniquely apt, if imperfect, lens for viewing and understanding how digital technology is transforming the creation and experience of identity in the space between our online and off-line worlds. This is the transmediated self.

While highlighting the importance of the mediatization of everyday life, Freeman and Gambarato (2019) contribute to Elwell's (2014) notion of transmediated self in the sense that 'one potentially important direction for the future of transmedia studies is for scholars to consider the increasing mediatization of life itself, and to better understand what it means to think of our digital lives as complex, intertwining, transmedial experiences' (Freeman and Gambarato, 2019: 9).

Moreover, Jansson and Fast (2019: 340) argue that the 'transmediated construction of human identities' is incorporated into our ordinary lives, and the consequence is that 'the socio-material prevalence of transmedia in everyday life now affects questions of who to be, who to interact with, and, ultimately, how to go about and feel about one's life, whether connected or not.' From a sociological perspective, the authors consider identity 'as a complex and negotiated interface between self and society rather than as a singular entity tied to particular areas of interest, media concepts, or narratives' (Jansson and Fast, 2019: 340). The transmedia identity (Jansson and Fast, 2019) and the transmediated self (Elwell, 2014) blur the membrane between off- and online life (Humphrey, 2019), creating a 'complex story-world of identity lived in the gap between the digital and the analog, the virtual and the real' (Elwell, 2014: 246). Humphrey (2019: 79) even states that 'we are the stories we tell ourselves and each other.'

In addition, Elwell (2014: 234) claims that 'in our age of constant connectivity and ubiquitous computing, self-identity is increasingly fashioned according to the aesthetics of transmedia production.' There are multiple approaches to understanding identity: from the idea of any attempt to create and maintain views about oneself (Renner and Schütz, 2008) to the shaping of someone's values, beliefs, practices, and discourses (Masolo, 2002), and to the sense that psychological identity is shaped by surroundings (Verhaeghe, 2014). In the context of the transmediated self, the outside world 'acts as a constant mirror of identity' (Verhaeghe, 2014: 7). Although on- and offline identities are not exactly equivalent, identity is shaped in the space between on- and offline experiences: 'We live inside that gap' (Elwell, 2014: 242). Elwell (2014: 234) therefore proposes that 'the transmedia paradigm, taken as a model for interpreting self-identity in the liminal space between the virtual and the real, reveals a transmediated self constituted as a browsable story-world that is integrated, dispersed, interactive, and episodic.'

Jansson and Fast (2019) relate transmedia identities to the social mobilisation sphere. The authors refer to social mobilisation as 'the claiming of voice, civil rights and recognition among certain social groups, especially minority groups, and marginalised communities' (342). Furthermore, Costanza-Chock (2011) calls it 'transmedia mobilization,' which 'involves engaging the social base of the movement in participatory media making practices across multiple platforms.' In a recent interview, Gerbaudo emphasises the importance of the 'we' in contemporary socio-technical mobilisation:

> collective identity was long deemed to be a condition for social movement mobilization; it is not anymore, as people can be basically mobilized without asking them to adhere to a 'we'. People can simply be mobilized at a personal level, by creating personalized action frames. My idea is that this is not the case: collective identity and identification are still very important in contemporary movements; we see proliferation of identities of all kinds.
>
> (Gerbaudo and Romancini, 2020: 113–114)

Elwell (2014: 246) also reinforces the presence of the collective dimension at the heart of the transmediated self, emphasising the fact that 'the transmediated self resembles an interactive performance involving multiple actors and encompassing multiple episodic narratives that are dispersed across an array of media platforms and yet integrated around an ongoing dialectic of identity formation.' Thus, the transmediated self plays an important role amid socio-technical transmedia mobilisations.

Gerbaudo and Treré (2015: 865) exemplify manifestations of collective identity online in social movements around the world, such as Occupy Wall Street, the Arab Spring, and the Indignados. In the case of Occupy Wall Street, for instance, the authors mention hashtags like #wearethe99percent as operational tools 'by means of which social movements define their collective sense of self, who they are and what they stand for.' We can trace a parallel situation with the hashtag #PrayforAmazonia in the context of the socio-technical mobilisations regarding the 2019 Amazon fires. In addition, Gerbaudo and Treré (2015: 865) argue that social media platforms such as Facebook and Twitter play a 'central role in the process of identity construction. They have been the sites where new collective names, icons, and slogans have been launched, and where a new iconography and lexicon has been forged.' This happened in the case of the transmedia mobilisation propagated by the hashtag #PrayforAmazonia.

The implementation of transmedia strategies in the realm of social mobilisation or activism was first described by Srivastava (2009, 2014) as transmedia activism. Notwithstanding, Costanza-Chock (2011, 2014) argues that the term transmedia mobilisation better reflects the practices involved in this kind of sociopolitical claim (like the one this chapter explores), as the term *transmedia activism* is concerned with the narratological aspects of transmedia storytelling practices (Bicalho, 2019). In contrast, Vieira (2013) refers to three levels of engagement in multiplatform social mobilizations: (1) adherence, (2) mobilisation, and (3) activism. Adherence implies a mere thematic identification with the cause, mobilisation occurs when network propagations are triggered, and activism is characterised by the maximisation involvement via systematic actions to increase the visibility of the cause (Gambarato, Alzamora, and Tárcia, 2020). Thus, the transmedia mobilisation originated by the hashtag #PrayforAmazonia is inserted in a semiotic context in which 'hashtags articulate related political positioning, forming symbolic links that highlight collective processes of meaning' and form indexical 'hyperlinks that bring together various publications, in specific media contexts and in different temporalities, from a common meaningful form' (Gambarato et al., 2020: 30).

This type of sociopolitical hashtag is at the centre of transmedia mobilizations with a concomitant relationship with the transmediated self and collective identities, shaping what Elwell (2014: 243) refers to as 'the story-world of "you,"' meaning the

transmedia product made up of sprawling identity markers ranging from likes, location, and friends to reading habits, data usage, and mortgage payments, all of which is algorithmically woven together to form the complex tapestry of your life in the space between the real and the virtual.

(243–244)

Departing from the #PrayforAmazonia transmedia mobilisation, it is possible to establish a parallel between the transmediated self (Elwell, 2014) and the approach proposed by Moloney (2013, 2020) when describing what he calls 'feral transmedia journalism':

This is not a planned and curated form of transmedia journalism. It is a natural form created by each individual as he or she engages with the story. It illustrates the idea that we can engage with multiple characters across multiple stories in multiple places to achieve what game designer Neil Young calls "additive comprehension." We are deeply engaged when rapidly moving events raise cultural, civil or environmental concerns, or [have]an immediate impact on our lives.

(Moloney, 2013)

Moloney (2020) proposes three types of transmedia storyworlds in rapidly evolving journalism contexts: (1) native, (2) emergent, and (3) feral. Native transmedia journalism applies to the cases in which its transmedia nature is designed from the start by the news producers. Emergent transmedia journalism occurs when transmedia stories emerge from traditional reporting, although they were not envisioned from the beginning. Feral transmedia journalism applies to the cases in which its transmedia nature was not designed by the news producers but instead, was shaped by massive public interest. As an example of the feral type, Moloney (2020: 4687) mentions 'the enormous, fast-changing, and complex feral transmedia storyworld of the COVID-19 pandemic.' In this sense, we approach the #PrayforAmazonia mobilisation as a feral transmedia storyworld – it exists in other taxonomies of storytelling, not just in journalism – born from the extensive interest of various actors within national, transnational, and international collective identities.

The hashtag #PrayforAmazonia was not defined by a certain media outlet or restricted to one social media network: the hashtag embraced an array of media entities and individuals, and was inspired by previous uses of the hashtag #Prayfor. In 2011, the earthquake in Tohoku, Japan, ignited the first of these hashtags with #PrayforJapan (Margolin, 2016). Ever since, #Prayfor hashtags have become the normative response to tragic events that cause a worldwide outcry, such as the 2013 Boston marathon explosions (#PrayforBoston) and the 2017 terrorist attack in London (#PrayforLondon). Researchers suggested that hashtag dynamics are governed by complex

contagion models in which multiple sources of exposure are required before other individuals adopt the same behaviour (Fink et al., 2016; Mønsted et al., 2017). Consequently, the 'more people see sympathy expressed with #PrayFor, the more they expect #PrayFor is where others will look for sympathy. And so the more they direct their messages to it' (Margolin, 2016). Nevertheless, the religious overtone of #Prayfor hashtags has been criticised as a possible detraction from initiatives for real action (Browden, 2015). To understand how the trajectories of hashtags related to the Amazon fires reveal multiple transmediated selves – including the transmediatic dispute of meanings among different identities – we continue with a semiotic analysis centred on #PrayforAmazonia.

Methodology of the Analysis

This study is based on a combination of quantitative and qualitative methodological procedures. From a quantitative perspective, we automatically and manually collected data on Twitter to verify the predominant communicational activity in the investigated period from June 2018 to September 2019, as shown in Table 11.1. The qualitative perspective incorporates semantic levels of three selected cases for analysis according to Peircean semiotics. Our approach is based on Peirce's semiotic theory, specifically his notion of semiosis. Communication, according to Peirce, is a specific process of semiosis, that is, a sign process (Nöth, 2014). In the impossibility of ascertaining the entire communication process (semiosis), as it is infinite, we chose to investigate interrelated case studies in the corpus. We focus on Twitter to analyse how the collective actions in the context of the predominant trajectories of #PrayforAmazonia, related to the Amazon fires in August 2019, reveal the transmediatic dispute of meanings among different identities. Twitter's international scope, with local and global outreach, is adequate for the empirical perspective we investigated. The corpus is constituted by the interconnection of events related to the fires in the Amazon region mediated by the hashtag #PrayforAmazonia in the national (Brazil), transnational (countries of the Amazon rainforest region: Peru, Venezuela, Bolivia, Ecuador, and Colombia), and international (global) Twitter trending topics.

Although the Amazon fires occurred in August 2019, we found #PrayforAmazonia first appeared on Twitter in 2018, in another semantic context (the first tweet refers to a Spanish newspaper's criticism of President Bolsonaro, as mentioned in Table 11.1). The search for the first occurrence of this hashtag traces an extended trajectory.

As 'the prefix "trans" delineates singular media trajectory, insofar as it strategically points to the deviations and transgressions that usually characterise the tactical resignifications of collective actions' (Gambarato et al., 2020: 8), we investigate how and to what extent transmedia strategies and tactics permeate the trajectory of #PrayforAmazonia, taking into account the transmedia self sense involved in the dynamics developed around the hashtag.

As discussed in the previous section, we consider that the transmedia dynamics of #PrayforAmazonia generate a kind of feral journalism storyworld (Moloney, 2020), because its transmedia nature was not designed by the news producers (transmedia strategy) but instead, was shaped by massive public interest (transmedia tactics). Therefore, the hashtag is also a kind of transmedia mobilisation that involves modes of adherence, mobilisation and activism (Bicalho, 2019; Costanza-Chock, 2014; Vieira, 2013) around a common cause. In this case, the transmedia strategy is related to the social appropriation of the hashtag #Prayfor, observable as transmediated self and distinctive collective identities. Thus, the main analytical operator is the tactical resignification related to the transmediated self in the context of the hashtag #PrayforAmazonia on Twitter.

Data were automatically and manually collected using the TweetDeck (tweetdeck.twitter.com) and Trendogate tools (trendogate.com). The TweetDeck tool allows retroactive manual collection from specific hashtags, and the Trendogate tool allows collection of daily data from trending topics on Twitter in several simultaneous locations. Data about tweets using the hashtag #PrayforAmazonia have been collected since its first appearance in 2018. Data on trending topics were collected between August 19, 2019, and September 24, 2019, from the following locations: Peru, Venezuela, Bolivia, Ecuador, Colombia, Brazil (countries that constitute the Amazon region), and the World (global trendings).

The following hashtags are most frequently associated with #PrayforAmazonia: #amazonfire, #amazoniaenllhamas, #climatestrike, #fridaysforfuture, and #prayforamazonas. In association with #PrayforAmazonia, these hashtags operate as symbolic mediations that specify the theme investigated in each context of meaning. The study showed that the hashtag #PrayforAmazonia was highlighted nationally, transnationally, and internationally.

The number of replies to tweets using the hashtag #PrayforAmazonia peaked on August 23, 2019, and August 25, 2019. Among the most shared links during this period is an online petition (more than 35,000 shares) that calls for the suspension of international trade with Brazil because 'Brazil is not a reliable trade partner and its current leadership is a threat to the future of the planet' (Diem25, 2019) and the blogpost (almost 20,000 shares) about 14 ways to help Amazonas (Alhy, 2019). These two tweets exemplify the English (global) and Spanish (regional) languages involved in the corpus.

The Twitter users most mentioned in the corpus are institutional profiles. The main mention is @ONUMedioAmb, a user who refers to the United Nations (UN). The second is @lopezobrador, the official account of the president of Mexico. The third is @MartinVizcarraC, the official account of the president of Peru. Then @IvanDuque, the president of Colombia, and immediately after, @jairbolsonaro, the president of Brazil. (The data extractor did not differentiate between @ Jair.bolsonaro (with dot) and @jairbolsonaro (no dot), which may have interfered in the positioning of the data collected in the ranking.)

The diversity of the themes related to #PrayforAmazonia and the breadth of the communication activity generated around the trajectory of this hashtag during the period investigated require an analytical perspective that emphasises the dispute of meanings among different identities. According to Nöth (2020: 183), 'trajectories are in many ways at the root of signs and of processes of semiosis.' Thus, we opted for Peircean semiotic analysis of the communicational process of hashtags as a semiotic trajectory, focusing on three case studies intertwined by the symbolic mediation of the hashtag #PrayforAmazonia. The three cases are (1) the 'Day of Fire,' when the fires were allegedly planned by farmers, (2) the sky over São Paulo became dark with smoke from the fires, and (3) Bolsonaro's speech to the UN General Assembly.

From the Peircean semiotic viewpoint, 'the trajectory is related to the path of semiosis or sign action. The Peircean sign is a triadic entity (sign-object-interpretant) that unfolds continuously according to a purpose' (Gambarato et al., 2020: 3). We understand each hashtag #PrayforAmazonia as a triadic entity. It is a sign that is partially determined (object) by the events related to the Amazon fires, and it can produce some effects (interpretants), which can reframe some meanings of the hashtag according to the diversity of identities involved in it. The interpretant is a new sign that mediates one triadic entity and another by the association of the adjacent signs (collateral experiences). Thus, each social use of this hashtag can reframe its semiotic trajectory, its interpreted meaning.

According to Bergman (2010), collateral experience is related to previous familiarity with what the sign denotes. In this sense, each individual use of the hashtag #PrayforAmazonia expresses a set of meanings related to the specific familiarity with the context referenced by the hashtag. Moreover, it adds meanings from personal experiences with the theme (collateral experience). In other words, the social use of the hashtag redefines the course of the hashtag's meaning according to the variety of identities involved. In this way, an analysis of social use of selected cases of the hashtag is sufficient to demonstrate its communication process because this is infinite.

The following criteria guided the selection of the three cases to be analysed: (1) communication activity generated in the form of shares, visualisations, and comments; (2) the ability to manage diverse identity perspectives; and (3) the capacity to reframe the reference event. In the next section, we present the three cases and relate them to each other within the scope of the investigated hashtag.

Semiotic Analysis of #PrayforAmazonia

Day of Fire

The prominent social use of the hashtag #PrayforAmazonia during the 2019 Amazon fires was reported in the weekly magazine *Newsweek* (Georgiou, 2019). According to this news report, many social media accounts used the

hashtag #PrayforAmazonia to criticize the Brazilian government's lack of concern about the fires.

The Amazon fires were triggered by a group of Brazilian farmers on WhatsApp. The episode became known as the 'Day of Fire' (see Table 11.1). The first news report about the 'Day of Fire' was published on August 5, 2019, by *Folha do Progresso*, a local newspaper in the Amazon region (Piran, 2019). The conversation between rural producers on WhatsApp indicated August 10, 2019, was the day to promote fires in the region, with the aim of enlisting support from government authorities to expand cattle grazing areas in the Amazon. Notwithstanding, a year later, only 5% of those responsible for the 'Day of Fire' in the Amazon had been punished (Jornal Nacional, 2020). This situation emphasises the dimension of transmedia self because it involves multiple actors and encompasses multiple episodic narratives that are dispersed across an array of media platforms and yet integrated around an ongoing dialectic of identity formation (Elwell, 2014), as already discussed earlier in the chapter.

From a Peircean semiotic perspective, the media representation of the 'Day of Fire' can be understood as the sign, the episode of the farmers' conversation on WhatsApp can be understood as the object, and the social use of #PrayforAmazonia can be understood as the interpretant. Each social use of #PrayforAmazonia associates adjacent signs (collateral experience) in the semiosis, according to specific self-representation. Thus, the social use of this hashtag gives a collective dimension to each position in this topic. In this sense, the #PrayforAmazonia hashtag operates as sign mediation, or semiosis, because it produces new meanings in each particular sign association (collateral experience). The more visibility the hashtag reaches on the network, the greater the social reach of what the sign denotes, that is, the reference episode. Moreover, each social use of this hashtag contributes to enrich and diversify its semiosis. Thus, it also constitutes a process of transmediated self as it 'describes the integrated, dispersed, episodic, and interactive narrative identity experience in this space between the virtual and the real' (Elwell, 2014: 243).

According to studies reported by the BBC News Brasil (Gragnani, 2019), the social mobilisation in Portuguese, Spanish, English, and French on Twitter around the Amazon fires was different. The report highlighted the social use of the hashtag #PrayforTheAmazon, a variation of #PrayforAmazonia, in this context.

One example of how such differences can be represented is the game 'Olha o que está acontecendo na Amazônia!' [Look what is happening in the Amazon!], a transmedia extension related to the theme, in which the main character is Bolsonaro, and his goal is to destroy as many trees as possible. The game was shared with the hashtag #PrayforAmazonia (Ibanez, 2019). Social use of this hashtag to share this game operates as a semiosis that expands the transmedia narrative in question.

Day Became Night in São Paulo

On August 19, 2019, the sky of São Paulo, the largest city in Brazil (3,800 km from Manaus, the capital of the state of Amazonas), became completely dark during the day (see Table 11.1). The rare phenomenon was considered a consequence of the Amazon fires (G1 SP, 2019). It became one of the most commented on events on Brazilian Twitter, boosted the social use of the hashtag #PrayforAmazonia, and signalled yet another stage of the #PrayforAmazonia semiosis. This episode intensified the mobilisation of international actors, including celebrities such as Madonna, Leonardo di Caprio, and Viola Davis, who used the hashtag #PrayforAmazonia (Kirkland, 2019). They contributed to the creation of the 'sense of us' on social media, as argued by Gerbaudo and Treré (2015) and Gerbaudo and Romancini (2020). Photos of the skies above São Paulo becoming pitch black during the daytime shared on Twitter had an impact on the circulation of the sociopolitical hashtag #PrayforAmazonia (Bramwell, 2019).

On August 20, 2019, however, one of the most shared tweets using the hashtag #PrayforAmazonia – with more than a million likes and retweets – included aerial images of forest fires, but they did not show the situation in the Amazon at the time (Bramwell, 2019). From the Peircean semiotics perspective, the power of the image (the sign), referring to the Amazon fires (the object), generated poignant political meanings (the interpretant) especially when, on August 22, 2019, French President Emmanuel Macron himself shared one of these fake images (Macron, 2019). Another affecting example of political misuse of images re-signifying the Amazon fires occurred in September 2020, when the Brazilian minister of the environment, Ricardo Salles, shared on Twitter a video that denies the Amazon forest burned with images of the golden lion tamarin, an animal that lives exclusively in the Atlantic forest – far away from the Amazon (UOL, 2020).

In addition, still in August 2019, the transmediated self acquired new colours with President Macron's blunt criticism concerning the Amazon crisis and the inclusion of the topic in the agenda of the G7 (the group formed by the world's seven most-industrialised nations) meeting in Biarritz. In response, Bolsonaro liked a sexist Facebook post that unfavourably compared the French president's wife, Brigitte Macron (who was 66 years old at the time), and Bolsonaro's third wife, who was 37 years old (Euronews, 2019), generating a diplomatic feud. All these ramifications and tactical resignifications of the Amazon fires conform Moloney's (2020) feral journalism storyworld, as its transmedia nature was not planned by the news producers (transmedia strategy) but emerged organically on social media contexts (transmedia tactics). This situation reveals multiple transmediated selves, since it represents self-identity in the liminal space between the virtual and the real (Elwell, 2014). It is also a browsable storyworld that is integrated, dispersed, interactive, and episodic as it is typical of transmediated self contexts.

Speech at the UN General Assembly

On September 24, 2019, President Bolsonaro addressed the UN General Assembly (see Table 11.1). During the speech, in which he discussed conspiracies, he denied that the Amazon was on fire and 'blam[ed] Emmanuel Macron and the "deceitful" media for hyping this year's fires in the Amazon' (Phillips, 2019c). In a combative 30-minute speech, Bolsonaro claimed: 'Our Amazon is larger than the whole of western Europe and remains virtually untouched – proof that we are one of the countries that most protects the environment' (Phillips, 2019c). Among his controversial pledges during the UN speech, Bolsonaro positioned his intention to reduce the size of protected indigenous territories in the Amazon region to open such areas to commercial mining. In an attempt to present himself as a friend of the indigenous population, Bolsonaro invited a young indigenous supporter, Ysani Kalapalo, to attend his address at the UN. This manoeuvre was a response to indigenous leaders, including Raoni Metktire (the Xingu indigenous park's best-known leader), denouncing him before his UN speech (Phillips, 2019a).

Bolsonaro's controversies and hardline anti-environment rhetoric are interwoven with the surge of anti-indigenous violence in the Amazon (Phillips, 2019b). In December 2019, Greta Thunberg, the Swedish environmental activist, tweeted a condemnation of the murders of indigenous people fighting the illegal deforestation of the Amazon forest. In response, Bolsonaro hit back: 'It's amazing how much space the press gives this kind of *pirralha* [little brat]' (Phillips, 2019b), referring to Thunberg. However, she 'appeared to take Bolsonaro's disparagement as a badge of honour, changing her Twitter biography to Pirralha' (Phillips, 2019b).

The power of Bolsonaro's speeches (the sign), referring to the Amazon crises (the object), generated diversified political meanings (interpretants) nationally, transnationally, and internationally. In September 2020, Bolsonaro addressed the UN General Assembly via video with another polemic speech, repeating himself and insisting on blaming the international community for a 'brutal disinformation campaign about the supposed degradation of the Amazon as well as Brazil's Pantanal wetlands' (Dominguez, 2020). Unfortunately, the Amazon fires are far from over in Brazil and in other areas of the Amazon region. In September 2020, the smoke from Amazon and Pantanal fires reached São Paulo again (Fonseca, 2020), and during the same period, Bolivia declared a state of emergency because of the fires (Molina, 2020).

As demonstrated by the diversified trajectories of these cases related to the #PrayforAmazonia hashtag, transmedia identities permeate the social mobilisation sphere (Jansson and Fast, 2019), according to the collateral experience inscribed in each social use of the hashtag in the context of the 2019 Amazon fires. Therefore, the trajectory of the hashtag #PrayforAmazonia involves the transmediatic dispute of meanings among different identities.

Consequently, it embraces diversified transmediated selves permeating the hashtag dynamics.

Final Considerations

Sociotechnical transmedia mobilizations mediated by hashtags such as #PrayforAmazon reflect the intricate mechanism constituting the individual and collective sense of identity of transmediated selves characteristic of the contemporary connected world. 'We no longer "go online", rather the Internet is of a piece with the infosphere where we already are and of which we are increasingly a part' (Elwell, 2014: 235).

Transmediated selves expand beyond local geopolitical contexts and overflow locally, nationally, transnationally, and internationally. In this sense, we approached the #PrayforAmazonia mobilisation as a feral transmedia storyworld born from the extensive interest of various actors to understand how the trajectories of hashtags related to the Amazon fires reveal multiple transmediated selves and the transmediatic dispute of meanings among different identities.

As demonstrated, #PrayforAmazonia operates as sign mediation, or semiosis, because it produces new meanings in each sign association (collateral experience). The more visibility the hashtag reaches on the network, the greater the social reach of what the sign denotes, that is, the reference episode. In an interview for the Brazilian newspaper *Folha de S. Paulo*, Bruno Latour (Amaral, 2020) considers that what we see today in Brazil is a perfect storm: If politics has become so crazy, it is because the crisis is very deep, and it is about the climate. For him, if Brazil manages to find a solution, it will save the rest of the world. Perhaps this solution – if it comes – will reveal new transmediated selves connected to a hashtag that reflects a stronger action related to the political power of humanity instead of prayers for interference from the gods.

Acknowledgement

The authors thank Victor Góes Pacheco, an undergraduate student in Social Communication (UFMG/Brazil) and a recipient of the Scientific Initiation scholarship (CNPq/UFMG-Brazil), for carrying out automatic and manual data collection on Twitter and data systematisation.

References

Alhy. 2019. "14 Maneras de Ayudar al Amazonas [14 Ways to Help Amazonas]." *V for Vegetarian Blog*, August 23, 2019. Accessed 9. http://vforvegetarian.blogspot.com/2019/08/14-maneras-de-ayudar-al-amazonas.html

Amaral, Ana Carolina. 2020. "Se o Brasil Achar Solução para Si, Vai Salvar o Resto do Mundo, diz Bruno Latour [If Brazil Finds a Solution for Itself, It Will Save the

Rest of the World, Says Bruno Latour]." *Folha de S. Paulo*, September 12, 2020. Accessed November 6, 2020. https://www1.folha.uol.com.br/ambiente/2020/09/se-o-brasil-achar-solucao-para-si-vai-salvar-o-resto-do-mundo-diz-bruno-latour.shtml

Baldauf, Cristina. 2020. "Reflections on Democracy and the Participation of Society in Biodiversity Conservation." In *Participatory Biodiversity Conservation*, edited by Cristina Baldauf, 3–14. Cham: Springer.

Bergman, Mats. 2010. "C. S. Peirce on Interpretation and Collateral Experience." *Signs* 4: 134–161.

Bernardo, Kaluan. 2019. "Por Que Faz Sentido Usar #PrayForAmazonia nas Redes Sociais? [Why Does It Make Sense to Use #PrayforAmazonia on Social Networks?]." *TAL UOL*, August 26, 2019. Accessed October 20, 2020. https://tab.uol.com.br/noticias/redacao/2019/08/26/por-que-faz-sentido-usar-preyforamazonia-nas-redes-sociais.htm

Bicalho, Luciana A. G. 2019. "A Função Mediadora das Hashtags no Processo de Impeachment de Dilma Rousseff: Semiose e Transmídia [The Mediating Role of Hashtags on the Impeachment Process of Dilma Rousseff: Semiosis and Transmedia]." PhD diss., Federal University of Minas Gerais, Brazil.

Bloomberg. 2018. "Pick for Brazil's Environment Ministry Accused of Favoring Industry." *Bloomberg*, December 10, 2018. Accessed October 20, 2020. https://news.bloomberglaw.com/environment-and-energy/pick-for-brazils-environment-ministry-accused-of-favoring-industry

Borges, André. 2019. "Governo Quer Usar Fundo Amazônia para Indenizar Desapropriações [Government Wants to Use Amazon Fund to Indemnify Expropriations]." *O Estado de S. Paulo*, May 25, 2019. Accessed October 26, 2020. https://sustentabilidade.estadao.com.br/noticias/geral,governo-quer-usar-fundo-amazonia-para-indenizar-desapropriacoes,70002842939

Bramwell, Kris. 2019. "Brazil Fires Prompt 'Prayers' for Amazon Rainforest." *BBC*, August 23, 2019. Accessed October 26, 2020. https://www.bbc.com/news/blogs-trending-49406519

Browden, George. 2015. "Paris Attacks: Poignant Cartoon Uses #PrayForParis Hashtag to Plead 'We Don't Need More Religion'." *The Huffington Post*, November 14, 2015. Accessed October 26, 2020. https://www.huffingtonpost.co.uk/2015/11/14/paris-attacks-cartoon-pray-for-paris-hashtag-religion_n_8563360.html?guccounter=1

Costanza-Chock, Sasha. 2011. "Transmedia Mobilization." Accessed August 31, 2020. https://cyber.harvard.edu/events/luncheon/2011/03/costanzachock

Costanza-Chock, Sasha. 2014. *Out of the Shadows, into the Streets! Transmedia Organizing and the Immigrant Rights Movement*. Cambridge, MA: MIT Press.

Diem25. 2019. "Suspend Free Trade with Brazil!" Accessed September 10, 2020. https://i.diem25.org/en/petitions/37

Dominguez, Claudia. 2020. "Is the Amazon Safe in Bolsonaro's Hands?" *CNN*, September 23, 2020. Accessed October 26, 2020. https://edition.cnn.com/2020/09/22/americas/brazil-bolsonaro-unga-amazon-intl/index.html

Elwell, J. Sage. 2014. "The Transmediated Self: Life between the Digital and the Analog." *Convergence: The International Journal of Research into NewMedia Technologies* 20 (2): 233–249.

Euronews. 2019. "Brazil's Jair Bolsonaro Attacks Macron's Wife in 'Sexist' Facebook Post." Accessed October 26, 2020. https://www.euronews.com/2019/08/26/brazil-s-jair-bolsonaro-attacks-macron-s-wife-in-sexist-facebook-post

Fellet, João. 2019. "Índios se Aliam a Antigos Inimigos Contra planos de Bolsonaro na Amazônia [Indians Ally with Former Enemies against Bolsonaro's Plans in the Amazon]." *BBC News Brasil*, September 2, 2019. Accessed October 26, 2020. https://www.bbc.com/portuguese/brasil-49528317

Fink, Clay, Aurora Schmidt, Vladimir Barash, Christopher Cameron, and Michael Macy. 2016. "Complex Contagions and the Diffusion of Popular Twitter Hashtags in Nigeria." *Social Network Analysis and Mining* 6 (1): 1–19.

Fonseca, Iolanda. 2020. "Amazon, Pantanal Fires Spread over 4,000 Kilometers, Smoke Reaches Neighboring Countries." *The Rio Times*, September 21, 2020. Accessed October 26, 2020. https://riotimesonline.com/brazil-news/miscellaneous/covid-19/smoke-from-amazon-and-pantanal-fires-spreads-over-4000-kilometers-and-reaches-neighboring-countries/

Freeman, Matthew, and Renira R. Gambarato. 2019. *The Routledge Companion to Transmedia Studies*. New York: Routledge.

G1 SP. 2019. "O Dia Vira 'Noite' em SP com Frente Fria e Fumaça de Queimadas na Amazônia [Day Turns into 'Night' in SP with Cold Front and Smoke from Burning in the Amazon Region]." Accessed October 26, 2020. https://g1.globo.com/sp/sao-paulo/noticia/2019/08/19/dia-vira-noite-em-sao-paulo-com-chegada-de-frente-fria-nesta-segunda.ghtml

Gambarato, Renira R., Geane C. Alzamora, and Lorena Tárcia. 2020. *Theory, Development and Strategy in Transmedia Storytelling*. New York: Routledge.

Georgiou, Aristos. 2019. "#PrayforAmazonia Trends as Brazil's Jair Bolsonario Blasted for Inaction over 3-Week-Long Forest Fires Ravaging the 'Lungs of our Planet'." *Newsweek*, August 20, 2019. Accessed October 26, 2020. https://www.newsweek.com/pray-amazonia-brazil-jair-bolsonaro-forest-fires-lungs-planet-1455189

Gerbaudo, Paolo, and Richard Romancini. 2020. "Paolo Gerbaudo: Digital Media and Transformations in Activism and Contemporary Politics." *Matrizes* 14 (1): 109–122.

Gerbaudo, Paolo, and Emiliano Treré. 2015. "In Search of the 'We' of Social Media Activism: Introduction to the Special Issue on Social Media and Protest Identities." *Information, Communication & Society* 18 (8): 865–871.

Gomez, Jeff. 2010. "Storyworlds: The New Transmedia Business Paradigm." YouTube, Video, 22:15, TOC Presentation. https://www.youtube.com/watch?v=81Ol6Tbjt5k

Gragnani, Juliana, 2019. "Amazônia Eleva Meio Ambiente a Prioridade nas Redes [Amazon Raises Environment as Priority in Social Media Networks]." *BBC News Brasil*, August 28, 2019. Accessed October 26, 2020. https://www.bbc.com/portuguese/salasocial-49474313?fbclid=IwAR37JVdFtlHD2heG-s0MWgYNNe5pPM-jIGdDUleJKZwTymTmiCN_kdBfKUc

Humphrey, Michael. 2019. "The Self as Transmediated Story: Examining Performance and Identity on a Life Storytelling Social Media Site." In *Transmedia Earth Conference: Medios, Narrativas y Audiencias en Contextos de Convergencia [Transmedia Earth Conference: Media, Narratives, and Audiences in a Convergence Context]*, edited by Maria Isabel Villa, Diego M. Bermúdez, and Mauricio V. Arias, 79–98. Medellin: EAFIT.

Ibanez, Helder. 2019. "Olha o Que Está Acontecendo na Amazônia! [Look What Is Happening in the Amazon]." *Ñintendo Blog*, August 23, 2019. Accessed October 26, 2020. https://www.naointendo.com.br/posts/x9yvktmmzm0-olha-o-que-esta-acontecendo-na-amazonia

Jansson, André, and Karin Fast. 2019. "Transmedia Identities: From Fan Cultures to Liquid Lives." In *The Routledge Companion to Transmedia Studies*, edited by Matthew Freeman and Renira R. Gambarato, 340–349. New York: Routledge.

Jornal Nacional. 2020. "Apenas 5% dos Responsáveis pelo Dia do Fogo na Amazônia Foram Punidos [Only 5% of Those Responsible for the Day of Fire in the Amazon Were Punished]." Accessed October 26, 2020. https://g1.globo.com/jornal-nacional/noticia/2020/08/10/apenas-5percent-dos-responsaveis-pelo-dia-do-fogo-na-amazonia-foram-punidos.ghtml

Keck, M.E., and Sikkink, K., 2014. *Activists beyond Borders: Advocacy Networks in International Politics*. Ithaca, NY: Cornell University Press.

Kirkland, Justin. 2019. "Celebrities Are Speaking Out in Response to Brazil's Amazon Rainforest Fires." *Esquire*, August 23, 2019. Accessed October 26, 2020. https://www.esquire.com/entertainment/a28797636/amazon-rainforest-fires-brazil-celebrity-reaction/

Macron, Emmanuel. 2019. Twitter, August 22, 2019, 9:15 p.m. https://twitter.com/EmmanuelMacron/status/1164617008962527232

Margolin, Drew. 2016. "Another Tragedy, Another #PrayFor, But What Does It Really Say About Who Cares for Whom?" Accessed September 2, 2020. https://theconversation.com/another-tragedy-another-prayfor-but-what-does-it-really-say-about-who-cares-for-whom-62588

Masolo, Dismas A. 2002. "Community, Identity and the Cultural Space." *Rue Descartes* 36 (2): 19–51.

Molina, Fernando. 2020. "Bolívia Declara Emergência Nacional por Causa de Incêndios na Amazônia [Bolivia Declares State of Emergency Because of Amazon Fires]." *El Pais*, Septev9-17/bolivia-declara-emergencia-nacional-por-causa-de-incendios-na-amazonia.html?utm_source=Facebook&ssm=FB_BR_CM&fbclid=IwAR3b4A5luERH8S9X0PqvfmEW39iTtTzDl00QjgrWuEADyI1qYVaAqOVp2EE#Echobox=1600354268

Moloney, Kevin. 2013. "Breaking News as Feral Transmedia Journalism." *Transmedia Journalism Blog*, October 22, 2013. Accessed August 31, 2020. https://transmediajournalism.org/2013/10/22/breaking-news-as-native-transmedia-journalism/?fbclid=IwAR3tnEB9FDjjsnd5NXRSHS6Jo7uEoMg9dINmi14Lysw1TjcxAs32GZ0MA78

Moloney, Kevin. 2020. "All the News That's Fit to Push: The New York Times Company and Transmedia Daily News." *International Journal of Communication* 14: 4683–4702.

Mønsted, Bjarke, Piotr Sapieżyński, Emilio Ferrara, and Sune Lehmann. 2017. "Evidence of Complex Contagion of Information in Social Media: An Experiment using Twitter Bots." *PLoS ONE* 12 (9): 1–12.

Nöth, Winfried. 2014. "Human Communication from the Semiotic Perspective." In *Theories of Information, Communication and Knowledge: A Multidisciplinary Approach*, edited by Fidelia Ibekwe-San Juan and Thomas M. Dousa, 97–119. New York: Springer.

Nöth, Winfried. 2020. "Trajectory: A Model of the Signs and Semiosis." *Sign Systems Studies* 48 (92/4): 182–191.

Phillips, Tom. 2019a. "Brazilian Indigenous Leaders Denounce Bolsonaro before UN Speech." *The Guardian*, September 23, 2019. Accessed October 26, 2020. https://www.theguardian.com/world/2019/sep/23/jair-bolsonaro-un-brazilian-indigenous-leaders

Phillips, Tom. 2019b. "Greta Thunberg Labelled a 'Brat' by Brazil's Far-Right Leader Jair Bolsonaro." *The Guardian*, December 10, 2019. Accessed October 26, 2020. https://www.theguardian.com/environment/2019/dec/10/greta-thunberg-jair-bolsonaro-brazil-indigenous-amazon

Phillips, Tom. 2019c. "Jair Bolsonaro Says 'Deceitful' Media Hyping Amazon Wildfires." *The Guardian*, September 24, 2019. Accessed October 26, 2020. https://www.theguardian.com/world/2019/sep/24/jair-bolsonaro-says-deceitful-media-hyping-amazon-wildfires

Piran, Adécio. 2019. "Dia do Fogo: Produtores Planejam Data para Queimada na Região [Day of Fire: Farmers Plan Date for Fires in the Region]." *Folha do Progresso*, August 5, 2019. Accessed October 27, 2020. http://www.folhadoprogresso.com.br/dia-do-fogo-produtores-planejam-data-para-queimada-na-regiao/

Renner, Karl-Heinz, and Astrid Schütz. 2008. "The Psychology of Personal Web Sites." In *Handbook of Research on Computer Mediated Communication*, edited by Sigrid Kelsey and Kirk St. Amant, 267–282. Hershey, PA: IGI Global.

Reuters. 2019. "Norway Stops Amazon Fund Contribution in Dispute with Brazil." *Reuters*, August 15, 2019. Accessed October 26, 2020. https://www.reuters.com/article/us-brazil-environment-norway-idUSKCN1V52C9

Saccone, Valeria. 2018. "Ganó Bolsonaro, Pierde la Amazonia: Todo lo Que Esta Victoria Implica para el Planeta [Bolsona Won, the Amazon Loses: Everything This Victory Implies for the Planet]." *El Confidencial*, October 29, 2018. Accessed August 31, 2020. https://www.elconfidencial.com/mundo/2018-10-29/gana-bolsonaro-pierde-amazonia-planeta_1636847

Sengupta, Somini. 2018. "What Jair Bolsonaro's Victory Could Mean for the Amazon, and the Planet." *The New York Times*, October 17, 2018. Accessed August 31, 2020. https://www.nytimes.com/2018/10/17/climate/brazil-election-amazon-environment.html

Srivastava, Lina. 2009. "Transmedia Activism: Telling your Story across Media Platforms to Create Effective Social Change." Accessed August 31, 2020. https://web.archive.org/web/20130515174049/http:/www.namac.org/node/6925

Srivastava, Lina. 2014. "The Opportunities of Narrative: Story-Based Impact." Accessed August 31, 2020. http://archiv.recampaign.de/wp-content/uploads/2015/02/214227049-Prasentation-Srivastava-ReCampaign-2014.pdf

UOL. 2020. "Salles Compartilha Vídeo Sobre Amazônia Com Imagens da Mata Atlântica [Salles Shares Video about Amazon with Images of the Atlantic Forest]." Accessed October 26, 2020. https://noticias.uol.com.br/meio-ambiente/ultimas-noticias/redacao/2020/09/10/salles-compartilha-video-sobre-amazonia-com-imagens-da-mata-atlantica.htm

Verhaeghe, Paul. 2014. *What about Me? The Struggle for Identity in a Market-Based Society*. Translated by Jane Headley-Prôle. London: Scribe.

Vieira, Vivian P. P. 2013. "O Papel da Comunicação Digital na Primavera Árabe: Apropriação e Mobilização Social [The Role of Digital Communication in the Arab Spring: Appropriation and Social Mobilization]." Accessed August 31, 2020. http://www.compolitica.org/home/wp-content/uploads/2013/05/GT05-Comunicacao-e-sociedade-civil-VivianPatriciaPeronVieira1.pdf

Watanabe, Phillippe. 2018. "Desmatamento na Amazônia Cresce 14% e É o Maior Desde 2008 [Deforestation in the Amazon Grows 14% and Is the Highest Since 2008]." *Folha de S. Paulo*, November 23, 2018. Accessed August 31, 2020. https://www1.folha.uol.com.br/ambiente/2018/11/desmatamento-na-amazonia-cresce-14-e-e-o-maior-desde-2008.shtml

Zhouri, Andréa. 2006. "O Ativismo Transnacional pela Amazônia: Entre a Ecologia Política e o Ambientalismo de Resultados [Transnational Activism by the Amazon: Between Political Ecology and Results Environmentalism]." *Horizontes Antropológicos* 12 (25): 139–169.

12 The Kabir Project
Using Transmedia Work to Disrupt Right-Wing Narratives of Othering

Fathima Nizaruddin

Introduction

Transmedial construction of various kinds of right-wing identities is a fairly common phenomenon within contemporary post-digital media cultures. Though the modality of such constructions and the socio-political contexts against which they emerge differ, they invariably rely on the notion of an undesirable 'other' to carve out exclusivist identities using markers such as race, religion, ethnicity, language, nationality or gender. In such scenarios, how can transmedia projects intervene to create spaces that aid the narration of identities that move beyond narrow and violent conceptions about the boundaries between the self and the other? What role does a conceptualisation of transmedia as an ecology that is not limited to commercial franchises (Jansson and Fast, 2019) play in making sense of the significance of such spaces?

This chapter will explore these questions by focusing on the work of *The Kabir Project* that was initiated by Indian documentary filmmaker Shabnam Virmani in 2002. *The Kabir Project* began as a response to the cycles of violence around essentialist notions of Hindu and Muslim identities; such violence is a key tool within the mobilizational efforts of right-wing Hindu majoritarian or Hindutva groups in contemporary India. Since the colonial times, sectarianism around Hindu and Muslim identities has a history of fomenting violence and unrest in the Indian subcontinent.[1] The immediate impetus that prompted Shabnam Virmani to start *The Kabir Project* was the pogrom that took place in the Indian state of Gujarat in 2002 (Santhanam, 2018); more than 1,000 people, mostly Muslims, were killed in this pogrom (Majumder, 2011).

In order to situate *The Kabir Project* as a transmedia work, it is important to move beyond commercial conceptions of transmedia that restrict it to storytelling or seriality (Freeman, 2019). Though *The Kabir Project* does not emerge from a commercial understanding of transmedia work, it is possible to locate its universe within prevailing definitions of transmedia documentary. According to O'Flynn, 'A transmedia documentary distributes a narrative across more than one platform, it can be participatory or not, can invite audience-generated content or not, tends to be open and evolving, though

not always' (O'Flynn, 2012: 143). The corpus of work that emerges out of The Kabir Project fits well within the scope of this definition. The various constituents of the project such as books, website, online archive, videos uploaded to YouTube, music CDs, documentary films and offline events and workshops add to 'additive comprehension' whereby the diverse constituents contribute to the world built around the project (Jenkins, 2011). In the context of this particular work, rather than looking for a storyline that emerges across diverse platforms, it will be more productive to envisage the multiple platforms and sites of engagements around the project as forming a common ethos (Freeman, 2019). In *The Kabir Project*, this common ethos is that of love and it mainly relies on the work of the fifteenth-century South Asian poet Kabir to form networks and interactive spaces around this ethos. A subject position that does not place the individual as apart from the rest of the universe is central to the formation of this ethos of love which invites everyone to a *desh* (country) without borders and boundaries where distinctions between 'you' and 'I' disappear (Rikhi and Virmani, 2019). The imagination of such a country is present within the work of Kabir. A brief outline of the components of the project as well as the networks and processes around it can help to situate the role of *The Kabir Project* within the broader transmedia ecology in which it operates.

The Kabir Project

The Kabir Project situates itself as 'a series of ongoing journeys in quest of Kabir, the 15th century north Indian mystic poet as well as other Bhakti, Sufi and Baul poets in our contemporary worlds' (Kabir Project, n.d.). Kabir, whose work is central to the project, was a poet who most probably lived in the fifteenth century (Hess and Singh, 2002). He is termed as one of the 'best-loved poets to have emerged in South Asia in last 1000 years' (Vajpeyi, 2012: 43); while it is difficult to trace the exact details about Kabir's upbringing, most scholars infer that he belonged to a low caste family of converts to Islam and was a weaver by profession (Vaudeville, 1993). Kabir was critical of the religious orthodoxies of his time and refused to identify as either a Hindu or a Muslim. Within *The Kabir Project*, the figure of Kabir, who used idioms from the lives of ordinary people to present iconoclastic ideas that challenged existing caste hierarchies and sectarian divisions, becomes a locus for creating an affective universe that places 'love as the primary moving force of life' (ajab shahar – Kabir Project, 2014). By using a range of online platforms, events and media forms including documentary films and books, this project forms sites of engagement that invite those who encounter them to move beyond narrow notions of sectarian identities.

The project is housed at the educational institution Srishti Institute of Art, Design & Technology[2] in the city of Bangalore, India, and it has had a sustained existence for almost two decades since Virmani initiated the processes of the project in 2002. The four feature-length documentary films that are

part of the project place the filmmaker Virmani's journeys in search of Kabir within the broader socio-political context of contemporary India. Within the universe of the project, the oral traditions around the poetry of Kabir that the filmmaker encounters become the locus to articulate an imagination that questions boundaries on the basis of diverse identificatory positions including those of caste, religion, nation, or gender; this imagination invites the audience to Kabir's 'country of love' (Virmani, 2008a). Apart from Kabir, the project also draws inspiration from other poets from Bhakti, Sufi and Baul traditions in South Asia, whose verses express a similar imagination. Bhakti points to the possibility of accessing God through devotion and participation without intermediaries and rituals. Early modern Bhakti literature, which flowered in vernacular poetry across South Asia, allowed many lower caste and women poets to question existing social hierarchies. Though Bhakti and Sufi traditions are generally viewed as part of Hindu and Muslim religious fields respectively, in South Asia these traditions considerably influenced each other (Burchett, 2019). Similarly, the Baul poetic tradition from the Bengal region 'is said to be a syncretic outcome of Sahajayana Buddhism, Vaishnava ecstatic devotionalism and Sufism' (Lorea, 2016: 29). It will not be accurate to term the diverse Bhakti, Sufi and Baul traditions which have a history of over several centuries as 'heterodox'.[3] However, *The Kabir Project* draws from the more heterodox aspects of these traditions.

While using the framework of transmedia to understand the processes of *The Kabir Project*, we need to take into account the argument that transmedial construction of narratives cannot be situated as a solely modern phenomenon (Carignan, 2019). Jenkins (2006) points out that a person who lived in mediaeval times would encounter the story of Jesus through multiple cultural forms including a performance, tapestry or sermon; each of these encounters in turn would contribute to an additive understanding of the story. In a similar fashion, the vast corpus of Bhakti, Sufi and Baul traditions that *The Kabir Project* draws from have also been historically narrated across diverse media and cultural forms. For example, Kabir's verses were sung by wandering minstrels, and this allowed them to have a transregional reach in South Asia (Callewaert, 2008); this process of circulation happened over a span of several centuries, and the verses changed according to local contexts. There are also notable written corpuses of Kabir's work; however, it is not possible to argue that they are any more 'authentic' than the verses from prominent oral traditions (Agrawal, 2009).

Despite many differences, it is possible to find a common ethos of love across both textual and oral traditions around the work of Kabir (Agrawal, 2009). In what could be seen as a kind of 'collaborative authorship' (Jenkins, 2006: 111), later poets and singers added their own verses to the corpus of Kabir's work, and this makes it difficult to ascertain the exact authorship of individual verses (ajab Shahar- Kabir Project, 2016).[4] The transmedia universe of *The Kabir Project* draws from this rich multiplicity around Bhakti, Sufi and Baul literature. However, while acknowledging the possibility of

positioning some aspects of these traditions as transmedia, it is also important to locate the interventions of *The Kabir Project* within the post-digital communication ecosystem in India where transmedial formulation of a majoritarian right-wing Hindutva identity has a significant presence.

Transmedial Constructions of Right-Wing Hindutva Identity

In contemporary India, right-wing Hindutva groups constantly evoke the spectre of danger that India faces from the Muslim minority within the country as well as the Islamic Republic of Pakistan, the 'enemy' across the border.[5] As mentioned before, the roots of these narratives can be traced to the colonial times when those who aligned with both Hindu and Muslim used several means including violence to further their political claims. While Hindutva groups were not significant in terms of electoral politics in the early decades of independent India, a series of mobilizations by the Sangh Parivar group of organisations that subscribe to the majoritarian Hindutva ideology made a remarkable shift in this situation. Today BJP (Bharatiya Janata Party), the political arm of the Sangh Parivar, is in power in India under Prime Minister Modi, who is viewed as an icon of Hindu pride within Hindutva populist narratives.[6]

This ascent to power of BJP was marked by the expansion of the Hindutva ecosystem of hate (Nizaruddin, 2020). The processes within this ecosystem of hate that locate Muslims as 'dangerous others' help in forming Hindutva-based Hindu identities, which in turn leads to the electoral consolidation of Hindu votes in favour of BJP. The most significant expansion of this ecosystem of hate in recent times occurred through the mobilizations around the Ram Janmabhoomi agitation by the Sangh Parivar groups in the 1980s and early 1990s. This agitation, which aimed to build a temple for the Hindu god Ram after demolishing the sixteenth-century mosque, Babri Masjid, at Ayodhya in the state of Uttar Pradesh used *yatras* or journeys as the chief form of communication to circulate Hindutva narratives that position Muslims as barbarians whose existence in India has been a relentless effort to obliterate the 'glorious Hindu civilization'.[7] Within this reductionist narrative, the more than thousand-year-old history of South Asian Islam gets reduced to a series of temple destructions, treachery against Hindu kings and rape of Hindu women. The Ram Janmabhoomi agitation which used the figure of the arrow wielding Hindu god Ram as a symbol of Hindu pride triggered Hindu-Muslim riots across India; this agitation led to the destruction of Babri Masjid in 1992 by militant Hindutva groups. According to Hindutva claims, the sixteenth-century mosque that bears the name of the Muslim Mughal emperor Babar was made at the birth site of the mythical god Ram after demolishing a temple that existed at the site.[8] The chief outcome of this mobilisation was the consolidation of a Hindutva-based Hindu identity. This in turn helped BJP to emerge as a formidable electoral force.

The expansion of the Hindutva ecosystem of hate and the consolidation of a Hindutva based Hindu identity that happened through the mobilizational efforts of Sangh Parivar can be situated as a transmedial endeavour. Along with public processions, rallies and riots, various media forms ranging from print and video material to audio cassettes of incendiary speeches by Hindutva leaders worked together to create the narrative of a dangerous and disloyal Muslim (Brosius 2005; Manuel, 1996; Panikkar, 1993). If we use Jenkins' terminology, this was a narrative that could not be contained within the limits of a single medium (Jenkins, 2006), and multiple forms of communication worked together to create it. Here we need to take into account the performative dimensions of identity construction where iterative practices contribute to the formation of a particular subject (Butler, 1999). The iteration of Hindutva narratives across diverse media forms and public spaces produced essentialist notions about the 'civilizational divide' between Hindus and Muslims. The ubiquity of these narratives has the effect of reducing the identificatory positions available in an extremely diverse country like India into the Hindu and its primary 'other', i.e., the Muslim.[9] The production of these monolithic categories disavows the composite nature of identities as well as the presence of syncretic traditions that exist outside the borders of essentialist notions about the 'Hindu' and the 'Muslim'.

Against this context, the transmedial circulations of *The Kabir Project* create interactive spaces that provide options for narrating a self that is not bound by sectarian notions of identity. If 'transmediated self' is understood as a 'complex story world of identity lived in the gap between the digital and analog' (Elwell, 2013: 246), then these interactive spaces can be mapped as integral elements within the constitution of this self.

Transmediated Self within the Context of *The Kabir Project*

Even while acknowledging the potential of looking at the formation of transmediated self as an artistic project that is distributed across various platforms (Elwell, 2013), we need to take into account the way in which identity is constructed and regulated politically (Butler, 1999). The narration of self across various platforms and the performance of what Elwell (2013) calls *onlife* cannot be situated as a series of endless possibilities. In the case of India, we have seen how specific socio-political circumstances create a situation where the proliferation of divisive configurations of Hindu and Muslim identities limits the available and permissible identificatory positions. If the formation of self is a relational process (Lebow, 2008) that occurs through interactions with societal circumstances and community relations, then discussions on transmedial construction of self should consider such interactions as crucial elements for analysis. The case of *The Kabir Project* provides an interesting example of how a transmedia project can intervene within the available configurations around identity formation in a given context.

In an atmosphere where essentialist categories of Hindu and Muslim identities have a formidable presence, the universe of *The Kabir Project* questions the very premise behind such categorisations. This is done by centering the project around an ethos of love that draws from syncretic and heterodox Bhakti, Sufi and Baul poetic traditions from South Asia that challenge narrow conceptions of self that inform sectarian divisions and hierarchies on the basis of religion or caste. In *The Kabir Project*, the focus is on creating a world that transcends the boundaries and divisions around the 'self' and the 'other'. It uses the imagination about a country of love within Kabir's work to speak about a world without boundaries. Along with the work of Kabir, the project employs the strands of poetry from Bhakti, Sufi and Baul traditions in South Asia and conversations around them that assert the 'oneness' of the universe to create interactive spaces that challenge the distinctions between the self and the so-called other. A section from the documentary film *Had Anhad* (Virmani, 2008b) from *The Kabir Project* corpus provides a good glimpse into the conception of self that lies at the core of the project. In this section, Linda Hess, the Kabir scholar who teaches at Stanford University, elaborates on the concept of *Shunya* in Indian philosophy, which is important within the work of Kabir. According to her, *Shunya* refers to the lack of 'any permanent graspable selfhood'; since everything in the world is in a flux, there is no permanent self and as a result, 'you are no longer afraid of losing that thing you never had' (Virmani, 2008a). This approach is radically different from right-wing identity formulations that rely on the notion of a self that faces possible obliteration by the 'other'.

So, the sense of transmediated self that the interactive spaces around *The Kabir Project* help to configure acknowledges the limitations of attempting to define a restricted idea of self that is separate from other beings. In these spaces, the ethos of love within Bhakti, Sufi and Baul poetry becomes the locus to formulate across diverse platforms, a sense of self that is not bound by such restrictions. Within this ethos, the divine is understood and felt as love; in Kabir's work, such an understanding situates love as a framing principle for social interactions with fellow beings (ajab shahar – Kabir Project, 2014). As a result, religious tropes that hold the affective world of Hindutva lose their divisive hues within the universe of *The Kabir Project*. For example, the project uses the verses of Kabir sung by renowned folk singer Prahlad Tipanya to talk about a Ram who is present within everyone and everything; this Ram or sense of divine is radically different from the avenging Hindu god Ram in Hindutva narratives.

The project becomes a catalyst to form a new network of people and listening communities who partake in a worldview where the self is imagined as one with the universe; this imagination does not recognise the boundaries between the self and the other. This imagination and networks and communities around it have a long tradition of existence in South Asia. The major contribution of *The Kabir Project* is the formation of a network through the filming process and events that bring these communities into contact with each other to form

a larger universe. As singers from India and Pakistan sing and discuss the work of Kabir, they become part of the yarn of friendship or *taana-baana* that *The Kabir Project* intends to weave together (Kabir Project, n.d.).

These networks and songs come together within the transmedia world of *The Kabir Project*, including the films and recorded versions of performances. They offer sites of engagements where audience members who encounter them are invited to explore the possibility of forming a subject position that moves above narrow sectarian divisions. Audience members can explore this possibility by participating in the events that are part of the field of *The Kabir Project* or by encountering the media material that is part of the project's corpus. Here we need to take into account the manner in which independent Indian documentary filmmakers build embodied publics (Kishore, 2018) around their films, which very often focus on social issues. Shabnam Virmani comes from this tradition of filmmaking, where the filmmakers are not 'content merely with representing politics but seek to expand the domain of documentary and transform audiences into social participants' (Kishore, 2018: 124). The practice of filmmakers travelling with their films across the country to do community screenings is a crucial part of this approach that leads to the formation of embodied publics. These practices get further expanded in the case of *The Kabir Project*, which is not limited to one single screen film. Many of the singers who are crucial actors within the universe of *The Kabir Project* have huge followings of their own. The participation of the singers as social actors within the documentaries and as performers within the corpus of the project brings the community of listeners around them in contact with *The Kabir Project*.[10] Similarly the audience members who get acquainted with the work of the singers through the videos, website or films of *The Kabir Project* have an opportunity to have offline interactions with at least some of the singers through events hosted (or co-hosted) by *The Kabir Project*. The pedagogic experiments of *The Kabir Project* including workshops for educators as well as children also add to this rich field of face-to-face interactions around the project. The YouTube channel and the websites of the project act as the locus of the networks and interactions that aid in the formation of the publics around the project.

The songs, documentaries, videos, books and performances that form the corpus of *The Kabir Project* can be viewed as a kind of proliferation that is different from the Hindutva configurations. One of the books that is part of *The Kabir Project* (Rikhi and Virmani, 2019) provides an excellent insight into the kinds of subject formations that occur within the world of the poets and listeners that inspires the project. The book talks about 'the sense of self' that 'expands as you participate in song ... transcending for those moments all social limitations ... and oppressions' (Rikhi and Virmani, 2019: xvi). It refers to the centuries-old traditions of singing these songs that allowed lower caste and marginalised poets to imagine a country of love without boundaries. This possibility of transcending limited notions of self through singing and poetry is key to the world-building processes of *The Kabir Project*.

Here, songs act as vehicles to transfer an imagination that frames the perceived differences between the self and the other as delusion. The imagination of the city of love (Virmani, 2008a) that *The Kabir Project* invokes might seem to have nothing in common with the situation in contemporary India, where Hindu and Muslim identities are at the centre of violent political mobilizations. However, the formation of a larger public around this imagination that has existed in South Asia for over several centuries might contribute to the evolution of a less strife-filled future. The transmedial universe of *The Kabir Project* can be placed as an effort in the direction of such a future. The ways in which *The Kabir Project* builds upon an older tradition of oral transmission of the songs show that the role of transmedia ecology in shaping identities is not essentially a modern phenomenon. While *The Kabir Project* uses multiple forms of media platforms including YouTube and websites, the shaping of an embodied public around the project involves a remediation of earlier forms of performance and circulation of Sufi, Bhakti or Baul poetry. Remediation refers to the 'relationship between "new media" and traditional media' (Bolter, 2007) and the manner in which they borrow and refashion from each other. So, while situating the role of transmedia forms in producing notions of self in the post-digital world, we need to trace the lineage of such productions. The socio-political circumstances that enable such productions and the publics that sediment around them might be different in diverse historical moments. However, tracing the continuities and ruptures within such productions will help to avoid a technocentric perspective while evaluating such productions. At the same time, the case of *The Kabir Project* shows how specific artistic and curation practices of a transmedia work can use available technologies and platforms to form interactive spaces that are conducive to the narration of transmediated selves that are not bound by exclusivist notions of identity. Within the universe of this project, the filmmaking process plays a central role in forming such interactive spaces.

The Filmmaking Process and the Collaborative Universe of *The Kabir Project*

In *The Kabir Project*, the filmmaking process works as a catalyst to bring together a community of singers, academics, public intellectuals, artists, educators, students and ordinary people who use the work of Kabir and other poets to form an ethos of love that does not differentiate between the self and the 'other'. The argument that the discussions about the political significance of a documentary film should not be limited to the 'effects' of the finished film on its audience (Whiteman, 2004) is pertinent to an analysis of *The Kabir Project*. This perspective points to the political significance of the filmmaking process in terms of the diverse communities it brings together and the changes that the filmmaking process catalyses. This observation becomes all the more relevant in the case of transmedia work that is open-ended.

The metaphor of *yatra* or journey that *The Kabir Project*'s website uses to describe its processes is useful to understand the manner in which this work builds a world that is based on an ethos of love. Virmani's journeys bring her to many new people, including the 'rural rock star' of the Malwa region, Prahlad Tipanya, who sings Kabir songs, and Kabir scholar Linda Hess as well as Farid Ayaz and Shafi Mohammed from Pakistan, who sing the works of Sufi and Bhakti poets. The singers mainly come from traditions that have a repertoire of verses that work against the configurations of sectarian identities and the violence around them. For example, Tipanya sings the lines of Kabir: 'If you say Hindu, I'm not that/ Muslim? Not that either ... I play in both' (ajab shahar – Kabir Project, 2015c). Similarly Pakistani singers Farid Ayaz and Abu Mohammed sing the song 'Padhaaro Mhaare Des' (Come to my country) before an Indian audience; while singing, Ayaz adds that he is talking about the 'undivided country' (ajab Shahar – Kabir Project, 2015d). The audience roars with applause at this reference to the division between India and Pakistan on the basis of religious differences. The song that is uploaded on *The Kabir Project*'s YouTube channel has over 1.4 million views. Virmani's filming process leads to the formation of new networks where singers and the communities of audiences around them widen their repertoire.[11] Such networks and the interactive spaces that emerge around them expand the configurations that sustain imaginations which question essentialist notions of identities, including those of the Hindu and Muslim. In short, in *The Kabir Project*, the filmmaking process plays an important role in forming a collaborative universe that facilitates the narration of transmediated selves that emerge from an ethos of love.

Conclusion

The manner in which the transmedial formations of *The Kabir Project* build an affective world around the ethos of love shows the possibilities for using transmedia work to contest violent configurations of majoritarian right-wing identities. In the case of this particular project, this contestation is done through an interrogation of the very premises behind the categorisation of religious identities that lies at the heart of the right-wing political mobilizations in contemporary India. This interrogation is done by relying on the strands of thought that exist within specific Sufi, Bhakti and Baul poetic traditions in South Asia that question the existence of a permanent graspable self that is separate from the rest of the universe. The oral traditions of such poetry that build affective formations that refuse to distinguish between the self and the other inform the processes of world building of *The Kabir Project* that use offline events and workshops as well as video, audio, print and online materials and platforms. The *taana-baana* (warp and weft) of friendship (Kabir Project, n.d.) that forms through this process of world building produces an embodied public around the ethos of love that is central to the project. This world asks those who encounter it to burn their houses (ajab

shahar – Kabir Project, 2015a) or narrow the framework of identities so that they can become part of an imagined community of a country of love that does not recognise any boundaries or sectarian identities. This country of love is very different from the lifeworld of contemporary India, where right-wing formations attempt to mobilise communities around hate, anger and violence for political gain.

However, the manner in which *The Kabir Project* gathers an embodied public around this imagination of a country of love shows the possibilities of a future that moves beyond such violent constructions of identity. The way in which the processes of the project expand the existing networks of heterodox traditions that question sectarian notions of the identity as well as the remediation of poetry and performance from such heterodox traditions within the corpus of *The Kabir Project* points to the need to place the role of transmedia ecologies in forming specific subject positions in their specific historical and cultural contexts. This will allow us to understand the transmedial construction of identities as a part of a continuum rather than as a rupture caused by particular technologies.

Acknowledgement

This chapter was made possible through a post-doctoral fellowship from the International Research Group on Authoritarianism and Counter-Strategies (IRGAC) of the Rosa Luxemburg Stiftung.

Notes

1. The bloodshed around the partition of undivided India into the nation-states of India and Pakistan was a result of such sectarian mobilizations.
2. Now it is the Srishti Manipal Institute of Art, Design and Technology.
3. Similarly, while the Kabir Project uses the term 'mystic' to refer to the poetry from the above-mentioned traditions that inspire its corpus, there are differences of opinion among academics about the suitability of using 'mystic' as an overarching term to refer to such traditions (Bashir, 2011).
4. This is the case with the work of many other poets from Bhakti, Sufi and Baul traditions.
5. India and Pakistan have a history of conflict with each other, and there is a major ongoing territorial dispute between the two nation-states.
6. The pogrom of 2002 in the Indian state of Gujarat occurred during the chief ministership of Modi.
7. Indian civilization becomes synonymous with 'Hindu civilization' in Hindutva narratives. The Hindutva definition of 'Hindu' is not limited to the Hindu religious identity. Writings by Hindutva ideologues attempt to subsume followers of religions originated in the Indian sub-continent such as Buddhism, Jainism or Sikhism also as 'Hindu'. For a detailed account of the manner in which the Hindutva uses of the term 'Hindu' has evolved since the colonial times, see Sharma (2002).
8. This claim is based on belief rather than any concrete historical evidence (Varma and Menon, 2010).
9. Though both Muslims and Christians are outgroups according to the Hindutva discourses, due to historical reasons and their percentage in the population, Muslims remain the primary 'other'.

10 For example, the documentaries that are part of The Kabir Project were extensively screened in the Malwa region of Madhya Pradesh; some of the key singers within The Kabir Project come from this region.
11 The Festival of Kabir at Bangalore, India, organized by The Kabir Project in 2009 in collaboration with other organizations, brought Indian and Pakistani singers whose work is featured within the project together for concerts and other activities.

References

Agrawal, Purushottam. 2009. *Akath kahānī prema kī: Kabīra kī kavitā aur unkā samaya*. New Delhi: Rajkamal Prakashan.
ajab shahar – Kabir Project. 2014. '"My Personal and Political Kabir" by Purushottam Agrawal'. YouTube. 2014. https://www.youtube.com/watch?v=bWyTFl6s62s
ajab shahar – Kabir Project. 2015a. *'Burn down Your House, Says Kabir': Ashok Vajpeyi*. https://www.youtube.com/watch?v=ug0GT9bYjYs
ajab shahar – Kabir Project. 2015c. '"Kahaan Se Aaya Kahaan Jaaoge?" by Prahlad Tipanya'. YouTube. 2015. https://www.youtube.com/watch?v=zRuOAjnY5aQ
ajab shahar – Kabir Project. 2015d. '"Padhaaro Mhaare Des" by Farid Ayaz & Abu Mohammed'. YouTube. 2015. https://www.youtube.com/watch?v=heHxA8G_yOw
ajab shahar – Kabir Project. 2016. '"There Are Multiple Kabirs Challenging the Literary Canon," Says Apoorvanand'. YouTube. 2016. https://www.youtube.com/watch?v=t7a24_EJI6U
Bashir, Shahzad. 2011. *Sufi Bodies: Religion and Society in Medieval Islam*. New York: Columbia University Press.
Bolter, Jay David. 2007. 'Remediation and the Language of New Media'. *Northern Lights: Film & Media Studies Yearbook* 5 (1): 25–37. https://doi.org/10.1386/nl.5.1.25_1
Brosius, Christiane. 2005. *Empowering Visions: The Politics of Representation in Hindu Nationalism*. London: Anthem.
Burchett, Patton E. 2019. *A Genealogy of Devotion: Bhakti, Tantra, Yoga, and Sufism in North India*. New York: Columbia University Press.
Butler, Judith. 1999. *Gender Trouble: Feminism and the Subversion of Identity*. London; New York: Routledge.
Callewaert, Winand M. 2008. 'Singer's Repertoires in Western India'. In *Devotional Literature in South Asia: Current Research: 1985-1988*, edited by R. S. McGregor, 29–35. Cambridge: Cambridge University Press.
Carignan, Marie-Eve. 2019. 'Transmedia Religion: From Representation to Propaganda Strategy'. In *The Routledge Companion to Transmedia Studies*, edited by Matthew Freeman and Renira Rampazzo Gambarato, 364–372. New York; London: Routledge.
Elwell, J. Sage. 2013. 'The Transmediated Self: Life between the Digital and the Analog'. *Convergence* 20 (2): 233–249. https://doi.org/10.1177/1354856513501423
Freeman, Matthew. 2019. 'Transmedia Charity: Constructing the Ethos of the BBC's Red Nose Day Across Media'. In *The Routledge Companion to Transmedia Studies*, edited by Matthew Freeman and Renira Rampazzo Gambarato, 306–313. New York; London: Routledge.
Hess, Linda and Shukdeo Singh. 2002. *The Bijak of Kabir*. New York: Oxford University Press.
Jansson, André, and Karin Fast. 2019. 'Transmedia Identities: From Fan Cultures to Liquid Lives'. In *The Routledge Companion to Transmedia Studies*, edited by

Matthew Freeman and Renira Rampazzo Gambarato, 340–349. New York, London: Routledge.
Jenkins, Henry. 2006. *Convergence Culture: Where Old and New Media Collide*. New York; London: New York University Press.
Jenkins, Henry. 2011. 'Transmedia 202: Further Reflections'. Henry Jenkins. 2011. http://henryjenkins.org/blog/2011/08/defining_transmedia_further_re.html
Kabir Project. n.d. 'About Us | the Kabir Project'. Kabir Project. Accessed 10 August 2018. http://www.kabirproject.org/about%20us
Kishore, Shweta. 2018. *Indian Documentary Film and Filmmakers: Independence in Practice*. Edinburgh: Edinburgh University Press.
Lebow, Alisa. 2008. *First Person Jewish*. Minneapolis: University of Minnesota Press.
Lorea, Carola. 2016. *Folklore, Religion and the Songs of a Bengali Madman: A Journey between Performance and the Politics of Cultural Representation*. Leiden: Brill.
Majumder, Sanjoy. 2011. 'Narendra Modi "allowed" Gujarat 2002 Anti-Muslim Riots,' 22 April 2011, sec. South Asia. https://www.bbc.com/news/world-south-asia-13170914
Manuel, Peter. 1996. 'Music, the Media, and Communal Relations in North India, Past and Present'. In *Contesting the Nation: Religion, Community, and the Politics of Democracy in India*, edited by David Ludden, 119–139. Philadelphia: University of Pennsylvania Press.
Nizaruddin, Fathima. 2020. 'Resisting the Configurations for a Hindu Nation'. *HAU: Journal of Ethnographic Theory* 10 (3). https://doi.org/10.1086/711891
O'Flynn, Siobhan. 2012. 'Documentary's Metamorphic Form: Webdoc, Interactive, Transmedia, Participatory and Beyond'. *Studies in Documentary Film* 6 (2): 141–157. https://doi.org/10.1386/sdf.6.2.141_1
Panikkar, K. N. 1993. 'Religious Symbols and Political Mobilization: The Agitation for a Mandir at Ayodhya'. *Social Scientist* 21 (7/8): 63–78. https://doi.org/10.2307/3520346
Rikhi, Vipul, and Shabnam Virmani. 2019. *One Palace, a Thousand Doorways- Songlines through Bhakti, Sufi, and Baul Oral Traditions*. New Delhi: Speaking Tiger.
Santhanam, Radhika. 2018. 'Making Kabir Your Own'. The Hindu. 2018. https://www.thehindu.com/entertainment/music/making-kabir-your-own/article24461054.ece
Sharma, Arvind. 2002. 'On Hindu, Hindustān, Hinduism and Hindutva'. *Numen* 49 (1): 1–36. https://doi.org/10.1163/15685270252772759
Vajpeyi, Ananya. 2012. *Righteous Republic: The Political Foundations of Modern India*. Cambridge, MA; London: Harvard University Press.
Varma, Supriya, and Jaya Menon. 2010. 'Was There a Temple under the Babri Masjid? Reading the Archaeological "Evidence"'. *Economic and Political Weekly* 45 (50): 61–72.
Vaudeville, Charlotte. 1993. *A Weaver Named Kabir: Selected verses with a Detailed Biographical and Historical Introduction*. Delhi; New York: Oxford University Press.
Virmani, Shabnam. 2008a. *Chalo Hamara Des: Journeys with Kabir & Friends (English)*. https://www.youtube.com/watch?v=waOosA3Rf1g
Virmani, Shabnam. 2008b. *Had Anhad: Journeys with Ram & Kabir*. https://www.youtube.com/watch?v=Dr83axn1IbM
Whiteman, David. 2004. 'Out of the Theaters and into the Streets: A Coalition Model of the Political Impact of Documentary Film and Video'. *Political Communication* 21 (1): 51–69. https://doi.org/10.1080/10584600490273263-1585

Index

Pages in **bold** refer to tables and pages followed by n refer to notes.

abstractions (of dimensions) 88
actant 95; identity 33; roles 34
action versus character (Aristotelian dichotomy) 27
action: flattening 88
Adams, N. 135
additive comprehension (Young) 167
advertising 4, 95, 151
affective economy (Jenkins) 23, 120
AI 5, 6, 127
algorithmic logic 55, 86, 93–96
algorithmic time 92
Alzamora, G.C. vii, 161–178
Amazon fires (2019) 161–178; indigenous populations 164; international protest demonstrations (August 2019) **163**; renewed outbreak (2020) 173; timeline **162–163**
Amazonia: New Paths for Church (2019) 164
anonymity 137, 140–142, 150, 151
anticipation 76, 78
antifeminism 147–157 *passim*, 157n1, 157n4
Anzaldúa, G. 126
appearance 29, 105, 106, 110, 119, 136
Apple 30
apps 91–92, 100, 140
Arendt, H. 112, 125; *Human Condition* (1958) 64n2
Aristotle 73–74
art 119, 133; original versus reproduction 124
astroturfing 142
attentional gate model 74
audience 76–77, 120, 126, 187; capable of rewriting texts 114

audience reception theory 114
augmented reality (AR) 143–144
Augustine, St. 76, 77
authentic artificiality 114
authenticity 35, 48, 80, 114, 126; lack of 119
autobiographical narrative 70
avatars 122, 125
axiology 33, 36; definition 33
Ayaz, F. 187
Ayodhya: Babri Masjid 182, 188n8
Ayodhya: Ram Janmabhoomi 182, 188n8
Ayres, Y.M. 13–15, 17

Bachelard, G. 112; *Poetics of Space* (1994) 123–125
Bagger, C. vii, 39–51
Bangalore 189n11
Bangalore: Srishti Institute 180, 188n2
Baudrillard, J. 63, 86
Baul poetry 181, 184, 186, 187, 188n4
Bazin, A. 87, 95
BBC 141, 142, 171
Beckham, D. 17
behaviour, appropriate 41, 43
Bennett, L. 125–126
Bergman, M. 170
Bertetti, P. vii, 22–38
Bhakti literature 181, 184, 186, 187, 188n4
Bharatiya Janata Party (BJP) 182
big data 54, 94
Black Trans Lives 144
blogs 28, 29, 149
blue 30
Bolivia 168, 169, 173

Index

Bolsonaro, J. 162, **162–163**, 164, 168–173; speech at UNGA (2019) 170, 173–174; UNGA address (via video, 2020) 173
Boston marathon explosions (2013) 167
boundaries: dissolution (work and tourism) 52–66
Bourdieusian studies 57–58
Boys Don't Cry (motion picture) 135
brands 3, 22, 23, 59
Brazil 161, 168, 169, 174; *see also* Amazon fires
Brown, D.W. 77
Bumble 152
Buonomano, D. 71–77 *passim*, 80–81
Burns, C. 141, 142
Buzzfeed 16

cable television 113, 126, 138
Campanioni, C. vii-viii, 112–129
Canada 17, 150, 157n5
cancel culture 15–17, 142
capitalism 52, 117
Caprio, L. di 172
career-consciousness 44–45
caste 180, 181, 184, 185
celebrities 15; virtual self (situation within transmedial storyworlds) 17–19
celebrity [attribute] 39, 112–114, 118, 119; fosters inter-active community 120; melts into audience 114; 'no longer unattainable' 122
celebrity culture 4
celebrity studies 113
celebrity-audience dialectic 125
Chad (generic alpha male) 155
Cheney-Lippold, J. 89
Cheng, A.A. 121–122
chronoception 73, 74, 81
cisgender 133, 137, 149, 157n1
citizenship in organisation 44–46
Clayton, J. 140
clock time 73, 81
close-up (film technique) 119–121, 127–128
collaborative universe 186–187
collateral experiences 170, 171, 173, 174
collective identity 165–166
comedians 15–16
commodification 3, 54, 106
Confidencial (Spanish newspaper) 162, 168

connectivity 55–63 *passim*, 78, 90, 99, 110, 137, 165
consciousness 72, 76, 82
consumers 4, 23, 113
content curation 32
context collapse (Marwick and Boyd) 60
contrasting stimulations (Simmel) 126
conviviality 44, 46–47
Coope, U. 74
Costanza-Chock, S. 165, 166
country of love 181, 184, 185, 188
Courtés, J. 25
COVID-19 pandemic 28, 52–53, 63n1, 78; feral transmedia journalism 167, 172, 174
coworking spaces 53, 56–58, 62–63, 64n3
Cox, L. 133–136
Crawford, K. 93
Crimp, D. 123, 125–127
cultural capital 58, 101, 106, 109
culture 72, 112, 126
Cut 14

Dalby, J. viii, 1–6, 69–84
Daniels, J. 151
dating apps 79, 148, 149, 152–154
Davis, V. 172
De Souza e Silva, A. 101
de-differentiation 53, 56, 58; sustained by transmediatization 62–63; variants 59–60
death 87–88
Debord, G.: *Society of Spectacle* (1967) 126
decapsulation 60
decentered subjectification (Campanioni) 116
deep work (Newport) 55–56
deforestation **162–163**, 173
Deleuze, G. 12–14, 16, 86, 96
Dennett, D. 70, 71
desh (country) 180
diachronic identity 25
diachronic individuals 72, 79
diachronic self 73, 79
diachronic transformations 25, 27
digital data: free-floating state (instantiation of self) 94
digital detox 53, 58, 61–63
digital narratives 139–140
digital punctuality (Flusser) 92
digital self: locating 100–102

digital self-tracking technologies 85–98
digital technologies 4–5, 90, 157
digitally-tracked self 90–96
Dignam, P.A. 154–155
Disclosure (2020) 134–136, 140
disconnection (from digital transmedia) 63
disconnectivity imperative 52
Disney: Marvel franchise 16
Dragebjerg farm 61–62
dreams 113, 116
Duque, I. 169
dwell: etymology 124
Dyer, R.: *Heavenly Bodies* (1986) 119

Eco, U.: interpretive semiotics 24
economic capital 106, 154
Elwell, J.S. 4, 5, 78, 161, 164–167, 183
enterprise social media (ESM) 39–51; analysis 43–47; background 40–42; case studies 40; data collection 43; ideal user traits 46; identity, social media, transmedia 40–42; professional self 42; self-directed usage and career consciousness (case #1, Isak) 43–45, 48; social world-directed usage and citizenship in organisation (case #2, Oliver) 43–46; strategies 43–47; system-directed usage and conviviality (case #3, Louise) 43, 44, 46–48
entropy 75
episodic individuals 72, 79
episodic self 73, 79, 80
essentialist notions 179, 183, 184, 187
Estado de S. Paulo (newspaper) 163
European Union 103, 134, 144
Everyday Carry 11
everyday life 1, 23, 29, 30, 34, 40, 53, 58, 63n1, 157, 164–165
evidence of self 70
evidence of time 73
exclusivity 58
existential identity: sub-levels 27
expectation 43, 47, 60, 100, 105, 106, 116, 120, 121, 125
experience 77
experiencing self (Kahneman) 71
expert users 28–36

Facebook 13, 19, 27, 43, 55–56, 59, 60, 108, 137, 138, 161, 172; central role in identity construction 166; 'passive sharing' 29; selfies 54–55; vacation photographs 60
Facebook Live 17
Facebook Messenger 11, 47
Facetune 122, 128n1
facial recognition 113, 127
facialization of fantasy 112–115
fakecels 152, 153
fan culture 148, 154–156
Fanon, F. 112, 116, 127; *Black Skin, White Masks* [1952] 113
fans 4, 17
fantasy: co-produced 112–129; facialization 112–115; filling gap with reality 119; repetition 119
Fast, K. viii, 4, 24, 40, 52–66, 147, 156, 165
favorite places (internet) 124
Feifer, M. 58
feminism, feminists 150, 158n11; *see also* antifeminism
Ferrari, D. 28–29, 31–32, 34
fiction 71; transmedia theories 156
fictional characters 26, 27, 36, 70, 135, 156
figurative identity: definition 29
Fink, M. 156
Fitbit 91, 95
Flusser, V.: crisis of alphabetic culture 95; imaginations (first and second degree) 85–98; *Into Immaterial Culture* (2015) [1986] 88
Foer, J.S. 95–96
Folha de S. Paulo (newspaper) **162**, 174
Folha do Progresso (newspaper) 171
food 2–3, 29
format 117
Foucault, M. 89; panopticon 122–123
four-dimensional instantiation: flattening into zero-dimensionality of digital code 90–96
fourth industrial revolution (Schwab) 1–2
Franceschini, D. 36
Frandsen, K. 43, 44
Franklin, B. 90
Freeman, M. 1–6, 164
Frith, J. 101
future media: trans futures 143–144

Galvao, R. **163**
Gambarato, R.R. viii, 161–178
games 77, 78, 79, 116–117, 171

gaming 80, 87
Gamson, J.: *Claims to Fame* (1994) 112–113
Gazi, J. viii, 9–21
Geertz, C.: deep play 118
gender 103, 110, 139, 152
generative fictions 119
Genesis 115, 117
geodata 109; monetisation 110
geomoments 101, 105, 106, 109
geotagging 99–111; analysis 103–107; corpus of study and methods 102–103; definition 100; reviews 102–103
Gerbaudo, P. 165–166, 172
Getsy, D. 135
Giannitrapani, R. 28–36
Giddens, A.: 'project of self' 9
GLAAD 135
glamour: 'has faded from our lives' (Cheng) 122; shifting of 115–128
Glee (television series) 156
global identity 34, 35
global narrative 34, 35
global positioning system (GPS) 91
Goffman, E. 22, 61
Gomez, J. 164
Gonzalez Rodriguez, M.F. viii, 99–111
good taste 58
Google 31, 57, 60, 138, 164; acquisition of Fitbit (2019) 95
Gosciola, V. 75–76
granularity 73, 74, 100
Greimas, A.J. 25–26, 31, 33
Griffith, D.W. 119
Guardian (newspaper) 141
Guardians of Galaxy (franchise) 16
Guattari, F. 12–14, 16, 137, 139
Gujarat pogrom (2002) 179, 188n6
Gunn, J. 16–18
guru dell'ovvio (guru of obvious) 28
gynocentrism 149

Had Anhad (documentary film, 2008) 184
Hall, S. 25
hardware 30, 137
Hardy, T.: 'ache of modernism' 122
Harris, L.A. 116
Harris, N.: 'operational aesthetic' 126
Hart, A.: *Unfit for Purpose* (2020) 79
Hart, K. 15–17, 18
hashtags 11, 161–162, 174; sociopolitical 166

hate crime 142–144
Hattingberg, M. von 124
head-mounted displays (HMDs) 80
helper 35, 36
Hess, L. 184, 187
heterarchy 1, 2
heuristics (Kahneman) 69–70
Hindus 179–190
Hindutva identity 179; transmedial constructions 182–183
historical epochs 1–2
histories of ourselves (Rovelli) 71, 79
Hjelmslev, L. 27
Hold 53
Hollywood 14, 16
homepage 124
homophobia 15, 148
Honneth, A. 55
housing 2–3
Hughes, J. 71
human level 74, 75
Humphrey, M. 165
Hunting, J. 80
Huxtable, J. 118–119
hybrid digital detox retreat 61–62
hyper-connectivity 55, 56

I: 'experiencing self' versus 'remembering self' (Kahneman) 71, 72, 79
identity 125, 133; construction across media (semiotics approach) 22–38; definition in non-essentialist, relational way 24; discursive nature 25; marketplace 23–24; tethering and outsourcing 113; types 27
identity construction 40, 41, 48, 183; actual or fictional 27; performative dimensions 183
identity construction online: model of analysis 26–27, 36
ideologically motivated violent extremism (Canada) 150
images 24, 29
imagination 115
imagination (first-degree): definition 88
imagination (second-degree): definition 89
immanence (plane) 12
Impact Hub 56
impersonation 113, 117, 127
in real life (IRL) 5, 126, 139
Incel (with capital 'I'): definition (an ideology) 157n3; fan culture 154–165; key irony 158n11; as

Index

transmedial construction 147–160; wiki page 156
incel (lower case 'i') 147–160; definition (a person) 157n2–157n3; identity creation 155
India 179–190; partition (1947) 188n1
indigenous populations **162**, 164, 173
influencers 15, 113
Instagram 5, 11, 13, 14, 18, 28–30, 34, 43, 59, 99, 100, 102–107, 109, 121, 151; personal outbursts 27; platform for visually-oriented content 102; reviews 103
internet 22, 90, 91, 107, 108, 112, 124, 126, 136, 143, 147, 148, 150, 151, 157, 174; 'creates reality' (maxim) 119; flattening of time and space 122; online personal branding process 24; online personal identity 26; use scheduling 56
internet users: communication through multiple platforms 11
interpretant (Peircean semiotics) 171–173; definition 170
intimacy 113, 119, 120, 121; requires privacy 125; virtual consumption 123–126
intranet 42
involuntarily celibate *see* incel
irrationalism 89; second-degree imagination (Flusser) 93
IWG (owner of Spaces and Regus) 56

Jackman, H. 17, 18
Jansson, A. viii–ix, 4, 24, 40, 52–66, 147, 156, 165
Japan 14, 15, 90, 167
Jenkins, H. 23, 59, 181, 183; 'transmedia as adjective' 69, 76, 77
Jerry Springer (NBC Universal, 1991–2018) 136
Joker (film, 2019) 156
Jorgensen, C. 135
journaling 90, 92
journalism 17, 39, 167, 169, 172

Kabir (C15 poet) 180–181, 184–185, 187, 189n11
Kabir Project (2002–) 179–190; constituents 180; filmmaking process and collaborative universe 186–187; transmediated self 183–186
Kahneman, D. 69–70, 72, 79, 82
Kalapalo, Y. 173
Kant, I. 107–108
Kawara, On 90
Kelly, K. 90
King, B. 142
King, M.L., Jr. 142
Koss, K. ix, 133–146
Kurzweil, R. 75

Langellier, K.M. 114, 123
language 169, 171
Lanier, J. 5
Lash, S. 58, 59
Latour, B. 174
LGBT+ people 140, 142–144
lifestyle 13–14, 24, 94, 106, 108
liminal space (Elwell) 4, 5, 78, 161, 164, 165, 172
LinkedIn 28, 30, 31, 41, 44–45
Linklater, R. 85
liquid life conditions 55
local identity 34
LockMeOut 53
logistical labour 60, 63, 64n2
logistical practices 53
Lomborg, S. 43, 44
London 158n8; terrorist attack (2017) 167
love ethos 180, 181, 184, 186, 187
lovemark (Roberts) 23
Lupton, D. 85, 90, 91

Macron, B. 172
Macron, E. 172, 173
made in own image 112–129
Madonna 172
manosphere 147–160; 'antifeminist coalition' 148; definition 157n1
marketing 23, 28
marketplace of identities 23–24
Marling, S. 18
Marrone, G. 27
Marwick, A.E. 9
masculinity 148, 149, 151, 154, 157, 158n11
mass media 2, 126, 137, 143; antifeminist propaganda (foundational role) 150; trans objectification 134–136
Mathiesen, T. 122, 126
Matrix (film, 1999) 149
Maugham, J. 142
McBride, S. 138, 140
McGuigan, J. 23

Index

media 1, 15, 17, 39, 61; dimensionalities of space, time, action 87–90; erosion of boundaries 152; *see also* mass media
media holarchy 69, 78
memory 70, 71, 73, 76, 78, 81, 82; virtual context 79–80
Men Going Their Own Way 149, 158n6
men's rights 148, 150, 151, 157, 157n1
Merleau-Ponty, M. 112, 115–116
Meta 40, 41
metadata 100, 101
metaphysics 12, 16, 18
metaverse (Web3) viii, 5, 6, 79
Metktire, R. 173
Metzinger, T. 71; *Ego Tunnel* (2009) 70
Microsoft 39, 45
Milan 32, 33
Miller, Q. 156
Minassian, A. 150
minorities 137–138, 144
misogyny 147, 148, 157; translocal 150–154
mobile devices 4, 5
modal identity 33
modalization: definition 33
Modi, N. 182, 188n6
Mohammed, Abu 187
Mohammed, Shafi 187
Moloney, K. 167
motion pictures vii, ix, 16–18, 25, 76–77, 80, 85, 93, 114, 115, 119–120, 135, 149, 156; filmmaking process 186–187; *see also* Kabir Project
multiplatform social mobilisations: three levels (Vieira) 166
multiuser domains (MUDs) 25
murder 134, 135, 144, 173
music 75–78; 'fundamentally dissimilar' to transmedia 76–77
Muslims 179–190

Nafus, D. 90, 94
narrative 138; definition as cognitive construct 16; disintegration with poststructuralism 113
narrative dimension 26
narrative event 114, 121, 125
narrative identity 27, 33–36
narrative script (Ryan) 10
National Center for Transgender Equality (USA) 136

National Institute of Spatial Research (INPE) **163**
nationality 103, 179
natural world (Greimas) 26
NBC (United States) **162**
Neff, G. 90
neoliberal self (McGuigan) 23
neoliberalism 3, 117, 148, 153–154, 158n11
neurons 75
neuroscience 71, 72
New York Times **162**
Newport, C. 55–56
newsletters 28, 29, 31, 32
Newsweek 170
Newton-Smith, W.H. 73
Ng, J. ix, 85–98
Nizaruddin, F. ix, 179–190
non-governmental organisations 47
non-work vii, 57
norm versus use 27
Norway, Norwegians 63n1, **163**
Nöth, W. 170

O'Flynn, S. 179–180
O'Neill, R. 153–154, 158n8
object (Peircean semiotics) 170–173
OffTime 53
onlife (Elwell) 183
oppositional consciousness (Dignam and Rohlinger) 154–155
ornamental digital detox retreat 62
othering: right-wing narratives 179–190
ourselves 76
out of time 81

Pacheco, V.G. 174
Padhaaro Mhaare Des (song, 'Come To My Country') 187
painting 88, 89, 133
Pakistan 182, 185, 187, 188n1, 188n5, 189n11
participants 77, 78
pattern recognition theory of mind (Kurzweil) 75
PBS Digital Studios 87–88
peak-end rule (Kahneman) 82
peer-to-peer surveillance 9, 16
Peircean semiotics 25, 168, 170, 171, 172
perception 74, 112, 120
performance 113–116, 119, 126
performativity 113, 115, 118

Index

performer participants 127
permanence principle 25
perpetual connectivity 61
personal identities 4–5
personal narrative 114; 'personal' in 118
personal narrative performance 123
personal storytelling: analysis 29–36; constructing identities across media (semiotics approach) 22–38; narrative identity 33–36; proper identity 29–31; relational identity 31–33
personal transmedia strategy 27–29
personality 19, 26, 35, 37, 96, 105, 153
Pew Research Center 136
phenomena: 'quantic character' (Flusser) 89
photographs 30, 96, 100; 'most interesting subject' 116
photography 89, 92
Pick-Up Artists (PUAs) 149, 158n7–158n8
pixels 88, 89, 100, 105
Planck scale, Planck time 73
plane of immanence: Riemannian smooth space 14
play 4; politics of 112–129; social and political agency 115–128
podcasts 28, 29, 31, 149, 156
portraiture 118, 121
post-digital asylum 61–62
post-digital reflexivity 53
post-digital self 54, 62–63; future projects 63, 64n3; transmedia (dissolution of boundaries between work and tourism) 52–66
post-digital workplace 56–58
post-tourism (Feifer) 58–59; post-digital version 59
postmedia 134, 137–139; definition 136; trans representation 136–138
postmediality (Guattari, 1990) 137
postmodernism 59, 62–63, 113, 123
Pratten, E. ix, 147–160
Prayfor... (series of hashtags) 167–168
PrayforAmazonia (hashtag) 161–178; associated hashtags (listed) 169; background 162–164; first appearance (2018) 168; methodology 168–170; peak 169; selection criteria (for case studies) 170; themes 170; timeline **162–163**; triadic entity 170

PrayforAmazonia (case studies) 170–174; 1. day of fire 170–171; 2. sky over São Paulo 170, 172; 3. Bolsonaro's speech to UNGA 170, 173–174
pretending 114–115
privacy 48, 121
private versus public 22, 23, 114
process 77
production without reproduction (limit as edge) 126–128
professional self 42
professional transmedia selves: enterprise social media 39–51
proper identity 27, 29–31
psychology 3, 72
public sphere: privatization 23
punctual culture (Flusser) 89

QAnon 158n10
qualitative studies 15, 63n1, 99, 168
quantified self (QS) 90, 92
quantitative methodology 99, 168
quantum field 74
quantum physics 71, 72

race 148, 153, 179
rape 152, 182
rational representations (of information) 92–93
rational to irrational 90–96
Rauch, J.: *Slow Media* (2018) 56
Rawvana 13–15
re-differentiation 53, 63
re-presentation 85
real 112–115
real and virtual (space between) 4, 78, 161, 164, 165, 167, 171, 172
real world 108, 156; people faking it in 114–115
recognition theory (Honneth) 55
recording media 85
Red Pill 148–150, 154
Reddit 11, 151, 154
REFACE (face swap app) 128n1
relational identity 27, 31–33
relations: types (actorial, spatial, temporal) 31
relevance 54
religion 3, 179, 181, 184, 187, 188n7; 'faith' 72, 73
remembering self (Kahneman) 71, 72, 79

reputation 23, 55
retreats 61
Reynolds, R. 17–18
Richards, R. 135
Riemannian mathematics 12
right-wing narratives 179–190
Rilke, R.M. 124
Roberts, K. 23
Robeson, P. 120
Rodger, E. 150
Rohlinger, D.A. 154–155
Rolodex of aspirations 113
Romancini, R. 165, 172
Rovelli, C. 70, 76, 79; classic principle of entropy 75; no 'things', only 'events' 74; on 'clock time' 73; on 'self' 71
Ryan, M-L. 9–10, 11–12; 'being a narrative' versus 'having narrativity' 10, 13; narrative script (key elements) 16

Saint-Gelais, R. 11
Salles, R. **162**, 172
Sangh Parivar 182–183
São Paulo **163**; Amazon fires (2020 repeat) 173; day became night (2019) 172
Sardinia 28, 29, 31–33
Saussure, Ferdinand de 24–25
scalar expectancy theory (SET) 74, 81
Schwab, K. 1–2
Scolere, L. 43
segmenting 53
Segreto, G. ix, 22–38
self: communication 7–66; definition problem 3, 69, 70–75, 78; geotagging 99–111; narrativity 3; 'no such thing' (Metzinger) 70; politics 131–190; technologies 67–129; transmediated across media platforms 96; virtual construction 10
self and other 3, 24, 184, 186, 187
self-consciousness 16, 19, 114
self-help 55, 56
self-identity 78, 165; definition 29
self-knowledge through numbers 92–93
self-management 16, 17
self-as-memory 71
self-as-narrative 71, 72
self-portraiture 116, 121
self-presentation 41, 43, 45, 46, 48, 120
self-production 17
self-promotion 23, 48, 55

self-representation 11, 30; strategies 28
self-tracking 90; definition (Lupton) 85; non-digital methods 90
selfies 9, 15, 29, 30, 46, 112, 118, 120–123; identity formation and behaviour 10; irrationalism 93; semiotic object 10; transmediated 113
Selwyn, N. 1
semiosis 168, 174
semiotic objects: relational framework 12–13
semiotic society 59
semiotic units 13, 17; attribution of hypocrisy 16; virtual self 10–13
semiotics 22–38; identity in 24–26
sense of self 117
Serano, J.: *Whipping Girl* (2007) 135–136
serial characters 27
Seurat, G.P. 76
sexual marketplace 148, 149, 153, 154
sexuality 3, 148, 152, 156
Sherman, C. 126–127
Sherman, J. 94
Shunya concept 184
sign (Peircean semiotics) 170–174 *passim*
Simmel, G. 126
singers 185–187, 189n10–189n11; songs 186
smart objects 91–92
smartphones 15, 52, 60, 69, 117; apps 53; iPhone 30; normalization 54; sensors 91
Snapchat 11, 17, 43
social capital 23, 54, 106, 109
social condition 54
social distinction 57
social justice 148, 151
social media 1, 4, 23, 42, 69, 118, 156; apps 143; interconnected user identity 11; normalization 54; purposes (professional versus social) 11; strategies 29; transmedia narrative construction 9–21
social media influencers 13, 15
social media platforms 18, 28, 137, 138; ranking order (of popularity) 11
social networking 23, 25, 26, 79
social politics: exhausting 133
social world 43–46, 48
societies of control (Deleuze) 86, 96
sock accounts 141; definition 140

software 42, 46, 91–93, 137, 143
soiveillance 9, 16, 18, 19
soul 73, 119
South Asia 179–190
Southern Poverty Law Centre 143
space 99, 101; categorical function 102; 'inter-defined' with identity 32
space-time-action (crossing) 85–98
spatio-temporal matrix: algorithmic logic 85–86; loss of uniqueness 96
spatio-temporality 87, 88, 94; free-floating 93
spectators 116, 120, 124, 126
speed of light, speed of sound 71
Srivastava, L. 166
Stacy: definition 155
Stark, F.: *My Best Thing* (2018) 125
status 55, 57
Stephens, M.A.: *Skin Acts* (2014) 120
Stirling, E. 1
stone 74
story of (virtual) self 9–21
storyworlds 166; celebrities (virtual self-situation) 17–19; narrative construction (three variations) 13–19
strategic recognition work (Fast and Jansson) 53, 55, 63
Strawson, G. 71–72, 79, 80
subject 35–36
Sufi tradition 181, 184, 187, 188n4
surveillance 54, 122
synapses 75
synchronic identity 25
System 1 and System 2 (Kahneman) 70–71
system-directed usage 43, 44, 46–48

taana-baana (warp and weft) of friendship 185, 187
Tárcia, L. ix, 161–178
Teena, B. 135
Tegmark, M.: *Life 3.0* (2017) 81
Telegram 27, 28
television 135–137
temporal window of integration 71
temporality 16
thematic identity 31, 34
thematic roles 37; co-occurrence 31; definition (Greimas) 31
thematic sub-component 31
Thunberg, G. 173
Tiddia, G. 28–33, 36
Tiidenberg, K. 10–11
TikTok 11, 141, 151

time 69–84, 90; compression and dilation 81; definition problem 69, 73–75; fluidity 73, 79, 81; 'found within ourselves' 73–76, 78; necessary aspect of 'self' 73, 79
Time (magazine) 136
time's arrow 75, 79
timing: prospective versus retrospective 80–81
Tinder 99–109 *passim*, 152, 153; geosocial dating media network 102; reviews 103–105
Tipanya, P. 184, 187
Tomassi, R.: *Rational Male* (2013) 149
total digital detox retreat 61
tourism 31, 36; dissolution of boundaries (by transmedia) 52–66
tourism of others 59
touristification of work (Fast and Jansson) 62–63
transcendence 133
transdisciplinary framework 4, 112
Transgender Law Center (USA) 136
transhumanism 71, 83
translocative self 107–109
transmedia 139; as adjective 69, 76–78; definition 150–151; definition (Gosciola) 75–77; definition problem 3, 5, 69; dissolution of boundaries (work and tourism) 52–66; essential principle 69; key issues 86; location 4; modes (process versus experience) 77; as noun 69, 78; property (consistent and lasting) 69; requires participants 77; is transgender 139–140
transmedia activism (Srivastava) 166
transmedia age 1–5, 138, 143
transmedia characters: definition 27
transmedia constructions: right-wing Hindutva identity 182–183
Transmedia Earth Conference (Medellin, 2017) 75
transmedia identities 4; code of conduct 103; formation 127; locative dimension 99–111
transmedia journalism: types (Moloney) 167; emergent 167; feral 167, 169; native 167
transmedia mobilisation 114, 165, 166; within national, transnational and international identities 161–178
transmedia narratives 36; construction 9–21

transmedia producers 47–48
transmedia production 78, 112, 156, 164, 165
transmedia selves: conceptualisation 1–6; definition 4–5; immanent critique 53; materialize in post-digital social landscape 63; nature (further attention required) 63; overall principle of book 1; zero-dimensionality 85–98
Transmedia Selves (this book): aims 3–5; conceptual latitude 3; delay in publication (importance) 6
transmedia storytelling 127; definition (Gomez) 164
transmedia strategy 169, 172
transmedia studies 154; future directions 164
transmedia tactics 169, 172
transmedia technologies: translocal misogyny 150–154
transmedia theory 39, 40
transmedia tourism 53, 54
transmedia tourist 58–62; digital detox retreats (post-digital asylum) 61–62; logistical labour 59–61; threat of decapsulation 59–61
transmedia work 54; used to disrupt right-wing narratives 179–190
Transmedia Work (Fast and Jansson, 2019) 52, 56
transmedia worker 54–58; post-digital workplace 56–58; 'sometimes off' is new 'always on' 55–56
transmediality 147, 155; definition 4; narratology discourse 12
transmediascape 157
transmediated self 162, 167; collective sense of identity 174; definition (Elwell) 161, 164, 183; expansion beyond local geopolitical contexts 174; Kabir Project context 183–186; in midst of transmedia mobilisation 164–168
transmediation 92, 93
transmediatization (Fast and Jansson) 40, 52, 58–60; social consequences 54; sustains de-differentiation 62–63; utmost consequence 63
transparency 107, 118, 119, 121, 122
Transsexual Day of Remembrance (TDOR) 143
transsexual futures: future media 143–144

transsexual men 135
transsexual narratives 139–140
transsexual objectification: mass media 134–136
transsexual representation: postmedia 136–138; transmedia era 133–146
transsexual visibility: by choice 140–141; by force 141–143; transmedia 138
transsexual women 134–136, 138
trans* 133–134, 140, 143; definition 133
transtemporal self: transmedia, self, and transtextual characters 27
Trendogate 169
Treré, E. 166, 172
TripAdvisor 99, 102–103, 109; prominent review platform 102; reviews 103, 106–107
Troma Entertainment 16
Trump, D. 158n10, **162**
Trustpilot review site 102–103
Turkle, S. 25
TweetDeck 169
Twentieth Century Fox: *Deadpool* (motion pictures, 2016, 2018) 17–19
Twitch (social gaming site) 140, 142
Twitter 11, 13, 15–17, 28, 29, 31, 32, 43, 138, 140–143, 158n10; Amazon fires 161–178; central role in identity construction 166; personal outbursts 27

Unger, R.M.: *Passion* (1984) 96
United Kingdom 61, 134, 142–144, 157n5; white paper (2019) 1
United Nations 169; UNGA **163**
United States 135, 136, 142–144, 157n5; presidential election (2020) 158n10; trans people (murder rates) 134
United States: Supreme Court 135
University of Gloucestershire 79, 80
University of São Paolo 88
Urry, J. 58, 59

Valentini, E. 28–32, 35–36
vegan lifestyle 13–15
video games 87–88
videos 4, 107; incels 151–152
Vieira, V.P.P. 166
violence 138, 142, 144, 150, 152, 156–157, 179, 182, 186
Violi, P. 25

Virilio, P. 116; *Aesthetics of Disappearance* (2009 translation) 114, 129
Virmani, S. 179, 180–181, 184–187
virtual memories 80, 82
virtual reality 80, 82, 116
virtual self 9–19, 80; narrative construction (three variations) 13–19; semiotic units 10–12; storyworld 13–19
Vonnegut, K., Jr. 22
voyeurism 114, 115, 120

Waking Life (animated film, 2001) 85
Warhol, A. 90; three-minute screen tests 120
We Met in Virtual Reality (film, 2022) 80
WeWork 56; public Instagram account (inspirational quotes) 57
wearable devices 91, 92, 93
websites 4, 14, 107, 138, 151; personal 28, 29
Weibel, P. 133, 134
Weiner, J. 41
Welsh, R.E. 119
Westworld (HBO, 2016–) 117, 123; Reunion episode 127–128; Trompe-l'œil episode 114–115, 127
WhatsApp 11, 29–30, 108, 161; Amazon fires (2019) 171

Whelan, A. 10–11
Wi-Fi 56, 62
Willett, R. 9
Wired magazine 90
Wolf, G. 90
women 18, 100, 105, 126, 147–160, 181, 182
work: collapsing borders (with 'leisure') 53, 55; dissolution of boundaries (by transmedia) 52–66; versus 'labour' 64n2
workification of tourism (Fast and Jansson) 63
Workplace (Meta) 39–48; communicative norm transgression 46; comparison 47
writing 88, 89, 93, 118, 121

X-Men franchise 18, 19

yatra (journey) metaphor 182, 187
Young, N. (game designer) 167
YouTube 11, 13–14, 17, 28, 87, 137, 138, 143, 149, 151, 154, 156, 185, 187; Kabir Project 180; launch (2005) 136

Zahedi, C. 85
Zeigler, K.R. 143
zero-dimensionality 85–98
Zuckerberg, M. 41

Printed in the United States
by Baker & Taylor Publisher Services